SEEING SILENCE

BOOKS BY MARK C. TAYLOR

Abiding Grace: Time, Modernity, Death
Last Works: Lessons in Leaving
Speed Limits: Where Time Went and Why We Have So Little Left
Recovering Place: Reflections on Stone Hill
Rewiring the Real: In Conversation with William Gaddis,
 Richard Powers, Mark Danielewski, and Don DeLillo
Refiguring the Spiritual: Beuys, Barney, Turrell, Goldsworthy
Crisis on Campus: A Bold Plan for Reforming Our Colleges and Universities
Field Notes from Elsewhere: Reflections on Dying and Living
After God
Mystic Bones
Confidence Games: Money and Markets in a World without Redemption
Grave Matters (with Christian Lammerts)
The Moment of Complexity: Emerging Network Culture
About Religion: Economies of Faith in Virtual Culture
The Picture in Question: Mark Tansey and the Ends of Representation
Hiding
Imagologies: Media Philosophy (with Esa Saarinen)
Nots
Disfiguring: Art, Architecture, Religion
Michael Heizer: Double Negative
Tears
Altarity
Erring: A Postmodern A/Theology
Deconstructing Theology
Journeys to Selfhood: Hegel and Kierkegaard
Religion and the Human Image (with Carl Rashke and James Kirk)
Kierkegaard's Pseudonymous Authorship: A Study of Time and the Self

BOOKS EDITED BY MARK C. TAYLOR

Critical Terms for Religious Studies
Deconstruction in Context: Literature and Philosophy
Unfinished: Essays in Honor of Ray Hart

SEEING SILENCE

MARK C. TAYLOR

THE UNIVERSITY OF CHICAGO PRESS

Chicago and London

The University of Chicago Press, Chicago 60637
The University of Chicago Press, Ltd., London
© 2020 by The University of Chicago
Published 2020
Paperback edition 2022
Printed in the United States of America

31 30 29 28 27 26 25 24 23 22 1 2 3 4 5

ISBN-13: 978-0-226-69352-1 (cloth)
ISBN-13: 978-0-226-82003-3 (paper)
ISBN-13: 978-0-226-69366-8 (e-book)
DOI: https://doi.org/10.7208/chicago/9780226693668.001.0001

Library of Congress Cataloging-in-Publication Data

Names: Taylor, Mark C., 1945– author.
Title: Seeing silence / Mark C. Taylor.
Description: Chicago: University of Chicago Press, 2020. | Includes
 bibliographical references and index.
Identifiers: LCCN 2019038423 | ISBN 9780226693521 (cloth) |
 ISBN 9780226693668 (e-book)
Subjects: LCSH: Silence — Religious aspects. | Silence (Philosophy)
Classification: LCC BL619.85 T39 2020 | DDC 128/.4 — dc23
LC record available at https://lccn.loc.gov/2019038423

for
Kirsten and Aaron
Taylor, Jackson, Elsa, Selma
This is your inheritance.

All profound things, and emotions of things are preceded and attended by Silence.... Silence is the general consecration of the universe. Silence is the invisible laying on of the Divine Pontiff's hands upon the world. Silence is at once the most harmless and the most awful thing in all nature. It speaks of the Reserve Force of Fate. Silence is the only Voice of our God.

HERMAN MELVILLE

At a certain point you say to the woods, to the sea, to the mountains, Now I am ready. Now I will stop and be wholly attentive. You empty yourself and wait, listening. After a time you hear it: there is nothing there. There is nothing but those things only, those created objects, discrete, growing or holding, or swaying, being rained on or raining, held, flooding or ebbing, standing, or spreading. You feel the world's word as a tension, a hum, a single chorused note everywhere the same. That is it: this hum is the silence ... Nature does not utter a peep—just this one.... There is a vibrancy to silence, a suppression, as if someone were gagging the world. But you wait, you give your life's length to listening, and nothing happens. The ice rolls back, and still that single note obtains. The tension, or lack of it, is intolerable. The silence is not actually suppression; instead, it is all there is.

ANNIE DILLARD

CONTENTS

SEEING SILENCE

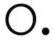

O.

Silence is no weakness of language.
It is, on the contrary, its strength.
It is the weakness of language not to know this.

EDMOND JABÈS

Close your eyes, open your ears. Close your eyes, open your ears and listen. Listen attentively, listen patiently. What do you hear? Now imagine ... try to imagine the impossibility of imagining Now. Imagine, try to imagine not being—not being here, not being now. Not being here, not being now, not being elsewhere, not being anywhere. Imagine being before being. Imagine being after being. Imagine being Not. Imagine not imagining. Imagine not being. What do you hear? Keep listening, listening attentively, listening patiently. Whom do you hear? Whom do you not hear? What do you hear? What do you not hear? Nothing, perhaps? Perhaps nothing? What is the sound of Nothing? Silence, perhaps? Perhaps silence? What does hearing silence sound like? What does hearing silence mean? Does hearing silence mute silence? What does not hearing or not being able to hear silence mean? Keep listening, keep thinking, keep asking until you hear, if not silence itself, echoes of silence by seeing nothing.

Pause. Pause to ponder. Pause to ponder a lingering question: What color is silence? Perhaps white? Perhaps black? Perhaps something in between—something approximating infinite shades of gray? Through a strange synesthesia, to see the invisible is to hear silence, and to hear silence is to see the invisible.

Silence is stillness—stillness is silent. Not merely the absence of noise, silence is the stillness that sounds and resounds in all sounds and echoes in every word. There is no Word without silence, and no silence without Word.

Silence is the ever-receding horizon of words. Words allow silence to speak by unsaying itself. To hear silence is to betray silence—to hear by not hearing, to tell by not telling, to reveal by not revealing. Telling Not. Hearing Not. Revealing Not. The lapse of language is the stillness that stirs in the rustling of words.

Silence. The impossibility *of* silence. Gods, like mortals, sometimes speak, sometimes do not; they sometimes remain silent by speaking, sometimes speak by remaining silent. "Whither is God?" screamed Nietzsche's madman. "I will tell you. *We have killed him*, you and I. All of us are his murderers. But how did we do this?"[1] We have killed God by having forgotten how to hear silence. If, however, to hear silence is to silence silence, then the death of God is unavoidable. The question that remains is whether there is an other silence, a deeper silence, a silence beyond silence yet to be heard in the stillness that surpasses understanding.

Religion is the apprehension of the Unspeakable, Unnamable, Unknowable, Unfigurable once named "God" or "God beyond God." "God" is one of the pseudonyms of "the Real"—there are others, many others. Neither here nor there, neither now nor then, the Real is always near, yet forever distant. It (the gender is insistently neutral) approaches by withdrawing, and withdraws by approaching. The pulsating rhythm of the Real marks and remarks the ebb and flow of life and death. Unspeakable, Unnameable as such, the Real remains shrouded in silence, or, perhaps, silence is the Real itself. Silence is the whence and whither of all that is and everything that is not. We come from and return to silence, and in-between, silence is the in-between, endlessly murmuring to still the noise created to avoid it. A plenitude that is a lack, and a void that is a fullness, the *ligare* of *re-ligare* binds and rebinds us to the silence that haunts all that once seemed real. To hear silence is to find stillness in the midst of the restlessness that makes creative life possible and the inescapability of death acceptable.

Without. Before. From. Beyond. Against. Within. Around. Between. Toward. With. In.... Silence. Not present without being absent, not absent without being present, and, thus, never a position or pro-position, but always a pre-position. Thirteen plus one stations along an errant path that no longer has to be merely the *Via Dolorosa*. The silence that punctuates the stages along life's way allows saying to be said and the Unsayable to be heard. If we listen to silence perhaps gods, and with them mortals, will be reborn. Perhaps.

Nul point: neither negative nor positive, but somewhere in between.

Before the beginning, it's always a question of origin. How does a book originate? Where does the Word come from? Where do any words come from, and where are they heading? What is the origin of this book? How did it begin? Where will it end? Can it ever end?

The beginning is not the same as the origin. As beginning emerges, the origin recedes, leaving in its wake a past that becomes the horizon of a future that endlessly approaches without ever arriving. While the beginning marks a *point* in time, the origin is never present, nor is it absent. The ever-elusive origin that is our end is the silence that forever shadows the present as its missing source.

As everything else, this book began with death—first, the death of the mother, then the death of the father, and finally the death of everyone who once knew them. On September 2, 1992, my father died at the age of eighty-four; almost four years earlier, my mother died five days before Christmas, and nine days before their fiftieth wedding anniversary. During the months following my father's death, my brother, Beryl, and I faced the melancholy task of sorting through and clearing out all the possessions my parents had collected during their time together. Each object held a story—some known, many unknown. Since this was the only house they had ever owned and we had always lived in growing up, every object carried memories of times long forgotten. For days that turned into weeks, we wrestled with countless impossible decisions about what to save and what to dispose of or give away. With a keen sense that our parents were watching, each decision was fraught with the prospect of guilt. How could we discard so much that was so dear to them? Time was short, and the realtor urged us to proceed as quickly as possible so the house could be put on the market before winter.

We began in the basement, made our way through the first and second floors. In the large closet beside our parents' bedroom, we found my father's cameras—his Linhof, which he used for portraits; his treasured 35 mm Leica, with which he took thousands of slides of family life and trips; and the reliable Rolleiflex I had used to learn how to photograph (fig. 1). We eventually reached the attic, where our family, like many others, kept their secrets. We discovered box after box filled with stuff I assumed my mother and father had thrown away long ago—old toys and games, baseball bats and gloves, my first football helmet, an all-wool baseball uniform my father had worn when he played semiprofessional baseball, childhood cowboy hats and boots, a cap pistol, play smoke guns, and the real family shotguns and rifles

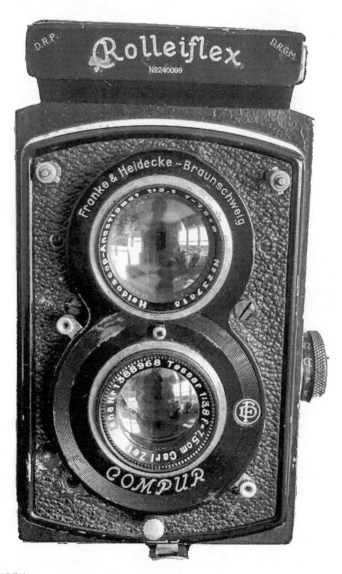

FIGURE I.

my father, brother, and I had used when hunting on the Gettysburg farm where my father was raised and in the mountains surrounding my mother's hometown. Some boxes were labeled, most were not — every one was full of surprises.

In a dark corner under the rafters, we discovered unmarked boxes stuffed with pictures. My father had been a semiprofessional photographer and had started a photography club for students in the New Jersey high school

where he and my mother taught and where I studied. He began taking black-and-white and eventually moved to color. In between, my mother, who sometimes painted, tinted the portraits he took with oil paints applied with Q-tips. The boxes were filled with every kind of photograph he had taken—family snapshots, formal portraits, slides from every holiday and all our family trips. Even though our memories were fuzzy, my brother and I recognized almost all of the faces in these photographs, and we had been told about or recalled, more or less vaguely, the occasions they recorded. Several more boxes, however, were filled with intriguing photographs taken by someone before my mother and father had been born. A few were images of our grandparents when they were young, and even two or three of our great grandparents, but neither my brother nor I had any idea who the rest of these people were. Dozens of nameless faces taken by nameless photographers, who had been important enough for my parents to save until their dying day. Who were these people? Stressed for time, we could not pause to study the photographs, and my brother took them home to examine later.

Though the task was emotionally draining, the days we spent together reliving our past, often in silence, were an important time for my brother and me. Eventually, we finished, the house sold, and we returned to our lives that had been so cruelly interrupted. I never thought about boxes of photographs until a year ago when they unexpectedly arrived in the mail with a note from my brother. "I found these boxes in the garage a few weeks ago. I packed them away after cleaning out the house and forgot about them. Looked through all the pictures and have no idea who these people are. Maybe you'll have better luck. If not, feel free to throw all of them away."

I could not throw away the photographs and slowly became obsessed with them. Most of the photographs seemed to show the small Pennsylvania coal-mining town where my mother had been born, met and married my father, and where both of them had started their teaching careers. On the outskirts of town, they now lie buried with their secrets. Many of the pictures appeared to have been taken at least one hundred years ago. Faces—countless faces of people who were part of our family history but now were destined to remain forever unknown. Who were these people, and why had our parents saved all these pictures? In the years since we had cleaned out the attic, everyone who might have been able to identify the people in the photographs had died. No one was left to tell their stories. Lives once lived are quickly wrapped in a silent cloak of oblivion. Nothing seals death more than questions you can no longer ask.

Half of the images were black-and-white, and half were sepia. Among the dozens of photos, five were especially intriguing. One was a posed por-

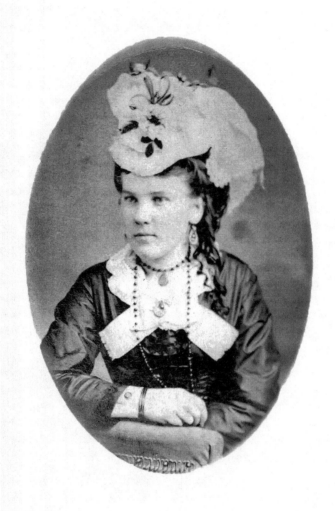

FIGURE 2.

trait of a pensive young woman dressed to the nines—bracelet, beads, what appeared to be a satin dress with a decorative collar, and a headpiece fit for a royal occasion (fig. 2). What was she thinking? Where was she expecting to go? With whom did she hope to spend her life? In another photograph, seven young men wearing overalls and caps posed in the doorway of a brick building beside what looked like the front tire of a Model-T Ford (fig. 3).

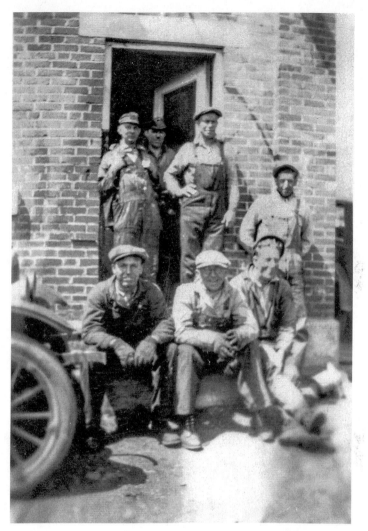

FIGURE 3.

What foreign lands had they come from? Did they work above ground in the machine shop of the mines, while eastern European immigrants labored deep underground? There was another posed portrait taken by a professional photographer (fig. 4). A man bald except for a white wreath of hair and bushy beard stared blankly into space, while his wife, dressed in black, stood beside him with her comforting hand resting on his shoulder. Had their lives been filled with disappointment? If they had ever known joy, you could not read it in the lines of their faces. Did they bequeath my mother her austere Puritanism, which she passed on to me? One photograph with a fuzzy edge

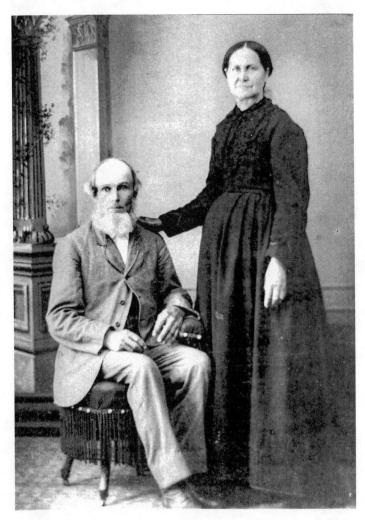

FIGURE 4.

seemed to float in a white void. It showed a dour man with a big moustache wearing a white shirt, vest, and bowtie, holding a fiddle, with a sign behind him that reads "In the Lord Jehovah is everlasting strength" (fig. 5). Was this my mother's maternal grandfather, whose name I do not know? If so, why had my mother been silent about him? The final photograph was of two young girls, who appear to be sisters (fig. 6). They were wearing white dresses and posed as if dancing with one foot barely touching the ground. They were so young, so beautiful, so hopeful. Their faces were filled with anticipation. Did they still dance as they grew older? Did their joy outweigh their sorrow? Did they die fulfilled? Roland Barthes might have been commenting on this

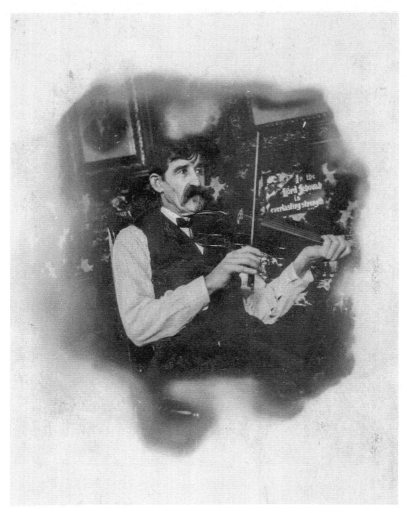

FIGURE 5.

photograph when he wrote, "these two little girls ... how alive they are! They have their whole lives before them; but they are also dead (today), they are then *already* dead (yesterday)."[2]

For several weeks, these photographs haunted me like icons of a reality I could not name. Karl Ove Knausgaard observes, "there is something ghostly about all photographs from this early period. . . . That is perhaps the most incredible thing about these early photographs, that they related to time in such a way that only the most lasting of appearances are visible and the human form is shown to be so fleeting and ephemeral that it leaves no trace anywhere."[3] The longer I looked, the more it seemed they were staring at

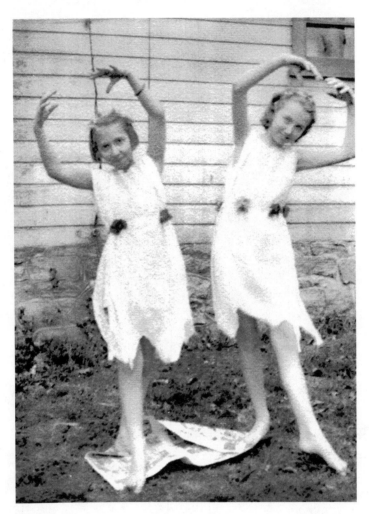

FIGURE 6.

me from a terrifyingly ancient past. But it was not what I saw or didn't see that was so fascinating; it was what I heard in what I couldn't hear that arrested my attention. Gradually, I began to realize that in these baffling family photographs, I was seeing silence—not only the silence of a forgotten past that once was recoverable, but a more profound silence beyond silence that is the origin and end of all that is and all that is not. In the gaze of these faces, I saw the silence that soon would be my own. To hear silence is to listen to the world without you.

I learned many things about light in a dark room. My father taught me how to take pictures, develop film, and print photographs before I was ten years old. I spent countless hours helping him and learning all he could teach me about the art he loved. Eventually, I knew enough to work by myself. For two summers, my job was to take pictures for the Recreation Department at the town's ten playgrounds and deliver finished photos to the office of the local newspaper by 9:00 every Monday morning. As a result of this experience, I understood from a very young age that the eye is not a blank screen upon which images are projected; to the contrary, images are created rather than received, taken, or shot. In the days before the automation of digital cameras, the creation of the image began by coordinating film speed, aperture opening, and length of exposure. The f-stop is the gauge of the opening, clearing, or something like what Derrida following Heidegger and Plato labels the "*khora*" that allows the lighting of the film to occur. The shutter speed regulates the length of the exposure. In this process, everything is a matter of spacing and timing—if the opening is too big or the exposure speed too slow, the photograph is overexposed; if the opening is too small or the shutter speed is too fast, the photograph is underexposed. Like the iris of the eye, the aperture is the invisible hole that makes vision possible.

My early work with black-and-white photography persuaded me that nothing is ever simply black or white—everything is a different shade of gray. As important as the forms and shapes is what occurs or does not occur between them. While the nuances of the interplay of black and white create contrasting images, pure white and pure black are not so much colors as something like the colorless silence from which articulate forms emerge. Everything we see or don't see and hear or don't hear is formed, deformed, and reformed by a play of shades and shadows that creates a penumbra surrounding whatever can be figured. Commenting on the French Impressionist Camille Pissarro, Julian Bell asks, "What is a shadow? Nothing in itself, you might say: a mere local lack of light, in a space that is otherwise lit up. Light, which allows us to see and know the world, is the normal precondition for picturing things. Cast shadows may help us interpret a picture by indicating where light comes from and where objects stand, but if you survey art history, you will find the majority of painters giving them minor parts at most. A minority, however, turns these assumptions upside down, treating shadow as the preexistent condition of light. . . . Take shadow and light as opposite ends of a scale, and the tonal notes lying between them offer a means to compose pictorial music."[4] When the picture, if it is a picture, is a

pure white or pure black monochrome painting, the pictorial music score is the silence of John Cage's *4'33"*.

If taking photographs taught me the importance of modulating light and darkness, printing photographs taught me that what we see and what we hear is decisively shaped by what we do not see and what we do not hear. Every photograph is framed and cropped even if it is not staged. When you zoom in to enlarge an image, worlds that previously had been invisible suddenly appear. When you zoom out with a wide-angle lens, broader perspectives suddenly open. Awareness is always the product of framing, screening, and filtering, which simultaneously figure forms and silence visual and auditory noise. Furthermore, the art of film photography involves not only the subtle contrast of dark and light but also the interplay between negative and positive. When printing photographs, the negative is placed in the enlarger backward and upside down, and when it is projected everything is reversed. As light passes through the film, the negative becomes positive— what is dark on the negative becomes light on the positive, and what is light on the negative becomes dark on the positive. The light interacts with the silver halide on the surface of the photographic paper to reveal a hidden image. The interrelation of the aperture of the enlarger and the length of exposure in printing repeats the interaction of the shutter speed and film speed when taking the photograph. The exposed paper is then placed in a chemical developer, which interacts with the light-sensitive crystals in the emulsion on the paper. This chemical process converts the latent image into a positive photograph. At the precise moment the image is fully formed, the paper must be quickly transferred to the stop bath, which deactivates the developer. If the paper is in the developer too long, the image becomes too dark, and if it is not in the developer long enough, the image is too light. Finally, the photograph is placed in fixer, which removes unexposed crystals on the surface of the paper, preventing the image from darkening until it turns black. When this process is complete, the photograph is washed in water and dried.

What makes photographs so intriguing is not their ability to fix time in a frozen instant, but the gradual process through which the image emerges. Creating a memorable photograph involves many of the coincidences, contradictions, and paradoxes that lend life its vitality and inescapable mystery: the interaction of light and darkness, positivity and negativity, presence and absence, opening and closure, proximity and distance, fixity and fluidity, form and formlessness. Watching the image appear on a blank white surface submerged in liquid is like being present at the moment of birth, or even the instant of the creation of the cosmos. Form emerges from formless-

ness, what had been undifferentiated is differentiated, and the inarticulate is articulated. In this moment, the Word breaks (the waters of) a silence it can never finally be silenced. This was the silence I saw in the photographs hidden in the attic for so many years. The longer I pondered them, the more I knew that if I could learn to listen to this silence, I might be able to hear the wor(l)d anew.

FROM DEATH TO BIRTH

In his widely influential essay "The Work of Art in the Age of Mechanical Reproduction," Walter Benjamin writes, "It is no accident that the portrait was the focal point of early photography. The cult of remembrance of loved ones, absent or dead, offers the last refuge for the cult value of the picture. For the last time the aura emanates from the early photographs in the fleeting expression of a human face."[5] Two of the most influential discussions of photography in the latter half of the twentieth century, developed by Martin Heidegger and Roland Barthes, follow Benjamin in associating photographs with death. Heidegger's view of the photographic image echoes Plato's claim that painting guards "a solemn silence."[6] Heidegger unfolds his argument in his account of Kant's interpretation of the imagination in *Kant and the Problem of Metaphysics*. He takes as his point of departure an image or, more precisely, an image of an image—a photograph of a death mask. This is not just any death mask, it is the death mask of Blaise Pascal, who wrote so memorably in his *Pensées*, "When I consider the short duration of my life, swallowed up in the eternity before and after, the little space which I fill and even can see, engulfed in the immensity of spaces of which I am ignorant and which know me not, I am frightened and am astonished at being here rather than there; for there is no reason why here rather than there, why now rather than then. Who has put me here? By whose order and direction have this place and time been allotted to me? ... The eternal silence of these infinite spaces terrifies me."[7] Though Kant insisted that the starry heavens above, like the moral law within, filled him with awe rather than terror, he could never penetrate the silence that surrounded and pervaded him.

According to Kant, the function of the imagination is to mediate cognition and sensation by schematizing the twelve categories of understanding through the two forms of intuition—space and time. The mind creates the world in its own image by processing the data of the senses through the programmed code of the categories. While this procedure lends experience coherence, it cuts the mind off from ambient surroundings and thereby conceals rather than reveals reality as such. In terms of Maurice Blanchot, cited

by Jacques Lacan, "the word is the death of the thing," or, phrased differently, the image is the death of the Real. "This making-sensible," Heidegger argues, "can now no longer mean: to get an immediate look, intuition from a concept; for the concept, as the represented universal, cannot be represented in a *repraesentatio singularis*, which the intuition certainly is. For that reason, however, the concept is essentially not capable of having a likeness taken."[8]

Word and image make the disappearing without which appearances are impossible appear. By figuring this unavoidable disappearance, the photograph becomes the shadow of death, which is the origin of life. For Heidegger, to become an authentic individual, it is necessary to confront rather than avoid death. Though death is inevitable, it remains elusive because it can never be experienced as such. When death is "there," I am not, and when the "I" is "there," death is not. Death, therefore, can be experienced only in another person's death as an unmasterable alterity. The photograph of the death mask is the figure of the Unfigurable, Unnameable, Unknowable, Unspeakable, which no conception can grasp and upon which every conception depends. Blanchot indirectly suggests the far-reaching implications of Heidegger's reading of Kant.

> If true language is to begin, the life that will carry this language must have experienced its nothingness, must have "trembled in the depths; and everything in it that was fixed and stable must have been shaken." Language can only begin with the void; no fullness, no certainty can ever speak; something essential is lacking in anyone who expresses himself. Negation is tied to language. When I first begin, I do not speak in order to say something, rather a nothing demands to speak, nothing speaks, nothing finds its being in speech and the being of speech is nothing. This formulation explains why literature's ideal has been the following: to say nothing, to speak in order to say nothing. … Literature is a concern for the reality of things, for their unknown, free, and silent existence; literature is their innocence and their forbidden presence, it is the being which protests against revelation, it is the defiance of what does not want to take place outside.[9]

To speak in order to say nothing, to reveal what resists revelation is to remain silent even when speaking.

Barthes goes even farther than Heidegger when he claims that death is the "*eidos*" of the photograph. *Camera Lucida* is an extended exercise in mourning his mother's death. Barthes's endless reflection is set in motion by a particular photograph of his mother he found after her death. "There I was, alone in the apartment where she had died, looking at these pictures of

my mother one by one, under the lamp, gradually moving back in time with her, looking for the truth of the face I had loved. And I found it. The photograph was very old. The corners were blunted from having been pasted into an album, the sepia print had faded, and the picture managed to show two children standing together at the end of a little wooden bridge in a glassed-in conservatory, what was called a Winter Garden in those days. My mother was five at the time (1898), her brother was seven."[10] Though other photographs are included in the book, this one is conspicuously missing. This absence is not accidental but is omnipresent, and it renders every image and all Barthes's words spectral. Each image has what he labels a "*punctum*," which, like the navel of Freud's dream, is a point of contact with the unknowable. In contrast to the "*studium*," which is a general code that makes images readable, the punctum is a "string, speck, cut, hole—and also a cast of dice."[11] So understood, the punctum functions as the opening, lighting, aperture that allows the articulation of the singular, which is the trace of the missed encounter with the Real.

> What the Photograph reproduces to infinity has occurred only once: the Photograph mechanically repeats what could never be repeated existentially. In the Photograph, the event is never transcended for the sake of something else: the Photograph always leads the corpus I need back to the body I see; it is the absolute Particular, the sovereign Contingency matte and somehow stupid, the *This* (this photograph, and not Photography), in short what Lacan calls the *Tuché*, the Occasion, the Encounter, the Real, in its indefatigable expression. In order to designate reality, Buddhism, *sunya*, the void; but better still: *tathata*, as Alan Watts has it, the fact of being this, of being thus, of being so; *tat* means *that* in Sanskrit and suggests the gesture of the child pointing his finger at something and saying: *that, there it is, lo!* but says nothing else; a photograph cannot be transformed (spoken) philosophically, it is wholly ballasted by the contingency of which it is the weightless, transparent envelope.

Even this experience—if it is an experience—cannot overcome the interminability of mourning and melancholy because for Barthes, every death is a "total undialectical death."[12] The negation of the image cannot be negated, and, therefore, the death of the Word cannot be overcome. The spectral photograph is the trace of the disappearance of real presence that leaves the self exiled from itself and leaves the world disenchanted. One name for this incomprehensible event is the death *of* God—both the death God harbors and the death of the God that harbors death. Commenting on Heidegger's reading of Kant's interpretation of the imagination, Jean-Luc Nancy argues,

"The true beginning of the death of God is the removal of divine intuition from the world and from experience, which is then precisely the assignation of death to the place of the origin, there where a world springs from nothing, in an inverted repetition of the gesture of creation."[13]

But why? Why must the place of origin always be the space and time of death and never birth? Why are "serious" writers always preoccupied with death, mourning, melancholy, dread, and despair? Why for so many writers and artists is profundity dark rather than light, perhaps unbearably light? Why are surfaces always superficial and never deep? Why are so many people—especially writers, philosophers, artists, and critics—afraid to admit levity, pleasure, contentment, beauty, even joy? Susan Sontag, doubtlessly expressing the conviction of her longtime partner Annie Leibovitz, insists "the most enduring triumph of photography has been its aptitude for discovering beauty in the humble, the inane, the decrepit. At the very least, the real has a pathos. And that pathos is—beauty."[14] Why not embrace the beautiful rather than the monstrous? Why can't negation be negated? What if philosophy took as its point of departure being-toward-birth rather than being-toward-death? The no-longer of death and the not-yet of birth reflect each other but are not quite mirror images of the same impossibility. When birth occurs I am not, and when the "I" is, birth has always already occurred. The silence of the beginning is not the same as the silence of the end, and the silence of the middle differs from both. If, as Blanchot insists, "what makes language possible is that it strives for the impossible," then *in medias res* the Word might simultaneously strive for the silence of Before and the Silence of After.[15] If the impossibility *of* silence were nonetheless possible, there might be an inverted repetition in which the past of birth and origin becomes our future, and the future of death and destruction becomes our past.

The *punctum* is not necessarily the *eidos* of death. The poet Edmond Jabès, who understood the dimensions of the point better than any other writer, goes so far as to insist that "the point is God."[16] Citing the *Kabbalah*, he elaborates, "When God, *El*, wanted to reveal Himself He appeared as a point." The point punctuates language with the silence that makes words possible yet leaves them inadequate. In the concluding volume of his magisterial work, *The Book of Questions*, imaginary rabbis continue their "infinite conversation."

> *("God was the first to break the silence,"* he said.
>
> *"It is this breakage we try to translate into human languages."*
>
> *"Vowels make us see, make us hear. Vowels are image and song. In our ancestors' script, vowels are points.*

"God refused image and language in order to be Himself the point. He is image in the absence of images, language in the absence of language, point in the absence of points," he said.)[17]

The point can be natal as well as fatal. Not only the *Zim Zum*, but also the bindu marks the navel of the universe, which is the point where creation begins. The white bindu dwells within the *bindu visarga*, which is related to Shiva and the moon, and the red, rather than black, bindu is within *muladhara*, which is related to Shakti and the Sun. The interplay of dark and light, moon and sun, creates and sustains the rhythm of the cosmos. Is this the red of Angelus Silesius's rose that is without why?

SILENCES

Ludwig Wittgenstein famously concluded his influential *Tractatus Logico-philosophicus* by asserting, "Whereof one cannot speak thereof one must be silent." Less often noted is that a few lines earlier, he claims, "There is indeed the inexpressible. This *shows* itself; it is the mystical."[18] The terse style of his numbered propositions reflected the austere style of his fellow Viennese Adolf Loos, who confidently declared that ornament is a crime. During an era when artists and architects were promoting the excesses of Art Deco, Wittgenstein and Loos insisted that clarity, purity, and precision were not merely aesthetic matters but actually held metaphysical and moral significance. Their aesthetic was ascetic. The same desire for purity that led Wittgenstein to strip away every unnecessary word led him to withdraw from the clamor of fin de siècle Vienna and retreat to stillness at the far end of Lustrafjordin Skjolden, Norway, where he found the peace and solitude that enabled him to develop his writing in new directions and to become the architect he had always longed to be. Looking back on this period, he wrote, "I cannot imagine that I could have worked in any other place as I have done here. It is the silence and, perhaps, the magnificent landscape; I mean its quiet gravity."[19] His biographer, Ray Monk, underscores the importance of his time in Skjolden.

> The beauty of the countryside—ideal for the long, solitary walks he needed as both a relaxation and a meditation—produced in him a kind of euphoria. Together they created the perfect conditions in which to think. It was perhaps the only time in his life when he had no doubts that he was in the right place, doing the right thing, and the year he spent in Skjolden was possibly the most productive of his life. Years later he used to look back on it as the one

time that he had some thoughts that were entirely his own, when he had even "brought to life new movements in thinking." "*Then* my mind was on fire!" he used to say.[20]

For many of the most original minds, silence fans the embers of creativity and enriches life far beyond what words and images can directly convey. The elegant austerity of Wittgenstein's propositional *Tractatus* expresses a puritanical reticence that characterizes some of the most important modern art, architecture, and literature. However, its simple propositional style cannot convey the multiple sounds of silence.

Paradoxically, silence is polyphonic. Beckett shrewdly warns, "Silence, yes, but what silence! For it is all very fine to keep silence, but one has also to consider the kind of silence one keeps."[21] In his probing study of what he describes as modern anti-literature, Ihab Hassan identifies two types of silence.

> In one, language aspires to Nothing; in the other, it aspires to All. The correlative of the first is Number, and the correlative of the second is Action. In the former, literature moves, as we have noted Blanchot says, toward its disappearance. This is perhaps the strain of Mallarmé, Kafka, and Beckett. In the latter, literature strains, as Gaston Bachelard believes, toward a monstrous re-integration of the self in "la vie ardente." . . . Both strains find their source in a kind of terror.[22]

As we will see in what follows, these two modalities of silence correspond to the two basic drives that, according to Freud, underlie human life—*Thanatos* and *Eros*. Though Susan Sontag never directly refers to Hassan's work in her influential essay, "The Aesthetics of Silence," her argument rests on an elaboration of his analysis. What Hassan describes as positive and negative forms of silence, Sontag labels loud and soft silence.

> The loud style is a function of the unstable antithesis of "plenum" and "void." Notoriously, the sensuous, ecstatic, translinguistic apprehension of the plenum can collapse in a terrible, almost instantaneous plunge into the void of negative silence. With all its awareness of risk-taking (the hazards of spiritual nausea, even of madness), this advocacy of silence tends to be frenetic, and overgeneralizing. It is also frequently apocalyptic, and must endure the indignity of all apocalyptic thinking: namely, to prophecy the end, to see the day come, to outlive it. . . .
>
> The other way of talking about silence is more cautious. Basically, it pre-

sents itself as an extension of a main feature of traditional classicism: the concern with modes of propriety, with standards of seemliness. Silence is only "reticence" stepped up to the nth degree.... But while the clamorous style of proclaiming the rhetoric of silence may seem more passionate, more subdued advocates (like Cage, Johns) are saying something equally drastic. They are reacting to the same idea of art's absolute aspirations (by programmatic disavowals of art); they share the same disdain for the "meanings" established by bourgeois rationalist culture, indeed for culture itself in the familiar sense.[23]

While these contrasts are helpful, Hassan and Sontag overlook the more fundamental distinction between the unsaid, which can be expressed but is voluntarily withheld, and the Unsayable, which can never be expressed. Gerard Manley Hopkins describes voluntary silence in his poem "The Habit of Perfection."

> ELECTED Silence, sing to me
> And beat upon my whorlèd ear,
> Pipe me to pastures still and be
> The music that I care to hear
>
> Shape nothing, lips; be lovely-dumb:
> It is the shut, the curfew sent
> From there where all surrenders come
> Which only makes you eloquent.
>
> Be shellèd, eyes, with double dark
> And find the uncreated light:
> This ruck and reel which you remark
> Coils, keeps, and teases simple sight.[24]

Without, Before, From, Beyond, Against, Within, Around, Between, With, In "elected silence" there is a more profound silence that remains unfathomable. The relation between these two silences is asymmetrical—the unsaid presupposes the Unsayable, which lends it depth and weight.

The longer one ponders the multiple dimensions of silence, the richer its resonances become. Silence can be divine or demonic, loving or hateful, restorative or traumatic, comforting or cruel. It can unify or isolate, allow freedom or impose bondage and repression. Silence can be a form of resistance or submission, punishment or reward. It can express awe or horror, astonishment or bafflement, joy or sorrow. In addition to this, silence changes

with place and time. The silence of the city is not the same as the silence of the country, and the silence of the forest is not the same as the silence of the desert. The silence of the monk's cell is not the same as the silence of a jail cell. Northern silence is not the same as southern silence, and eastern silence is not the same as western silence. The silence of winter is not the same as the silence of summer, and the silence of autumn is not the same as the silence of spring. The silence of the past is not the same as the silence of the future, the silence of the beginning is not the same as the silence of the end, the silence of birth is not the same as the silence of death. The silence of youth is not the same as the silence of age, and the silence of midday is not the same as the silence of midnight. To sound the depths of silence, it is necessary to be patiently attentive to its many elusive nuances. How you hear silence determines the course and dis-course of your life.

ARTFUL SILENCE

Why approach silence through art? More specifically, why approach silence through visual art? What could it possibly mean to see silence? And what could it possibly mean to hear the invisible?

"Silence" is such a strange—perhaps even impossible—word. It inevitably negates itself in its very articulation. In this way, "silence" *betrays* itself—it is simultaneously transgressive and revealing. To say "silence" is to break silence, and as Beckett cautions, "silence once broken will never again be whole."[25] Georges Bataille describes "silence" as a "slippery word [*un mot glissant*]." "I say *word*," he explains, "it could just as well be the sentence into which one inserts the word, but I limit myself to the word *silence*. It is already, as I have said, the abolition of the sound that the word is; among all words it is the most perverse, or the most poetic: it is the token of its own death."[26] *Le mot glissant* "says" the Unsayable by unsaying itself in the very act of saying. In this way, silence shows itself by withdrawing in and through its own expression.

"Silence" poses an abiding question that extends far beyond this particular word. How is it possible to include in discourse that which is the very condition of the possibility of discourse and by its very nature eludes discourse? Fraught with ambiguity and obscurity, silence can only be art(-)iculated artfully.

What if Hegel were wrong? What if art is not a thing of the past? What if not everything can be said? Can be known? Can be named? Can be figured? Can be coded? Hegel's name is not always proper—it is also shorthand for what literary critic Frank Kermode and novelist Julian Barnes aptly describe

as "the sense of an ending." The end of art. The end of philosophy. The end of metaphysics. The end of history. The end of "man." In this context, the end does not mean cessation but the closure that comes with the complete comprehension of the logic and rationale of everything that is. Though all is not (yet) known, all is in principle knowable. In the language of Hegel's speculative philosophy, the Real is rational and the rational is real. Modifying Heidegger's famous claim in "The Question Concerning Technology," it becomes possible to conclude that everywhere man turns, he *hears* only himself. At this point of closure, Heidegger asks, what is the task of thinking at the end of philosophy? Responding to his own question, he critically invokes Hegel's claim to have reached absolute knowledge. "Questioning in this way, we can become aware of how something which is no longer the matter of philosophy to think conceals itself precisely where philosophy has brought its matter to absolute knowledge and to ultimate evidence."[27] The task of thinking at the end of philosophy is, therefore, to think the unthought that makes thinking possible. In alternative terms, the task of thinking at the end of modernity and postmodernity is to hear the unheard that makes hearing language and everything else possible. This unheard, which might be unhearable, is silence.

Silence is the horizon, limit, edge, border, margin of language as well as life. If Hegel is right, every conversation is finite because it comes to an end when perfect clarity and transparency are achieved. If, however, Hegel is wrong, every conversation is infinite—*un entretien infini*—because something unsayable and unhearable is forever held (*tenir*) between (*entre*) participants. Probing "the limit-experience" in *L'entretien infini*, Blanchot, commenting on Bataille's *L'expérience intérieure*, writes,

Thus, at present, the problem brought forth by the limit-experience is the following: how can the absolute (in the form of totality) still be gotten beyond. Having arrived at the summit by his actions, how can man—he the universal, the eternal, always accomplishing himself, always accomplished and repeating himself in a Discourse that does no more than endlessly speak of itself—not hold to this sufficiency, and go on to put himself, as such, in question? Properly speaking, he cannot. And yet the interior experience [*l'expérience intérieure*] insists upon this event that does not belong to possibility; it opens in this already achieved being an infinitesimal interstice by which all that is suddenly allows itself to be exceeded, deposed by an addition that escapes and goes beyond. A strange surplus. What is this excess that makes the conclusion ever and always unfinished? Whence comes this movement of exceeding whose measure is not given by the power that is capable of everything? What

is this "possibility," after the realization of every possibility, that would offer itself as the moment capable of reversing or silently withdrawing them all?[28]

Since the "infinitesimal interstice," which is the "strange surplus" of language, cannot be represented or comprehended in concepts or words, Hegel's strategy of exhaustively translating all images and representations (*Vorstellungen*) into concepts (*Begriffe*) is bound to fail. There is always an overlooked, exceeded, repressed remainder that cannot be articulated and, thus, forever remains silent.

In the final analysis, Hegel was wrong—we apprehend much that we cannot comprehend, and this apprehension lends life its creative edge. To begin to fathom, which is not to say plumb, this apprehension, it is necessary to reverse the Hegelian trajectory, which has informed much of the history of the West by retranslating ideas and concepts into images and representations. This reversal disrupts the processes of disenchantment and demystification that have defined modernity and postmodernity. As we will see, the complicated rhythms of these intertwined trajectories are not only a matter of language and knowledge, but are also cosmological, anthropological, and theological or a/theological.

No artist has heard the impossibility *of* silence more clearly than John Cage. In 1961, Cage published a book entitled simply *Silence*, which includes two essays that are actually one—"Lecture on Nothing" and "Lecture on Something." The work is graphically designed as stanzas in a musical score. Cage explains, "There are four measures in each line and twelve lines in each unit of the rhythmic structure. There are forty-eight such units, each having forty-eight measures. . . . The text is printed in four columns to facilitate a rhythmic reading. . . . This should not be done in an artificial manner . . . , but with the rubato which one uses in everyday speech."[29] Ample white space and highlighted punctuation leave gaps and intervals that Cage refuses to fill or close. He begins "Nothing,"

I am here , and there is nothing to say.
those who wish to get somewhere , let them leave at
any moment . What we re-quire is
silence ; but what silence requires
 is that I go on talking .

If there is nothing to say, it would seem to be prudent to remain silent. If, however, one's purpose is to allow silence to be spoken and heard, then, Cage insists, it is necessary to go on talking. His wager is that the Unsayable can

be said in and through the failure of language. "Something" turns out to be "much ado about nothing." Cage concludes without ending,

Nothing has been said .
Nothing is communicated. And there is no use of symbols or
intellectual references. No thing in life requires a symbol since it is clearly
what it is: a visible manifestation of an invisible nothing.
All somethings equally par-take of that life-giving nothing.
But to go on again about someone said: "What?"
And I forgot to mention it before. He said, "What about
All those silences?" How do I know when[30]

Cage's *Silence* is something like his commentary on his famous work *4′33″*, which he composed at Black Mountain College, where he was teaching with the painter Franz Klein and the poet Charles Olson. The work debuted on August 29, 1952, in Maverick Concert Hall in the avant-garde enclave of Woodstock, New York. Accomplished pianist David Tudor walked on stage, took his seat in front of the piano, closed the keyboard cover and sat silently. There were three movements of 30″, 2′23″, and 1′40″, precisely timed with a stopwatch. At the beginning of each movement, he would repeat the gesture of opening and closing the keyboard cover and sitting silently. Many in the audience were frustrated, some were outraged and regarded the event as an exercise in self-indulgence. Toby Kamps explains that, for Cage, "far from a stunt, the work stood as the culmination of years of research into alternate models of music and consciousness. Indian classical arts in particular impressed him with the view that 'art imitates nature in her manner of operation.' From this standpoint, the main function of art is not representation in any conventional sense but should be understood instead as a process by which the artwork opens onto, and thus illuminates, the time, space, and context in which it is located. Although Cage was unclear on whether his formal studies of Buddhism predated *4′33″*, the piece clearly has deep correspondences with the philosophy of Zen."[31]

Cage's purpose in *4′33″* remains, perhaps deliberately, unclear. Is the piece designed to allow the audience to hear silence or to help them understand the impossibility of silence by becoming attentive to ambient noise that usually is repressed? In the course of his research, Cage visited the anechoic chamber at Harvard University. In this quietest of all environments, he was surprised that what he heard was not silence but the sound of his beating heart, the murmur of blood circulating in his arteries and veins, and the buzz of electricity pulsing in his brain. As a result of this experience, Cage went

so far as to declare, "There is no such thing as silence." Expressing his frustration with the response to the initial performance of *4′33″*, he complained, "They missed the point. . . . What they thought was silence, because they didn't know how to listen, was full of accidental sounds. You could hear the wind stirring outside during the first movement. During the second, raindrops began pattering on the roof, and during the third the people themselves made all kinds of interesting sounds as they talked or walked out."[32]

While Cage eventually admitted the impossibility of hearing silence, his quest had been set in motion by a vision of something approaching silence in paintings by his longtime friend Robert Rauschenberg. Cage prefaces his "Lecture on Nothing" with a parenthetical aside.

(The white paintings caught whatever fell on them; why did I not look at them with my magnifying glass? Only because I did not yet have one? Do you agree with the statement: After all, nature is better than art?) Where does beauty begin and where does it end? Where it ends is where the artist begins. In this way we get our navigation done for us. If you hear that Rauschenberg has painted a new painting, the wisest thing to do is to drop everything and manage one way or another to see it. . . . The thing is, we get the point more quickly when we realize it is we looking rather than that we may not be seeing.[33]

On the white surface of Rauschenberg's canvases, Cage saw the silence that allowed him to hear what he never before had heard. Morgan Falconer explains that "Cage viewed the 'White Paintings' less as images that projected the artist's expression, than as backdrops against which the flux of the world might stand out, an understanding at which he arrived through his appreciation of Henri Bergson and Zen Buddhism."[34] As we will see, the contemplative silence of the Zen rock garden makes it possible to hear the nearly mute eloquence of the quotidian.

It is surprising how many modern and contemporary visual artists have been preoccupied with silence. Duchamp went so far as to declare, "Silence is the best art one can produce: It is unsigned and for the benefit of everyone."[35] For many artists, the silence of the invisible and the invisibility of silence are questions of black or white. Whether plenum or void, the pure white or black surface cannot be translated into words without leaving an inexpressible remainder. Rauschenberg was not the only artist preoccupied with white monochromatic or near-monochromatic painting. Others included Jasper Johns, Kazimir Malevich, Ellsworth Kelly, Agnes Martin, Robert Ryman, Mino Argento, and Lucio Fontana. What Malevich and

Rauschenberg saw in white they also painted in black. Other artists were exclusively preoccupied with black monochromes or quasi-monochromes—Ad Reinhardt, Mark Rothko, Frank Stella, Alan McCollum, Mary Corse, Jennie C. Jones, and Oliver Mosset. This is not, of course, to suggest that these different paintings are the same any more than it is to insist the sounds silence tolls are indistinguishable. To the contrary, the indeterminacy of the images creates the possibility of hearing the polyphony of silence.

From July 30 to April 21, 2013, the Menil Foundation in Houston mounted an exhibition entitled *Silence*. For reasons that will become apparent in what follows, it is important to note that this exhibition was adjacent to the Rothko Chapel, whose entrance is marked by Barnett Newman's sculpture of a pyramid whose tip has been knocked off and on which a broken obelisk is precariously balanced.[36] The chapel was initially designed by Philip Johnson to display Rothko's fourteen black quasi-monotone paintings, which he entitled *Stations of the Cross*. Curators Josef Helfenstein and Lawrence Rinder write, "This exhibition and catalogue project comes at an especially noisy moment, as the din of digital life increasingly hollows out silence and any attendant powers of concentration."[37] This important exhibition, which received too little critical attention, thoughtfully explored multiple dimensions of silence raging from the latent spirituality of Reinhardt's abstract paintings to Andy Warhol's photograph *Sing Sing's Death Chamber*, which was the source for his *Electric Chair* series, as well as chilling works by Andreas Sterzing and Gran Fury, both entitled *silence = death*. In addition to the printed score for Cage's *4'33"*, other notable works in the exhibition included Joseph Beuys, *The Silence, The Silence of Marcel Duchamp Is Overrated, Noiseless Blackboard Eraser*; Marcel Duchamp, *With Hidden Noise*; Mark Manders, *Silent Head on Concrete Floor*; Christian Marclay, *Gold Silence (The Electric Chair), Pink Silence (The Electric Chair), Silver Silence (The Electric Chair), Yellow Silence (The Electric Chair)*; and Bruce Nauman, *Violins Violence Silence*. The exhibition also included Ingmar Bergman's *The Silence*, which concludes his dark trilogy whose previous films were *Through a Glass Darkly* and *Winter Light*.

The most provocative work in the show, inspired by Cage's *4'33"*, was the record of a performance piece, *One Year Performance 1978–1979*, by the Taiwanese-born artist Tehching Hsieh, who locked himself in an 11'6" × 9' × 8' cage from September 30, 1978 to September 29, 1979. Kamps explains that the cage was equipped with a cot, lightbulb, and bucket and was located inside a New York City loft. For the entire year, Hsieh did not talk, read, write, watch television, or listen to the radio. Visitors were permitted to view

the performance at designated times, and a lawyer certified that the artist never left the cage.[38] Roberta Smith underscores the important relation of this performance to other works with similar ambitions.

> The extended duration of Mr. Hsieh's pieces aligns him with more peace-loving meditative artists who measure time through calm, unvarying repetition. Examples include Hanne Darboven's journal-like scrawls; Roman Opalka's gray number paintings; Jonathan Borofsky's 1969–1970 "Counting from 1 to 2,740,321," a waist-high stack of typing paper covered with hand-written numbers held down by a large plastic ruby; and just about anything by On Kawara, best known for his date paintings. It is the compression of these two strains that gives Mr. Hsieh's work its impact. You comprehend their extent in the instant; thinking them through makes them expand in your mind.[39]

The broad range of works in this exhibition underscores the importance of the visual arts for a renewed appreciation for the abiding significance of silence.

In the following pages, I will attempt to hear this stillest of words by taking as my point of departure the work of visual artists: "Before": James Turrell; "From": Barnett Newman; "Beyond": Ad Reinhardt; "Against": Mark Rothko; "Within": Anish Kapoor; "Between": Michael Heizer; "Toward": Donald Judd and Robert Irwin; "Around": Ellsworth Kelly; "With": Tadao Ando and Zen rock gardens. I will attempt to create a dialogue by establishing what is, in effect, an infinite conversation among artists, writers, philosophers, and theologians. Reversing while at the same time repeating the *Via Dolorosa*, the arc of this journey bends toward silence. As Blanchot writing on Kafka and literature insists, "To write is to involve one's existence, one's values and, to a certain extent, to deny perfection; but it is always the hope of writing perfectly, the hope for perfection. And to write is finally to be responsible for the impossibility of writing, to be, like the heavens, silent, 'an echo only for the dumb'; but to write is to name silence, to write while forbidding oneself to write."[40] The question that lingers after (the) all has been said is: can the *Via Dolorosa* also be a *Via Jubilosa*?

I.

WITHOUT

The present state of the world and the whole of life is diseased. If I were a doctor and were asked for my advice, I should reply: Create Silence! Bring men to silence. The Word of God cannot be heard in the noisy world of today. And even if it were blazoned forth with the panoply of noise so that it could be heard in the midst of all the other noise, then it would no longer be the Word of God. Therefore create Silence.

SØREN KIERKEGAARD

WOODLAND TRAILS

For many years, I have spent late afternoons year round walking, running, and skiing on the woodland trail that follows the crest of Stone Hill. The silence of the forest changes with the seasons. In winter, silence is cold and brittle, and occasionally is broken by a snapping branch or cracking ice on the nearby pond. Spring silence is moist with the expectation of buds and leaves about to burst. Often chipmunks and squirrels chatter, but birds rarely call. Summer silence is hot and dusty. The heat of the day quiets all but a bird whose melodious song makes the silence surrounding it all the more vibrant. Though I have heard this call for more than forty years, I still do not know the name of this singing bird. Along with the seasons, silence changes with the light. My favorite silence on Stone Hill is autumnal. As August gives way to September, fields of goldenrod turn yellow and leaves in this North Country begin to change their color early. Having begun its southward journey several months earlier, the sun is lower in the sky, and its rays reflected from the colorful fields and leaves cast a mellow glow. In late afternoon, the buzzing of insects sometimes subsides and leaves in its wake a very special

silence I have heard nowhere else. It is as if the light becomes a palpable presence pressing on the tympanum of the ear to create a resonance that lasts long after darkness falls. The silent sound of this autumnal light is always tinged with a strangely sweet melancholy for what is passing away. To see this light is to hear a silence that is truly golden.

More than a century and a half ago 130 miles directly east of Stone Hill, Henry David Thoreau withdrew to Walden Pond to get away from the speed of the expanding railroad, the buzz of the newly invented telegraph, and the ceaseless chatter of village busybodies. Though he never said so, Thoreau agreed with Pascal, who believed that "all of humanity's problems stem from man's inability to sit quietly in a room alone."[1] After building his own room in the woods, Thoreau labored and meditated for two years. When he emerged, he wrote, "Our inventions are wont to be pretty toys, which distract attention from serious things. They are but improved means to an unimproved end. . . . We are in great haste to construct a magnetic telegraph from Maine to Texas; but Maine and Texas, it may be, have nothing important to communicate."[2]

Today many people take their newfangled inventions and pretty toys with them into the forest. I often meet students from the nearby college and visitors to the art museum at the other end of the trail. They are usually alone and more often than not are talking on their cell phones or listening to music on their iPods. Sometimes I stop to ask why they bring their devices into the woods rather than enjoy the quiet of the forest. The most common response is bafflement—a look that suggests that the question is not why they have earbuds but why I do not. Occasionally, very occasionally, someone averts his or her gaze, suggesting a hint of embarrassment or guilt. Rather than earplugs to create a sense of silence by keeping out noise, earbuds and headphones let in noise to mute the silence that seems unbearable to so many people. It is clear that it has never occurred to most of the runners and walkers I meet along the woodland path not to bring their phones with them. Phones and iPods as well as many other devices have become prostheses without which people think they cannot live.

Why has this occurred? Why have we become addicted to noise? Why have we forgotten how to hear silence? Why do we dread silence and seek to avoid it? Why is silence a threat and not a draw? Why do we crave the din and need the buzz? Why are we hooked on noise?

The word "noise" derives from the Latin *nausea* ("seasickness" with extended senses in popular usage, e.g., "unpleasant situation," "noisy confusion") and the Greek *nausea* (from *naus*, ship) by way of the Old French *noyse*.[3] This etymology suggests that noise is associated with sickness. Ever

the discerning diagnostician, Michel Serres writes, "Countless illnesses come from not knowing when to be silent or how to live anywhere but inside a hard shell of words that chaff and scratch. Language kills time, silence is more golden than a golden tongue, giving us back duration, our only real treasure, causing our shocked senses, sealed tight by the thundering of language and the intimidation of sense to blossom. Taste, listen, sniff, caress, examine — silently."[4] Is there a cure for this sickness? Might curing oneself of noisy distraction be redemptive? If, as Melville suggests, "Silence is the only Voice of our God," then noise might be the death of God, and the cultivation of silence might make it possible again to hear what once was named "God."

CULTIVATING AD-DICTION

Modernity and its extension in postmodernity are noisy — to be modern one must learn to live *without* silence. Modernization, industrialization, and urbanization are bound in recursive loops that increase the speed and volume of life. When people move from the country to the city, and countries shift from agricultural to industrial economies, the decibel level rises and silence eventually all but disappears. With the transition from industrial capitalism first to consumer capitalism and then to finance capitalism, noise both changes and expands. This noise is not only audio but also visual. As modernity morphs into postmodernity, the loud noise of factories and machines comes to be accompanied by the incessant hum of computers and electronic devices connected in local and global networks transmitting millions of sound bites and images that assault the senses night and day. With changes in the technologies of production and reproduction, the external noise of industrial machines is intensified by electronic and digital noises that are both pervasive and invasive. Private space and time disappear in the relentless din and glare of cacophonous public space and time. For some people, proliferating noise is a welcome sign of progress; for others, it is a symptom of the metastasizing disease that plagues the modern and postmodern worlds. In his book *The Perennial Philosophy*, published in 1945, Aldous Huxley writes,

> The twentieth century is, among other things, the Age of Noise, mental noise and noise of desire — we hold history's record for all of them. And no wonder; for all the resources of our almost miraculous technology have been thrown into the current assault against silence. The most popular and influential of all recent inventions, the radio, is nothing but a conduit through which prefabricated din can flow into our homes. And this din gets deeper, of course,

than the ear-drums. It penetrates the mind, filling it with a babel of distractions—news items, mutually irrelevant bits of information, blasts of corybantic or sentimental music, continually repeated doses of drama that bring no catharsis, but merely create a craving for daily or even hourly emotional enemas. And where, as in most countries, the broadcasting stations support themselves by selling time to advertisers, the noise is carried from the ears, through the realms of phantasy, knowledge and feeling to the ego's central core of wish and desire.[5]

Not everyone is so adverse to noise. From the beginning of modern art in the ateliers of Europe to its flourishing at Black Mountain College and in the studios of SoHo, artists have been fascinated by noise. French economist, social theorist, and political advisor Jacques Attali begins his suggestive study *Noise: The Political Economy of Music* by arguing:

Art bears the mark of its time. Does this mean that it is a clear image? A strategy for understanding? An instrument of struggle? In the codes that structure noise and its mutations we glimpse a new theoretical practice and reading: *establishing relations between the history of people and the dynamics of the economy on the one hand, and the history of the ordering of noise in codes on the other; predicting the evolution of one by the forms of the other; combining economics and aesthetics; demonstrating that music is prophetic and that social organization echoes it.*[6]

What Attali excludes is as suggestive as what he includes—read against the grain, his analysis of noise helps to illuminate the relationship between silence and the visual arts.

Among the first twentieth-century artists to recognize the aesthetic, economic, and political significance of noise were the Italian Futurists. On February 20, 1909, Filippo Marinetti published "The Futurist Manifesto" on the front page of *Le Figaro*. In this paean to speed and noise, he writes,

We declare that the splendor of the world has been enriched by a new beauty: the beauty of speed. A racing automobile with its bonnet adorned with great tubes like serpents with explosive breath ... a roaring motor car which seems to run on machine-gun fire, is more beautiful than the Victory of Samothrace....

We will sing of the great crowds agitated by work, pleasure and revolt; the multi-colored and polyphonic surf of revolutions in modern capitals: the nocturnal vibration of the arsenals and the workshops beneath their violent

electric moons: gluttonous railway stations devouring smoking serpents; factories suspended from the clouds by the thread of their smoke; … adventurous steamers sniffing the horizon; great-breasted locomotives, puffing on the rails like enormous steel horses with long tubes for bridle, and the gliding flight of airplanes whose propeller sounds like the flapping of a flag in the applause of enthusiastic crowds.[7]

During the following decades, the noise Marinetti venerated turned deadly. As Stephen Kern points out, the crisis of August 1914 would have been "unfathomable to anyone who had lived before the age of electronic communication. In the summer of 1914 the men in power lost their bearings in the hectic rush paced by flurries of telegrams, telephone conversations, memos, and press releases; hard-boiled politicians broke down and seasoned negotiators cracked under the pressure of tense confrontations and sleepless nights, agonizing over the probable disastrous consequences of their snap judgments and hasty actions."[8] Snap judgments and hasty actions led to the explosive violence of the first global war.

Where others heard the sounds of death and destruction Marinetti's protégé Luigi Russolo heard music in modern machinic noise. What Marinetti had done for literary and visual arts, Russolo did for musical arts. Barclay Brown explains the long-term influence of Russolo's work. "The doctrines of *musique concrète* find their first expression in Russolo's opening manifesto (from March 1913), which envisions entire symphonies composed of the sounds of everyday urban life. Russolo's awareness of the sea of sound in which we live, his consciousness of the expressive musical possibilities of noise inevitably link him with such contemporary figures as Pierre Schaeffer and John Cage."[9] Writing in Italy in the midst of war (1916), he issued his own ode to noise — *The Art of Noise: Futurist Manifesto*. Peace, tranquility, and silence, he argues, are the past; disruption, unrest, and noise are the future. "Ancient life was all silence. In the nineteenth century, with the invention of machines, Noise was born. Today, Noise is triumphant and reigns sovereign over the sensibility of men. Through many centuries life unfolded silently, or at least quietly. The loudest of noises that interrupted this silence was neither intense, nor prolonged, nor varied. After all, if we overlook the exceptional movements of the earth's crust, hurricanes, storms, avalanches, and waterfalls, nature is silent." For modernists, silence is a thing of the past. Russolo continues, "We futurists have all deeply loved and enjoyed the harmonies of the great masters. Beethoven and Wagner have stirred our nerves and hearts for years. Now we have had enough of them, and *we delight much more in combining in our thoughts the noises of trams, of automobile engines, of*

carriages and brawling crowds, than in bearing down again in the 'Eroica' or the 'Pastorale.'"[10] As these comments make clear, Russolo's interest in *musique concrète* was completely different from Cage's preoccupation with the relation between silence and the noise of the everyday world. In contrast to Cage, who longed for the undisturbed experience of total presence in the present moment, Russolo looked forward to the disruption of the present by futuristic noisy machines.

While Marinetti heard poetry in noise, noise was music to Russolo's ears. Though he acknowledged that "the variety of noises is infinite," he carefully developed a taxonomy of sounds by mapping noises onto a grid that anticipates Cage's graphic scoring of his lectures on Nothing and Something published in his book *Silence*. Russolo's use of space in this diagram creates something like what eventually would become concrete poetry. Recalling the inverse relation between negative and positive in photographic printing, it becomes possible to begin to imagine a taxonomy of silence in the interstitial gaps punctuating Russolo's words.

TABLE 1. Taxonomy of Sounds

1	2	3	4	5	6
Roars	Whistling	Whispers	Screeching	Noises	Voices of
Thunderings	Hissing	Murmurs	Creaking	obtained	animals and
Explosions	Puffing	Mumbling	Rustling	by	people
Hissing roars		Muttering	Humming	beating	
Bangs		Gurgling	Crackling	on	Shouts
Booms			Rubbing		Screams
				metals	Shrieks
				woods	Wails
				skins	Hoots
				stones	Howls
				pottery	Death
				etc.	rattles
					Sobs

Source: Luigi Russolo, *The Art of Noises* (2005), 8

Russolo was not only a theoretician of avant-garde music, he was also a composer and a practitioner of aleatory music. To create this new music, he had to invent new musical instruments. The first instrument he displayed publicly was named a *burster*, which "produced a range of 'ten wholetones,' including all intermediate microtones" that approximated the noise similar to an automobile engine. He also created "a *hummer* (which sounded like an electric motor), a *rubber* (with a metallic scraping sound), and a *crackler* (somewhat like a cross between a mandolin and a machine gun)."[11] Shortly after issuing his manifesto, he invited a small group of friends and colleagues

to Marionetti's home in Milan to hear his compositions *Awakening of a City* and *Meeting of Automobiles and Airplanes*, which featured sixteen of his new instruments. Brown records an account of the event published by a correspondent of the London *Pall Mall Gazette*.

> At first a quiet even murmur was heard. The great city was asleep. Now and again some giant hidden in one of those queer boxes snored pretentiously; and a newborn child cried. Then, the murmur was heard again, a faint noise like breakers on the shore. Presently, a far-away noise rapidly grew into a mighty roar. I fancied it must have been the roar of the huge printing machine of the newspapers.
>
> I was right, as a few seconds later hundreds of vans and motor lorries seemed to be hurrying towards the station, summoned by the shrill whistling of the locomotives. Later, the trains were heard speeding boisterously away. ... Finally, all the noises of the street and factory merged into a gigantic roar, and the music ceased.[12]

Just as Cage's revolutionary composition *4'33"* met with more outrage than appreciation, so many in Russolo's audience resisted his innovations.

For avant-garde artists throughout the twentieth and twenty-first centuries, the relation between art and capitalist modes of production and reproduction has been complex. On the one hand, many artists have been critical of the economic, political, and social inequities capitalism creates and sustains. Through their art, they attempt to develop critiques of the socioeconomic system they think is so harmful. On the other hand, their commitment to innovation expressed in the modernist dictum "Make it new!" provides precisely the rationalization and justification for capitalism's relentless search for profit through a wasteful strategy of planned obsolescence. The interplay between capitalism and modernism has always been a two-way street: artists—often supported by the people and corporations their work satirizes and criticizes—appropriate new technologies to create what they regard as revolutionary music and art, and marketers preoccupied with profitable returns on their investments use popular music and art to sell products and expand market share. Little is more disappointing to a generation raised on the gospel of sex, drugs, and rock and roll, than to hear the tunes of Bob Dylan, the Beatles, and the Rolling Stones being used to sell everything from cars to soft drinks. When considered in this historical perspective, it becomes clear that the current addiction to noise and aversion to silence is no accident; it is at least in part the result of a carefully crafted

strategy that has been developed by businesspeople and advertising agencies for companies over many years. Noise moves products, and the louder the noise, the faster more stuff sells.

Don DeLillo has captured the importance of the noise endemic to modernism and postmodernism better than any other writer in his prescient novel *White Noise*. He wanted to title this work *Panasonic* (pan, all, applying to all + sonic, of or relating to sound), but was prevented from doing so because of objections raised by the Japanese multinational electronics company bearing that name. DeLillo's story is set in a small bucolic midwestern college town similar to the place where I am now writing. The time is precisely fifty years ago—the fateful year 1968, when the axis of the world shifted. With Cold War raging in Vietnam, race riots on city streets, colleges and universities in turmoil, and political assassinations, the postwar world order seemed to be unraveling. The plot centers on Jack Gladney, who is a professor renowned for creating a new field of Hitler studies; his fourth wife, Babette; and their four children and stepchildren. Death is literally in the air. The first section of the book is entitled "Waves and Radiation," and the second "The Airborne Toxic Event." Jack and Babette are obsessed with death and seek pharmaceutical relief by taking Dylarma, which is supposed to alleviate the terror of mortality. Visible dangers obscure a more subtle and insidious toxicity that is transmitted through the airwaves and creates a white noise that infects minds and controls lives. Images and sounds sent through rapidly proliferating media are a virus that transforms reality into an endless play of simulacra. Early in the novel, Jack and his colleague Murray, who teaches a course on car crashes and is tethered to his television, visit a nearby tourist attraction—"the Most Photographed Barn in America." Jack recalls,

> We stood near a grove of trees and watched the photographers. Murray maintained a prolonged silence, occasionally scrawling notes in a little book.
>
> "No one sees the barn," he said finally.
>
> A long silence followed.
>
> "Once you've seen the signs about the barn, it becomes impossible to see the barn."
>
> He fell silent once more. People with cameras left the elevated sight, replaced by others.
>
> "We're not here to capture an image, we're here to maintain one. Every photograph reinforces the aura. Can you feel it Jack? An accumulation of nameless energies."
>
> There was an extended silence. The man in the booth sold postcards and slides.

"Being here is a kind of spiritual surrender. We see only what the others see.... We've agreed to be part of a collective perception. This literally colors our vision. A religious experience in a way, like all tourism.[13]

The image becoming real and the real becoming image create a self-amplifying loop that silences the Real.

While Marinetti and Russolo sing the praises of industrialization, DeLillo sounds the alarm about the danger of images promulgated by the consumer economy. Nowhere is the noisy culture of images more vividly on display than in American supermarkets. Jack and Babette go shopping and bump into Murray, but their conversation is interrupted by incessant noise. "The toneless systems, that jangle and skid of carts, the loudspeaker and coffee-making machines, the cries of children. And over it all, or under it all a dull unlocatable roar, as of some form of swarming life just outside the range of human apprehension."[14] In the three decades since *White Noise* was published, the explosion of consumer products and the images and sounds promoting them has continued unabated. As the number of products increases, the need for advertising grows. The advertising industry arose in the late nineteenth century in response to marketing needs created by mass production. The initial advertising media were print—newspapers, magazines, leaflets, and catalogs. In 1880, annual advertising expenditures totaled $200 million; by 1904, this amount had risen to $821 million; and in 1917, it had reached $1.6 billion. With the invention and commercialization of radio and television, advertising became more visible, noisier, and more invasive.[15] Through the first half of the twentieth century, advertisements were designed for mass markets. Mass production could not thrive without mass consumption, which required mass advertising. All of this changed with the invention of the personal computer, handheld devices, and so-called social media connected in distributed networks. The collection of vast amounts of data that can be processed by ultra-high-speed computers creates a surveillance system that makes it possible to track activities and target consumers with ads tailored to their personal preferences. When everything is for sale and lines of communication are cluttered, the most precious commodity is people's attention. Mass production and mass advertising increasingly give way to the mass customization of products and targeted ads promoting them. This competition for attention comes with a high price—in 2017, advertising spending was $207 billion in the United States and $535 billion worldwide.[16]

Increasingly sophisticated technologies combine with advances in neuroscience to create new techniques that make subliminal advertising seem

primitive. Noise pervades private as well as public space and invades and rewires the brain. With sounds and images bombarding everyone 24/7, there is nowhere to run and nowhere to hide. Ubiquitous advertisements become the Muzak that keeps the engines of production humming. Muzak, in fact, was one of the first technological uses of sound for behavior modification. George Owen Squier anticipated Napster and iTunes when he invented Muzak, which initially was intended to deliver music to individual customers through a subscription service system that circumvented newly emerging radio stations. Impressed by the marketing effectiveness of the word "Kodak," Squier coined "Muzak" for the name of the company he founded in 1922. As radios became more common, he changed his strategy and began marketing to commercial clients. When Warner Brothers acquired Muzak in 1937, its reach quickly expanded to fill factories, offices, and stores with the sound of programmed music. More important, the company developed a "Stimulus Progression" program, which customized "the pace and style of the music provided throughout the workday in an effort to maintain productivity. The music was programmed in fifteen-minute blocks, gradually getting faster in tempo and louder and brassier in instrumentation, to encourage workers to speed up their pace. Following the completion of a fifteen-minute segment, the music would fall silent for fifteen minutes. This was partly done for technical reasons, but company-funded research also showed that alternating music with silence limited listener fatigue, and made the stimulus effect of Stimulus Progression more effective."[17] As television became more popular than radio, advertisers expanded their strategy by using visual images in ways that were impossible in print media. Images merged with sounds to create what art critic Lucy Lippard, commenting on the work of Jules Olitski, labeled "visual Muzak."[18]

During the latter half of the twentieth century, these processes greatly accelerated and the level of audio and visual noise rapidly increased. Following the lead of slot machine manufacturers, companies producing electronic games, devices, and apps designed audio and visual signals to addict users by literally rewiring their brains. Hooked consumers were the Holy Grail for advertisers. Brain monitoring and imaging technologies have created a new field known as "neuromarketing," in which market researchers use electroencephalography, magnetoencephalography, functional magnetic resonance imaging, and eye-tracking technologies to monitor subjects' responses to products and advertisements. Data collected from these experiments are then used in the development of advertising campaigns.

In addition to using neuroscience to assess the effectiveness of visual

images, advertisers have extended this technique to analyze the effect of audio signals. This research has led to the new tactic of "sonic branding" and "acoustic branding." In his informative study, *In Pursuit of Silence: Listening for Meaning in a World of Noise*, George Prochnik reports, "Designers are now dedicating themselves to provoking moods and emotional connection from sounds of every dimension made by individual products themselves. Sonic branding is fast becoming a major business. More and more product noises are now manipulated to punch up the consumer's desire to purchase. . . . Everything we buy is going to join the acoustical menagerie endlessly bleating out its sonic identity to every passerby." While much of this noise is ambient, "Hypersonic sound, a relatively new technology that dispenses with the loudspeaker altogether by shooting a super-focused ray of sound directly at its target, is only an extreme version of what most of the new noise is trying to do. When the acoustical laser beam of hypersonic sound hits the ears, it feels as though a projected voice is speaking inside the 'listener's' skull."[19]

The use of emotion to sell products is as old as advertising itself. In recent years, however, new research and technologies have led to much more sophisticated and troubling practices. In 2014, the Institute of Neuroscience and Psychology published a report that reduced the number of basic human emotions to four: happy, sad, afraid/surprised, and angry/disgusted. In *Unconscious Branding: How Neuroscience Can Empower (and Inspire) Marketing*, Douglas Van Praet explores how researchers and advertising agencies are developing ways to use signs and images to manipulate human emotions. Van Praet also founded a consulting business "whose approach to marketing draws from Unconscious Behaviorism and applies neurobiology, evolutionary psychology, and behavioral economics to business problems."[20] As we have seen, apprehension, which eludes cognitive comprehension, traditionally has been the domain of art. The white noise of consumer and finance capitalism is a symptom of the commodification of both works of art and human emotions.

At times the practices resulting from this research border on the ridiculous. Not only stores but also restaurants are using music to manipulate customers. "The first rigorous study of the effects of fast music on the pace of dining was conducted in the mid-1980s. Customers exposed to slow music spent significantly longer at table: an average of 56 minutes as opposed to 45 minutes. Another study . . . demonstrated that people increased the speed of their chewing by almost a third when listening to faster, louder music, accelerating from 3.83 bites a minute to 4.4 bites a minute."[21] When the volume is amplified, the rate of consumption accelerates and profits increase.

Automated systems are now being used to increase the number of customers served by raising the volume of music during the busiest hours and lowering the volume during slow hours.

Today's wired world is polluted by the ceaseless white noise that inevitably accompanies the machines of production as well as noise deliberately created by marketers, who act like loud carnival barkers with global megaphones. Noise pollutes the environment as much as the noxious waste that is the byproduct of processes of material production. Since capitalist entrepreneurs have co-opted the revolution that was supposed to have been created by turning up the volume of rock and roll to ear-splitting levels, perhaps silence rather than noise can become a strategy of resistance. No longer turn on, tune in, drop out, but turn off, tune out, let go.

But turning off, tuning out, and letting go are not easy, and might actually be impossible. One of capitalism's greatest strengths is its capacity to appropriate and turn to its own ends every tactic and strategy devised to resist it. Just when noise reaches a fever pitch, silence begins to become a draw, and entrepreneurs and advertisers find ways to commodify silence. In a noisy world, silence becomes a luxury fewer and fewer people can afford. While some companies create earphones and earbuds to pipe sound directly into the ears and brain, other companies create expensive noise-canceling earphones to manage noise pollution. When investors can make money by both creating a mess and cleaning it up, it is difficult to break the cycle of immoderate production and consumption. In a manner similar to profiting by recycling paper and plastic bottles, marketing silence has become a way to cash in on noise pollution. One ambitious entrepreneur has actually invented a machine to produce silence. In an article entitled "'Silence Machine' Zaps Unwanted Noise," published in *New Scientist*, Marina Murphy reports that Selwyn Wright, an engineer at the University of Huddersfield in Yorkshire, has patented a "Silence Machine" that "works by analyzing the stream of sound waves from a noise source, and generating sound that is exactly out of phase and neutralizes the incoming sound waves." This creates "'sound shadow' in which everything but the unwanted noise will still be audible."[22] It never seems to have occurred to Wright that his sound shadow is nothing other than a new solipsistic filter bubble.

The commodification of silence has been taken to disturbing extremes with a growing number of commercial products and practices. For example, the *Wall Street Journal* heralds the Mercedes-Maybach 5600, which sells for $190,275, with the blaring headline "The Silence is Deafening." Swiss watchmaker Vacheron Constantin's wristwatch "masterpiece" with "the purest chime" and "a silent speed regulator to minimize background noise" has a list

price of $409,900.[23] The most widespread marketing of silence takes place in the leisure and travel industry. Posh retreats like the Esalen Institute in Big Sur; Spirit Rock in Marin County; the Omega Institute in Rhinebeck, New York; Plumb Village near Bordeaux; and Kripalu in the Berkshire Mountains of Massachusetts are marketed by offering guests a quiet respite from the hectic pace of daily life. Most often these centers feature instruction in meditation and other mindful practices for people who can afford the high price of unplugging to escape noise and learning how to meet the seemingly impossible challenge of doing nothing. There is a growing list of companies that package luxury meditation retreats with foreign travel to "exotic" places.

When silence becomes a luxury only the wealthy can afford, the cacophony of the market is finally victorious.

CHANNELING

Dictators dictate—they speak without listening, and impose silence on everybody else. Their own voices so infatuate them that they feel compelled to wrap themselves in a narcissistic cocoon. DeLillo's choice of Hitler studies for Jack Gladney's area of specialization is both canny and once again prescient. In a wired world, the person who controls the microphone holds the power. This power is never wielded by individuals alone because monitoring and distributing discourse presupposes complex systems. While Hitler exercised power through the early mass media of radio and film, today email, Twitter, and other visible and invisible social media have become channels through which control is established and reinforced. With the growing automation of these systems, self-generating algorithms silently create autonomous networks that program unknowing agents to pursue ends they mistakenly believe are their own. Today the most powerful dictators are not individuals, but corporations and government agencies whose invisible networks silently regulate thought and behavior.

Søren Kierkegaard recognized the deleterious effects of modern mass communications technologies and, correspondingly, the importance of silence as a political means for maintaining power as well as a tactic for resisting domination. He published his longest and most penetrating mediation on silence in *Fear and Trembling* (1843) under the pseudonym Johannes de Silentio.[24] Two of his other important pseudonyms—Johannes Climacus and Anti-Climacus—also suggest the importance of silence. Kierkegaard chose this name to recall John Climacus, who spent his life as a monk in Saint Catherine's Monastery on the Sinai Peninsula in Egypt. Around 600, Climacus wrote a tract entitled *The Ladder of Divine Ascent* in which he

identified one step for every year in Jesus's life. Originally written for monks in a nearby monastery, this short treatise became one of the most widely read and influential works of Byzantine spirituality. In step 11, entitled "On Talkativeness and Silence," Climacus writes, "Talkativeness is the throne of vainglory on which it loves to show itself and make a display. Talkativeness is a sign of ignorance, a door to slander, a guide to jesting, a servant of falsehood, the ruin of compunction, a creator of despondency, a precursor of sleep, the dissipation of recollection, the abolition of watchfulness, the cooling of ardor, the darkening of prayer. . . . The friend of silence draws near to God, and by secretly conversing with Him, is enlightened by God."[25]

Though Kierkegaard never directly quoted this work, his criticism of the dehumanizing effects of modern mass media echoes many of Climacus's concerns. In his brief book *The Present Age* (1845), Kierkegaard effectively describes our world of automated answering machines, talking robots, Siri, Alexa, standardized testing, and online dating.

> Eventually, human speech will become just like the public: pure abstraction—there will no longer be someone who speaks, but an objective reflection will gradually deposit a kind of atmosphere, an abstract noise that will render human speech superfluous, just as machines make workers superfluous. In Germany there are even handbooks for lovers; so it probably will end with lovers being able to sit and speak anonymously to each other. There are handbooks on everything, and generally speaking education will soon consist of knowing letter-perfect a larger or smaller compendium of observations from such handbooks, and one will excel in proportion to his skill in pulling out the particular one, just as the typesetter picks out letters.[26]

Just as linotype led to the standardization of spelling and grammar, so print media standardize thought and control conduct.

For Kierkegaard, authenticity requires clear self-consciousness and the willingness to take responsibility for one's decisions, which have serious consequences because they constitute a person's eternal identity. Modern mass media and the society they create, Kierkegaard claims, repress individuality by programming people to do what others want them to do. Rather than thinking for themselves and taking responsibility for their decisions, people unwittingly channel the ideas and desires of anonymous others. Talk degenerates into idle chatter in which people speak but say nothing. In a certain sense, Kierkegaard admits, "Chatter suspends the passionate disjunction between silence and speaking."[27] But the silence of chatter is inauthentic

silence of empty talking heads, rather than the authentic silence of responsible reflection.

In the nineteenth century, newspapers played the role that twenty-four-hour cable news and social media play today. Far from simply reporting what has happened, so-called news media are pre-diction machines designed to regulate behavior. Contrary to expectation, modern communications technologies make communication all but impossible. Programming people results in a process Kierkegaard describes as "leveling." In a journal entry entitled "Homogeneity—Heterogeneity," written in 1854 near the end of his life, he explains this important idea.

> The tyrannizing, leveling world of time present is always trying to change everything into homogeneity so that all become mere numbers, specimens.
>
> History, on the other hand, is interested only in what has preserved itself in heterogeneity within its own period, without, however, automatically regarding every such heterogeneity as the truth.
>
> The world of present time presumably considers a change to homogeneity as ennoblement, cultivation; the truth is that it consumes individuals and wastes them.[28]

The erosion of individual differences through the homogenization of language as well as thought creates what Marxist philosopher Herbert Marcuse describes as "one-dimensional" people, who become little more than a number in an anonymous "crowd" or nameless "herd."[29] As we will see in chapter 7, one-dimensional subjects become completely transparent to others, even if they are not to themselves. As the media virus infects the brain and mind, leveling absorbs the interiority that is essential for authentic individuality. Members of this crowd have no secrets, and, without secret interiority, people are less than human.

Looking back from the distance of two centuries, the accuracy of Kierkegaard's criticism of modern media is astonishing. With the advent first of radio and television, and then of personal computers, mobile phones, countless apps, and the Internet, the process of leveling has accelerated until it has created outward and inward panopticism. The twentieth-century philosopher who continued and extended Kierkegaard's analysis of media is Martin Heidegger. Heidegger explicitly appropriated Kierkegaard's account of chatter to develop his interpretation of "idle talk [*Gerede*]," and recast his notion of the crowd in his discussion of the anonymous "They [*das Man*]." In modern and postmodern society, the "I" is increasingly silenced by the anony-

mous "they" or "one" whose quiet voice rustles everywhere. "The Self of everyday Dasein," Heidegger writes, "is the they-self [*das Man-selbst*], which we distinguish from the *authentic Self*—that is from the Self which has been taken hold of in its own way. As the they-self, the particular Dasein has been *dispersed* into the 'they,' and must first find itself. . . . *Proximally*, it is not 'I,' in the sense of my own self, that 'am,' but rather the Others, whose way is that of the 'they.'"[30] Playwright Harold Pinter makes Heidegger's point in considerably less convoluted language. "There are two silences. One when no word is spoken. The other when perhaps a torrent of language is being employed. This speech is speaking of a language locked beneath it. This is the continual reference. The speech we hear is an indication of that which we don't hear. It is a necessary avoidance, a violent, sly, anguished or mocking smoke screen which keeps the other in its place. When true silence falls we are still left with echo but nearer nakedness. One way of looking at speech is to say that it is a constant stratagem to cover nakedness."[31]

Rather than an infinite conversation in which individual participants jointly probe the depths of existence, what appears to be a profound dialogue is actually a superficial monologue. Just as the relentless exercise of the will to power leads to a world in which "everywhere man turns he *sees* only himself," so ceaseless chatter creates self-reinforcing echo chambers in which everywhere people turn they *hear* only themselves. In such a world, noise silences the silence that threatens to interrupt trivial talk. Like water striders skimming across the surface of a pond, "the chattering class" fears that if they stop talking, they will sink into the bottomless void opened by silence. For Heidegger, by contrast, silence can be therapeutic. When language becomes totally debased and speech becomes noise, the best strategy for resistance and possibly even a cure is silence.

> *Keeping silent* is another essential possibility of discourse, and it has the same existential foundation. In talking with one another, the person, who keeps silent can "make one understand" (that is, he can develop an understanding), and he can do so more authentically than the person who is never short of words. Speaking at length about something does not offer the slightest guarantee that thereby understanding is advanced. On the contrary, talking extensively about something covers it up and brings what is understood to a sham clarity—the unintelligibility of the trivial. But to keep silent does not mean to be dumb. . . . Keeping silent authentically is possible only in genuine discoursing. To be able to keep silent, Dasein must have something to say—that is, it must have at its disposal an authentic and rich disclosedness of itself. In that case, one's reticence [*Verschwiegenheit*] makes something manifest, and

does away with "idle talk [*Gerede*]." As a mode of discoursing, reticence articulates the intelligibility of Dasein in so primal a manner that it gives rise to a potentiality-for-hearing which is genuine, and to a Being-with-one-another which is transparent.[32]

In the years since *Being and Time* was published, language has been debased far beyond anything Heidegger could have imagined, creating what Susan Sontag describes as "word-clogged reality."[33] Michel Serres, who is one of the most insightful interpreters of this decline, writes,

> Today we are living through an acute crisis of languages. The media broadcasts hundreds of words and deliberately uses ungrammatical or vulgar language to show it has the common touch. Poets are losing their ear for language, and the intelligentsia has long since driven them away.... The crafting of language is becoming rare, no-one is inclined to take the trouble. Those who say, or believe, that they hold our fate in their hands have never appeared so barbaric — by barbaric I mean those whose utterance consists of belching and stomach rumbling, usually the sound of a dominant language.[34]

The accelerating debasement of language and correlative coarsening of personal and social life are caused by three closely interrelated process, which are fraught with paradox: globalization, digitization, and customization/privatization. Technologies that were supposed to connect people now separate them; the more interconnected the world becomes, the less people are able to listen to each other. Closed networks, customized apps, and personalized media create echo chambers. Contrary to expectation, social media have turned out to be antisocial. Locked in solipsistic bubbles, people talk but have forgotten how to listen; they converse only with like-minded people and attempt to silence others with whom they disagree. The entire communications system rests on the foundation of self-regulating binary codes designed to reduce ambiguity by excluding or repressing whatever falls between 0 and 1. When channels of communication are closed, information becomes noise, and voices rise until they become, paradoxically, "the sound of silence."

> And in the naked light I saw
> Ten thousand people, maybe more
> People talking without speaking
> People hearing without listening
> People writing songs that voices never share

No one ever dared
Disturb the sound of silence.

"Fools," said I, "You do not know
Silence like a cancer grows...."[35]

There are, however, other sounds of silence that are restorative and even redemptive. The white noise resulting from DeLillo's airborne toxic event is not only the result of a nuclear disaster or chemical spill; it is also created by the relentless sounds of the modern and postmodern world that are difficult but not impossible to stop. Paralyzed by her fear of death, Babette asks Jack,

"What if death is nothing but sound?"
"Electrical noise."
"You hear it forever. Sound all around. How awful."
"Uniform, white."
"Sometimes it sweeps over me," she said. "Sometimes it insinuates itself into my mind, little by little. I try to talk to it. 'Not now, Death.'"[36]

If noise is white, what color is silence? If death is black, what color is life? If sound is death, might silence be life? If so, then the challenge is to find ways to get silence back into words. In the last chapter ("Nothing") of his sixties counterculture classic, *Love's Body*, Norman O. Brown anticipates the "Lecture on Nothing" published in the book *Silence*, written by his friend and erstwhile colleague at Wesleyan University's Center for Advanced Study—John Cage.

To reconnect consciousness with the unconscious to make conscience symbolical, is to reconnect words with silence; to let silence in. If consciousness is all words and no silence, the unconscious remains unconscious.

To redeem words, out of the market place, out of barking, into silence; instead of commodities, symbols.

When silence
Blooms in the house, all the paraphernalia of our existing
Shed the twitterings of value and reappear as heraldic devices.
(Robert Duncan)[37]

Having been programmed to live without silence, it is necessary to learn how to live without noise by going back before the beginning to the silence of the origin.

2.

BEFORE

A pregnant emptiness. Object-loss, world-loss, is the precondition for all creation. Creation is in or out of the void; *ex nihilo*.

NORMAN O. BROWN

What is the world like to the newborn baby?

Light, dark. Cold, warm. Soft, hard.

The whole array of objects in a house, all meaning deriving from relations within a family, the significance that every person within, all this is invisible, hidden not by darkness but by the light of the undifferentiated.

KARL OVE KNAUSGAARD

SEEING LIGHT LISTENING TO YOU

Light listens. Listens patiently, listens attentively, and then responds. How do you listen to light listening? How do you respond to light responding? What do you hear? What can you say?

James Turrell is obsessed with light. Light, he believes, is the immaterial material, medium, and matrix of life and art. In a 1999 interview with Richard Whittaker, he reflects, "There is a truth in light. That is, you only get light by burning material. The light that you get is representative of what is burned. So whether you take hydrogen or helium, as in the sun, or whether you decide to burn xenon in a bulb, or neon, or tungsten wire, something must be burned to get this light. The light that comes off this material burned, is characteristic of that material burned, at the temperature at which it is burned. So you can then put a filter in between or you can bounce it off

paint, but there is truth in light. There are some very interesting experiments that were done several years ago. They show that *light is aware that we are looking.*" He proceeds to explain this extraordinary claim about light, noting that Heisenberg's Uncertainty Principle "almost gets to the point where it has a lot to do with what we want to prove. I mean, we're a part of this experiment. We enter into it in ways that can't be denied. This can be troubling and it troubles a lot of scientists, but I think it also is affirming of the fact that we're not apart from nature. In fact, that's one of our greatest conceits, to even think that we're somehow apart from nature."[1]

In this extraordinary vision, light listens and responds, forming and transforming human beings as much as they shape light. For Turrell, the task of art at the end of modernism and postmodernism is to see seeing by learning how to listen to the silence of light. In developing his aesthetic education, he deploys sophisticated technology to explore the most primitive experiences that make us human. His lifelong pursuit of light begins in the total silence of a completely dark room. To sit in darkness and walk in light with Turrell is to return to a time outside of time in time, a time *before* the beginning of the world and *before* the beginning of oneself. This Before is the silent origin of all that is and is not.

While Turrell was a student at Pomona College in the 1960s, he attended a performance by John Cage of his provocative work *4'33"*. Turrell recalls,

> I was impressed by the quality of the statement. I didn't really understand it but I knew it was important.... There was something about that experience at that very time that challenged our understanding of things. People got up and walked out, and I thought, 'This is amazing, whatever this person has done.' Whatever I witnessed there, it was something that hit people right where they live. People say [to me], well, you're experimenting with light. I'm *not* experimenting with light at all, I'm making *statements*. Are painters experimenting with paint when they make a painting? Are poets experimenting with words? This is where I live. This is what touches me, and hopefully affects you. It has something to do with how you think or how you live or how you thought the world was arranged.[2]

If, as Cage demonstrated, cultivating the experience of silence could clarify sound, then perhaps the experience of darkness could illuminate light. To explore this possibility, Turrell had to find a way to combine total silence and complete darkness.

In 1968, the Los Angeles County Museum of Art entered into an agree-

ment with ten corporations to sponsor the innovative program "Art and Technology" to fund and facilitate collaboration between artists, scientists, and engineers. This program brought Turrell together with Robert Irwin with whom he shared many interests.[3] In his report on the program he oversaw, Maurice Tuchman recounts Irwin's initial discussions with representatives from Lockheed Aircraft Corporation. "At Rye Canyon, there was an anechoic chamber (a room heavily insulated against outside noise stimuli and thus non-reverberant), and a chamber into which sound and visual stimuli could be introduced for the purpose of testing human responses to various sensory phenomena. These were precisely the kinds of research facilities to which Bob wished to gain access."[4] Irwin was already in conversation with Turrell, who had studied perceptual psychology at Pomona College and was conversant with much of the relevant scientific literature. Ed Wortz, head of the Garret Corporation's Life Science Department, joined Irwin and Turrell, and in January 1969, their proposal was approved. The primary focus of their investigation was the effect of sensory deprivation on audio and visual perception. To conduct their experiments, it was necessary to build their own anechoic chamber whose description provides the blueprint for much of Turrell's future work. "There will be no light or sound stimuli at first in the chamber, and any that will be presented will be determined by forthcoming experiments; expected stimuli will be something on the order of subthreshold light flashes and sound flashes 'reorienting stimuli'; these stimuli will increase gradually to the point which seems to be between hallucination and reality. Time spent in the chamber will be between 5–10 minutes."[5] The aim of their research project was to demonstrate how the *absence* of sound and light make hearing and seeing possible. If this could be demonstrated, it would be possible to conclude that silence and darkness are the origin of hearing and vision.

It is important to recall that these experiments were taking place at the precise moment the psychedelic revolution was exploding and there was growing interest in non-Western religion and meditative practices. Wortz was a practicing Buddhist and had scientifically investigated the meditation practices of Tibetan monks. While flying relief missions in South Asia as a conscientious objector to the war in Vietnam, Turrell had reported experiences that were "bizarre, confusing, and hard to deal with."[6] In addition to this unsettling visual experience, the ruins of Angkor Wat in Cambodia and Pagan and Borobudur in Burma left a lasting impression on him. Turrell, Irwin, and Wortz not only acknowledged but warmly welcomed the interplay of science, art, and religion in their work. "What we are dealing

with," they explain, "are meditative states." "The preconditioning sets up a state of meditation, so when they first leave the chamber they will be in that encapsulated form. Then we want to take them slowly out of that form to a specialized space where they change from one being oriented inwardly to their own space or space of awareness that extends maximally about 6 feet around themselves, where they push their experience outward to the space outside."[7] As their work progresses, their conclusions appear to be more consistent with the insights of Zen masters than with the protocols of traditional science.

Koan

Strenuous effort to understand intellectually a purely intellectual question that has no intellectual resolution. (Who were you before you were born? What is the sound of one hand clapping? What's the meaning of the word Mu?)—pick your own.[8]

Turrell was drawn to the wisdom of Buddhism and Hinduism, but his religious roots lie firmly in the West—he was raised a Quaker. "My grandmother," he confesses, "used to tell me that as you sat in Quaker silence you were to go inside to greet the light. That expression stuck with me."[9] While most previous artists had been primarily interested in light insofar as it illuminates objects, Turrell is fascinated by light as such. Light becomes his medium, which he sculpts as much as light sculpts our eyes. "We eat light, drink it in through our skins. With a little more exposure to light, you feel part of things physically. I like the power of light and space physically because then you can order it materially. Seeing is a very sensuous act—there's a sweet deliciousness to feeling yourself seeing something."[10]

For Quakers, seeing light requires silence. In his meditation entitled "God is Silence," Pierre Lacout writes,

Deep silence is the very condition for religious experience. In this deep silence, there comes a Silence deeper still which is religious experience in its purest form. I want to express this experience and so I seek for the right words. And the richest words I find are the simplest, the most silent ones: Presence, Inner Light, Love, Life. Yet I am still aware how much silence is to be preferred to words. . . . If I speak again it is to awaken to this silence souls ready to receive it. But I am convinced that neither the written nor spoken word will ever be as precious as Silence. For, in the soul dwelling in silence, God Himself is silence.[11]

The challenge Turrell's art poses is to listen to the silence speaking in the light.

When Turrell shifts his work from the laboratory to his studio, he once again begins his inquiry about light in silent dark rooms. He began working on a series entitled *Dark Spaces* in 1969–70. His first formal piece, *Pleiades* (1983), was presented at the Mattress Factory in Pittsburgh. The following year he completed *Hind Sight*, which is currently on display in the Massachusetts Museum of Contemporary Art (Mass MoCA). This work creates conditions that enable a person to look behind or, more precisely, before vision. As with all Turrell's art, *Hind Sight* takes time to experience and understand. One of the great virtues of Turrell's work is that it cannot be rushed—he produces slow art for an age obsessed with speed.

The Dark Spaces are designed to replicate experience in an anechoic chamber. Admission to *Hind Sight* is limited to two people at a time, who remain in a totally silent and dark room for fifteen minutes. To enter the space, it is necessary to blindly follow a handrail that leads through a labyrinth to two chairs that must be found by touch. The initial experience of total darkness is thoroughly disorienting; though it is not forbidden to speak, it seems improper to do so. For the first few minutes, afterimages from the world of light persist; as your eyes adjust to the absence of light, the images fade and for what seems to be a prolonged interval, there is nothing to see. You are completely immersed in a total blackness. After an uncertain period, a reddish glow seems to envelop you and a fuzzy dim light appears at what looks like to be the far end of the room. At first this light is indeterminate, then obscure forms gradually begin to emerge from the surrounding darkness. These quasi-shapes, which never come into focus, appear to float slowly from the lower left to the upper right corner of the space. The vague, shifting shapes are a pale white with fringes that have a hint of pink. It remains impossible to know whether you can believe your eyes. As the fuzzy shapes continue to float in front of you, it feels like you are submerged in an ancient sea watching the original forms of primordial life beginning to emerge. After the allotted time has expired, a voice breaks the silence and you must follow the handrail to find the way out. As you emerge from the darkness, it takes a few minutes for your eyes to readjust to the light. The attendant explains that nothing changed the whole time you were in the chamber—the entire experience is created by a stationary light located at the far edge of the room near the floor.

While Turrell's Dark Spaces immerse one in primal darkness, his Skyspaces bring heavenly light down to earth. In a poem entitled "Speaking for Light," Turrell writes,

This is the light we are given
Every evening we unfold the light
And every morning fold it back
To return the blue sky.

This is the light that's passing through
Just beneath that usually seen
Who owns it? You who look.
Not to be held, but known.[12]

Turrell began experimenting with what became his signature works in the
Mendota Hotel, which served as his studio in the early 1970s. In addition
to Dark Spaces, Turrell cut holes in walls and the ceiling to create some-
thing like a giant pinhole camera or a camera obscura that could actually be
entered. "The Mendota was a Plato's Cave," he explains. "The projections
became a representation of reality—not that they're unreal at all it's just that
they are a small distinct part of reality. We are sitting in the cave looking at
the reflection of reality with our backs to it. The spaces themselves are per-
ceivers and perform perception. These rooms were camera-like spaces that
apprehend the light so as to be physically present within the space."[13] Far
from passive vessels, these spaces actively perceive and perform perceptions.
Turrell creates spaces to make it possible to see light listening to and perceiv-
ing those who are viewing it.

Italian art collector Giuseppe Panza di Biumo was so impressed with the
Mendota rooms that he commissioned the first Skyspace in 1974 for his villa
in Varese. Panza describes the impact of Turrell's work by comparing it to
the experience of light in the desert.

Desert total lack of life serenity light. elementary
shapes. Circular horizon. earth flat disc. disc of
the sun light. absence of monotony. Ideal abstract-
tion. natural expression. inexhaustible source
of impressions.
heavenly vault. finite and infinite. Charged with
identifiable but precise energy flowing life.
limit of perceiving the possible. The possible is not
real, seeing and not reaching, desiring and not
obtaining the whole experience. Attraction and
repulsion. Night = light—always light—greater
and greater distances.[14]

In the following years, Turrell created more than seventy-five Skyspaces in different settings, shapes, and sizes. Some are public, some are private; some are cut into existing structures, some are created by constructing new structures. His most ambitious Skyspace is *Roden Crater*, located in Arizona's Painted Desert.[15] Turrell is aware of ancient precursors of these works like Buddhist stupas, Egyptian and Mesoamerican pyramids, and Hopi kivas. One of his most elegant Skyspaces is located on the campus of Rice University in Houston, right next to Michael Heizer's massive sculpture *45°90°180°*. *Twilight Epiphany* (2012) is distinctive because it has two openings and two viewing levels, one of which is inside and the other outside. The structure is a grass-covered steppe pyramid open at the top. Hovering over this opening above the pyramid, there is an elevated roof-like structure with a smaller square opening. Viewing benches are placed along the walls of both enclosures. As you move from level to level and from outside to inside to outside, the intensity, quality, and color of the light change. In addition to this, sound is muffled in the interior viewing space.

A different kind of Skyspace is located several miles from *Twilight Epiphany*. *One Accord* (2000) is the centerpiece of the Live Oaks Friends Meeting House. Turrell worked with Leslie K. Elkins Architects to create a contemporary vernacular building located inconspicuously on a tree-lined street in a residential Houston neighborhood. The outside of the building is an unadorned gray in the plain style favored by Quakers. The Skyspace is a perfectly rectangular opening with a retractable roof cut into a gently curved soft white ceiling. Along the seam joining the ceiling and the walls there is ambient light that can be modulated. In keeping with the principles of Quakerism, there is no pulpit and no ornaments or decorations. Wooden benches crafted with the refined simplicity reminiscent of Shaker design are organized in straight rows facing each other around an empty rectangular space that shadows the Skyspace. The doors and windows on facing walls are perfectly symmetrical. Once again recalling the importance of his grandmother's religion for his artistic vision, Turrell reflects, "Well, the Quakers often talk about the light inside. In fact, the light inside everyone. She [Turrell's grandmother] was talking literally about the relationship between the light inside and the light outside. Even with the eyes closed, we have vision, as in a dream. My grandmother believed the purpose of meditation or contemplation was to wait upon the Lord and meet up with the light inside. The temple is within. So Quakers could make good viewers of art."[16] In the silence of the Meeting House light becomes a religious experience.

Turrell explains, "I make spaces that apprehend light for perception and in some way gather it or seem to hold it."[17] Vision, however, is far from

simple, and to apprehend light, it is necessary to retrain your eyes to see what they have been programmed to overlook. Commenting on *Twilight Epiphany*, Turrell admits, "We weren't made for this light. We're made for the light of a cave, and for twilight. Twilight is the time we see best. When we dim the light down, and the pupil opens, feeling comes out of the eye like touch. Then you really can feel color, and experience it."[18]

I took Turrell's advice and visited the Live Oaks Meeting House at twilight on a clear spring evening. With dusk approaching, the roof retracted to reveal a crystal clear blue sky. It was as if the shutter of a camera clicked to expose the aperture that lets in the light. Though the ceiling and rectangular opening were curved, the Skyspace looked completely flat. There was nothing there, yet the aperture appeared to be a colored film or the surface of a flawless monochromatic painting. Over the course of the next twenty minutes, this painting changed from a brilliant Klein blue to the darkest black of a Rothko or Reinhardt painting, or Anish Kapoor's super-absorptive Vantablack. What was most puzzling was that I did not recognize the phases of these changes while they were occurring, but only realized how distinctive the different colors were when I later looked at the photographs I had taken. The pictures presented a time-lapsed series of changes that were too subtle, continuous, and slow for my eyes to process while they were occurring. As I thought about this insight, it became obvious that the experience of color, like the experience of everything else, is a contrast effect. Watching snapshots of the slow-motion film unfolding before me like a Muybridge sequence, I saw shades I had never before observed that were too subtle for words to describe. These colors changed not only with time, but also with place. When I stepped outside the Meeting House, the color of the sky was completely different from what I saw inside. Turrell explains, "I don't actually change the color of the sky, I change the context of vision, which gives a very different color to the sky. And it's only then you realize that you're the one that really makes the color of the sky. This is not something that has a color, it's that we attribute to it and it's very easy to see how that can be worked just by changing the context of this vision and kind of knowing that, and knowing these anomalies in how we perceive is helpful in realizing how we create the reality within which we live."[19] Turrell assists in creating the colors of the Skyspaces by modulating the interplay between interior and exterior light to give the sense that changes are coming from the outside.

Turrell's Skyspaces work in paradoxical ways. Everything is turned inside out and outside in, as well as upside down and downside up. By bringing the heavens down to earth, he confounds interior and exterior space as well as cosmic and human time. The opening encloses and the closure opens fini-

tude to the infinite. What appears to be a painted surface turns out to be an endless height that is an abyssal depth. Summarizing the effect of his work, Turrell writes,

> You will notice during the change from day to night an intensity of color that you will find nowhere else. If you then go outside you will see a different colored sky. You color the sky. The work is about your seeing not mine. The colors can be intensely sublime and beyond what we would normally see. The amount of light in the space allows for the seeing over several planets and a few stars, but there is a blackness of depth and softness that is unparalleled, because it has no surface. The blackness is a complete black body, absorbing and sucking light. It arises simply out of the contrast between the inside of a space where there is light in relation to a space where there is none.[20]

Though the experience of the Quaker Meeting House was moving in ways words cannot capture, there was still something missing. The Skyspace did not allow me to "walk into the light" in the same way *Hind Sight* had allowed me to walk into the dark. Nor had light entered me as I entered it to the same extent that darkness had entered me as I entered darkness. Something like the picture frame of the Skyspace not only connected inside and outside but also separated them, creating a membrane that had not been punctured. To complete the experience Turrell and I were searching for, I had to walk *through* the frame. I took this final step when I literally entered *Perfectly Clear*, once again at Mass MoCA. *Perfectly Clear* is a Ganzfeld (from the German word for complete or total field). The Ganzfeld was created in the 1930s by psychologist Wolfgang Metzger to study subjects experiencing a featureless field devoid of any objects. Turrell's Ganzfelds are the inverse of his Dark Spaces—they totally immerse you in an illuminated void.

To pass through the frame of *Perfectly Clear* is to enter a ritual space where revelation can occur. Between outside and inside, there is a vestibule that is something like the tympanum of a Gothic cathedral.[21] As when approaching any sacred space, you begin by taking off or covering your shoes. Once again, the work is perched atop a stepped pyramid. Ascending fourteen steps, you pass through the picture frame and actually enter the work of art. If Skyspaces simulate the eye or a camera with the aperture functioning like the iris, crossing this threshold is like stepping inside an eyeball behind the lens. Turrell explains,

> I went from working with the picture plane cutting to the outside, which can look like an opaque flat space, which you wait to enter with consciousness.

Some people have tried to dive through apertures of Space Division Constructions expecting it to be soft inside. With the Ganzfelds, I allow you to enter the pictorial plane itself as if you are entering the painting. These works get more sculptural of course, but it still has the idea of using three dimensions in a hypothetical way. It is still about dissolving the dimensional quality or in some way reordering the dimensioning, in the language of painting.[22]

As dimensions gradually dissolve, you have nothing to focus on—absolutely nothing. Every thing and every body disappears in a glow created by invisible LEDs programmed in a fifty-two-minute cycle that changes from soft blue, pink, and lavender to radiant shades of yellow and green. Every four minutes, flashing red strobe lights briefly interrupt the visual field. As your eyes adjust to the Ganzfeld, the edges of the walls, ceiling, and floor disappear. Most disconcerting of all, the floor beneath you vanishes and you seem to be floating in the void. Here, as in *Hind Sight*, your eyes play tricks on you. When you turn to look at the outside world from inside the frame, the white wall of the entry space changes colors with the alternating rhythms of the field. Turrell seems to be answering the questions we have heard Nietzsche ask: "How could we drink up the sea? Who gave us the sponge to wipe away the entire horizon? Whither are we moving? Away from all suns? Are we not plunging continually? Backward, sideward, forward, in all directions? Is there still any up or down? Are we not straying as though through an infinite nothing?"[23] Turrell responds, "I am interested in this new landscape without horizon. If you go into the Ganzfeld pieces it is a little bit like the landscape that you can find when flying around through cloud or fog. You can also find it in 'whiteout' conditions when you go skiing and get into snowfall, it can happen that you are not really sure anymore which way is up or down. This occurs in diving, too. We are moving into the territory of horizonless space that you can also experience in outer space without gravity."[24]

In this seamless environment, differences, distinctions, determinations, and articulations disappear and what remains is an undifferentiated, indistinct, indeterminate, and inarticulate space. In the absence of any clear distinction between subject and object, or self and other, all sense of individual identity disappears. But this is not precisely the sensation of unity because no I remains to undergo the experience. It is, strangely, something like the experience of nonexperience. Paradoxically, to the extent that any awareness remains, this void feels more like a fullness or plenitude than an emptiness or a lack. By stepping across the boundary through the picture frame, you transgress the limit of experience and enter the impossible space-time where

the coincidence of presence and absence, fullness and emptiness, plenitude and lack becomes possible. Contemplative Thomas Merton quotes the thirteenth-century Flemish mystic John of Ruysbroeck.

> The interior man enters into himself in a simple manner, above all activity and all values, to apply to himself a simple gaze in fruitive love. There he encounters God without intermediary. And from the unity of God there shines into him a simple light. This simple light shows itself to be darkness, nakedness, and nothingness. In this darkness, the man is enveloped and plunges into a state without mode, in which he is lost. In nakedness, all consideration and distinction of things escape him, and he is informed and penetrated by a simple light. In nothingness he sees all his works come to nothing, for he is overwhelmed by the activity of God's immense love, and by the fruitive inclination of his spirit he ... becomes one spirit with God.[25]

Ruysbroeck might well have been describing his experience of Turrell's Ganzfeld. This is the fecund silence before birth and not the barren silence after death.

FORE-SIGHT

In 1962, the English translation of Maurice Merleau-Ponty's *Phenomenology of Perception* was published. This work had an enormous impact on many artists, but was especially important for sculptors as different as Richard Serra, Robert Morris, and James Turrell. Rather than creating idealized objects placed at a distance, these artists took sculpture off the pedestal in order to explore ways of transforming spectators into participants by literally getting them into the work of art. For Turrell, one of the richest passages in Merleau-Ponty's seminal text effectively describes the experience he was attempting to create.

> When ... the world of clear and articulate objects is abolished, our perceptual being, cut off from its world, evolves a spatiality without things. This is what happens in the night. Night is not an object before me; it enwraps me and infiltrates through all my senses, stifling my recollections and almost destroying my personal identity. I am no longer withdrawn into my perceptual look-out from which I watch the outlines of objects moving by at a distance. Night has no outlines; it is itself in contact with me and its unity is the mystical unity of the *mana*.[26]

Merleau-Ponty's phenomenology of perception is an extension of Kant's critical philosophy intended to reverse the revisions of Kant developed in Hegel's speculative idealism. By rereading Hegel's writings against the grain, Merleau-Ponty sought to reveal what they are constructed to conceal. What is hiding in speculative philosophy, he argues, is the nonknowledge at the heart of knowledge, and the blindness that makes sight possible. Kant's critical philosophy is designed to counter Humean skepticism by establishing the conditions of the possibility of knowledge, morality, and aesthetics. He maintains that knowledge involves the synthesis of the forms of intuition (space and time) and the categories of the understanding with what he describes as the "sensible manifold of intuition." The mind functions like a programmed computer that processes data through the activity of the imagination.[27] Since the structure of the mind is universal, everyone processes data in the same way and, thus, "objective" communication is possible. But this so-called objectivity inevitably remains subjective because it is impossible to know reality as such or, in Kant's phrase, "the thing-in-itself." In this subjective idealism, the world is, in the final analysis, *silent*. Hegel's philosophical mission is to break this silence by allowing the world to speak. Toward this end, he translates Kant's subjective idealism into absolute idealism in which mind and world are isomorphic. The keystone of Hegel's system is his *Science of Logic* in which he develops a speculative rendering of the divine Logos that forms the foundation of self and world. Hegel eliminates Kant's thing-in-itself by arguing that the mind and the world as such share a common structure and, thus, "speak" the same language. Hegel's system concludes with Absolute Knowledge, in which everything and everyone become completely comprehensible. Philosophy is the attempt to eliminate silence by demonstrating that nothing is unsayable, unknowable, unnamable, unfigurable.

Merleau-Ponty does not simply reject Hegel's system but contends that there are at least two Hegels. In his early writings, which culminate in the *Phenomenology of Spirit*, Hegel emerges as an "existential" thinker who never forgets the tensions and contradictions of concrete human experience. After 1807, however, his systematic preoccupations led him to insist that every opposition can be overcome through all-encompassing reason. Merleau-Ponty is drawn to the early Hegel but is critical of his late philosophy of reflection that forms the foundation of much modern philosophy and indirectly informs the modernist doctrine of art for art's sake. Following Heidegger, Merleau-Ponty argues that the task of thinking at the end of philosophy is to think what philosophy has left unthought. Unlike Hegel, who is convinced that everything is knowable even if it is not yet known, Merleau-Ponty believes that consciousness and self-consciousness are always incom-

plete because there is always an excessive remainder that cannot be programmed and, thus, eludes comprehension. Contrary to expectation, it is precisely what cannot be known that makes knowledge possible. Merleau-Ponty undoes speculative/specular philosophy from within by seeing what it does not see and hearing what it does not hear.

> The eye of spirit, the mind's eye also has its blind spot but because it is of spirit or mind, it cannot be unaware of it, nor treat it as a simple state of non-vision, which requires no particular mention, the very act of reflection which is so *quoad nos* its act of birth. If it is not unaware of itself—which would be contrary to its definition—the reflection cannot feign to unravel the same thread that the mind would first have woven, to be the mind returning to itself within me, when by definition it is I who reflect. The reflection must appear to itself as a progression toward a subject X, an appeal to subject X.[28]

By bending back on itself to become self-reflexive, reflection exposes the blind spot that simultaneously makes vision possible and leaves it incomplete.

To apprehend this X, Merleau-Ponty goes back beyond the beginning to the origin of knowledge by turning his attention toward the unknowable birth or "*advent* of being conscious." "The mistake of reflective philosophies," he argues, "is to believe that the thinking subject can absorb into its thinking or appropriate without remainder the object of its thought that our being amounts to knowledge. As a thinking subject we are never the unreflective subject that we seek to know; but neither can we become wholly conscious, or make ourselves into the transcendental consciousness."[29] For the philosophy of reflection, which begins with Descartes's inward turn and reaches closure in Hegel's comprehensive speculative system, the autonomous, self-reflexive subject is the alpha and omega of thought and, as such, is the foundation of all knowledge and self-knowledge. Through critical reflection, the self seeks to become completely transparent to itself. For Merleau-Ponty, by contrast, the self-conscious cogito remains irreducibly obscure because it is secondary to more primordial perceptual processes it presupposes but cannot comprehend. Self-consciousness is always *subjected* to a "phenomenal layer" of sensibility that is "literally prelogical and will always remain so." This rudimentary layer of the subject is inaccessible to the reflective cogito, but it is accessible to what Merleau-Ponty describes as "the prereflective cogito."

> There is, therefore, another subject beneath me, for whom a world exists before I am here, and who marks out my place in it. This captive or natural spirit

is my body, not that momentary body, which is the instrument of my personal choices and which fastens upon this or that world, but the system of autonomous "functions," which draw every particular focus into a general project. Nor does this blind adherence to the world, this prejudice in favor of being occur only at the beginning of my life. It endows every subsequent perception of space with its meaning, and it is resumed at every instant. Space and perception generally represent, at the core of the subject, the fact of his birth, the perpetual contribution of his bodily being, a communication with the world more ancient than thought.[30]

The "anonymous functions," which are "more ancient than thought," constitute the blind spot without which vision is impossible. Vision, therefore, is always shadowed by a residual invisibility. "When I say then that every visible is invisible, that perception is imperceptions, that consciousness has a *'punctum caecum,'* that to see is always to see more than one sees—this must not be understood in the sense of a *contradiction*—It must not be imagined that I add to the visible perfectly defined as in Itself a non-visible (which would be only objective absence) (that is, objective presence *elsewhere*, in an *elsewhere* in itself)—One has to understand that it is the visibility itself that involves non-visibility—In the very measure that I see, I do know *what* I see."[31] Like Barthes's *punctum* and Jabès's point, Merleau-Ponty's *punctum caecum* reveals the unrevealable blindness at the heart of insight and silence in the midst of words that remains the "non-knowing [*non-savoir*]" that is the condition of the possibility and impossibility of knowing.[32]

By creating *Dark Spaces*, *Skyspaces*, and *Ganzfelds*, Turrell attempts to apply Merleau-Ponty's phenomenology of perception by creating the conditions that make it possible to see seeing. As early as his proposal for the Art and Technology program, Turrell explains, "what we tend to accomplish is to bring you to an awareness of perception, of perceiving yourself perceiving, pressing the information against the senses—making the sense of reality a sense of the senses."[33] In his illuminating essay, "Inner Light: The Radical Reality of James Turrell," Michael Govan explains, "Turrell offers a glimpse not of something out there but of the light and space *behind* the eye." His concern, therefore, is not merely sight, but, more important, foresight. Govan continues, "In fact, the artist has said that perception is his true medium. The greatest revelations borne by Turrell's art are a deeper understanding of what it is to be a perceiving being and an awareness of how much of our observation and experience is illuminated by the 'inner light' of our own perception."[34] If to perceive perceiving is to perceive the imperceptible

that makes perception possible, to see seeing is to see the unseeable that makes seeing possible.

One of the most startling things I learned many years ago working in my father's dark room developing and printing pictures is that the world itself is not colored. It is virtually impossible to imagine a world without color; after all, even black, white, and gray are colors. To see a colorless world is as impossible as to know Kant's thing-in-itself. It seems no more possible to image the complete absence of color than it is to hear absolute silence. By creating the conditions necessary to perceive perceiving and to see seeing, Turrell attempts to show how the colored world we all know is created. Though he never cites William James, Turrell's strategy in effect applies the extraordinarily prescient insight expressed in *The Principles of Psychology* to the work of art. To appreciate the implications of this seminal insight, it is helpful to recall that "to sculpt" derives from the Latin *sculpere*, which means to carve.

The mind, in short, works on the data it receives very much as a sculptor works on his block of stone. In a sense the statue stood there from eternity. But there were a thousand different ones beside it, and the sculptor alone is to thank for having extricated this one from the rest. Just so the world of each of us, howsoever different our several views of it may be, all lay embedded in the primordial chaos of sensations, which gave the mere *matter* of the thought of all of us indifferently. We may, if we like, by our own reasonings unwind things back to that black and jointless continuity of space and moving clouds of swarming atoms which science calls the only real world. But all the while, the world *we* feel and live in will be that which our ancestors and we, by slowly cumulative strokes of choice, have extricated out of this, like sculptors, by simply rejecting certain portions of the given stuff."[35]

Turrell's sculptures sculpt the eye by retraining it both to see what it overlooks and to perceive the processes that make perception possible.

In the years since Merleau-Ponty wrote *The Visible and the Invisible*, psychology, biology, cognitive science, and neuroscience have developed a much more sophisticated understanding of the mechanisms of vision. Though both the approach and the language are very different, these scientific investigations confirm Merleau-Ponty's most important conclusions. Light sculpts the eye as much as the eye sculpts light. Perception and conception are joined in feedback and feedforward loops. In his informative book *A Natural History of Seeing: The Art and Science of Vision*, Simon Ings explains, "Reti-

nas are sculpted by the kind of light they are exposed to. Blurred light encourages visual abilities that do not rely on clearer images: areas devoted to the detection of movement, and to providing good all-round vision in dim light. Well-focused light favors visual abilities that make use of plentiful light in a fine-grained view of the world. This is why photoreceptors of the vertebrate retina have evolved and specialized into rods and cones."[36] This complex process of sculpting has a "subjective" and an "objective" side: the eye processes the data it receives, and the light shapes the eye that figures it. In other words, sensuous perception rewires the brain, which, in turn, reconfigures the mind in ways that transform perception.

Color, then, is the product of the interaction between different wavelengths of light reflected from objects in the world and the eye. Vision requires the effective processing of massive streams of data carried by light. Screening or filtering begins at the most rudimentary level of perception. Human physiology limits vision to between 400 and 750 nanometers, which is a narrow range of the overall light spectrum. Further constraints are created by the structure and biochemistry of the eye, as well as the neural architecture of the brain. It is difficult to comprehend the astonishing complexity of the brain and its wiring network. There are an estimated 100 billion neurons in the brain, each of which is connected to approximately 10,000 other neurons. These neurons can process more than one bit per second. "Each human eye," George Lakoff and Mark Johnson point out, "has 100 million light-sensing cells, but only about 1 million fibers leading to the brain. Each incoming image must therefore be reduced in complexity by a factor of 100. That is, information in each fiber constitutes a 'categorization' of information from about 100 cells. Neural categorization of this sort exists throughout the brain, up through the highest levels of categories that we can be aware of."[37] As one moves from lower to higher levels of schematization, the range of awareness narrows.

Within these fixed constraints, it is possible to expand the bandwidth of perception to the limit, where one can apprehend the time *before* time and the place *before* space that is the nonsite of the creation of the world and the nonsight that is the birth of perception. Describing his most ambitious and magnificent Skyspace, *Roden Crater*, Turrell makes a startling claim revealing his preoccupation with the origin before every creation.

> Roden Crater has knowledge in it and it does something with that knowledge. Environmental events occur; a space lights up. Something happens there, for a moment, or for a time. It is an eye, something that is itself perceiving. It is a piece that does not end. It is changed by the action of the sun, the moon,

the cloud cover, or what day of what season that you're there and it keeps changing. When you're there, it has visions, qualities, and a universe of possibilities.[38]

Seeing light listening to you. Hearing the invisible in the visible. Creation is in Wallace Stevens's fine phrase, "a poem within a poem."[39] Poiesis is the infinite process of world making through which the Word emerges from the silence it never leaves behind.

DE-LIMITING THE IN-FINITE

"God is at home," says Meister Eckhart, "We are in the far country."

We are most deeply asleep at the switch when we fancy we control any switches at all. We sleep to time's hurdy-gurdy; we wake, if we ever wake, to the silence of God. And then, when we wake to the deep shores of light uncreated, then the dazzling dark breaks over the far slopes of time, then it's time to toss things, like our reason, and our will; then it's time to break our necks for home.[40]

In his widely influential book *The Sacred and the Profane*, Mircea Eliade writes,

The most ancient sanctuaries were hypaethral or built with an aperture in the roof—"the eye of the dome," symbolizing break-through from plane to plane, communication with the transcendent.

Thus *religious architecture simply took over and developed the cosmological symbolism already present in the structure of primitive habitations*. In its turn, the human habitation had been chronologically preceded by the provisional "holy place," by a space provisionally consecrated and cosmicized. . . . This is as much as to say that all symbols and rituals having to do with temples, cities, and houses *are finally derived from the primary experience of sacred space*.[41]

Like Tadao Ando, with whom he collaborated on two important projects, Turrell's most important works are liminal—breaking through from plane to plane both above and below ground, they create a passageway connecting the heavens, the earth, and the underworld.[42] So situated, the work of art marks the de-limitation of the boundary simultaneously joining and separating the finite and the in-finite. In an essay entitled "The Origin of the Work of Art," Heidegger argues that the margin between the planes of the sky's "clearing" and the earth's "self-secluding" is the site of the temple.

A building, a Greek temple, portrays nothing. It simply stands there in the middle of the rock-cleft valley. The building encloses the figure of the god, and in this concealment lets it stand out into the holy precinct through the open portico. By means of the temple, the god is present in the temple. This presence of the god is in itself the extension and the *delimitation* [emphasis added] of the precinct as a holy precinct. It is the temple-work that first fits together and at the same time gathers around itself the unity of those paths and relations in which birth and death, disaster and blessing, victory and disgrace, endurance and decline acquire the shape of destiny for human being.... The temple-work, standing there, opens up a world and at the same time sets this world back again on earth, which itself only emerges as native ground.... The temple, in its standing there first gives to things their look and to men their outlook on themselves. This view remains as long as the work is a work, as long as the god has not fled from it. It is the same with the sculpture of the god.... It is not a portrait whose purpose is to make it easier to realize how the god looks; rather, it is a work that lets the god himself be present and thus *is* the god himself.[43]

By joining and separating the heavens and the earth, the temple, which figures the work of art, not only lets god be present, it is god. But whose god is this? What is the name of this god?

Long obsessed with pyramids and caves, Turrell creates pyramids that are caves and caves that are pyramidal. Ancient pyramids were monuments to gods, and the style of pyramids changed with the god worshipped. The most popular pyramids, located at Giza on the outskirts of Cairo, were built as monumental tombs for the pharaohs, who themselves were believed to be gods. In an essay entitled "The Obelisk," Georges Bataille explains,

Each time death struck down the heavy column of strength, the world itself was shaken and put in doubt, and nothing less than the giant edifice of the pyramid was necessary to reestablish the order of things: the pyramid let the god-king enter the eternity of the sky next to the solar Ra, and in this way existence regained its unshakable plenitude in the person of the one it had recognized.... The great triangles that make up their sides "seem to fall from the sky like the rays of sun when the disc, veiled by the storm, suddenly pierces through the clouds and lets fall to earth the ladder of sunlight." Thus they assure the presence of the unlimited sky on earth.[44]

These pyramids were designed to facilitate the passage of the deceased emperor to Ra by orienting the structures in a way that directed a beam of

light to the body of the god-king. Turrell appropriates this cosmic design in Roden Crater, which is a conic pyramid. The central feature of this work is a 849′ tunnel that rises at an 8° grade to join a circular piece of white marble, measuring 7′ in diameter and 4″ thick, with a Skyspace named *Sun and Moon Room*. The Image Stone and opening at the end of the tunnel are precisely aligned so that for the ten days surrounding the vernal equinox, sunlight passes through the opening and down the tunnel. Halfway along the passage, there is a retractable lens that is 5′ in diameter, making Roden Crater the largest naked-eye telescope in the world. Since the lens is refractive, the image the sun casts on the stone is true rather than reversed. When there is solar activity, sunspots can be detected on the Image Stone. Every 18.6 years, the moon lines up and projects its image directly on the stone's white face.

In Mesoamerican culture, by contrast, "pyramids with their tips knocked off" serve as altars for human sacrifices offered to placate vigilant gods.[45] Like these ancient ruins, Turrell's pyramids are decapitated, though the sacrifices he stages are not bloody. His most significant work in the Mesoamerican style is located on the Yucatan peninsula in Mexico. Entitled *Agua de Luz* ("Water of Light"), two things make this work especially interesting: first, it joins a pyramidal Skyspace with underground caves often filled with water; and second, Turrell designed it with Philip Glass to include an amphitheater for Glass's performances. The Mayans, like the Egyptians, constructed their pyramids to capture celestial events. The ancient Mayans believed that the 2012 winter solstice, which took place one month after Glass's inaugural performance, would be the end of what they called Baktun 13, which was a 144,000-day planetary cycle. Michael Govan reports that in constructing the pyramid, Turrell worked with Mayan craftsmen.

> Like ancient structures nearby, Turrell's is a stepped, three-tiered pyramid that rises tall enough to clear the canopy of the jungle for a clear 360-degree view at the top. It is sited, like those ancient structures, near a cenote, the deep, natural, cavelike pits in the Yucatan limestone bedrock that make available the groundwater beneath and were the center of Mesoamerican myth and ritual. … His pyramid, like most—from those in Egypt to the stupas of Asia to those of the ancient Americas—connects land and sky. Turrell took advantage of the underground waters of the cenote to literally link the underworld to the sky in reference to Mayan cosmology that describes the origins of the universe as only the sea and the sky.[46]

By joining the sky to subterranean caverns, Turrell figures the return of the work of art as well as the cosmos to their most primordial origin.

As we have seen, Turrell acknowledges that his Skyspaces recall Plato's allegory of the cave, but he fails to note that his conclusions are the opposite of Plato's. While Plato believes that the deceptive senses trap one in the shadowy realm of appearances, Turrell is convinced that sense experience is revelatory and actually discloses the truth of the world. In the history of religion and philosophy, the significance of caves extends far beyond Plato's limited experience. From the Greek Oracle at Delphi and the lairs of Hermes, Pan, Gaia, and Dionysus to Mohammed's site of revelation, and both Buddhist stupas and early Christian catacombs, caves have been the site of prophesy, ecstasy, and, most important, silent meditation.

In this context, it is important to note that it was in a cave that the Greek philosopher Plotinus (203–270 CE) first experienced *henosis*, which is union with the divine that takes place beyond the borders of cognition. "Often I have woken up out of the body to myself, out from all the other things, but inside myself; I have seen a beauty wonderfully great and felt assurance that then most of all belonged to the better part; I have actually lived the best life and come to identity with the divine; and set firm in it I have come to that actuality [*energeia*] setting myself above all else in the realm of Intellect."[47] The sense of profound beauty that such out-of-body experiences bring is often accompanied by an intense sense of joy that lasts long after the moment passes. Here the cave becomes the dark room where it is possible "to go inside to greet the light." In his *Enneads*, Plotinus develops an interpretation of his experience, which is the foundation of Neo-Platonism and has deeply influenced the long tradition of negative theology.[48]

In *Lascaux, or The Birth of Art*, Bataille argues that the cave is not only philosophically and religiously significant, but is also the place of "the origin of the work of art," as well as the birthplace of the human race. Fabricating his personal myth of origin, he writes, "the Cave of Lascaux, lying in the Valley of Vezere, is not only the most splendid, the richest of known prehistoric caverns containing paintings; Lascaux provides our earliest *tangible* trace, our first sign of art and so also of man."[49] The creation of works of art differentiates human beings from their previous animal condition. Throughout the history of religion, sky gods have tended to be male, and earth gods have tended to be female. Gustave Courbet's reclining woman in *The Origin of the World* (1866) prefigures Bataille's interpretation of the Lascaux caves. To enter the cave is to return to the silent maternal matrix that is the origin of every person. "Every beginning," Bataille argues, "supposes what preceded it, but at one point night gave birth to day and the daylight we find at Lascaux illuminates the morning of our immediate species. It is the man

who dwelt in this cave of whom for the first time and with certainty we may finally say: he produced works of art; he is of our sort." Bataille sees this moment of birth in the astonishingly elegant figures drawn on the intestinal walls of the cave.

The Site of Our Birthplace

A marvel for that visitor who journeys thither from the modern cities of these industrial times; but still more of a marvel in the eyes of the men who ordered its magnificence: such appears the Lascaux Cave, which transports us back to those dim, lost moments when the human voice first began to make itself heard. This, then, is our birthplace. But it has not been fittingly remembered, nor given the renown it deserves. It would seem that our prehistorians sin through excessive modesty: they have been chary of praise for a discovery ... made in consequence of some youngsters' curiosity.[50]

Bataille follows Freud when he insists that the desire to return to the maternal origin is fraught with danger. Like entering into Turrell's Dark Spaces and Ganzfelds, to return to the origin is to go back to a condition *before* differentiation, determination, distinction, and articulation. The fulfillment of this desire would be the sacrifice of the individual self brought about by the meeting of Eros and Thanatos. As I have noted, birth, like death, can never be experienced because when it occurs I am not, and when I am, it is not. The experience of nonexperience leaves one "speechless." Nonetheless, Bataille names the loss of self "inner experience."

NON-KNOWLEDGE LAYS BARE.

This proposition is the summit, but must be understood in this way: lays bare, therefore *I see* what knowledge was hiding up to that point, but if I see, *I know*. Indeed, I know, but non-knowledge again lays bare what I have known. If nonsense is sense, the sense which is nonsense is lost, becomes nonsense once again (without possible end).

If the proposition (non-knowledge lays bare) possesses a sense—appearing, then disappearing immediately thereafter—this is because it has the meaning: NON-KNOWLEDGE COMMUNICATES ECSTASY. Non-knowledge is ANGUISH before all else.... In ecstasy, one can *let oneself go*—this is satisfaction, happiness, plenitude. Saint John of the Cross contests rapture and the seductive image, but calms himself in the theophantic state.

Bataille recognizes that this ecstatic "experience" is so contradictory that it is actually "impossible," or, more precisely, "The Impossible" itself. Retreat into the darkness of the cave is the "deep descent into the night of existence. Infinite pleading, to drown oneself in anguish. To slip over the abyss and in the completed darkness experience the horror of it. To tremble, to despair, in the cold solitude, in the eternal silence of man (foolishness of all sentences, illusory answers for sentences, only the insane answer of night answers). The word *God*, to have used it in order to reach the depth of solitude, but to no longer know, hear his voice. To know nothing of him. God final word meaning all words will fail further on."[51] The experience of the Impossible can be apprehended only through *les mots glissants*, which remain silent even when spoken.

The similarity of the experiences of birth and death should not obscure their no less important differences. The anguish of birth occurs when the Word breaks the waters of silence. Blanchot labels Bataille's *expérience intérieure* "the limit-experience [*l'expérience-limite*]." "The limit-experience is experience itself: thought thinking that which will not let itself be thought; thought thinking more than it is able by an affirmation that affirms more than can be affirmed. This more itself is the experience: affirming only by an excess of affirmation and, in this surplus, affirming without anything being affirmed—finally affirming nothing."[52] So understood, the limit-experience is, paradoxically, the experience of de-limiting the in-finite. To step across the threshold of the work of art is to enter the limitless space-time of the Infinite. In this fleeting moment, the infinite is not the opposite of the finite, but is in finitude as the boundless source of the not-yet where being and nonbeing, something and nothing are one. The Infinite is the yet-to-be-determined, the yet-to-be-defined, the yet-to-be-differentiated, the yet-to-be-distinguished, the yet-to-be-articulated, the yet-to-be-named, the yet-to-be-spoken that is the boundless horizon of life. To imagine this nonbeing, to apprehend this nothing is as impossible as hearing the silence that forever remains before the birth of the Word.

More a womb than a tomb, the silence of the Before is the *nihil* from which creation eternally emerges. The work of art—true art—makes us human because it is the ceaseless quest to hear silence by seeing the invisible. To "go inside to greet the light" with Turrell is to see seeing, and to see seeing is to see the silence of what once was named "God." Medieval mystic and negative theologian Nicholas of Cusa (1401–1464) might well have been commenting on Turrell's remarkable art when he wrote on his "Dialogue on the Hidden God,"

The name "God" comes from *thero*, which means "I see." For God is in our realm as sight is in the realm of color. For color is attained in no other way than by sight, and in order that sight can freely attain every color, the center of sight is without color. Therefore, because sight is without color, sight is not found in the realm of color. And so to the realm of color sight is nothing rather than something. For the realm of color does not attain any being outside its realm, but it maintains that everything that exists is in its realm. But sight is not found there. Therefore, sight, because it exists without color, is unnameable within the realm of color, for no color's name corresponds to it. But sight has given a name to every color through its differentiating judgment. Hence, in the realm of color all naming depends on sight, but sight's name, the derivation of every color's name is discovered to be nothing rather than something. God, therefore, is to all things as sight is to visible things.[53]

3.

FROM

At the appropriate time it becomes unavoidable to reflect on how mortal language and its articulation takes place in speaking as the sound of the silence of difference. Any uttering, whether in speech or writing, breaks the silence. On what does the peal of silence break? How does the broken silence come to resound in words?

MARTIN HEIDEGGER

PRESENTING SILENCE

In the introduction to the *Phenomenology of Spirit*, Hegel anticipates the course he will follow by drawing an analogy to the Stations of the Cross. "Now because it has only apparent knowledge for its object, this exposition seems not to be Science, free and self-moving in its own peculiar shape; yet from this standpoint it can be regarded as the path [*Weg*] of natural consciousness, which presses forward to true knowledge; or as the way of the soul journeys through the series of its own forms as though they were stations appointed for it by its own nature, so that it may purify itself for the life of the Spirit, and achieve finally, through a completed experience of itself, the awareness of what it really is in itself."[1] In the course of this journey, consciousness and self-consciousness progress from the most rudimentary form of awareness, sense-certainty, to what Hegel regards as Absolute Knowledge. The stations along this way mark the self-negation (crucifixion) of every inadequate form of awareness and its sublation [*Aufhebung*] in a higher form of consciousness or self-consciousness (resurrection). At the end of this journey, silence gives way to the Word, and nothing remains unsayable or unsaid.

Or so Hegel claims. However, if one listens carefully, it becomes possible to hear a resounding silence that is the death-knell or *glas* of speculative philosophy as well as its expression in modern and postmodern culture and society.[2] Hegel begins by leaving out something, and this something—or, more precisely, no-thing—returns at the end to interrupt the resurrection of the Word. The first station on the way to Absolute Knowledge is the immediacy of sense-certainty—Here (space) and Now (time) in the "This." The "This" of sensuous immediacy is completely undifferentiated, indeterminate, and inarticulate. To make his *point*, Hegel constructs a thought experiment by taking the example of night.

> It is, then, sense-certainty itself that must be asked: "What is the *This*?" If we take the "This" in the twofold shape of its being, as "Now" and as "Here," the dialectic it has in it will receive a form as intelligible as the "This" itself is. To the question: "What is Now?," let us answer, e.g., "Now is Night." In order to test the truth of this sense-certainty a simple experiment will suffice. We write down this truth; a truth cannot lose anything by being written down, any more than it can lose anything through our preserving it. If *now*, *this noon*, we look again at the written truth we shall have to say that it has become stale.

By beginning his interpretation of the evolution of consciousness with sense-certainty, whose origin is sensuous immediacy, Hegel's argument re-enacts the complex interplay between origin and beginning that I considered in the previous chapter. The example of writing introduces the question of the relation of language or the Word to the Real as such. Language is intended to re-present the real, but actually results in the "vanishing of the Now and Here."

> The Now that is Night is *preserved*, i.e., it is treated as what it professes to be, as something that *is*; but it proves itself to be, on the contrary, something that is *not*. The Now does indeed preserve itself, but as something that is *not* Night; equally, it preserves itself in the face of the Day that it now is, as something that also is not Day, in other words, as a *negative* in general.[3]

Rather than re-presenting the Here and Now, the Word presents the disappearance of presence. As I have noted, Blanchot and Lacan insist "the word is the death of the thing." The "thing" turns out to be the silent "no-thing" that shows itself "in" language by hiding. Hegel *believes* the death of the "This" is finally overcome in apocalyptic vision at the end of history. But the circle remains incomplete because Hegel's beginning is in his end in a way

he did not intend. The original overlooked, left out, repressed remainder returns at the end to fill empty words with silence.

What Hegel attempts to write, Barnett Newman struggles to paint. Yve-Alain Bois goes so far as to claim that Newman was "a phenomenologist, obsessed with the 'hic et nunc' and with identity and plenitude."[4] He was preoccupied with capturing presence in the present: *Moment* (1946), *Here I* (1950), *Here II* (1965), *Here III* (1965–66), *Now I* (1965), *Now II* (1967). His entire *oeuvre* can be organized around two elliptical foci: presence-present and birth-creation. In a diary he kept during the mid-1940s, Newman expressed his deepest commitments as a painter.

> The present painter is concerned not with his own feelings or the mystery of his own personality, but with the penetration into the world-mystery. His imagination is therefore attempting to dig into metaphysical secrets. To that extent his art is concerned with the sublime. It is a religious art which through symbols will catch the basic truth of life, which is its sense of tragedy.... In trying to go beyond the visible and known world he is working with forms that are unknown even to him. He is therefore engaged in a true act of discovery in the creation of new forms and symbols that will have the living quality of creation.[5]

Newman was slow to arrive at this sense of mission. Born in 1905, he was the son of emigrants from Russian Poland. His father, Abraham, became a successful businessman whose company manufactured men's clothes. Not religiously devout, his father was a committed Zionist, who instilled in his son a strong sense of injustice and passion for radical politics. Newman was drawn to art from a young age and studied at the Art Students League while he was still in high school. Ever the pragmatist, Abraham resisted his son's interest in art, but eventually agreed to allow him to attend City College of New York, where he studied literature and philosophy. In college he continued to pursue drawing and painting at the Art Students League. Thomas Hess reports that one of the most influential classes Newman took "was a philosophy course conducted by Scott Buchanan in which the curriculum progressed backward from Bertrand Russel to Vico." The philosopher who left the deepest impression was Spinoza, whose principle of intellectual intuition held "the key to the meaning of art" for Newman. It was, he said, "'a moment of self-discovery of what painting is ... that it's something more than an object.'"[6] Newman's youthful enthusiasm for Spinoza led to his lifelong conviction that feeling is a more important faculty than reason for ascertaining truth. In an interview on the occasion of his 1950 show at the

Betty Parsons Gallery, he explained, "These paintings are not 'abstractions,' nor do they depict some 'pure' idea. They are specific and separate embodiments of feeling, to be experienced, each picture for itself. They contain no depictive allusions. Full of restrained passion, their poignancy is revealed in each concentrated image."[7]

It took Newman a long time to find the most effective way to express this conviction with paint. Though he was an active participant in the debates swirling in the lively postwar art scene in New York City, his own work was slow to develop. When he finally found his mature style, his overall output remained relatively modest. Newman produced only 120 paintings and 300 total works. His reticence in creating art was a deliberate strategy consistent with the spiritual and philosophical vision informing his work.

Throughout the 1930s, Newman's thinking remained in limbo. Along with other New York artists like Mark Rothko, Franz Kline, Willem de Kooning, Jackson Pollock, and Tony Smith, he was searching for a definitive American art that would mark a clear break with Europe. To support himself during this period, he taught high school art classes. His polemical reviews and tracts kept him involved in discussions that eventually led to the American transformation of avant-garde art. Newman's Grand Tour consisted of regular visits to the Metropolitan Museum of Art and as many gallery shows as he could attend. He continued to expand his education by studying botany, geology, and ornithology, and learning Yiddish. He also remained interested in radical politics and in 1933 became so disgusted with Tammany Hall corruption that he declared himself a candidate to become the mayor of New York City. On November 4, 1933, the *New York World Telegram* published Newman's political manifesto. A. J. Liebling summarized the candidate's position on art.

NOTHING FOR ART

"The present political campaign in New York has now run long enough to reveal that once again the artist, the musician, the writer, the actor, the teacher, the scientist, the thinker, and the man of culture generally, have nothing to hope for from the candidates."

"The artist is free," Mr. Newman went on. "He doesn't belong in a government of expediency. Expedience always proves inexpedient in the long run. Vote for Communism as a protest, and you help saddle yourself with a regime incompatible with art."

Free music and art schools in every district ... are included in the Newman-Bordulin platform.[8]

Newman openly acknowledged that there was no possibility he would win, but he was convinced of the importance of his gesture of protest.

As often happens, the revelation that confirmed Newman's faith in what was emerging as his favored style occurred unexpectedly. In 1949, he and his wife, Annalee, took a trip to Akron, Ohio, where they visited the Native American burial mounds at Fort Ancient. The particular earthwork that impressed Newman was similar to the shape of a Mesoamerican step pyramid like those that obsess Turrell. In this sculpture, Newman saw the possibility of a distinctive American art that surpassed the greatest achievements of the past. In an important account of what became the cornerstone of his art, Newman reports,

> Here in the seductive Ohio Valley are perhaps the greatest art monuments in the world, for somehow the Egyptian pyramid by comparison is nothing but an ornament—what difference if the shape is on a table, a pedestal, or lies immense on a desert? Here is the self-evident nature of the artistic act, its utter simplicity. There are no subjects—nothing that can be shown in a museum or even photographed; [it is] a work of art that cannot even be seen, so it is something that must be experienced there on the spot: The feeling [is] that here is the space; that these simple low mud walls make the space; that the space outside, the dramatic landscape looking out over a bridge one hundred feet high, falling land, the chasms, the rivers, the farmlands and far-off hills, are just picture postcards, and somehow one is looking out as if inside a picture rather than outside contemplating any specific nature. Suddenly one realizes that the sensation is not one of space and its manipulations. The sensation is the sensation of time—and all other multiple feelings vanish like the outside landscape.... The concern with space bores me. I insist on my experiences of sensations of time—not the *sense* of time but the physical *sensation* of time.[9]

The time that preoccupied Newman is not time past or time to come, but time present. Attempting to describe his epiphany, he recalls "a sense of place, a holy place. Looking at the site you feel, Here I am, *here* ... and out beyond there [beyond the limits of the site] there is chaos, nature, rivers, landscapes ... but here you get a sense of your own presence.... I became involved with the idea of making the viewer present: the idea that 'Man is Present.'"[10] Present, Presence: "Moment." "Here." "Now." "Not There—Here." One year earlier, Newman had painted *Onement I*, which he claimed was his personal breakthrough. When compared to his mature works, this painting's modest size—27¼" × 16¼"—is distinctive. This is the first time Newman had used his signature vertical line, which he labeled the zip, to

define the structure of the work by marking the boundary between two equal rectangles. To make the zip, he placed masking tape on the canvas and left it there. The strip "is covered by light cadmium red oil paint that Newman laid on with a palette knife directly from the tube. This is thick and irregular painting. . . . There is no geometric line at all, as the zip partially obscures, and partially does not, the left and right edges of the masking tape. The zip bears marks of many directions, and many starts and stops. It reads in clear contrast to the much more smoothly and evenly painted field of Indian red."[11]

As with all of Newman's paintings, the title is integral to the work— *Onement I*. "Onement" describes the condition in which division is overcome. Such at-onement can occur either during life or after death. In death all oppositions are overcome, and all differences, determinations, and distinctions are reabsorbed in primal oneness. This final unity is the mirror image of the primal unity—before the beginning and after the end are one. In between birth and death, presence can be experienced only as the non-experience of the Here and Now in the Moment, which is always already vanishing. This evanescent Now exceeds both images and words and, therefore, remains incomprehensible. In his widely influential essay "The Sublime and the Avant-Garde," Jean-François Lyotard writes, "Newman's *now* which is no more than *now* is a stranger to consciousness and cannot be constituted by it. Rather, it is what dismantles consciousness, what deposes consciousness, it is what consciousness cannot formulate, and even what consciousness forgets in order to constitute itself."[12]

To understand the relevance of Lyotard's point for Newman's art, it is helpful to return to Kant's critical philosophy, where he developed what has become the normative interpretation of the sublime for modernism and postmodernism—*The Critique of Judgment* (1790). The Third Critique (aesthetics) is the boundary, edge, limit simultaneously joining and separating the First Critique (thinking, theory) and the Second Critique (acting, practice). When reason is pushed to the limit, concepts, ideas, and words become empty and effectively fall silent. Kant argues, "precisely because there is a striving in our imagination towards progress *ad infinitum*, while reason demands absolute totality, as a real idea, the same inability of the part of our faculty for the estimation of the magnitude of things of the world of sense to attain to this idea, is the awakening of a feeling of a supersensible faculty within us. . . . *The sublime is that, the mere capacity of thinking which evidences a faculty of mind transcending every standard of sense*."[13] Kant distinguishes two modalities of the sublime: the mathematical and the dynamic. The example

he uses to illustrate the excess of the mathematical sublime is Egyptian pyramids whose size and magnitude, he maintains, are overwhelming. Imagining a visitor to Giza, Kant writes, "the feeling comes home to him of the inadequacy of the imagination for presenting the idea of a whole within which that imagination attains its maximum, and, in its fruitless efforts to extend this limit, recoils upon itself, but in so doing succumbs to an emotional delight."[14]

While the mathematical sublime is quantitative, the dynamic sublime is qualitative. The phenomenon Kant cites to illustrate the dynamic sublime is the overwhelming power of nature. Perhaps invoking Kant, Newman once went so far as to declare, "I am nature!"[15] "In what we are accustomed to call sublime in nature," he explains, "there is such an absence of anything leading to particular objective principles and forms of nature corresponding to them that it is rather in its chaos or its wildest and most irregular desolation, provided size and might are perceived, that nature chiefly excites us in the ideas of the sublime." Whether mathematical or dynamic, the delight caused by the sublime is a strange delight that Kant calls a "negative pleasure," or even "feeling of displeasure."[16] The negative pleasure produced by prodigious excess distinguishes the sublime from the pleasure created by the harmonious balance and reassuring equilibrium of beauty.

In a brief essay, "The Sublime is Now," published in *Tiger's Eye* (1948), Newman distinguishes new American art from the formalism of European art, which he traces back to Platonic idealism. "The confusion in philosophy is but the reflection of the struggle that makes up the history of the plastic arts. To us today there is no doubt that Greek art is an insistence that the sense of exaltation is to be found in perfect form, that exaltation is the same as ideal sensibility—in contrast, for example, with Gothic or baroque, in which the sublime consists of a desire to destroy form, where form can be formless."[17] Newman became convinced that the purpose of art is not to represent beautiful images and forms, but is to present sublime formlessness.

> I believe that here in America, some of us, free from the weight of European culture, are finding the answer, by completely denying that art has any concern with the problem of beauty and where to find it. . . . We are reasserting man's natural desire for the exalted, for a concern with our relationship with absolute emotions. . . . We are freeing ourselves of the impediments of memory, association, nostalgia, legend, myth, or what have you, that have been the devices of Western European painting. Instead of making *cathedrals* out of Christ, man, or "life," we are making [them] out of ourselves, out of our own feelings.[18]

While Newman found his individual style in *Onement* and the subject of his work on the Ohio mound, he did not develop an effective way to convey the absolute feeling of the sublime until he painted his monumental *Vir Heroicus Sublimis* (1950/1951). As Kant insists, when considering the sublime, size matters. When Newman first visited the Louvre in 1968, he was surprised by the size of some of the paintings he previously had known only in reproductions. While some abstract expressionists were experimenting with larger formats, Newman realized that at a certain point quantitative increase leads to qualitative change. When he moved his studio from his apartment to 110 Wall Street, he had enough space to create very large paintings. *Vir Heroicus Sublimis* measures 8′ × 18′. As with all of Newman's paintings, there is no frame separating the viewer from the work. In addition to exploding the size, he shifts the canvas from a vertical to a horizontal axis and increases the number of zips from one to five distributed unevenly to create spatial and temporal intervals of different lengths. The expansive field of the work is a brilliant red, which bears no trace of a brushstroke. The hard-edged zips vary in color from white and cream to orange and coral. When *Vir Heroicus Sublimis* was first displayed in Newman's one-person show at the Betty Parsons Gallery in 1951, he added an explanatory instruction of the wall. "There is a tendency to look at large pictures from a distance. The large pictures in this exhibition are intended to be seen from a short distance."[19] When viewed at close range, the painting engulfs you in a red glow where all distinctions and differences dissolve. The effect is virtually the same as crossing the threshold limit and entering Turrell's Ganzfeld or sitting in his Dark Space. Subject and object disappear to create a sense of at-onement. In this way, *Vir Heroicus Sublimis* becomes, impossibly, the experience of what I, or more precisely the I, cannot experience. Rather than the attempted representation of the sublime as in a Turner seascape, for Newman, the "experience" of the sublime occurs in the painting itself. The painting, in other words, is an event, a happening. In the absence of subject and object, this event leaves one speechless—the only response is to fall silent.

Alain Corbin begins his richly suggestive book *Historie du Silence: de la Renaissance à nos jours* by writing:

> Silence is not only the absence of noise. We have almost forgotten this. Auditory landmarks have been altered, weakened, they have lost their sacredness. The fear, or even the dread, of silence has intensified. In the past, the men of the Occident used to enjoy the depth and savor of silence. They viewed it as a condition for reverence, contemplation, focus on one's inner self, meditation, orison, reverie, creation, and above all the inner place from which speech

would spring. They detailed the social strategies of silence. To them painting was words of silence.[20]

Painting as "words of silence"—it is hard to imagine a better description of Newman's most important work. Since the sublime is formless, indeterminate, and undifferentiated, the artist faces the impossible challenge of imagining the unimaginable, saying the unsayable, and articulating the inarticulate. In a strange way, the success of Newman's work is its failure, which makes it possible to see silence.

CONTRACTIONS AND CONCEPTIONS

Contract (Latin *contrahere*, to draw together): An agreement between two or more parties; to enter into by contract: establish or settle by formal agreement; to acquire or incur; to reduce in size by drawing together, shrink; to shorten word or words by omitting or combining some of the letters or sounds.

Contraction: A shortened word; the shortening, and often thickening, of functioning muscle.

Concept (Latin *concipere*, to take to oneself): a general idea or understanding; a thought or notion.

Conception: the ability to form mental concepts; that which is mentally conceived; a beginning, a start; the formation of a zygote capable of survival and maturation in normal conditions.[21]

In the history of the West, two dominant theological alternatives have been organized around two foundational principles: "in the beginning was the Word" (Gospel of Saint John), and "in the beginning was the Deed" (Goethe, Freud). Hess introduces his discussion of *Onement* by quoting the lines from Goethe's *Faust* with which Freud concludes *Totem and Taboo*.

It is written: In the beginning was the Word.
Here I am stuck at once. Who will help me on?
I am unable to grant the Word such merit, I must translate it
differently
If I am truly illuminated by the spirit.
It is written: In the beginning was the Mind.
But why should my pen scour
So quickly ahead? Consider that first line well.
Is it the Mind that effects and creates all things?

It should read: In the beginning was the Power.
Yet even as I am changing what I have writ,
Something warns me not to abide by it.
The spirit prompts me, I see in a flash what I need,
And write: In the beginning was the Deed.[22]

Newman's zips reenact this creative flash. When he declares that his art makes cathedrals "out of ourselves, out of our own feelings," he is suggesting that the creation of the work of art is actually an extension of God's creative deed. Newman's *point* is not so much that God is the Creator but that creativity is divine. Hess explains that what critics have tended to overlook is that Newman "had taken his image of Genesis, of the creative act, of the artist as God, and expanded it into an ardent, pulsing glow of color. The secret symmetry that informs his structure, that was his starting point on the blank canvas and that had opened up a space for him to paint in, was as invisible as the God to whose actions it alludes and to whose presence the Kabbalists testified in ways as private and hermetic as Newman's."[23]

Newman's God is a strange, though not an alien God, who approaches by withdrawing, reveals by concealing, and speaks by remaining silent. With his elusive zips, we return to the question of the point—not Barthes's *punctum*, which is the trace of death, but Jabès's point, which is the beginning of life. In Newman's zip, it is possible to detect echoes of Wassily Kandinsky's analysis of the point of departure for the work of art. In his book *Point and Line to Plane*, he writes,

> The geometric point is an invisible thing. Therefore, it must be defined as an incorporeal thing. Considered in terms of substance, it equals zero.
>
> Hidden in this zero, however, are various attributes which are "human" in nature. We think of this zero—the geometric point—in relation to the greatest possible brevity, i.e, to the highest degree of restraint which, nevertheless, speaks.
>
> Thus we look upon the geometric point as the ultimate and most singular *union of silence and speech.*

Far from inert, the point whose "potentiality for endless movement" generates the line, which, in turn, produces the plane.[24] Just as the Word creates speech out of silence, so the interplay of point, line, and plane creates three-dimensional forms out of the formlessness of empty space.

Though Newman was not devout in the traditional sense, he was always preoccupied with spiritual and even theological or, more precisely, a/theo-

logical themes.[25] In an early series of works— *The Beginning* (1946), *Moment* (1946), *The Command* (1946), and *Genetic Moment* (1947)—he begins his long reflection on the whence of life. As his painting matures with his thinking, he transforms the unnamable vanishing point the Kabbalah names the Zim Zum into the straight line of his zips. Robert Rosenblum has argued that Newman's work is the painterly equivalent of negative theology. We will see in more detail in following chapters that there are different versions of negative theology. As I have noted, in the Neoplatonic tradition the excessive plenitude of divine being overflows in what had been the void to create the world. By contrast, in the Kabbalistic tradition, which Newman follows, the world is created by the *withdrawal* of divine plenitude into the Zim Zum. Gershom Scholem explains that according to Isaac Luria (1534–72), "The first act of *En-Sof*, the Infinite Being, is therefore not a step outside but a step inside, a movement of recoil, of falling back upon oneself, of withdrawing into oneself. Instead of emanation we have the opposite, contraction. The God who revealed himself in firm contours was superseded by one who descended deeper into the recesses of His own Being, who concentrated Himself into Himself, and had done so from the very beginning of creation."[26] The withdrawal into the *En-Sof* leaves in its wake ten *Sefiroth* through which the Divine continuously creates and sustains the cosmos.

In this scheme, theology, cosmology, and anthropology are different aspects of the same process. The Deed that issues in creation is the primordial withdrawal of Being into an absolute "Abyss" or "Unground" (*Abgrund*). Since creation begins with withdrawal and birth begins with contraction, everything and everybody who ex-ists (*ex*, from + *sister*, to take a position) is delivered *from* an Other that is never present as such. The God of the Kabbalah is figured, which is not to say represented, in Newman's paintings as a *deus absconditus* who is revealed in and through concealment. Paradoxically, contraction is expansion, and limitation is de-limitation. Commenting on Scholem's analysis in an article devoted to the similarities between the theosophic vision of Jacob Boehme (1575–1624) and Jewish esotericism, Eliot Wolfson clarifies this important point.

"Just as the human organism exists though the double process of inhaling and exhaling and the one cannot be conceived without the other, so the whole of Creation constitutes a gigantic process of divine inhalation and exhalation." I would modify Scholem's view by noting that it is not only that the "perpetual tension" of the cosmic process entails that every expression . . . is preceded by withdrawal . . . , but rather, more paradoxically, that the expansion itself is a withdrawal in the same manner that every disclosure is a concealment . . . ,

since what is disclosed is the concealment and the concealment cannot be disclosed as concealment unless it is concealed. The concentration of the limitless to a delimited space is perforce an attenuation of the limitlessness. Every creative act of the infinite must be seen through the prism of this twofold process, although I must emphasize again that the two processes occur contemporaneously and not consecutively.[27]

As we will see in the following chapters, the metaphysical principles underlying Kabbalistic mythology and theology also inform orthodox and unorthodox versions of Christianity as well as Sufi mysticism. Since the *En-Sof* is beyond all distinction, difference, and definition, it cannot be articulated and, thus, remains unsayable and unknowable. In his paintings, Newman attempts to figure the unfigurable that no words can capture. The Zim Zum—I am tempted to say Zip Zum—stages the withdrawal that is the beginning of creation. In some works, the zip is vertical, suggesting the connection of earth to the heavens and depths; in other paintings, the zip is horizontal, suggesting the ever-receding horizon of the past and future that frame the present. This unsayable horizon is the origin from which (the) all emerges.[28] The originary contraction is marked and remarked by the three points of an ellipsis . . . that sounds the primal silence without which there is no Word.

Several additional paintings and two, rather three, sculptures make this point. In 1949, Newman completed *End of Silence*, which is more similar in size and style to *Onement* than to *Vir Heroicus Sublimis*. The painting, which is 38″ × 30″, depicts a vertical cadmium band that is wider and more uneven than the zip in *Onement*. Unlike the flawless ground of *Vir Heroicus Sublimis*, the two dark maroon rectangles created by the band show lingering signs of the work of Newman's palette knife, suggesting turbulence rather than tranquility. Silence ends with the abrupt break of the zip that creates order out of chaos by articulating figures that emerge from the formless ground. In this way, the zip forms the boundary, border, and limit of the In-finite. Since formlessness appears as the contraction that releases form, *End of Silence* is at the same time the endless echo of silence in the genesis words.

The generative word is never transparent because it is always doubled by an impenetrable silence that remains irreducibly obscure. The second painting that is relevant in this context is *Abraham* (1949). As always, Newman's work begins with the duplicitous title that frames the work. Abraham is both the father of the Jewish people and the father of the artist. This work is large—82¾″ × 34¼″—and very dark. A broad black zip bisects the canvas,

leaving two asymmetrical greenish black fields on either side. *Abraham* suggests the most important work by two of Newman's colleagues—Ad Reinhardt and Mark Rothko. This painting is one of Newman's successful efforts to paint "words of silence." Citing Kabbalist Azriel of Gerona (1160–1238), Wolfson indirectly illuminates Newman's painting.

> "From the power of what is hidden ... there emerges what is heard ... , and from what is heard what is seen. We have no business with what is hidden, but only with what is heard." ... Beyond what is seen is what is spoken, and beyond what is spoken is what is hidden, but the latter is inaccessible to human cognition except as the trace of what is inaudible and invisible in the gradations associated as the sites of audibility and visibility. In the mythical account of the engendering of the ineffable name is encrypted the esoteric method of transmitting secrets, to speak tacitly, to write invisibly, to cover openly. Beyond the word—inscripted, vocalized, contemplated—there are the letters that carry on into the clamor of silence.[29]

But what word? Whose word sounds this silence? And to whom is the word addressed? Who, if anyone, hears the silence of this word?

One year later, Newman returned to the question of presence and the present in his first sculpture bearing the ambiguous title *Here I* (1950). Never satisfied that the Here and Now is here and now, he returns to this theme repeatedly—*Here II* (1965), *Here III* (1965–66). The repeated iteration of "Here" points to the absence rather than the presence of the present moment. Though *Abraham* and *Here I* are completely different, they are joined by the proper name. The dramatic story of God's command for Abraham to sacrifice his only son Isaac is recounted in the book of Genesis.

> And the two of them went together and came to the place of which God had spoken. There Abraham built an altar and arranged the wood. He bound his son Isaac and laid him on the altar on top of the wood. Then he stretched out his hand and took the knife to kill his son; but the angel of the Lord called to him from heaven, "Abraham, Abraham."
> He answered, "Here I am." (Genesis 22:9–12)

Here I—Here I am. As Kierkegaard shows in *Fear and Trembling*, the voice of God that breaks silence reduces Abraham to silence.[30]

Here I consists of two vertical elements that are about 8′ tall, which is the same height as the zips in *Vir Heroicus Sublimis*. These two columns are

mounted in a base that resembles the mound where Newman's formative revelation struck him like a bolt of lightning hurled from the sky. *Here I*—Is this One or I? And why is the I doubled? Why two, not one, or one as two, and two as one? In its original form, one vertical element is made of wood and chicken wire covered with plaster, and the other is thinner and hard-edged, as if it had been cut by a machine rather than made by hand. It is clear that *Here I* is a sculptural version of the figure of the zip separated from any ground. What remains unclear is how this "I" is to be read. Is it the I of Onement, or is it the "I" of the subject whose identity is always supposed to be proper? The ambiguity appears to be deliberate. Just as the Here and Now are never totally here and now, so the I is never fully present in the present. I becomes II while remaining I. Always sent *from* an elsewhere that is near, the "I" is forever double because it is shadowed by a non-present that makes its own presence both present and incomplete. In this way, the "I" itself appears to be the clearing or the open place marked by the zip where God's approaching withdrawal and withdrawing approach can be heard in the invisibility implied in the work of art.

In 1963, architect Richard Meier invited Newman to participate in an exhibition at the Jewish Museum by designing a synagogue. Newman had long been thinking about such a project and responded enthusiastically. Hess explains the way Newman adapted his zip to form the basis of his design of the synagogue. "The germ of the idea came from two sources. In the early 1950s, he told Tony Smith that he had figured out a new way to show paintings in architecture. It involved a wall zigzagging at ninety-degree angles, the elements alternately window and masonry. Thus a painting would hang on a solid section of the wall at right angles to it and would be a floor-to-ceiling window."[31] In the synagogue the point that had become a line becomes a plane that creates a three-dimensional structure.

Though the synagogue was never built, it provided the blueprint for Newman's last sculpture—*Zim Zum* (1969). This work, which is made from corten steel and measures 8′ × 15′ × 6′6″, consists of two facing walls that are made from six steel panels set at right angles and separated by an empty space. Viewed from above, the adjacent Zs appear to be a series of interrupted symmetrical squares separated by a zip-like line. The void in the midst of these errant walls repeats the zip that rends Newman's canvases. As one enters this interstitial space, the surrounding world seems simultaneously to expand and contract. This place, which really is no place, is *Makom*. Hess effectively summarizes the way the various strands of Newman's work that I have been tracing come together in the synagogue design and the *Zim Zum* sculpture.

The zigzag windows, then filling the hall with light and thrusting into the light-filled space, enact the Luriac drama of the Tsimtsum that took place between "Day before One" and "Day One." They are oriented across the nave so that point faces point, angle rushes away from angle to heighten the feeling of Divine "contraction," also articulated with the heavy stone walls which act as piers between which the windows are compressed. *Makom* is the "place," the locus where man stands, face to face with the Torah, with "The Word," with "White Fire" and "Black Fire"—it is a mound reminding us of Newman's epiphany at the mound-builder's sanctuary near Akron and also of the mounds into which are thrust the vertical elements in his first sculpture, "Here I."[32]

By drawing one into the revealing void of the Zim Zum, Newman creates the possibility of returning to "the origin of the work of art" where the silence of the word can be heard.

TOLLING SILENCE

The words have become so familiar that it is easy not to hear them. "In the beginning of Creation, when God made heaven and earth, the earth was without form and void, with darkness over the face of the abyss, and a mighty wind that swept over the surface of the waters. God said, 'Let there be light,' and there was light; and God saw that the light was good and He separated light from darkness. He called the light day, and the darkness night. So evening came, and morning came, the first day."[33] *From* darkness to light, *from* water to land, *from* silence to Word. Is it any longer possible to hear these words anew?

No thinker has plumbed the depth of the relation between silence and language more thoughtfully than Martin Heidegger. He describes what he labels the "abyssal groundless ground" of Being as a "foundational reticence."[34] In a seminal passage in an essay entitled "Language," he writes,

Language speaks as the peal of silence. Silence stills by the carrying out, the bearing and enduring, of world and things in their presence. The carrying out of world and thing in the manner of silencing is the eventful taking place of the dif-ference. Language goes on as the taking place, occurring, or event of the dif-ference for world and things.

The peal of silence is not anything human. But on the contrary, the human is indeed in its nature given to speech—it is linguistic. The word "linguistic" as it is here used means: having taken place out of the speaking of language. What has thus taken place, human being, has been brought into its own by

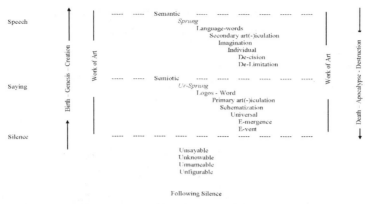

FIGURE 7. Martin Heidegger's argument in *On the Way to Language* (1959)

language, so that it remains given over or appropriated to the nature of language, the peal of silence. Such appropriating takes place in that the very *nature*, the *presencing*, of language *needs and uses* the speaking of mortals in order to sound as the peal of silence for the hearing of mortals. Only as man belongs within the peal of silence are mortals able to speak in *their own* way in sounds.[35]

Since the wandering course Heidegger charts from silence to language to silence is difficult and complex, a diagrammatic summary might be helpful (fig. 7).

"*Language*," Heidegger insists, "*is grounded in silence*."[36] Silence, however, is a peculiar ground because it is not temporally prior to language or speech, which it purportedly grounds. Rather than sequential, language and silence are bound in a relationship through which their simultaneous occurrence creates a *coincidentia oppositorum* that is not dialectical. Accordingly, the realization of silence is negation in language, and the realization of language leaves it inadequate because of its failure to still silence. Theologian Thomas J. J. Altizer effectively summarizes this perplexing point in a chapter entitled "Genesis" in his important book *The Self-Embodiment of God*.

Silence cannot simply be silent in the presence of speech, for silence speaks in the voice of speech, and speaks in that self-negating otherness which embodies itself in its own otherness. Silence as silence is absent in speech, but silence is present as the "other" of speech, and in that presence it embodies a new identity of itself. Accordingly, in the presence of speech we can only ask about a silence which is other than itself, and other than itself precisely in the

presence of speech. Consequently, we can respond to silence in the presence of speech by saying, and only by saying: In the beginning God.[37]

"In the beginning God." This is the God who brings being out of nothing through the Word. Language, Heidegger argues, forms the world in which we are destined to dwell. The articulation of language is the "event [*Ereignis*]" of genesis through which beings are created and appearances appear. In this way, "Saying is showing. . . . Showing causes to appear what is present, and to fade from appearance what is absent."[38] Saying turns us toward what turns away by approaching through withdrawing, and revealing by concealing. Heidegger might well have been describing the Zim Zum figured in Newman's zips and sculptures when he writes,

> What must be thought about, turns away from man. It withdraws from him. But how can we have the least knowledge of something that withdraws from the beginning, how can we even give it a name? Whatever withdraws refuses arrival. But—withdrawing is not nothing. Withdrawal is an event. In fact, what withdraws may even concern and claim man more essentially than anything present that strikes and touches him. . . . The event of withdrawal could be what is most present in all our present, and so infinitely exceed the actuality of everything actual.[39]

In order to clarify this complicated argument, it is helpful to draw several distinctions Heidegger does not explicitly make: Said/Saying, Logos-Language/Speech, and Semantic/Semiotic. In his influential *Course in General Linguistics*, Ferdinand de Saussure famously claims, "in language there are only differences . . . without positive terms."[40] Language, in other words, is a closed network of differences that creates self-referential signifying chains. Heidegger adds that these differences presuppose the "eventual taking place or occurrence of dif-ference." This active differentiating articulates what previously had been inarticulate. The etymology of "articulate" points to the process that Heidegger regards as essential for language. The word derives from the Latin *articulatus* (jointed, distinct), which is the past participle of *articulare* (to divide into joints, to utter distinctly). By differentiating the undifferentiated, the event of articulation marks the boundary or threshold of the differences that constitute the Logos. The second important point Saussure makes is the distinction between language (*la langue*) and speech (*la parole*). Language is the universal structure that is the condition of the possibility of speech for individuals. It is as if the mind were hardwired with a program that processes the data of experience. So understood,

language is the functional equivalent of the divine Logos in whose image human beings are created. This Logos can take forms as different as logic, generative grammar, genetic code, and computer programs. These different incarnations of the Logos share a common metastructure that can be binary, dialectical, or digital.

Saussure was preoccupied with the synchronic relations of linguistic structures, rather than with their diachronic emergence and history. He did not, therefore, ask about the origin of linguistic systems. Emmanuel Levinas seeks the origin Saussure overlooks by distinguishing the act or event of saying (*le dire*) from the structural order of the said (*le dit*). In its capacity as the said, language plays the role Western philosophy and theology traditionally assigned to the Logos. Heidegger points out that "the word *Ho Logos* names that which gathers all presencing and lets them lie before us in it. *Ho Logos* names that in which the presence of what is present comes to pass.... Language would be saying. Language would be the gathering letting-lie-before what is present in its presencing. In fact, the Greeks dwelt in this essential determination of language. But they never *thought* it."[41] Levinas, following Heidegger, attempts to think what philosophy has left unthought by seeking the silent origin *from* which language emerges.

In its capacity as the Logos, language creates the world we experience through a differential structure of signs. This network preexists individual subjects and speaks through them. As Kant argues in the First Critique and as we will see in more detail in chapter 7, the imagination synthesizes concepts (i.e., the said or the Logos) and data (i.e., the given) of experience to create rational knowledge. Since sensuous intuition exceeds the schemata that organize it, the imagination is unavoidably entangled in an unimaginable remainder. And since reason presupposes the activity of the imagination and knowledge presupposes sense data, reason always has a blind spot, and, therefore, all knowledge is infected with nonknowledge. Every act of linguistic mediation issues in the de-limitation of sensuous intuition that differentiates what had been undifferentiated. This articulation is secondary to a more primordial articulation that emerges through originary saying (*le dire*).

It is important to stress that this saying is not the act of an individual agent; rather, it is the anonymous deed or event that creates the structures that make it possible for individual subjects and objects to emerge. "Saying," Levinas argues, "is precisely not a game. Anterior to the verbal signs it conjugates, anterior to the linguistic systems and the semantic play of colors, a foreword preceding languages, it is the proximity of the one to the other [*l'un à l'autre*], the engagement of the approach, the one for the other, the very

significance of signification."⁴² Saying, then, is the original or preoriginal articulation of the Logos, which, in turn, becomes the differential structure of language through which the world is conceived. Conception is both an ontological and an epistemological process—the world is created and conceived through the Word. The act of creation is not a once-and-for-all event but happens continuously through the linguistic activity of individual agents through whom, in Heidegger's famous phrase, "*Die Sprache spricht.*"⁴³ As the origin of the differences and distinctions that make articulation possible, saying is "beyond the logos, beyond being and non-being, beyond essence, beyond the true and non-true."⁴⁴

To understand the operation of the said, it is necessary to recognize its constitutive limits. Inasmuch as saying is the condition of the possibility of the said, saying cannot be comprehended in language. Language presupposes an event that remains inconceivable and, thus, is unspeakable. Saying is neither programmed nor planned but is an aleatory event that erupts like an unexpected bolt out of the blue. This is why Heidegger argues that everything that is original (*ursprünglich*) involves an original leap (*Ursprung,* origin, source, inception—*Ur,* original + *Sprung,* leap). This leap leaves a gap or clears an opening that exposes both *le dire* and *le dit* to an alterity that withdraws from every gesture to grasp it. Saying is the "exposure to the other [*l'Autre*]."

> The said, contesting the abdication of the saying that everywhere occurs, in this said, thus maintains the diachrony in which, holding its breath, the spirit hears the echo of the otherwise [*l'autrement*]. The hither side, the pre-liminary, which the pre-originary saying animates refuses the present and manifestation, or lends itself to them only out of time. The unsayable saying [*Le Dire indicible*] lends itself to the said, to the ancillary indiscretion of the abusive language that divulges or profanes the unsayable. But it lets itself be reduced, without effacing the unsaying in the ambiguity or the enigma of the transcendent, in which breathless spirit retains a fading echo.⁴⁵

Here the transcendent "appears" not as the distant Wholly Other but as the proximate alterity that language both needs and cannot bear.

Just as Kant's analysis of conception presupposes something inconceivable, so Levinas's *le dit* and *le dire* presuppose an unsayable that makes all saying possible. The unsayable, unnameable, unfigurable is the unknowable that remains wrapped in silence. Language is the *betrayal* of silence. "Betray" is a suggestive word that has several conflicting meanings including *inter alia* to give up to, or place in the power of an enemy by treachery or disloyalty; to

be or prove false; to disappoint hopes and expectations; to lead astray or into error; and to disclose or reveal with breach of faith (a secret, or that which should be kept secret).[46] The betrayal of silence is its violation through the dis-closure of dis-course. The only way silence can be heard is through its betrayal in language. As Levinas argues, "In language qua said everything is conveyed before us, be it at the price of a betrayal. . . . Language permits us to say, be it by betrayal this *outside of being*, this *ex-ception* to being, as though being's other were an event of being."[47] Since the event that issues in the presence of being is never present, it cannot be properly re-presented with words or concept. The origin of conception always remains inconceivable.

Though she works in the psychoanalytic tradition, Julia Kristeva's distinction between the semantic and semiotic aspects of language clarifies Levinas's interplay of saying and the said.[48] Like Saussure's *langue*, the semantic function of language involves clear distinctions among linguistic elements in a common code that has a binary structure. This is the domain of the Logos in all of its variations. While the semantic is digital, the semiotic is analog. Not reducible to discrete logical functions, the semiotic aspect of language involves the operation of obscure forces that cannot be coded. These processes interrupt conscious activity that can neither comprehend nor control them. This disruption "introduces errancy [*errance*] or fuzziness into language."[49] While such errancy cannot be logically grasped, it can be apprehended through the alternating cadence and rhythm of the work of art. Recalling Goethe and Freud, Kristeva writes,

> There would be a "beginning" preceding the word. Freud, echoing Goethe, says at the end of *Totem and Taboo*: "In the beginning was the deed." In that anteriority to language, the outside is elaborated by means of a projection from within, of which the only experience we have is one of pleasure and pain. An outside in the image of the inside, made of pleasure and pain. The non-distinctiveness of inside and outside would thus be unnamable, a border passable in both directions by pleasure and pain. Naming the latter, hence differentiating them, amounts to introducing language, which, just as it distinguishes pleasure from pain as it does all other oppositions, founds the separation of inside/outside. And yet, there would be witnesses to the perviousness of the limit, artisans after a fashion who would try to tap the pre-verbal "beginning" within a word that is flush with pleasure and pain.[50]

This preverbal coincidence of pleasure and pain that artisans and artists cultivate is the negative pleasure Kant identifies as the sublime. From this point

of view, the art that matters is transgressive — it crosses boundaries by soliciting the return of the repressed that language struggles to control.

Kristeva is primarily interested in literature, which she describes as essentially "poetic." Following Heidegger and Bataille, she does not limit poetry to a specific literary genre but extends the term to include all original creative activity. As Heidegger repeatedly points out, "poetry" derives from the Greek *poiein*, which means to make or create. The writer attempts to create by interrupting logical order with fuzzy language consisting of slippery words (*les mots glissants*) that say what semantically and syntactically proper language cannot say. When it is successful, poetic language betrays silence. Kristeva does not limit her analysis to literature but extends it to the visual arts, more specifically to painting. In a suggestive essay, "Giotto's Joy," she argues that what slippery words do in literature, differential shades of color do in painting. "Color is the shattering of unity. Thus, it is through color — colors — that the subject escapes its alienation within a code (representational, ideological, symbolic, and so forth) that it, conscious as a subject, accepts. Similarly, it is through color that Western painting began to escape the constraints of narrative and perspective norm (as with Giotto) as well as representation itself (as with Cézanne, Matisse, Rothko, Mondrian)....Color is not zero meaning; it is excess meaning through instinctual drive, that is, through death."[51] The death of zero meaning is at the same time the birth of art. Thanatos and Eros meet in the shattering "experience" of the sublime moment.

The endless modulation of colors in Newman's paintings creates semiotic rhythm of approach and withdrawal that eludes the formalization of semantic structures. "Saying," Heidegger insists, "will not let itself be captured in any statement. It demands of us that we achieve by silence the appropriating, initiating movement with the being of language — and to do so without talking about silence."[52] What cannot be stated in words can be performed in the work of art. Newman paints the saying that tolls silence by clearing the place where it can be heard in images that betray the unsayable. For Heidegger, this place is the origin of the work of art, which like Newman's zips and the Zim Zum of the Kaballah "holds open the Open of the world."

There are, I have argued in this context, two dimensions of silence. As Heidegger insists, "Everything spoken stems in a variety of ways from the unspoken, whether not spoken, or whether it be what must remain unspoken in the sense that it is beyond the reach of speaking."[53] In the former case, the unspoken can, in principle, be spoken, but it is willfully withheld; in the latter case, the unspoken is unspeakable. The more profound silence is the

mute ground of volitional silence as well as the words it punctuates. Genesis begins with the interplay of word and water—water figures the dark abyss that is the deeper silence out of which God creates the word. Heidegger realizes that this more expansive understanding of language can be misleading and searches for a more suggestive word. In "A Dialogue on Language," which is an imaginary conversation between "a Japanese and an Inquirer," he suggests an alternative word, which anticipates Levinas's argument.

> J: But can you find a more fitting word [than language]?
> I: I believe I have found it, but I guard it against being used as a current tag, and corrupted to signify a concept.
> J: Which word would you use?
> I: The word "Saying." It means: saying and what is said in it and what is to be said.
> J: What does "say" mean?
> I: Probably the same as "show" in the sense of: let appear and let shine, but in the manner of hinting.
> J: Saying, then, is not the name for human speaking. . . .[54]

This inhuman or transhuman saying through which appearances appear occurs in the work of art. Art is not a limited domain of activity but is the infinite creative process that gives birth to the world through human agents who are vehicles for a saying their minds cannot fathom.

As we have seen, the temple marks the site of the tension between the "self-disclosing" world and the "self-secluding earth." The secret of art is its capacity to show by hiding. Far from duplicitous dissembling, this play of hide-and-seek is, for Heidegger, the advent of truth. He names this truth *aletheia*, which is variously translated unclosedness, unconcealedness, disclosure. Traditionally this word has been understood as the opposite of *lethe* (oblivion, forgetfulness, concealment). Rather than timeless and eternal, truth as *aletheia* is the primal event that gives birth to time and history. Contrary to the common correspondence theory of truth, *aletheia* is "by no means the structure of an agreement between knowing and the object in the sense of a likening of one entity (the subject) to another (the Object)."[55] Truth is the clearing or lighting [*Lichtung*] that eventuates in the originary differentiation that makes every kind of correspondence possible. Communication is impossible apart from the silent pauses, lapses, and gaps in discourse. Opening discourse to what lies beyond it, truth eludes the oppositions it articulates. "Truth is un-truth, insofar as there belongs to it the reservoir of the not-yet-uncovered, the un-uncovered, in the sense of con-

cealment. In unconcealedness, as truth, there occurs also the other "un-" of a double restraint or refusal. Truth occurs as such in the opposition of clearing and double concealing. Truth is the primal conflict in which always in some particular way, the Open is won within which everything stands and from which everything withholds itself that shows itself and withdraws itself as a being."[56]

Along the border, margin, boundary, limit of Newman's zip, contraction is expansion—the withdrawal performed in the work of art creates the opening in which everything occurs and everyone appears. Forever unexpected, the originality of the ongoing creative process extends the original event of creation. The world is an in-finite work of art. By revealing the invisible, art betrays the silence from which all originates. "And yet—beyond what is, not away from it but before it there is still something other [*ein Andere*] that happens. In the midst of being as a whole an open place occurs. There is a clearing, a lighting. Thought of in reference to what is, to beings, this clearing is in a greater degree than are beings. The open middle [*Mitte*] is therefore not surrounded by what is; rather the lighting middle itself encircles all that is, like the Nothing we scarcely know."[57] This is the nothing of Wallace Stevens's "The Snow Man."

> For the listener, who listens in the snow,
> And nothing himself, beholds
> Nothing that is not there and the nothing that is.[58]

And this No-thing is the nonobjective object of negative theology.

4.

. . .

5.

BEYOND

LAST PAINTING

Go to any art opening in New York and everyone is wearing black. To show up in a brightly colored dress, blouse, suit, or shirt is totally *gauche*—simply *outré*. From Calvin Klein and Armani to Prada and Versace, color is out and black is in. The most fashionable style, it seems, is puritanical. If ornament is a crime for much modern architecture and art, color is a crime for art world fashion. It is as if gallery goers were monks and nuns, though hardly with a Trappist devotion to silence. Might this fashionable obsession with black reflect the displacement of religion by art for many people who have left churches, temples, synagogues, and mosques? There is a deeply spiritual dimension in much modern art that all too often is overlooked.[1] Where did this shift from religion to art come from, and when did it begin?

As the horrors of World War II gave way to the terror of the nuclear age and Cold War, the sense of an ending pervaded society and culture: the Death of God, the End of Religion, the End of Philosophy, the End of History, the End of Art, the Last Painting. Though many factors contributed to these developments, the philosophical and artistic roots of the preoccupation with ending can be traced to the final decade of the eighteenth century. In the years following the publication of Kant's *Critique of Judgment* (1790), a remarkable group of writers, artists, and philosophers including Hegel, Schelling, Fichte, Hölderlin, Novalis, Goethe, Schiller, August and Friedrich Schlegel, and Tieck gathered in the small German city of Jena, where they laid the foundation for what became modernism and postmodernism. By elaborating the far-reaching implications of Kant's analysis of the limitations of knowledge and the importance of art, they forged philosophical idealism and literary romanticism, which prepared the way for modern lit-

erature, theology, and art. In his influential 1960 essay "Modernist Painting," Clement Greenberg, whose critical writings effectively created the movement known as abstract expressionism, traced modernism to Kant's critical philosophy. "I identify Modernism with the intensification, almost the exacerbation, of this self-critical tendency that began with the philosopher Kant. Because he was the first to criticize the means itself of criticism, I conceive of Kant as, the first real Modernist." With his critical turn, Kant bent reflection back on itself to ascertain the limits of reason in its theoretical and practical activity. "Kant used logic," Greenberg continues, "to establish the limits of logic, and while he withdrew much from its old jurisdiction, logic was left the more secure in what there remained to it."[2] By establishing the limits of reason, Kant created an opening for the artistic imagination.

For the philosophers, writers, and artists gathered in Jena, art had a religious aura, which they believed could be personally and socially transformative. In *Letters on the Aesthetic Education of Man* (1794), Friedrich Schiller formulated the modern notion of the avant-garde by arguing that the aesthetic ideal formulated in the Third Critique is prescriptive rather than descriptive. Through aesthetic education, the artist attempts to transform human consciousness in a way that promotes revolutionary political activity. The artist becomes a prophet who leads his followers to the Promised Land. In a letter to Novalis, Friedrich Schlegel, who was one of the most creative and influential members of the Jena group, went so far as to declare, "I am thinking of founding a new religion or at least helping to preach it. Perhaps you are better qualified to make a new Christ—if so, he will find in me his St. Paul."[3] The member of the Jena group most able to found "a new religion" was neither Schlegel nor Novalis, but Friedrich Schleiermacher, whose passionate defense of religion in *On Religion: Speeches to Its Cultured Despisers* (1799) marked the beginning of modern theology.

As his title indicates, Schleiermacher's purpose in *On Religion* is explicitly apologetic. He seeks to present an interpretation of religion that responds to Enlightenment criticisms by avoiding as much as possible orthodox Christian dogma. Throughout the eighteenth century, philosophers attempted to reconcile faith and reason by developing new versions of the classical ontological, cosmological, and teleological arguments for the existence of God. When these arguments foundered as the result of the trenchant analyses developed by British empiricists John Locke and David Hume, Kant responded by writing his *Critique of Pure Reason* in an effort to "limit reason to make room for faith." In the Second Critique, he proceeded to shift the defense of religion from theoretical to practical reason. Belief in God, freedom, and immortality, he argued, are necessary presuppositions for moral activity.

For Jena idealists and romantics, Kant's philosophy exacerbated the problem of personal and social alienation and fragmentation by internalizing the divisions they were trying to overcome. The First Critique cut human beings off from the world, which they can never know, and the Second Critique split subjectivity between individual inclination and universal moral obligation.

Schleiermacher attempts to heal the alienation between self and world and the split of the self from itself by revealing a unity beyond theoretical and practical division. His most important contribution was to reinterpret religious faith in terms of feeling and aesthetic awareness. In the crucial second speech, he defines "the essence of religion" as "the sense and taste for the infinite."[4] By approaching religion in terms of art, Schleiermacher appropriates Kant's Third Critique to criticize his first and second critiques. He situates religion along the boundary between theory and practice, which, he argues, is the province of the sensibility characteristic of aesthetic experience. ("Aesthetic" derives from the Greek *aisthetikos*, which means pertaining to sense perception.) From this point of view, religion is not a matter of thinking or acting but of feeling (*Gefühl*). More specifically, religion involves a "unique intuition" in which the "primal" unity of subjectivity and objectivity is immediately apprehended.

What Schleiermacher describes is the origin Turrell and Newman were seeking in different ways, and Malevich and Reinhardt pursue in their paintings. Schleiermacher describes the primal oneness of this nonobjective and nonsubjective dimension as the

> first mysterious moment that occurs in every sensory perception, *before* intuition and feeling have separated, where sense and its objects have, as it were, flowed into one another and become one.... You must know how to listen to yourselves before your own consciousness. At least you must be able to reconstruct from your consciousness your own state. What you are to notice is the rise of your consciousness and not to reflect upon something already there. Your thought can only embrace what is sundered. Wherefore as soon as you have made any given definite activity of your soul an object of communication, you have already begun to separate. It is impossible, therefore, to adduce any definite example, for, as soon as anything is an example, what I wish to indicate is already past. Only the faintest trace of the original unity could be shown.[5]

Since this feeling is prior to the birth of the subject, it can never be consciously experienced. In this vanishing moment, "sense and object mingle and unite, then each returns to its place, and the object rent from its per-

ception, and you rent from the object are for yourselves, a feeling. It is this earlier moment I mean, which you always experience, yet never experience."[6] For Schleiermacher, this impossible "experience" implies the radical immanence of the infinite in the finite. Indeed, he goes so far as to declare that "divinity can be nothing other than a particular type of religious experience."[7] For others, the impossibility of consciously processing such experience points to a radically transcendent reality that remains shrouded in a cloud of unknowing. Whether immanent *before* the difference of subject and object, or transcendent *beyond* self and world, this feeling cannot be articulated and, therefore, remains immersed in silence.

The Jena philosophers, writers, and artists were convinced that the French Revolution signaled the dawn of a new era in which artists would assume the role of prophets who would lead their followers to the promised land of modernity. While the Reign of Terror cruelly shattered this dream, it did not die; rather, it went underground in a variety of occult beliefs and practices, and resurfaced a century later in Russia. What the French Revolution had failed to achieve in Europe, the Soviet Revolution would accomplish. In the *Phenomenology of Spirit*, Hegel confidently declared, "ours is a birthtime and a period of transition to a new era. Spirit has broken with the world it has hitherto inhabited and imagined."[8] This apocalyptic vision grew out of Hegel's profound sense of an ending. The entire course of natural evolution and human history, he believed, culminated in the birth of the modern state in nineteenth-century Prussia. This marked the dawn of the New Age, which was "the end of history." One of Hegel's influential interpreters—the Russian emigrant Alexandre Kojève—delivered a series of lectures in Paris (1933–39) in which he elaborated his account of the end of history in a way that was decisive for postwar philosophers, writers, and artists. According to Kojève's interpretation of Hegel, the end of history becomes the end of art, and, Ad Reinhardt added, art cannot end without the "last paintings."[9]

While the self-confidence of Hegel and his colleagues quickly faded in the confusion and turmoil of postrevolutionary Europe, it survived in the popular imagination as the result of the synthesis of their ideas with Eastern and Western esoteric traditions. Helena Blavatsky's (1831–61) theosophy and Rudolf Steiner's (1861–1925) antroposophy translated Hegel's difficult philosophical language into easily understandable terms that provided the foundation of the vision of several of the artists who created the modernist movement. The most important artist influenced by Blavatsky's theosophical vision was Wassily Kandinsky, who was the uncle of Alexandre Kojève.[10] For Kandinsky, the history ended in twentieth-century Moscow rather than nineteenth-century Prussia, and the gateway to what he described as the

"kingdom of the abstract" would be the Russian Revolution. Artists would be the advanced guard showing the way to this revolution. Echoing Hegel in the 1911 preface to *Der Blaue Reiter*, Kandinsky and his coeditor Franz Marc write, "A great era has begun: the spiritual 'awakening,' in the increasing tendency to regain 'lost balance,' the inevitable necessity of spiritual plantings, the unfolding of the first blossom. We are standing at the threshold of one of the greatest epochs that mankind has ever experienced, the epoch of great spirituality."[11] As Schleiermacher translated religious language into artistic images, so Kandinsky created paintings laden with religious or spiritual significance. Where religion once thrived, art now grew. In *Concerning the Spiritual in Art*, Kandinsky writes, "The abandoned churchyard quakes and forgotten graves open and from them arise forgotten ghosts." Kandinsky agrees with Schleiermacher rather than Hegel in his conviction that the Infinite or the absolute cannot be rationally comprehended, but can be directly experienced in feeling. "There are also philosophers of aesthetic who write profound books about an art which was yesterday condemned as nonsense. In writing these books, they remove the barriers over which art has most recently stepped and set up new ones which are to remain forever in the places they have chosen.... No such theory of principle can be laid down for those things that lie beyond, in the realm of the immaterial. That which has no material existence cannot be subjected to a material classification. That which belongs to the spirit of the future can only be realized in feeling, and to this feeling the talent of the artist is the only road."[12] By overcoming the crass materialism of every utilitarian project, artistic abstraction becomes something like an alchemical process that transforms base matter into spiritual reality. The technical term for this alchemical process is "sublimation" (Latin, *sublimare*, to sublime; sublime, *sub-*, up to + *limen*, threshold).[13] Sublimation operates below the threshold of consciousness to communicate what words cannot express.

Kandinsky argues that in the new art, "total abstraction and total realism converge." The real is not material as Marxist revolutionaries preached, but is actually spiritual. Abstract art expresses the real through a process of the dematerialization of the everyday world. By reducing representation to a minimum, abstraction eventually ends in silence. In his important study *The Theory of the Avant-Garde*, Renato Poggioli's comment on Stephane Mallarmé's poetry illuminates Kandinsky's understanding of the coincidence of abstraction and realism in art. "The modern mystique of purity aspires to abolish the discursive and syntactic element, to liberate art from any connection with psychological and empirical reality, to reduce every work to the intimate laws of its own expressive essence or to the given absolutes of

its own genre or means."[14] The real, then, is beyond discourse and is inexpressible in syntactical rules. When pushed beyond every limit, pure form collapses into the silence of formlessness. Donald Kuspit argues that the spirituality Kandinsky seeks in his art is the result of the intersection of two factors: alchemy and silence, which were both already evident "in his sense of 'total abstraction' and 'total realism' as different paths to the same goal. Total abstraction is a kind of silence: 'the diverting support of reality has been removed from the abstract.' Total realism is a kind of alchemy: 'the diverting idealization of the abstract (the artistic element) has been removed from the objective....' Total abstraction (complete silence about the world) and total realism (alchemical transmutation of the worldly object) involve the same process of reducing the 'artistic' to a minimum."[15]

For Poggioli, the silence of abstraction in which painters attempt to represent the unrepresentable is an aesthetic version of religious iconoclasm. Far from simply immanent, the God of abstraction is a *Deus absconditus* that is revealed in the feeling created by the void of images.

> Deliberate silence, deliberate negation, is a major way of sustaining the elusive spiritual atmosphere of the abstract work by ruthlessly reducing the artistic ('tasteful outer beauty') to an absolute minimum. Indeed silence attempts to eliminate beauty altogether. Paradoxically the absolutely silent becomes the radically beautiful.... The silence evokes an ecstatic sense of immediacy, an experience of radical beauty, breaking all the habits of mediation conventionally associated with perception. The achievement of silence is the logical conclusion of the process of negation that abstraction is. Conclusive silence is the irreducible outcome of reductive abstraction.[16]

Given this vision or lack of vision, the questions become: How is the silence of abstraction to be pictured? How can it be figured? How can it be painted? Once again we return to the questions with which we began. What color is silence? Perhaps white, perhaps black, perhaps something in between—something approximating the infinite shades of gray?

In 1915, at the Last Futurist Exhibition of Paintings 0,10 in Petrograd, Kasimir Malevich hung a work entitled *Black Square* (79.5 × 79.5 cm) in the upper corner of the room traditionally reserved for the religious icon in the homes of Russian Orthodox believers. The 0 specified the *point* simultaneously joining and separating the negative and the positive, and the 10 referred to the number of artists in the exhibition. Malevich's *Black Square* appears to float on a white square that forms a surrounding border. One year later he began a series of white on white works with superimposed squares

intended to evoke the feeling of infinity. For Malevich, as for Kandinsky, art was essentially spiritual. However, whereas Kandinsky used abstract figures to evoke the feeling of the absolute, Malevich turned to monochromatic painting to communicate the indeterminacy of the infinite. His work was deeply influenced by the Russian mystic P. D. Ouspensky, who was a follower of Blavatsky. For Ouspensky, spiritual reality could not be confined to the 3D world. In *The Fourth Dimension: A Study of an Unfathomable Realm* (1909) and *Tertium Organum: A Key to the Enigmas of the World* (1911), Ouspensky combined insights from Kant's philosophy, theosophy, and Eastern mystics to elaborate a theory of evolution in which human consciousness progressively moves toward infinite awareness. "This sense of the infinite," he writes, "is the first and most terrible trial before initiation. Nothing exists! A little miserable soul feels itself suspended in an infinite void. Then even this void disappears! Nothing exists. There is only infinity."[17]

Malevich describes the fourth dimension as "the nonobjective world." Like Schleiermacher's moment before the sundering of self and world, in Malevich's nonobjective world, there is neither subject nor object. Recalling Roland Barthes's *Writing Degree Zero*, Malevich concludes that he must "paint degree zero."[18] He actually went so far as to assert, "I have transformed myself into a zero of form, and have gone beyond 'o' to '1.'"[19] *Black Square* is the dark hole through which he tries to slip into the fourth dimension of reality. "When, in the year 1913," Malevich writes, "in my desperate attempt to free art from the ballast of objectivity, I took refuge in the square form and exhibited a picture which consisted of nothing more than a black square on a white field, the critics and, along with them, the public sighed, 'Everything which we love is lost. We are in a desert.... Before us is nothing but a black square on a white background!'" Malevich acknowledged that with this painting, art was wandering in the desert, but he did not regard this as the sign of loss that led to despair. Like many prophets and contemplatives of the past, he believed that the desert is the place where the transcendence of God is revealed.

But this desert is filled with the spirit of non-objective sensation which pervades everything.

Even I was gripped by a kind of timidity bordering on fear when it came to leaving 'the world of will and idea', in which I had lived and worked and in the reality of which I had believed.

But a blissful sense of liberating non-objectivity drew me forth into the 'desert', where nothing is real except feeling ... and so feeling became the substance of my life.

This was no "empty square" which I had exhibited but rather the feeling of non-objectivity.[20]

For Malevich, the desert of the real is where the silence of the infinite sounds.

Malevich's exercises in abstraction were met with incomprehension and even hostility. When his work was condemned as nihilistic, he responded with writings in which he tried to explain the deep resonances of his work with the long tradition of religious icons in Russian Orthodoxy. Like photographs of the dead, the gaze of the icon seems to come from a dimension that lies beyond ordinary experience. In the absence of objects, there is no subject; therefore the feeling of nonobjectivity is beyond the possibility of what I can experience. Nonetheless, "the black square on the white field," Malevich explains, "was the first form in which non-objective feeling came to be expressed. The square = feeling, the white field = the void beyond this feeling. . . . The suprematist square and the forms proceeding out of it can be likened to the primitive marks (symbols) of aboriginal man which represented, in their combinations, *not ornaments but a feeling of rhythm*."[21] Feeling as the void of feeling . . . there as not there . . . not there as there. The feeling of this rhythm of presence and absence is the repetitive pulsation through which the artist attempts to paint what cannot be said.

Malevich was not the only twentieth-century Russian artist to experiment with black and white paintings. In 1918, his fellow Suprematist Alexander Rodchenko completed a series of eight black paintings in response to Malevich's series of white paintings. Rodchenko's concerns, however, were more material than spiritual. While Malevich sought a transcendent realm beyond quotidian experience, Rodchenko attempted to bring people back to the concrete reality of everyday life. He eliminated color to focus on the materiality of the painted surface. Two years after his response to *Black Square*, both Malevich and Rodchenko were beginning to question the value of painting for advancing a revolutionary political agenda. Malevich wrote, "There can be no question of painting in Suprematism; painting was done for long ago, and the artist himself is a prejudice of the past."[22] Rodchenko was even more emphatic; the 1921 exhibition 5 × 5 = 25 provided the occasion for him to issue art's death notice. "Art is dead! . . . Art is as dangerous as religion as an escapist activity. . . . Let us cease our speculative activity [i.e., painting pictures] and take over the healthy bases of art—color, line, materials, and forms—into the field of reality, practical construction."[23]

An end but not *the* end, at least not yet. What died in Moscow was reborn in New York City, where Ad Reinhardt confidently declared, "I'm merely

making the last painting which anyone can make."[24] The last painting was the last word, and beyond the last word only silence.

End of painting as an art?
Working in form nearing end of its time
Shot its bold from the blue
Become pure by detaching itself from everything
Withdraw from sense objects, multiplicity ...
Nonsensuous, formless, shapeless, colorless, soundless, odorless
No sounds, sights, sensing, sensations No intensity
No images, mental copies of sensations, imagings, imaginings
No concepts, thinking, ideas, meaning, content
Repetition of formula over over again until loses all meaning ...
Trans-subjective
A thing that is not
A return Last word must always be secretly the first[25]

BLACK OR WHITE

Black or white? Black and white? Neither black nor white? Reinhardt had absolutely no doubt what color the last painting should be—*Black*. But is black a color? Or is it the absence of color? Is black black? Or is it a mixture of colors? Might black be white? After all, John Keats wrote, "There is a budding morrow in midnight."[26] And Nietzsche agrees, "A drop of dew? A vapor and fragrance of eternity? Don't you hear it? Don't you smell it? Just now my world became complete: Midnight is also Midday."[27] The puzzling history of the word "black" compounds the difficulties. "Black" is etymologically related to the word *blanc*, and derives from the Old English *blaec*, which is cognate with *blac*, meaning shining white. Black as white, white as black. If the last word is also the first, and Midnight is also Midday, then perhaps opposites meet in black-white, which might or might not be gray.

Black is not always monochromatic; it can even be achromatic. Citing the Japanese artist Katsushika Hokusai, Reinhardt distinguishes many shades of black: "a black which is old and a black which is fresh. Lustrous (brilliant black) and matte black, black in sunlight and black in shadow. For the old black one must use an admixture of blue, for the matte black an admixture of white; for the lustrous black gum must be added. Black in sunlight

must have grey reflections."[28] As Stephanie Rosenthal explains in her exhibition catalog *Black Paintings*, "Black's status as a color or non-color has changed more than once over the centuries. Aristotle called white and black (light and dark) the basic colors from which all others are derived. Not until the Renaissance did black and white cease to be seen as colors. . . . Later, Jesuit mathematician Louis-Bertrand Castle returned to the view of black not as the negation of color, but as a substance that comprised all colors. Reversing the hierarchy customary in his day, he accorded black the highest status: 'Everything comes from black and then loses itself in white.'"[29] For Reinhardt, black is a "non-color." "As an artist and painter," he admits, "I would eliminate the symbolic pretty much, for black is interesting not as a color but as a non-color and as the absence of color. I'd like then to talk about black in art—monochrome, monotone, and the art of painting versus the art of color."[30]

While concealing can be a way of revealing, through its withdrawal, the Real can become a distant Beyond that can be approached, if at all, only negatively. For Reinhardt, abstraction is negation; he insists that "you can only make absolute statements negatively." Explaining the implications of this position, he associates his black paintings with "a long tradition of negative theology in which the essence of religion, and in my case the essence of art is protected or the attempt is made to protect it from being pinned down or vulgarized or exploited."[31] Like many of his fellow artists in postwar New York, Reinhardt was troubled by the rapidly expanding art market and developed strategies to resist art's incessant commodification. Commenting on what became Reinhardt's signature works, Barbara Rose writes, "The black paintings, although not specifically 'religious,' are an effort to retrieve the dimension of the spiritual in a secular culture determined to reduce art to the status of a commercial trading commodity."[32]

In 1963, the influential art critic Harold Rosenberg famously declared, "Newman [1905–70] shut the door, Rothko [1905–70] pulled down the blinds, and Reinhardt [1913–67] turned out the light."[33] Perhaps because of their abiding investment in religion, all three artists were infatuated by what they regarded as the spiritual aura of black. While Newman and Rothko shared a Jewish heritage, Reinhardt was raised a Lutheran. There are, of course, as many Judaisms as there are Protestantisms, but there are important similarities between the two traditions. The God of Abraham, like the God of Luther, is a *Deus absconditus*, who, in Kierkegaard's telling phrase, is "infinitely and qualitatively different" and, thus, forever *beyond* and yet, paradoxically, somehow *within* the world. Though he never formally studied theology, Reinhardt was drawn to the mystical tradition in Christianity. He

was particularly interested in medieval mystics like Saint John of the Cross (1542–91), Nicholas of Cusa (1401–64), and Meister Eckhart (1260–1328). Their teachings influenced Rheinland mystics Johannes Tauler (1300–61), Henry Suso (1295–1366), and John von Ruysbroeck (1293–1831), and, in turn, shaped Luther's theology. The early modern philosophical and literary appropriation of this tradition prepared the way for the twentieth-century transformation of art that eventually led to Reinhardt's black paintings.[34] Johannes Tauler might well have been describing the work of Malevich and Reinhardt when he wrote that the mystical awareness of God

> is ineffable darkness and yet it is essential light. It is called an incomprehensible and solitary desert. This it certainly is; no one can find his way through it or see any landmarks for it has no marks which man can recognize. By "darkness" here you must understand a light which will never illuminate a created intelligence, a light which can never be naturally understood; and it is called "desolate" because there is no road which leads to it. To come there the soul must be led above itself, *beyond* all comprehension and understanding. Then it can drink from the stream at its very sources, from those true and essential waters. Here the water is sweet and fresh and pure, as every stream is sweet at its source before it has lost its cool freshness and purity.[35]

Like Newman, Reinhardt grew up in a family where politics was more important than religion. Unlike Newman, who satirically attacked the political establishment from within, Reinhardt drifted beyond the political mainstream and became involved with the Communist Party. Following Malevich and Rodchenko, he sought to combine abstract art with a revolutionary communist agenda. His political activities were serious enough to provoke FBI surveillance from the mid-1940s to the mid-1950s. In the long run, however, Reinhardt's experiences at Columbia University, where he encountered some of America's leading educators and most influential New York intellectuals, proved more decisive than his early political activity. His teachers included Franz Boas, John Dewey, Jacques Barzun, Louis Mumford, and Meyer Shapiro. More important than what went on in the classroom was what Reinhardt discovered through his close friendship with his classmate Thomas Merton. It was Merton who introduced him to the new world of Zen Buddhism that D. T. Suzuki presented in his Columbia lectures.

Merton was born in France; his father was a painter from New Zealand and his mother an American Quaker and artist. He was baptized in the Church of England. During World War I his family immigrated to the

United States, where he entered Columbia University in 1935. By 1939, he had received both a B.A. and a master's in English literature. His master's thesis focused on William Blake's writings and visionary paintings. Ever restless and increasingly distressed by developments that eventually led to World War II, Merton, inspired by the poetry of Gerard Manley Hopkins, converted to Catholicism in 1941. He was accepted into the Cistercian Order, entered the Abbey of Gethsemani near Bardstown, Kentucky, and one year later became a novitiate. In keeping with the Trappist tradition, Merton took a vow of silence. Against all odds, Merton and Reinhardt remained in contact over the years by writing, even though Merton was allowed to write only four letters a year. With the publication of his spiritual biography, *Seven Story Mountain* (1948), Merton became a major public figure and one of the most important spiritual leaders in the country.

Throughout his long journey, Merton's relation to Reinhardt and his art remained important. Reinhardt dubbed his friend the "Dean of the Great Quiet." For years, Merton asked Reinhardt to give him "some small black and blue cross painting (say about a foot and a half high) for the cell in which I perch." When Reinhardt finally relented and completed a painting for him, Merton expressed his appreciation with a description of what he saw as the spiritual inspiration of the work. "Almost invisible cross on a black background. As though immersed in darkness and trying to emerge from it. . . . You have to look hard to see the cross. One must run away from everything else and concentrate on the picture as though peering through a window into the night. . . . I should say a very 'holy' picture—helps prayer— an 'image' without features to accustom the mind at once to the night of prayer—and to help one set aside trivial and useless images that wander into prayer to spoil it."[36] Reinhardt's long correspondence with Merton deepened his appreciation for Catholic mysticism and Zen Buddhism. Most of what he learned about the importance of seeing silence in the work of art Reinhardt learned from Merton. Few words better express the spiritual vision behind Reinhardt's work better than Merton's *New Seeds of Contemplation*.

> The living God, the God Who is God and not a philosopher's abstraction, lies infinitely *beyond* the reach of anything our eyes can see or our minds can understand. . . . If nothing that can be seen can either be God or represent Him to us as He is, then to find God we must pass *beyond* everything that can be seen and enter into darkness. Since nothing that can be heard is God, to find Him we must enter into silence.
>
> Since God cannot be imagined, anything our imagination tells us about

Him is ultimately misleading and therefore we cannot know Him as He really is unless we pass *beyond* everything that can be imagined and enter into an obscurity without images and without the likeness of any created being.[37]

While Merton's influence ran deep, it took a while for Reinhardt to discover his artistic mission. During their undergraduate years, Reinhardt and Merton were regular contributors to the Columbia humor magazine entitled *Jester*, where Reinhardt developed his considerable talent for cartoons. In the years after graduation, he supported himself by producing commercial art, graphic designs, and illustrations for books. In his more serious work, he experimented with Surrealism, but eventually moved away from figurative work and started using darker colors like those favored by Newman and Rothko as well as many other artists at the time. David Sylvester points out that "black was a sacred color for the Abstract Expressionists: it was their lapis lazuli; they made a mystique of it."[38] In contrast to some, though not all, abstract expressionists whose work expressed personal feelings and emotions, the draw of dark abstraction for Reinhardt was its impersonality or anonymity. Instead of asserting himself, he was looking for a way to lose himself. John Cage's comment on Rauschenberg's white paintings, which, we have seen, inspired his composition *4'33"* and book *Silence*, effectively describes Reinhardt's mature work. "To whom. No subject. No image. No taste. No object. No beauty. No message. No talent. No technique (no why). No idea/No intention/No art/No feeling/No black/No white (no and).... The blind can see again the water's fine."[39]

Cage's words effectively capture the foundational principle of Reinhardt's art—negation. In a fragment entitled "On Negation," Reinhardt writes,

> ... anti-anti-art, non-non-art, non-expressionist,
> non-imagist, non-surrealist, non-primitivist, non-fauvist,
> non-futurist, non-figurative, non-objective, non-subjective,
> non-action, non-romantic, non-visionary, non-imaginative,
> non-mythical, non-organic, non-vitalist, non-violent,
> non-vulgar, non-naturalist, non-supernaturalist,
> anti-accident, anti-brute-junk-pop-folk-art, non-local,
> non-regionalist, non-nationalist, non-representational...[40]

The list could be extended without end. While for Cage and Rauschenberg, silence is white, for Reinhardt and Merton, silence is black.

From 1956 until the end of his life, Reinhardt painted only black works,

and from 1960 on, these paintings were all square — 5' × 5'. Neither the color nor the size is random. Malevich was not the first artist to paint a religious icon as a black square. In 1617, the English Rosicrucian Robert Fludd published a book entitled *Utriusque Cosmi*, which includes the image of a 5" × 5" black square. Along each side Fludd wrote *Et sic in infinitum*. Reinhardt's extension of this iconographic tradition is intended to bring about a transvaluation of values that reveals Nietzsche's midday in the midst of midnight. "My paintings," he confidently proclaims, "represent the victory of the forces of darkness and peace over the powers of light and evil."[41] In carrying out his strategy of negation, Reinhardt deploys three closely related tactics: homogenization, standardization, and repetition. He explores these issues in writings that are as important to his paintings as Newman's titles are to his works. The careful examination of Reinhardt's monochromatic squares and related texts reveals something hiding in plain sight that disrupts the unity they are supposed to present. The monochromes are not really monochromatic, the squares are not simply squares, and the repetition does not really repeat.

Reinhardt searches for a black darker than the night *beyond* night in which mystics East and West seek rapture. The dark paintings are not exactly the opposite of white; rather they make the disappearance of light appear. Eschewing all reflection, he drains oil from the paint to create the matte surface that absorbs light. In words as poetic as the paintings they describe, Reinhardt writes,

DARK

"Northern" preference for black medium
"Black" medium of the mind
Puritan, self-righteous, self-criticism
Conscience of a bad conscience
Luminous darkness, true light, evanescence
"Him that has made the dark his hiding place"
"Flight of the lone to the alone"
Perfection, central, cohesive, purifying principle
Polemic, dogmatic, scriptural
Leave temple images behind
Risen above beauty, beyond virtues, inscrutable, indescribable
Self-transcendence revealed yet unrevealed
Undifferentiated unity, oneness, no divisions, no multiplicity

No consciousness of anything
No consciousness of consciousness
All distinctions disappear in darkness
The darkness is the brilliance numinous, resonance . . .[42]

The effect of these paintings is not immediate. Like Turrell's Dark Spaces, Reinhardt's black paintings take time to appreciate and understand. The longer you linger with them, the more complex they become. Far from a static presence, the surface changes with time; as your eyes adjust you realize that the "colorless noncolor" is not really black, but rather is a mixture of dark red, maroon, blue, green, and purple. Once seemingly homogenous, the surface begins to shimmer with shades of difference.

Not only the color, but also the form or, in Reinhardt's terms, the "formless form" of the painting changes with time. The specific size of the black paintings is intended to serve as an alternative to what he regards as the excessive size of works by artists like Newman and Pollock. The standardization of the format further erases the hand of the individual artist and thereby furthers the goal of losing subjectivity in a primal or apocalyptic oneness. As we will see, this procedure anticipates the work of Minimalists like Donald Judd and Dan Flavin. In his description of the square, Reinhardt explains how he sees it is as extension of his principle of negativity. "A square (*neutral, shapeless*) canvas, five feet wide, five feet high, as high as a man, as wide as a man's outstretched arms (*not large, not small, small, sizeless*), one horizontal form negating one vertical form (*formless, no top, no bottom, directionless*), three (*more or less*) dark (*lightless*) no-contrasting (*colorless*) colors, brushwork brushed out to remove brushwork, a matte, flat, free-hand painted surface (*glossless, textureless, non-linear, no hard edge, no soft edge*) which does not reflect its surroundings—a pure, abstract, non-objective, timeless, spaceless, changeless, relationless, disinterested painting. . . ."[43] Perfectly square monochromatic "black" paintings are designed to reduce meaning to degree zero and thereby pass beyond consciousness into what the Christian Mystic Pseudo-Dionysus the Areopagite calls "the cloud of unknowing." But once again, the paintings change with time. Just as colors can be detected in the "colorless," so forms appear in the formless. Divisions within the squares create the appearance of underlying crosses as if this "black monk" were sending secret messages to his silent friend secluded in the Trappist monastery.

Reinhardt had confessed that he is a negative theologian who writes with paint. As in all apophatic theology, the intended end of his journey is perfect union with the divine. In the following lines, Reinhardt offers an eloquent

summary of the desire motivating his work, as well as the practices and writing of virtually all mystics.

ONE

> "Formless thou art, and yet
> thou bringest forth many forms, and then
> withdrawest them to thyself."
> "Differentiating itself and yet remaining in itself undifferentiated."
> "By letting go, it all gets done =
> the world is won by those who let it go!
> But when you try and try
> the world is then beyond the winning."
> "in the beginning is the end," vice-versa . . .
> No characteristic except its oneness
> It is not a thing nor a thing in it
> Neither white nor black, neither red nor green, of no color whatever
> Beingless, becoming not, nameless . . .[44]

The One proves elusive and the desire for unity is inevitably frustrated. Satisfaction, fulfillment, and redemption are always just *beyond* one's grasp, and, therefore, are infinitely deferred. This is why Reinhardt must paint the "same" painting again and again and again until the day he dies.

REPETITION COMPULSION

Susan Sontag argues that repetition is one of the basic principles of modern art. "If one does not perceive how a work repeats itself, the work is almost literally not perceptible and therefore, at the same time, not intelligible. Until one has grasped not the 'content,' but the principles of (and balance between) variety and redundancy in Merce Cunningham's 'Winterbranch' or a chamber concerto by Charles Wuoronin or Burroughs's *Naked Lunch* or the 'black' paintings of Ad Reinhardt, these works are bound to appear boring or ugly, or confusing, or all three."[45] To understand the reasons for Reinhardt's compulsion to repeat, it is helpful to return to two Christian mystics who were important for his belief and his work—Pseudo-Dionysus the Areopagite (late fifth century) and Nicholas of Cusa (1401–64).[46] For Dionysus, God is "the nameless one" shrouded in "divine silence, darkness, and unknowing," and as such is "wholly imperceptible and invisible." In the first chapter of *The Divine Names and Mystical Theology*, he writes,

O Trinity
> beyond being,
> beyond divinity,
> beyond goodness, and
> guide of Christians in divine wisdom,

direct us to the mystical summits
> more than unknown and beyond light

There the simple, absolved, and
> > unchanged mysteries of theology

> lie hidden in the darkness beyond light
> of the hidden mystical silence,

there, in the greatest darkness,
> that beyond all that is most evident
> exceedingly illuminates the sightless intellects.[47]

How is this recurrent "beyond" to be understood? Eight centuries later, Nicholas of Cusa offered the explanation Dionysus failed to provide. "Dionysus says in his *The Divine Names*, God, who is this maximum, 'is neither this nor that, and God is neither here nor there,' for just as God is in all things, so God is in none of them. For at the end of his *Mystical Theology*, he concludes that 'above all affirmation God is the perfect and unique cause of all things, and above the negation of all things is the excellence of the one who is utterly independent of all and beyond all.'"[48]

"God is *neither* this *nor* that," "*neither* here *nor* there," "above all affirmation, and above the negation of all things." Cusa devotes his entire life to exploring the strange beyond of neither/nor. The fundamental premise of Cusa's so-called negative theology is that God has no opposite. Just as Hegel argues that the opposition between the infinite and the finite negates infinitude by limiting it, so Cusa insists that any opposition negates the divine by restricting it. The challenge is to imagine a nonoppositional beyond through which being is, and nonbeing or nothing is not. The distinguishing feature of Cusa's writing is his repeated use of "neither/nor." In *On Learned Ignorance*, for examples, he writes,

> For truth is neither more nor less but indivisible.
> Furthermore, if we contract maximum to being and say that nothing is opposed to maximum being, then neither non-being nor minimum being would be its opposite.

Hence, it is not a unity of this sort that properly applies to God, but the unity to which neither otherness nor plurality nor multiplicity is opposed.[49]

The list could also be continued ad infinitum, but the point is clear—oppositions and negations limit and thereby negate the infinite God they are intended to affirm. This insight has far-reaching implications that are not immediately evident.

If one follows Cusa, the terms commonly used to designate that which eludes language are oppositional and, therefore, are misleading, if not completely wrong: Unsayable, Unknowable, Unnamable, Unfigurable, Undifferentiated, Inarticulate. Most important, God can no longer be conceived simply as One. Cusa is aware of the difficulty in finding a way to talk about the One. "Unity, however, cannot be number, for number, which admits a greater, can in no way be either simply minimum or simply maximum; but because unity is minimum, it is the beginning of all numbers, and because it is maximum, it is the end of all numbers. Therefore, absolute unity, which has no opposite is absolute maximumness itself, which is the blessed God. This unity, because it is maximum, cannot be multiplied for it is all that can be. It cannot, therefore, become number."[50] Is One that is not a number really one? This question raises a difficult but important point. Throughout the history of Western theology and philosophy, God, the Absolute, or the Real typically has been identified with oneness, unity, and identity.[51] A persistent philosophical and theological problem has been to explain how many derive from one, opposition arises from unity, and difference splits from identity. Cusa argues that the premise of the question is wrong. Since he thinks of numbers oppositionally (i.e., one is not two, and two is not one, etc.), he concludes that God is *neither* one *nor* many, but approximates the nul point—o—that makes enumeration possible. The problem is that this neither/nor cannot be expressed in words because, as Saussure taught us, language is a play of differences. Cusa anticipated Saussure's point in his *Dialogue on the Hidden God* (*Diologus de Deo abscondito*): "For it is a movement in differentiating reason that imposes names."[52] Neither one nor many, God is beyond, and yet not opposed to, language. The person of learned ignorance knows what he or she does not know, and says what cannot be said in words that paradoxically remain silent.[53]

Though not explicitly thematized, Cusa's neither/nor appears repeatedly in Reinhardt's writings and indirectly in the undulating rhythms of his black paintings. Keeping Cusa's insights in mind, it is helpful to return to Reinhardt's important text "One."

Totality, unity, finality wordless essence ...

No characteristics except its oneness ←

It is not a thing *nor* a thing in it

Neither white *nor* black, *neither* red *nor* green, of no color whatever

Beingless, becoming not, nameless.

Where there is nothing but the one, nothing is seen

Primary, unique, underivable from anything else

Aweful "absolute unapproachability" ←

Supra-rational

Ideogram for what is beyond utterance, "unutterableness

Chain of negations, Buddhist "theology of negation" ← [54]

Beyond the opposition of Reinhardt's principle of negation, there is a counter rhythm that complicates his painterly practice. Rather than a simple negative (apophatic) theology that is the opposite of positive (kataphatic) theology, Reinhardt's work might be described as a nonnegative negative theology that repeatedly alternates between negation and affirmation.

Through shades of difference that appear to be colorless black, and crossing forms hiding in the formless, Reinhardt paints what words cannot express. Since One is never really one, and Presence is never totally present here and now, endless repetition is the closest possible approximation to the silent beyond that is the nonobject of longing. For Reinhardt, the repetition of his black paintings is a ritual process that brings near what turns away; for viewers, participation in this ritual draws one into a beyond that is always elsewhere, yet ever near.

Two of the great theorists of repetition are Freud in *Beyond the Pleasure Principle* and Kierkegaard in *Repetition* and its companion volume *Fear and Trembling*. Freud's analysis illuminates the neither/nor of Reinhardt's "Beyond," and part of Kierkegaard's argument clarifies the either/or of Rothko's "Against."[55] Beyond and Against involve alternative sounds of silence. For Freud, repetition is a symptom of trauma, which begins with the original loss of unity that results from the separation from the mother. He reports that he discovered an activity he could not explain with his pleasure principle one day while he was watching his infant grandson when his mother was away. Though the child was too young to speak, he was able to act out his distress by playing a game something like hide-and-seek. He never cried when his mother left him, but had the disturbing habit of throwing small objects under his bed and then hunting for them.

As he did this, he gave vent to a loud, long-drawn-out "o-o-o-o," accompanied by an expression of interest and satisfaction. His mother and the writer of the present account were agreed in thinking that this was not a mere interjection but represented the German word *"fort"* ["gone"]. I eventually realized that it was a game and that the only use he made of any of his toys was to play "gone" with them. One day I made an observation that confirmed my view. The child had a wooden reel with a piece of string tied round it. . . . What he did was to hold the reel by the string and very skillfully throw it over the edge of his curtained cot, so that it disappeared into it, at the same time uttering his expressive "o-o-o-o." He then pulled the reel out of the cot again by the string and hailed its reappearance with a joyful *"da"* ["there"]. This, then, was the complete game—disappearance and return.[56]

Freud concludes that his grandson's game reenacts his mother's departure.

At the time Freud theorized that all psychic activity is governed by the pleasure principle. His interpretation of the structure and development of the personality is a psychological translation of ancient philosophical and theological ideas. Just as Plato's charioteer struggles to control two horses (body and soul) that want to run in different directions, so Freud's ego tries to balance conflicting demands of the id and superego.[57] His theory of the development of the personality repeats the pattern of progression from a condition of undifferentiation in which there is no difference between self and world or subject and object to a clearly differentiated individual subject who is distinct from his or her surroundings. Before the beginning *in utero* child and mother are one—there is no consciousness, self-consciousness, or desire. Birth is the traumatic separation of child from mother through which self and world simultaneously emerge. This split is, in effect, the fall into time and history. Desire begins with the loss of immediate satisfaction through separation of the child from the nourishing maternal matrix. With birth the conflict between desire (i.e., the pleasure principle) and the demands of the surrounding world (i.e., the reality principle) erupts. The increasing frustration of desire leads to the progressive individualization of the subject.

Freud defines the pleasure principle as the reduction of tension between competing desires within the self and the conflict between the self's and the world's demands. With the original separation from the mother, life becomes a prolonged effort to recover lost unity. Freud identifies two basic drives, which pursue the same goal from different directions—Eros and Thanatos. The aim of Eros is the perfect union of self and other in which two become one. Thanatos, by contrast, is the drive of the living person to return to the inorganic condition from which life is created. In both cases, the process of

differentiation or individuation is reversed, and the individual is reabsorbed in the generative matrix. In this moment, womb and tomb become one.

The seemingly simple game of *fort/da* threatened Freud's entire theory. If the child's game of *fort/da* repeats the traumatic experience of the absence of the mother, then there must be something *beyond* the pleasure principle. In an effort to explain this behavior while preserving the fundamentals of his theory, Freud argues that the child's game is an effort to master loss. "At the outset he was in a *passive* situation—he was overpowered by the experience; but, by repeating it, unpleasurable though it was, as a game, he took on an active part. These efforts might be put down to an instinct for mastery that was acting independently of whether the memory was in itself pleasurable or not."[58] The drive for pleasure becomes the will to mastery, which is an alternative expression of Nietzsche's will to power.

There is, however, another way to understand this beyond. Pleasure is not only the result of the reduction of tension but can also be created by the maximization of tension. This is the "negative pleasure" Kant associates with the sublime and Lacan labels "*jouissance.*"[59] The most intense pleasure is inseparable from the pain that results from the impossibility of experiencing the complete satisfaction of total unity. When it is vital, desire desires desire, not fulfillment. Rather than attempting to master loss, the compulsion to repeat can be understood as the solicitation of the pleasure that *comes* with the impossibility of satisfaction. The alternating rhythm of Reinhardt's repeated brushstrokes are the *fort/da* seeking the pleasure of Almost but not quite. Always only almost. Yve-Alain Bois concludes his essay, "The Limit of Almost," by commenting on Reinhardt's claim that negative theology is "the best analogy today" for his art.

> What Reinhardt means is that his negative language, and art, are naturally condemned to look religious—almost. It almost looks religious because, as does negative theology, it is concerned only with the "not that, but almost." The analogy is thus inevitable, but it is also a confusion. The logic of this confusion has been perfectly analyzed by Jacques Derrida, whose enterprise of deconstruction has also suffered from it: "As soon as a proposition takes a negative form, it is enough to push the negativity thus announced to its limit, for the proposition to resemble, at least, a theological apophantic. Each time I say: X is neither this nor that, nor the contrary of this or that, nor the simple neutralization of this or that with which it has *nothing in common*—being absolutely heterogeneous or incommensurable with it—I would commence to speak of God, under this name or under another." Negativity has many guises, many turns. Reinhardt is not Zen, not mystic, not agnostic, not dialectic, not

even deconstructive—not anything. But almost. *"Painting that is almost possible, almost does not exist, that is not quite known, not quite seen."* [60]

Bois is *almost* right, but not quite. The aura of religion does not fade in these paintings. Reinhardt associates ritual repetition of his paintings with the icon, like the one Malevich placed in the upper corner of the room. "The idea of an icon is to do a picture over and over again, to lose oneself in a few simple ideas to just get that rightness . . . no composition and color and expression, but invisibility." [61] Like staring at a photograph of a nameless person long departed, to gaze into the black paintings is to see the silence that lies beyond the Word.

6.

AGAINST

Mark Rothko is reported to have been reading two books at the time he committed suicide on February 25, 1970 — Friedrich Nietzsche's *The Birth of Tragedy* and Søren Kierkegaard's *Fear and Trembling*. Though Nietzsche and Kierkegaard differ in many ways, they share a preoccupation with silence. However, they approach the problem of silence from opposite directions. For Nietzsche, the silence surrounding us is the result of the radical immanence of the Real; for Kierkegaard, the silence beyond us is the result of the radical transcendence of the Real. Rothko saw in the writings of these two seminal philosophers a shared vision of the tragic dimension of life and the inescapable alienation of human existence.

Kierkegaard spent his entire life trying to drive a wedge between the opposites Hegel attempted to reconcile, such as subject/object, self/other, immanence/transcendence, human/divine. Far from an immanent presence that is completely revealed in nature and history, the Real is never present but always withdraws into a beyond that remains inaccessible as long as life continues. This Beyond is so distant that the Real actually seems to turn against this world and to confront individuals as an alien Other.[1] Paradoxically, this unnamable transcendence has been given many names, the most important of which for Kierkegaard are the "infinitely and qualitative different," the "Wholly Other," and simply "God." The most telling name, however, is the "Absolute." "Absolute," which derives from the Latin *absolvere* (*ab*, away + *solver*, to lose) means, *inter alia*, unconditional, unrelated to, and independent of anything else. So understood, the Absolute is that which withdraws from all relationships and, therefore, abandons self and world. This retreat ends in a silence that can be broken only by the unpredictable eruption of

the Word that communicates, if at all, only indirectly. Though the Wholly Other might be wrapped in pure light, abandonment casts a dark shadow over the world. Saint John of the Cross might well have been describing Kierkegaard's pilgrim when he wrote, "For it [the soul] feels within itself a profound emptiness and impoverishment of three kinds of good, which are ordained for the pleasure of the soul, which are the temporal, the natural and the spiritual, and finds itself set in the midst of the evils contrary to these, the apprehensions of the faculties and abandonment of the spirit in darkness. . . . [T]he soul must need be in all its parts reduced to a state of emptiness, poverty and abandonment and must be left dry and empty in the darkness."[2] To describe the way out of the abyss into which the soul sinks, many medieval mystics use the metaphor of a ladder. As I have noted, the most famous treatise in which this image appears is *The Divine Ladder of Ascent*, written by Johannes Climacus (also known as John the Ladder), who was a sixth- or seventh-century monk at the Monastery on Mount Sinai.

Kierkegaard, like the otherworldly God whose Word he probes, communicates indirectly.[3] He published his most popular works under pseudonyms, who represent the different points of view from which they are written. Kierkegaard appropriated the name Johannes Climacus for several of his most important works (*Philosophical Fragments* and *Concluding Unscientific Postscript to the Philosophical Fragments*), and used the pseudonym Anti-Climacus for *The Sickness unto Death*. While the ancient Johannes Climacus provides the ladder for a mystical ascent that leads to the perfect union with God, the modern Johannes Climacus gives readers a ladder that leads to the threshold of the Unknown where the individual must decide whether to make the leap of faith to believe in the transcendent God whose indirect Word never dispels the silence from which it emerges.

Kierkegaard developed his most prolonged meditation on silence in two books published on the same day in 1843—*Repetition: An Essay in Experimental Psychology* and *Fear and Trembling: Dialectical Lyric*. Both of these works take as their point of departure a story of a figure drawn from the Hebrew Bible—Job and Abraham. As was his custom, Kierkegaard also published three *Edifying Discourses* under his own name on the same day. The pseudonym for *Fear and Trembling* is Johannes de Silentio, and for *Repetition* is Constantine Constantius. It is important to note that from the publication of his first pseudonymous work, *Either/Or* in 1843, Kierkegaard remained silent about his authorship, and no one except his publisher knew who wrote the works. Not until *Concluding Unscientific Postscript* (1846) did he reveal his identity and strategy. While Reinhardt was compelled to repeat the "same" painting again and again, Kierkegaard was compelled to retell

the story of his broken engagement to Regina Olson again and again. *Fear and Trembling* and *Repetition* offer two versions of the "same" story. In *Fear and Trembling*, Johannes considers the conflict between religious calling and ethical responsibility; in *Repetition*, Constantine explores whether repetition is ever possible.

The argument in *Repetition* begins with the pseudonym—Constantine, name of the emperor responsible for Christianizing the Roman Empire, Constantius, second son of Constantine and emperor from 337 to 340. Writing shortly after his broken engagement to Regina, Kierkegaard explores the possibility of reestablishing the relationship he had just renounced. The young man is identified as "Your Devoted Nameless Friend," and Constantine is addressed as "My Silent Confidant." Turning to the Book of Job for guidance and consolation, the young man interprets his relation to his beloved as a "spiritual trial." Relief arrives unexpectedly not when he and the young girl are reunited, but when he hears that she has married someone else. Rather than falling into despair, the young man declares, "I am again myself. This self which another would not pick up from the road I possess again. The discord in my nature is resolved." As if trying to persuade himself of what he is saying, he interprets his own situation through Job's experience. "Is there not then a repetition? Did I not get everything doubly restored? Did I not get myself again, precisely in such a way that I must doubly feel its significance? And what is a repetition of earthly goods which are of no consequence to the spirit—what are they in comparison with such a repetition? Only his children Job did not receive again double, because a human life is not a thing that can be duplicated. In that case only spiritual repetition is possible, although in the temporal life it is never so perfect as in eternity, which is the true repetition."[4] Repetition occurs as the unexpected and undeserved gift of the transcendent God, who remains silent about the reason for his deeds.

The Book of Job does not, however, end as happily as the young man describes; he overlooks two of the most important points in the story. The restoration of Job's fortunes and possessions occurs in the prosaic epilogue and not in the concluding lines of the poem proper, which ends on a discordant note. God explains nothing to Job; rather than giving him the answers he is seeking, God remains silent about his motives and attempts to silence Job by the sheer assertion of his power.

> Then the Lord answered Job out of the tempest:
>> Who is this whose ignorant words
>> cloud my design in darkness?

Brace yourself and stand up like a man;
I will ask questions, and you shall answer.
Where were you when I laid earth's foundations?
Tell me, if you know and understand. (Job 32:1–4)

God gives no reason for Job's suffering other than the exercise of his omnipotent will. Though the litany of charges continues, Jack Miles points out that "Job concedes nothing. 'What can I answer You?' is an evasion. 'I am of small worth' may be true, but when has he claimed otherwise? 'I have spoken once, and will not reply;/Twice, and you will do so no more; are words that defy the thunder's demand that Job comment on his thunder."[5] Even God's thunderous words cannot silence Job, who responds by answering without answering. Miles translates Job's final words.

Then Job answered the Lord:
"You know you can do anything.
　Nothing can stop you.
You ask, 'Who is this ignorant muddler?'
Well, I said more than I knew, wonders quite beyond me.'
'You listen, and I'll talk,' you say,
　I'll question you, and you tell me'
Word of you had reached my ears,
　but now that my eyes have seen you,
I shudder with sorrow for mortal clay." (42:1–6)

"Structurally," Miles explains, "the Job-writer has created symmetry in the form of two demands and two refusals at length about justice and demands that God respond. God refuses. God speaks at length about power and demands Job respond. Job refuses. Sheer silence on Job's part would be, for dramatic purposes, a bit too ambiguous. It is important that Job respond just enough to let us know that he is refusing to respond, enough to answer in the negative our question Will he be taken in? Both of Job's responses to the Lord are refusals to respond. Thus does he prove that he has not been taken in."

While God fails to silence Job, what has long gone unnoticed is that Job actually silences God. Job, not God, gets in the last word. Miles is, to my knowledge, the first to realize that "the Lord's two-part speech to Job is his testament, his last words. He will not speak again in the Tanakh."[6] The qualification is important—"in the Tanakh" or in the Jewish Bible. To accept the claim that God falls silent after Job's refusal to respond, it is necessary to

follow the order of books in the Jewish Bible rather than the Christian Bible. The Jewish order moves the Prophets from the end where they are in the Christian "Old" Testament, to the middle and places the middle books—the more-or-less sapential books—to the end. Rather than the New Testament, what would come after the end would be a Mishnah and Talmud, which function as extensions of the Tanakh from within. Following Miles, Hebrew scripture ends with God's silence.

The silence Kierkegaard explores in *Fear and Trembling* becomes visible in Rothko's Houston Chapel.

> The time came when God put Abraham to the test. "Abraham," He called, and Abraham replied, "Here I am." God said, "Take your son Isaac, your only son, whom you love and go to the land of Moriah. There you shall offer him as a sacrifice on one of the hills which I will show you." So Abraham rose early in the morning and saddled his ass, and took with him two of his men and his son Isaac; and he split the firewood for the sacrifice, and set out for the place of which God had spoken. (Genesis 22:1–3)

The call that came from beyond was as unexpected as it was incomprehensible, but Abraham silently obeyed. He told Sarah nothing, said nothing to Isaac or his servants, and silently obeyed what he could not understand. Johannes de Silentio is a poet, not a believer, who finds Abraham both marvelous and horrifying. Unwilling or unable to believe, Johannes describes the movements of faith from the outside. He begins his "Dialectical Lyric" by offering four variations of the Abraham story in which it becomes clear that what most astonishes him is Abraham's silence. "It was early in the morning when Abraham arose, had the asses saddled, and left his tent, taking Isaac with him, but Sarah watched them from the window as they went down the valley—until she could see them no longer. They rode in silence for three days."[7] Three days . . . three long days. Imagine, just try to imagine walking in silence with your son whom you are going to murder without knowing why and not saying a word, not a single word. What was Abraham thinking? What was Isaac thinking? What was Sarah thinking? The future hung in the balance—not only Isaac's future, but the future of God's chosen people. Was this faith or madness? There is no way to be sure because God remains silent even when He speaks. Though Johannes probes many baffling questions, *Fear and Trembling* is a prolonged meditation on silence—the silence of human beings and the silence of God. What is said, what is not said, what cannot be said, what is not said in all saying.

Johannes concludes his meditation with a question. "Was Abraham ethi-

cally defensible in keeping silent about his purpose before Sarah, before Eleazar, before Isaac?"[8] It quickly becomes clear there is no simple answer to this question because silence is multifaceted. Johannes identifies three kinds of silence, which correspond to the three stages on life's way in Kierkegaard's dialectic of existence: aesthetic, ethical, and religious silence.[9] Unlike Hegel, who reduces faith to speculative reflection (theoretical reason) and Kant who reduces faith to moral activity (practical reason), Kierkegaard argues that faith is a totally private affair between an isolated individual and the radically transcendent God, who remains forever beyond, and even against human reason. Hegel, as we have seen, claims that the Logos is the foundation of all reality, and, therefore, everything is in principle sayable even if not all has yet been said. For Kant, the highest good is ethical action in which the individual represses or sublates his or her idiosyncratic inclinations in order to fulfill the universal obligation disclosed in the rational moral law. For Kierkegaard, at the religious stage of life, God is Wholly Other and the individual is higher than the universal; faith, therefore, cannot be reduced to either theoretical or practical reason.

Aesthetic silence is voluntary—a person can speak but chooses not to do so. As we will see in the next chapter, there can be many reasons for remaining silent. In *Fear and Trembling*, Johannes uses his own variation of Goethe's *Faust* to illuminate voluntary silence. In Johannes's version, Faust is "the doubter *par excellence*," who doubts everything, but, unlike Descartes, finds no certainty in his own self-consciousness. Having stared into the abyss of nonknowledge, Faust knows how doubt is able to

> rouse men up horrified, to make the world totter under their feet, to split men apart, to make the shriek of alarm sound everywhere. He realizes that if he were to communicate his doubt to Margaret [the poor, innocent young woman Faust madly loves] and others, their world would fall apart and so he chooses to remain silent. But Faust has a sympathetic nature, he loves existence, his soul knows no envy, he perceives that he cannot stop the fury he certainly can arouse ... he remains silent, he hides his doubt more carefully in his soul than the girl who hides a sinful fruit of life under her heart, he tries as much as possible to walk in step with other men, but what goes on inside himself he consumes and thus brings himself as a sacrifice for the universal.[10]

While Faust's decision might seem noble, from the ethical point of view, it is a violation of the basic moral principle of self-disclosure. There is no justifiable exception to the obligation to be open and honest with oneself and

with other people. To remain silent is to deceive and to deceive is to betray the moral law. "The ethical as such is the universal," Johannes explains. "As the universal it is the manifest, the revealed. The individual regarded as he is immediately, that is, as a physical and psychical being, is the hidden, the concealed. So the ethical task is to develop out of this concealment and to reveal himself in the universal. Hence whenever he wills to remain in concealment he sins and lies in temptation (*Anfechtung*), out of which he can come only by revealing himself."[11] What is sin from the ethical point of view can be faith from the religious point of view.

Abraham is different; his silent journey into the wilderness takes him to "the boundary of the unknown territory," where he approaches absolute silence, which is the silence of the Absolute. Johannes explains, "Abraham remains silent—but he *cannot* speak. Therein lies the distress and anxiety. Even though I go on talking night and day without interruption, if I cannot make myself understood when I speak, then I am not speaking. This is the case with Abraham. He can say everything, but one thing he cannot say, and if he cannot say that—that is, say it in such a way that the other understands it—then he is not speaking."[12] Faithful silence is the function of two interrelated factors. First, since God is "Wholly Other" or "infinitely and qualitatively different," the infinite cannot be comprehended in finite language, which reduces other to same. Second, since the individual has a totally private or absolute relation to the Absolute, the singularity of faith cannot be comprehended in the generality or universality of language.

Speech and silence, however, are not simply opposite; to the contrary, Abraham's speech mimics the divine Word by paradoxically speaking yet remaining silent. "Speak he cannot; he speaks no human language. And even if he understood all the languages of the world, even if those he loved also understood them, he still could not speak—he speaks in a divine language, he speaks in tongues." To speak in tongues is to say the Unsayable in words that betray the Logos by revealing what remains concealed. This is the paradox of faith—silence speaks and speech is silent. "First and foremost," Abraham "does not say anything, and in that form he says what he has to say."[13]

For Hegel, the "stations" along spirit's journey progressively overcome "unhappy consciousness" by negating every form of transcendence and reconciling the oppositions between God and self, self and other selves, self and world, and the self with itself. For Kierkegaard, the stages on life's way pass through a *Via Dolorosa* in which the individual becomes increasingly isolated from other individuals and eventually stands in fear and trembling over *against* the absolutely transcendent and totally unknowable God. Out-

wardly, the faithful individual is indistinguishable from the "unhappiest" person. "The unhappy one," Kierkegaard writes, "is the person who in one way or another has his ideal, the substance of his life, the plenitude of his consciousness, his essential nature, outside himself. The unhappy one is the person who is always absent from himself, never present to himself."[14] Never here but always elsewhere, the unhappiest person cannot be at home in this world.

VIA DOLOROSA

From the outside to the inside, Barnett Newman's influence is everywhere present in Rothko's Houston Chapel (1971). The original architect for the chapel was Philip Johnson, who also designed the campus and chapel of the nearby University of St. Thomas. Creative disagreements led to Johnson's withdrawal from the project. In his initial design, he conceived a building on a raised platform with a tall pyramid and an oculus that would allow light to enter. Rothko favored an octagonal plan like those in Byzantine churches and baptisteries. Though Johnson struggled to accommodate Rothko's suggestions for three years, they finally split over the issue of light. "Rothko did not object that Johnson's design was ugly or ludicrous. As always, Rothko was anxious about the lighting. Johnson imagined the harsh Texan light filtering down through the pyramid, then being diffused throughout the room. Rothko imagined his paintings displayed in space as close as possible to the one in which they were being created. He wanted to model the lighting on that of his new 69th Street studio, where, beneath the large skylight, he hung a parachute, which he could adjust to control the light."[15] It took several years to solve the lighting problem. The original use of a skylight favored by Rothko let in too much light, which would damage the paintings. In 1976, a metal baffle was installed to hide the oculus and shield incoming light. The all-seeing eye at the center of the structure is hidden, making the atmosphere of the chapel dark and confining even when the sun is bright.

The entrance to the chapel is announced by a rectangular reflecting pool surrounded by tall bamboo trees. In the middle of the pool, Newman's massive sculpture *Broken Obelisk* appears to float on the water's surface. Though conceived in 1963, this work was not made until 1967. John and Dominique de Menil commissioned this version of the work as a *memorial* to Martin Luther King, which was supposed to be installed outside Houston City Hall. When the mayor and city council members rejected the gift, the de Menils decided to place *Broken Obelisk* outside their Rothko Chapel. The

work, which weighs more than 60,000 pounds, is made of corten steel and consists of a 10′ 4″ pyramid with an inverted broken obelisk measuring 16′ 10″ precariously perched on it. In order to secure the obelisk, it was necessary to cut off the tips of both the large pyramid base and the smaller pyramid at the top of the obelisk and insert a steel pipe connecting the two.[16] Newman, like Turrell, had long been fascinated with pyramids and modeled his sculpture on the Great Pyramid at Giza. As we have seen, the pyramid is not merely a tomb but is also the site of passage for the Pharaoh to rise to the heavens to be united with the sun god Ra. Thomas Hess invokes this history to argue that the pyramid "is, literally, the 'Place of Ascent'—the point from which the dead king sails his astral boat up to the sun where he will spend eternity assisting the god Ra in the task of moving the sun across the heavens and beneath the earth." In this reading, the broken obelisk "suggests that the shaft goes on, upward, to the stars, and also has come down from them, in the vertical imperative of Genesis. . . . The sculpture, then, is not a confrontation with death, nor with the death-directed religion of Egypt; nor is it by any stretch of the imagination a 'memorial.' It is a celebration of life, of birth and renewal, in art and in man."[17] There is, however, another way to interpret this sculpture. Rather than representing the sun's rays joining the infinite and the finite, the broken obelisk could be understood as a broken ladder blocking mystical ascent and condemning human beings to a life of exile in a dark world where God falls silent. So understood, this work is an effective introduction to the transition from the bright light of the Texas sun to the darkness of the Rothko Chapel.

The second trace of Newman in the chapel is not actually present—his series of fifteen paintings he eventually titled *Stations of the Cross* (1955–66). The theme of this series can be traced to a Christian ritual dating back to the Byzantine era in which pilgrims follow the path Jesus took carrying his cross to Golgotha. Since the late fifteenth century, there have been fourteen stations. The *Via Dolorosa* (Way of Sorrow or Way of Suffering) begins with Jesus's condemnation to death (I), passes through his being nailed on the cross (XI) and death (XII), and ends with his being taken from the cross (XIII) and laid in the tomb (XIV). For pilgrims following in the steps of Jesus, this experience becomes the *imitatio Christi* in which they endure suffering with the hope that it will lead to future eternal life. The darkest moment in this journey comes in the ninth hour when Jesus was on the cross and cried out, "*Eli Eli lama sabachthani?*" "My God, my God, why hast thou forsaken me?" These words, which are from the twenty-second psalm, appear twice in the New Testament—Matthew 27:46 and Mark 15:34. In this

moment Jesus seemed to represent the most extreme moment of Kierke-gaard's unhappiest man. After his despairing last words, Jesus "gave a loud cry and died" (Mark 15:38). And then silence.

In 1966, Newman wrote a statement for the first exhibition of the Stations of the Cross at the Guggenheim Museum.

> *Lema Sabachthani*—why? Why did you forsake me? Why forsake me? To what purpose? Why?
>
> This is the Passion. This outcry of Jesus. Not the terrible walk of the *Via Dolorosa*, but the question that has no answer....
>
> *Lema?* To what purpose—is the unanswerable question of human suffering....
>
> The first pilgrims walked the *Via Dolorosa* to identify themselves with the original moment, not to reduce it to a pious legend; nor even to worship the story of one man and his agony, but to stand witness to the story of each man's agony; the agony that is single, constant, unrelenting, willed—world without end.
>
> "The ones who are born are to die
> Against thy will art thou formed
> Against thy will are thou born
> Against thy will dost thou live
> Against thy will die."[18]

Against. Against. Against. Against. No answer to the question "Why?" Only silence.

When Newman began these paintings, he did not envision a series and had not identified the theme of the Stations of the Cross. He started the sequence in 1958, after suffering a heart attack, which resulted in a prolonged stay in the hospital. He completed an additional painting in 1958 and two in 1960 before the project came into focus. The theme found him as much as he found the theme. "When I did the fourth one, I used a white line that was even whiter than the canvas, really intense, and that gave me the idea for the cry. It occurred to me that this abstract cry was the whole thing—the entire Passion of Christ."[19] The decision to paint a series titled *Stations of the Cross* might seem strange for an artist whose previous work had been in such serious conversation with the Jewish religious tradition. However, Newman was more concerned with human existence than with theological propriety. Though the passion of Jesus was his theme, his real subject was the inexplicability of human suffering. Commenting on the size of the paintings, which

all measured approximately 78″ × 60″, he explained, "I wanted human scale for the human cry. Human size for the human scale." As the theme began to consume him, his own work became a ritual pilgrimage along the *Via Dolorosa*. "I tried to make the title a metaphor that describes my feeling when I did the paintings. It's not literal, but a cue. In my work, each station was a meaningful stage in my own—the artist's—life. It is an expression of how I worked. I was a pilgrim as I painted."[20]

There is more defiance than acceptance of suffering in Newman's paintings. In the catalog for the Guggenheim show, Lawrence Alloway reports that Newman asked, "What is the explanation of the seemingly inane drive of man to be a painter and poet if it is not an act of defiance against man's fall and an assertion that he return to the Garden of Eden."[21] Perhaps this is the spirit that lends Newman's *Stations of the Cross* a tone more similar to Ellsworth Kelly's chapel than to Rothko's chapel.[22] Newman's paintings are light rather than dark and convey more a sense of levity than gravity. Of the fourteen paintings, four are all white—three are cream colored with white zips (9, 10, 11), one is pure white with a grayish-white zip (14). Eight paintings are predominately white with black zips—some are hard-edged, some are fuzzy—of varying lengths (1–8). Only two are black with white zips (12, 13). When viewed as a whole, the varying width and placement of the zips create a pulsating rhythm suggesting the interplay of appearance and disappearance. What is most surprising is that Newman breaks with tradition and adds a fifteenth station. This painting, titled *Be II* (1961/64), is completely white and is framed on the left with a fuzzy scarlet border reminiscent of *Vir Heroicus Sublimis*, and on the right with a sharp-edged black zip. When this work was first shown in 1962, Alan Stone, who was the gallery owner, named it *Resurrection*.[23] In this concluding supplement, it seems Newman was more concerned with "the garden of earthly delights" than with an otherworldly "kingdom of the abstract."

APPROACHING DARKNESS

Suicide is the self-imposition of the final silence. Perhaps it was inevitable that Rothko would end his life with suicide. Approaching darkness is the dominant theme that runs throughout his life and work. Rothko's sensitivity to the tragic sense of life is what drew him to Nietzsche's *The Birth of Tragedy*, and especially to Kierkegaard's *Fear and Trembling*. Kierkegaard's depiction of Abraham became a model for the work of the artist. As early as 1953, Rothko cited Kierkegaard's account of Abraham's sacrifice of Isaac

in *Fear and Trembling* as a model for the work of the artist. Rothko's interpretation of the Abraham/Isaac story changed over the years. As I have noted, Abraham's willingness to sacrifice Isaac can be interpreted as Kierkegaard's willingness to sacrifice Regina in order to fulfill his religious calling. Rothko saw in Kierkegaard's experience a foreshadowing of his own dilemma. In his landmark biography, James E. B. Breslin writes, "At the time of his death, one of the few books Rothko kept in his studio was a worn copy of Kierkegaard's *Fear and Trembling*. When he had drawn on that text in his 1958 lecture at Pratt, Rothko no longer identified with the son Isaac but with the patriarch Abraham: someone alienated from all those around him, even his wife, but his silent commitment to an act that went 'beyond understanding.'"[24]

In the months before his death, darkness was closing in on Rothko. In 1958, he suffered an aneurysm, which left him physically and mentally fragile. He also had emphysema and heart problems. In spite of his weakened condition, he continued to drink and smoke excessively. As his depression deepened, he sought psychiatric help and began taking several different antidepressants. To make matters worse, he was alienated from his wife, Mary Alice Beistle ("Mell"), and in 1969, two years after Ad Reinhardt's death, he started an affair with his wife, Rita Reinhardt. Though he claimed to be in love with Rita, Rothko could not leave Mell. His paintings grew darker with his mood. A year before his death, he began his *Black on Grey* series in which his signature three floating colored bands give way to two bands with black always on top of gray. But even these works were not dark enough. He once commented on Reinhardt's black paintings to Rita, "*I* should have painted them," but Rothko understood that Reinhardt believed in a way he could not. "The difference between me and Reinhardt is that he's a mystic. . . . By that I mean that his paintings are immaterial. Mine are *here*. Materially. The surfaces, the work of the brush and so on. His are untouchable."[25]

In the midst of all this darkness, there was a moment that might have offered some light. On June 9, 1969, Rothko was awarded an honorary degree by Yale University, which he had briefly attended. His response to Kingman Brewster's generous citation is revealing.

> When I was a younger man, art was a lonely thing: no galleries, no collectors, no critics, no money. Yet it was a golden time, for then we had nothing to lose and a vision to gain. Today it is not quite the same. It is a time of tons of verbiage, activity, consumption. Which is better for the world at large, I will not venture to discuss. But I do know that many who are driven to this life are des-

perately searching for those pockets of silence where they can root and grow. We must all hope that they find them.

The pocket of silence Rothko could not find in life, he found in death. Seven months later, he overdosed on pills and slashed the artery in his arm. "He left no note. As he had once remarked, 'Silence is so accurate.'"[26]

POCKET OF SILENCE

In 2010, John Logan's play *Red* received the Tony Award for Best Play. The play, which consists of an extended dialogue between Rothko and his assistant Ken, opens with Rothko in studio in 1958/59 sitting in front of a canvas for one of the murals he had been commissioned to complete for the Four Seasons restaurant, located in the Seagram Building on Fifth Avenue. This high-rise was Ludwig Mies van der Rohe's first commission in the United States, and his assistant was Philip Johnson. Ken questions Rothko's theories about art and eventually provokes him to give up the project and return the money he had been advanced. Expressing his disdain for pop art, Rothko explodes:

> ROTHKO: You know the problem with those painters? It's *exactly* what you said: They are painting for this moment right now. And that's all. It's nothing but zeitgeist art. Completely temporal, completely disposable, like Kleenex, like—
>
> KEN: Campbell's soup cans, like comic books— ...
>
> ROTHKO: Because those goddamn galleries will do anything for money— cater to any wicked taste. That's *business*, young man, not art! ... "Pretty." "Beautiful." "Nice." "Fine." That's our life now! Everything's "fine." We put on the funny nose and glasses and slip on the banana peel and the TV makes everything happy and everyone's laughing all the time.... How are you? Fine. How was your day? Fine. How are you feeling? Fine.... HOW ARE YOU?! HOW WAS YOUR DAY?! HOW ARE YOU FEELING?! Conflicted. Nuanced. Troubled. Diseased. Doomed. I am not fine. We are not fine. We are anything but fine.... Look at these pictures. *Look at them!* You see the dark rectangle, like a doorway, an aperture, yes but it's also a gaping mouthing like letting out a silent howl of something feral and foul and primal and REAL. Not nice. Not fine. *Real.* A moan of rapture. Something divine or damned. Something immortal, not comic books or soup cans, something beyond me and beyond now. And whatever it is, it's not pretty and it's not fine.... I AM HERE TO STOP YOUR HEART,

A howl. A *silent* howl. Like Edvard Munch's *Scream*. Something divine or damned. Earlier in the play Rothko anticipates the end not only of this series of paintings but his life. "There is only one thing I fear in life, my friend.... One day the black will swallow the red." Black swallows red in his Houston chapel.

> ROTHKO: I'm painting a series of murals now. I'll probably do thirty or forty
> and then choose which work best, in concert, like a fugue. You'll help me
> put on the undercoat and then I'll paint them and then I'll look at them
> and then paint some more....
> KEN: How do you know when it's done?
> ROTHKO: There's tragedy in every brushstroke.[27]

Rothko's vision is tragic. "Only that subject matter is valid," he insists, "which is tragic.... [T]he exhilarated tragic experience ... is for me the only sourcebook for art."[28] Remarkably, Rothko never visited the site in Houston and died one year before the chapel opened in 1971. He claimed to be an unbeliever, but his art probes issues and questions that are undeniably religious; indeed, art became his religion. "I am not interested in relationships of color or form or anything else.... I am interested only in expressing the basic human emotions—tragedy, ecstasy, doom, and so on—and the fact that lots of people break down and cry when confronted with my pictures shows that I *communicate* with those basic human emotions. The people who weep before my pictures are having the same religious experience I had when I painted them."[29] If Rothko's paintings provoke a religious experience, it is a strange religion that might better be described as religion without religion, or even religion *against* religion.

Though Rothko, like Newman, was Jewish, he was fascinated with the way some artists engaged Christian themes. Sheldon Nodelman reports that during a trip to Italy in 1966, Rothko was especially impressed by the pictures Fra Angelico had painted for the monastery of San Marco in Florence.[30] He was also influenced by the artwork in the basilica church of St. Maria Assunta at Torcello. During an earlier phase of his career, when his work was more representational, Rothko explicitly explored Christian themes—especially the crucifixion (e.g., *Crucifixion* [1936]; and *Crucifix* [1941–42]). Even when he left representation behind and arrived at his signature style, shadows of religion remained and, indeed, became more powerful as they

became less conspicuous. Both the form and content of the Houston chapel are saturated with religion.

As you enter the Houston chapel, you pass from the world of light to the world of darkness. The façade is completely unadorned brick with a dark cavernous opening making the building appear to be more like a mausoleum than a chapel. As if imitating gestures of negative theology, there are no steps, no columns, no signs, and no windows. Inside the rectilinear opening there are two large black doors. As I have noted, the octagonal structure of the building was inspired by Byzantine churches and baptisteries. Passing through the doors, you encounter a space organized by the intersection of paired axes and paired paintings that create unresolvable tensions. The entrance and apse are on a north-south axis that intersects the west-east axis to form a symmetrical cross. Superimposed on this cross is a second cross connecting the four angled walls. While the octagon creates a space that approximates a circle, suggesting repetitious rotational movement, the rectilinearity of the overlapping crosses suggests a directionality that implies the possibility of narrative coherence. These structural differences reflect contrasting interpretations of time. Though they are aniconic, the sense of narrativity is reinforced by the fourteen paintings, which, like Newman's work, suggest the Stations of the Cross.

As with Turrell's "Dark Spaces," it takes time for your eyes to adjust to the chapel's darkness. There is no artificial light—only the constantly changing natural light from the hidden oculus illuminates the interior space. Initially, all the "black" paintings look the same, but gradually differences begin to emerge. The paintings are positioned as paired opposites. At each point of the cross formed by the angled walls, there are single monochromatic paintings that are all the same size. At the points of the west-east axis of the other cross, there are seemingly identical triptychs, on the northern tip of the cross there is a third triptych larger than the other two. Centered between the two entrances there is a single nonmonochromatic painting. The quasi-circular space and hidden skylight create a claustrophobic sense of closure and gnawing suspicion that there is always something going on behind your back.

Moveable benches near the center of the chapel provide a place to sit and contemplate the paintings for a prolonged period of time. The longer you gaze at the works, the more differences emerge. In the mirrored triptychs on the horizontal axis, the center panel is slightly elevated, suggesting the cross of Jesus on Golgotha placed between the crosses of the two criminals crucified with him. These paintings are a deep black with dark reddish-gray border stripes that are reminiscent of Newman's zips. The appearance of symmetry between the facing triptychs is deceptive. The overall size of the

paintings is the same, but there are slight variations in the width of the borders, and the center panel on the west wall is hung 1¼″ lower than on the east.[31] The central panel in the triptych in the apse is not elevated but is wider than the paintings on either side of it. Rather than black, these three paintings are a deep purple with hints of red and blue. On closer inspection, what appear to be monochromes on the angled walls are actually subtle variations of purple with hints of underlying reds. The painting between the doors and opposite the apse differs from all the rest. A deep black vertical rectangle is framed by and floats above a dark purplish maroon rectangle. Though the fourteen paintings can never be grasped as a whole, taken together they enact a complex play of difference and repetition that keeps the viewer off balance. What at first seemed to be static formless forms are actually quasi-forms that are constantly moving and morphing. It is almost as if the surface of the paintings shimmer with ripples from some hidden depth. Rothko once said that his goal was to paint pictures "you wouldn't want to look at."[32] Breslin confirms this point when he observes that Rothko "wished to uncover the flux, the stuff, the emptiness behind the realm of forms—a substrate we *don't* want to look at."[33]

In addition to the way the paintings change with fluctuating natural light, time enters the work of art in another way. These paintings turn you toward what constantly turns away from you by drawing you toward something that seems to bar entry. Unlike Turrell's Ganzfelds, it is impossible to cross the threshold and enter the work of art. There is no mystical union here; to the contrary, something is forever retreating into a beyond that remains forever inaccessible. Paradoxically, this withdrawal is the draw of the work of art that keeps the viewer searching, asking, demanding more, more, more. But the answer is always "No," or, more precisely, the answer is always no answer but silence, and the viewer, like Job, is left to wonder why.

The bare white walls simultaneously separating and connecting the paintings deepen their darkness. Rothko's *Via Dolorosa* does not lead to resurrection or beyond resurrection to brightly colored *Be I, Be II*—rather, there is only unrelenting darkness. As the Real withdraws, the Stations of the Cross become circuitous, and the kairotic moment of revelation vanishes in the eternal return of a present that is never present. As Nodelman argues, "The repetition of formally identical pictorial units is necessary to demonstrate the nonrecurrence of the moment of encounter and thus the ultimate unavailability of the 'same' to itself. The experiential conditions of the installation are arranged to emphasize this unavailability. The continuously varying ambient light, the unstable flux of contrastive virtualities set in motion by

the play of peripheral vision, and the situation of crucial formal conjunctions at the thresholds of discriminability, whether of tonal values or of linear graphism, all conspire to frustrate the viewer's search for cognitive availability."[34] Rothko's chapel does not absorb you in a "cloud of unknowing," but leads you to the edge of the gulf separating you from the Unknown, where Johannes Climacus's question becomes urgent.

> What then is the Unknown? It is the limit to which reason repeatedly comes, and insofar, substituting a static form of conception for the dynamic, it is the different, the absolutely different. But because it is absolutely different, there is no mark by which it could be distinguished. When qualified as absolutely different, it seems on the verge of disclosure, but this is not the case; for reason cannot even conceive an absolute likeness. Reason cannot negate itself absolutely, but uses itself for this purpose, and thus conceives only such an unlikeness within itself as it can conceive by means of itself; it cannot absolutely transcend itself, and hence conceives only a superiority over itself as it can conceive by means of itself.[35]

Kierkegaard's repetition compulsion is not intended to heal the wounds of trauma but, to the contrary, to traumatize the subject by exposing it to an Unknown that can never be mastered. Rothko's circuitous journey is not Nietzsche's Eternal Return in which midnight is also midday, but is the eternal return of a night beyond night where black overwhelms red by absorbing all light. Reversing William Wordsworth, Rothko told his students, "All art deals with intimations of mortality." A decade later when someone asked him what the meaning of his chapel paintings was, he hesitated and answered, "the infinity of death ... the infinite eternity of death."[36]

The unavailability of the Other, the inaccessibility of the Unknown, and the infinity of death turn the self back on itself. For Rothko, the journey to selfhood must be undertaken alone—the farther along the stages on life's way you travel, the more isolated you become. Recalling the Romantic tradition dating back to David Casper Friedrich's *Monk by the Sea* (1808–10), which anticipates his mature style, Rothko once confessed that he was drawn to "pictures of a single human figure alone in a moment of utter immobility."[37] For years, Rothko had seen his artistic mission described in Kierkegaard's depiction of Abraham sacrificing Isaac. As darkness falls and the chapel walls close in, the viewer joins the artist standing alone atop Mount Moriah releasing a final desperate scream that is met with silence, absolute silence. No voice from the whirlwind, no voice substituting a lamb for a son.

Nothing but silence. Self against God. Self against world. Self against other selves. Self against itself. There is nothing more to say, but how to say this nothing?

SEAL OF DEATH

Playing a game. A game of black and white staged in infinite shades of gray. No exit. Black always wins. Checkmate.

No artist has developed a more extended and more profound meditation on silence than the Swedish filmmaker Ingmar Bergman. The silence of the cosmos. The silence separating family, friends, and strangers. Above all, the silence of God. Though never commenting on each other's work, Bergman's films can be understood as an interpretation of Rothko's art, and Rothko's paintings can be understood as a commentary on Bergman's films.

Silence is everywhere present in Bergman's work, but the theme is especially prominent in his trilogy: *Through a Glass Darkly* (1961), *Winter Light* (1963), and *The Silence* (1963), all of which are in black and white. Having been raised in the home of a Lutheran pastor during a time when Sweden was becoming increasingly secular, Bergman was preoccupied with the silence of God. *Through a Glass Darkly* explores the complex family dynamics of a woman suffering from schizophrenia, who has a terrifying vision of God as an evil spider trying to rape her. In *Winter Light*, a Lutheran pastor, Tomas Ericsson, who has lost both his faith and almost all his congregation admits his apostasy to a fisherman, Jonas Persson, despairing about the threat of atomic annihilation. When the pastor can provide no answers, Jonas commits suicide. After visiting Jonas's widow to offer his perfunctory condolences for her loss, Tomas proceeds to his church for his weekly service, though only his handicapped sexton and his erstwhile mistress are present. In late afternoon winter light, the church is as dark as the Rothko Chapel on an overcast day. Before the service begins, the sexton tells the priest that he has read the gospels as he had recommended and has some questions.

> SEXTON: The passion of Christ, his suffering.... Wouldn't you say the focus on his suffering is all wrong?
> PASTOR: What do you mean?
> SEXTON: The emphasis on physical pain. It couldn't have been all that bad. It may sound presumptuous of me, but in my humble way, I've suffered as much physical pain as Jesus. And his torments were rather brief. Last-

ing some four hours, I gather? I feel that he was tormented far worse on another level. Maybe I've got it all wrong. But just think of Gethsemane, Vicar. Christ's disciples fell asleep. They hadn't understood the meaning of the last supper, or anything. . . . They'd lived together day in and day out—but they never grasped what he meant. They abandoned him, to the last man. And he was left alone. . . . To be abandoned when you need someone to rely on—that must be excruciatingly painful. But the worst was yet to come. When Jesus was nailed on the cross he hung there in torment—he cried out—"God, my God!" "Why hast thou forsaken me?" He cried as loud as he could. He thought that his heavenly father had abandoned him. He believed everything he'd ever preached was a lie. The moments before he died, Christ was seized by doubt. Surely that must have been his greatest hardship? God's silence.

PASTOR: Yes.[38]

The Sexton says nothing more before leaving to light the church candles with organ music playing in the background. Tomas silently ascends steps to the altar and, vacantly staring into the empty church, recites, "Holy, Holy, Holy is the Lord of Hosts. The whole earth is full of his glory." Then silence.

The final play in the trilogy is *The Silence*. Though this film originally was titled *God's Silence*, Bergman is more concerned with the silence between people than the silence between God and His creatures. The setting is the dreary town of Timoka, Estonia, during wartime. ("Timoka" means "pertaining to the executioner.") Soldiers and military vehicles silently patrol the streets. Ester, her sister Anna, and Anna's ten-year-old son, Johan, are on a train heading for an unknown destination when they stop to stay in a once-grand hotel. Since they do not speak the same language as the locals, the sisters and the hotel staff cannot communicate. Ester is in the final stages of a terminal illness, and the drama of the film revolves around the tensions between the two sisters. The real failure of communication is between the sisters, who hate each other. Ester leaves Johan with Anna to pursue sexual escapades, and, upon returning, taunts her older sister with an exaggerated account of her exploits. As Ester's condition continues to deteriorate, she is overcome by the fear of isolation and death. Instead of expressing sympathy and offering her support, Anna declares that Ester always hated her and had regarded her as morally inferior. Appalled, Ester protests but to no avail; though she is a professional translator, Ester cannot communicate with those closest to her. The next morning Anna and Johan leave Ester to die alone in a strange land. Before their departure, Ester slips an enigmatic note into her

nephew's hand. "To Johan—words in a foreign language." When language is foreign, words remain silent even when spoken or written.

All the themes in the trilogy had been anticipated in Bergman's 1957 film *The Seventh Seal*, which is set in Denmark during the time of the black plague. The title is, of course, from the Book of Revelation, which had long fascinated Rothko. Nodelman reports that Rothko had been so impressed by El Greco's *Vision of St. John* (1608–14) that he insisted that Dominique de Menil, who funded his chapel, accompany him to the Metropolitan Museum of Art to see the painting. "El Greco's vision of last things," Nodelman suggests, "must have seemed pertinent at a time when Rothko's preoccupation with the chapel undertaking was all-consuming. In their opposite but equally awestruck ways, the late works of Fra Angelico and El Greco may hint at the effect upon the viewer at which Rothko himself was aiming and at the content of the chapel paintings as he conceived it."[39]

The Seventh Seal begins ominously with a raven, harbinger of death, soaring in an overcast sky. A knight, Antonius Block, and his squire, Jons, are resting on the beach while returning to Denmark after spending ten years on a crusade to the Holy Land. The knight rises, washes his face in the sea, and turns to see what appears to be a monk dressed in a black cape.

KNIGHT: Who are you?
DEATH: I am death.
KNIGHT: Have you come for me?
DEATH: I have been walking by your side for a long time.
KNIGHT: I know that.[40]

Death tells Antonius that he grants no reprieves, but the knight challenges Death to a game of chess. The wager is that death will be delayed as long as the games continue, and if the knight wins, he will be allowed to live. Predictably, Death draws black and the game begins.

As the knight and his squire continue on their long journey home, they encounter countless "evil omens"—a corpse with no eyes, horses eating horses, open graves, an execution ground where mercenaries are burning alive a young girl accused of being a witch. The one ray of apparent hope is a family, Mia (Mary), Jof (Joseph), and their baby Mikael, who are members of a traveling troupe heading for Elsinore, the home of Hamlet's castle, to perform on the church steps. Jof is something of a clown who has visions all the others ridicule. He wakens Mia to tell her he has seen the Virgin Mary and the baby Jesus. Jof is the only person who can see Death playing chess with Antonius; everyone else assumes he is playing against himself, which,

in a certain sense, he is. Throughout the film, the troupe stages a farce revealing human folly against the tragic backdrop of the looming apocalypse.

While the squire had given up faith long ago, the knight is a tormented soul suspended between belief and unbelief. Looking for a place to rest, they stumble upon a country church where an artist is painting an elaborate fresco of the Dance of Death. As the knight kneels before the altar, "pictures of the saints look down on him with stony eyes. Christ's face is turned upward, His mouth open in a cry of anguish." Bergman's Christ cannot move beyond the thirteenth station on the *Via Dolorosa*. Wracked by doubt and despair, Antonius turns to the confessional, where Death has secretly replaced the priest.

KNIGHT: Why can't I kill God within me? Why does He live on in this painful and humiliating way even though I curse Him and want to tear Him out of my heart? Why, in spite of everything, is He a baffling reality that I cannot shake off? Do you hear me?

DEATH: Yes, I hear you.

KNIGHT: I want knowledge, not faith, not suppositions, but knowledge. I want God to stretch out His hand toward me, reveal Himself and speak to me.

DEATH: But He remains silent.

KNIGHT: I call out to Him in the dark but no one seems to be there.

DEATH: Perhaps no one is there.

KNIGHT: Then life is an outrageous horror. No one can live in the face of death, knowing that all is nothingness.

The only respite from the darkness and gloom of the journey is when the knight and his squire meet the "holy family" and share a refreshing bowl of wild strawberries. But even in this moment of light, doubt clouds the knight's vision. He confesses to Mia, "Faith is a torment, did you know that? It is like loving someone who is out there in the darkness but never appears, no matter how loudly you call."[41] Every call for help, or even for love, is met with silence.

Searching for protection from the dangers lurking in the dark forest ahead, Mia, Jof, and their baby join the motley crew the knight has gathered along the way. While pausing to rest, the knight and Death once again take up their game, and Death quickly checkmates the knight. Having won their bet, Death asks,

DEATH: Did you enjoy your reprieve?

KNIGHT: Yes, I did.

DEATH: I'm happy to hear that. Now I'll be leaving you. When we meet
again, you and your companions' time will be up.
KNIGHT: And you will divulge your secrets.
DEATH: I have no secrets.
KNIGHT: So you know nothing.
DEATH: I have nothing to tell.

Death allows the knight and his companions to proceed to their destination,
where they discover that everyone except Antonius's wife, Karin, has fled the
castle. After an awkward reunion, Karin prepares the travelers' last supper.
As they are breaking bread and drinking wine together, Karin reads from the
Apocalypse of Saint John.

KARIN: "... and when the Lamb broke the seventh seal, there was silence
in heaven for about the space of half an hour. And I saw seven angels
which stood before God; and to them were given seven trumpets. And
another ..."

Three mighty knocks sound on the large portal. Karin interrupts her read-
ing and looks up from the book. Jons rises quickly and goes to open the door.

KARIN: "The first angel sounded, and there followed hail and fire mingled
with blood, and they were cast upon the earth; and the third part of the
trees was burnt up and all the green grass burnt away."

Now the rain becomes quiet. There is suddenly an immense, frightening
silence in the large, murky room where the burning torches throw uneasy
shadows over the ceiling and the walls. Everyone listens tensely to the still-
ness.

Death enters and stares at the group until the knight breaks the silence.
"From our darkness, we call out to Thee, Lord. Have mercy upon us because
we are small, frightened and ignorant."[42] But once again, there is no answer.
Death, swinging his scythe, leads the pilgrims in his dance across the hori-
zon and beyond into the gathering storm clouds in the heavens.

Checkmate: black trumps white and consumes red. God's silence turns
earth into a vast wasteland from which there is no exit. Painting and writ-
ing in the shadow of World War II and the emerging Cold War and atomic
age, Rothko and Bergman struggled to navigate the perplexing transition to
what is often misleadingly characterized as "the secular age." No longer able

to believe, but uncertain about unbelief, they were unable to let go of what they could no longer embrace. With God unwilling to answer their desperate calls, everywhere they turned, they heard nothing—nothing but sounds of silence, which drove Rothko to suicide and left Bergman unable to stop searching.

7.

WITHIN

Silence, yes, but what silence! For it is all very fine to keep silence, but one has also to consider the kind of silence one keeps.

SAMUEL BECKETT

WHIRLWINDS AND WHIRLPOOLS

Without ... Before ... From ... Beyond ... Against ... Within. The Unknowable, Unsayable, Unnamable is not only outside and beyond, but is also inside and within. Inside as an outside that cannot be interiorized, incorporated, assimilated. This interiority is wrapped in a silence that is impenetrable from the outside and inexpressible from the inside. All saying, therefore, is a not saying that says naught and all creating is a creating not. Is the silence of this dark interior the origin or extinction of light? Womb or tomb? Or something in between?

On May 3, 2017, Anish Kapoor's large-scale outdoor sculpture titled *Decension* was unveiled in Brooklyn Bridge Park. This work was first created for India's 2015 Kochi-Muziris biennale and was displayed in Galleria Continua in San Gimignano, Italy. Kapoor anticipated *Decension* years earlier with a black sculpture that resembles a whirlwind frozen in time (*Untitled* [1983]). In the more recent work, the whirlwind extends from the heavens, through the earth's surface, into the depths of the sea. It took more than three decades to develop the technology necessary to realize Kapoor's vision.

Decension is a continually swirling whirlpool that is 26′ in diameter. In previous iterations of the work, Kapoor treated the water with an artificial black dye that creates the appearance of a black hole; in the New York ver-

sion, the untreated water mirrors the colors of the nearby East River. The work is framed by the Brooklyn Bridge and the skyline of southern Manhattan. It is difficult to know how to classify this work of art. In response to a question of whether *Decension* is a sculpture, Kapoor impatiently responds, "Of course, it's a sculpture. I admit it doesn't look like a sculpture: it's a downward sculpture rather than an upward sculpture, but it is a sculpture. One thing that makes it a sculpture is that there's obviously artifice to it. It is artifice posing as a natural phenomenon. It's obviously been made, but the fiction is that it hasn't been made. That tension is an important part of the work."[1] As Kapoor suggests, this work breaks or, more precisely, inverts the rules of traditional sculpture to create what Michael Heizer calls "sculpture in reverse." Outside becomes inside, presence becomes absence, down becomes up, positive becomes negative. The spinning water creates a vortex that threatens to suck the viewer into a vertiginous descent. The sense of vertigo is exacerbated by the white noise of a constant hum and a steady vibration creating the sense that the ground is about to slip from beneath one's feet. In *Decension*, *Grund* becomes *Abgrund* (Abyss—*Ab*, away from + *Grund*, ground). The viewer is suspended above a void that seems unfathomable, and to make matters worse, there seems to be no end to the whirlpool. Water plummets into the void and mysteriously resurfaces only to fall again. Far from providing answers, Kapoor leaves viewers with questions. "How deep is it? Does it go to the center of the earth? What is it? What's making it? We want a measure of what we're looking at and when the thing refuses to measure, I think something else happens."[2] How to measure the unmeasurable, fathom the unfathomable, hear the Unnamable? The voice from the whirlwind becomes the silence of the whirlpool. Rather than answers to our questions, there is only silence . . . endless silence.

No writer is more attuned to the silence of abyssal vortices than Edgar Alan Poe. In his sonnet "Silence," he writes,

> There is a two-fold *Silence*—sea and shore—
>> Body and Soul. One dwells in lonely places,
>> Newly with grass o'ergrown; some solemn graces,
> Some human memories and tearful lore,
> Render him terrorless: his name's 'No More.'
> He is the corporate Silence: dread him not!
>> No power hath he of evil in himself;
> But should some urgent fate (untimely lot!)
>> Bring thee to meet his shadow (nameless elf,

That haunteth the lone regions where hath trod
No foot of man, commend thyself to God!³

A twofold Silence is a silence within silence, a silence that is more profound than the silence that is the opposite of speech. From the desert to the sea and everywhere in between there are echoes of silence. There is for Poe a terrifying silence that, paradoxically, can be brought by the relentless noise of frightful storms.

"Silence—A Fable." A nameless man is sitting in the shadow of a tomb when a Demon whispers in his ear, "Listen to *me*. . . . The region of which I speak is a dreary region in Libya, by the borders of the river Zaire. And there is no quiet there, nor silence."⁴ The "ghastly" river flows through a desert bounded by a "dark, horrible lofty primeval forest." Unlike the deserts where monks escape the buzz of the world, this desert rings with cacophonous noise. In the midst of the desert a huge rock rises etched with characters spelling DESOLATION. Atop this rock sits a man with "features of a deity" trembling in solitude. The lines on his face express his "disgust with mankind." The nameless narrator, overwhelmed by the noise of desolation, cries out "a curse of *silence*" as a frightful storm erupts. When the wind finally dies down, the thunder subsides, and the river withdraws, there is no voice throughout "the vast illimitable desert." The narrator "looked upon the characters of the rock, and they were changed; and the characters upon the rock were SILENCE." Far from reassuring, this silence is more menacing than noise, "and the man shuddered, and turned his face away, and fled afar off, in haste."

Poe was possessed by demons he could not escape because they were *within*. Everywhere he turned, he saw ghosts, shadows, doubles, tombs, and crypts. His imagination ran wild, leading him to heights that became depths he dreaded but could not resist. The abyss that consumed him was the source of the art that saved him at least for a while. His life was suspended between opposites symbolized by the North and South poles. He was always heading south toward the pole that was the vortex into which he, like many others at the time, believed all the waters of the world flowed and recirculated to come out of the mouth of the Nile and the American Nile, the Mississippi. He charts this journey toward the South Pole in "MS. Found in a Bottle," which is, among many other things, an incredible tale about "the origin of the work of art. "

In this tale, another nameless narrator tells the story of a ship sailing along the coast of Java when a violent storm suddenly rises and shatters the

vessel, leaving only two survivors. The narrator recounts, "By what miracle I escaped destruction, it is impossible to say. Stunned by the shock of the water, I found myself, upon recovery, jammed in between the stern-post and rudder. With great difficulty I gained my feet, and looking dizzily around was first struck with the idea of our being among breakers; so terrific, beyond the wildest imagination, was the whirlpool of mountainous and foaming ocean within which we were ingulfed."[5] Clinging to shattered remains of the ship and drifting south, the frightened survivors are tossed into the bottom of an abyss where they encounter a vessel manned by ghosts. The narrator "secrets" himself in the hold and, watching the ghosts, who speak a silent language he cannot understand, is overcome with "irrepressible reverence and awe mingled with the sensation of wonder." Like a negative theologian struggling to describe God, the narrator reports, "I have made many observations lately upon the structure of the vessel. Although well-armed, she is not, I think, a ship of war. Her rigging, build, and general equipment, all negative a supposition of this kind. What she *is not*, I can easily perceive; what she *is*, I fear it is impossible to say."

The ghost ship continues to drift toward the South Pole until it is caught in a current rushing toward the "dashing of a cataract." Drawn toward an endless abyss like Kapoor's whirlpool opening, the tale rushes to its conclusion. "Oh, horror upon horror!—the ice opens suddenly to the right and to the left, and we are whirling dizzily, in immense concentric circles, round and round the borders of a gigantic amphitheater, the summit of whose walls is lost in the darkness of the distance. But little time was left me to ponder upon my destiny! The circles rapidly grow small—we are plunging madly within the grasp of the whirlpool—and amid a roaring, and bellowing, and thundering of ocean and of tempest, the ship is quivering—oh God! and— going down!" But the end is not the end—"MS. Found in a Bottle" survives because the narrator had a plan. "I shall from time to time continue this journal. It is true that I may not find an opportunity of transmitting it to the world, but I will not fail to make the endeavor. At the last moment I will enclose the MS. in a bottle, and cast it within the sea."

"MS. Found in a Bottle" is a tale about the creative process of writing. The narrator's journey to the South Pole is Poe's journey inward. The demon that possesses him is his imagination, which he cannot control. This inner void, which simultaneously attracts and repels the artist, is the abyss that Kant discovered at the limit of reason. The mind is eternally restless and repeatedly struggles to comprehend what eludes its grasp. "This movement," Kant argues, "especially in its inception, may be compared with a vibration, i.e. with a rapidly alternating repulsion and attraction produced by one and

the same Object. The point of excess for the imagination (towards which it is driven in the apprehension of the intuition) is like an abyss in which it fears to lose itself."[6] The imagination operates along the border of form and form-lessness, order, and, in Kant's vivid terms "chaos, or in its wildest and most irregular disorder and *desolation*."[7] It was left to Heidegger to explain the importance of Kant's insight. "The original, essential constitution of human-kind, 'rooted' in the transcendental power of imagination, is the 'unknown' into which Kant must have looked if he spoke of the 'root unknown to us,' for the unknown is not that of which we simply know nothing. Rather, it is what pushes against us as something disquieting in what is known. And yet, Kant did not carry through with the more original interpretation of the transcendental power of imagination.... On the contrary: Kant shrank back from this unknown root."[8] To understand what so deeply unsettled Kant, try to imagine the impossibility of imagining. Imagine imagining the un-imaginable. Imagine being before being. Imagine being after being. Imagine being Not. Imagine not imagining.

The Unknowable, Unsayable, Unnamable is within us like a secret crypt that cannot be unlocked. Kant shrank back from this immanent Elsewhere, but he realized that this abyss is the origin of the work of art. By attempting to synthesize the forms of intuition and categories of understanding with the sensible manifold of intuition, the imagination seeks to bring order to chaos. In the First Critique, Kant argues, "this schematism of our understanding, in its application to appearances and their mere form, is an *art* concealed in the depths of the human soul, whose real modes of activity nature is hardly likely ever to allow us to discover, and to have open to our gaze."[9] Knowing is inescapably artistic even if the work (noun and verb) is not completely knowable. Where Kant drew back, Poe plunged in.

> To conceive the horror of my sensations is, I presume, utterly impossible; yet a curiosity to penetrate the mysteries of these awful regions, predominates even over my despair, and will reconcile me to the most hideous aspect of death. It is evident that we are hurrying onwards to some exciting knowledge—some never-to-be-imparted secret, whose attainment is destruction. Perhaps this current leads us to the southern pole itself. It must be confessed that a suppo-sition apparently so wild has every probability in its favor.

"Some never-to-be-imparted secret, whose attainment is destruction"—this is the origin of all art worthy of the name. At the last moment, the very last moment a strange bottle surfaces on the South Sea and the raging waves carry its message to the distant shores of India.

Like Poe, Anish Kapoor's life and art are suspended between polar oppo-sites: East/West, Hinduism/Judaism, Outer/Inner, Positive/Negative, Re-flection/Absorption, Color/Blackness, Geometric/Organic, Surface/Depth, Protrusion/Intrusion, Convex/Concave, Earth/Sky, Material/Immaterial, Unconscious/Conscious, Presence/Absence, Visible/Invisible, and Fullness/ Emptiness. What most intrigues Kapoor is neither one pole nor the other, but the strange void in between. He confesses, "In the end, I'm talking about myself. And thinking about making nothing, which I see as a void. But then that's something, even though it really is nothing."[10] The only way to figure this something that is nothing and nothing that is something is by plung-ing into the void that simultaneously separates and connects the opposites that make life possible, but whose tensions can become unbearable. "Bi-nary oppositions," Kapoor explains, "are the fundamental elements of the human condition. Capturing the void in matter is one way of creating drama, of placing the scene in a physically and psychologically clear language, in the sense that every form is either concave or convex. The materials used in Indian art can be perishable, such as bread, rice, and clay, or durable, such as stone and precious metals."[11]

Kapoor was born in Mumbai in 1954. His father was Hindu and his mother, whose family immigrated from Baghdad when she was an infant, was Jewish. Though he was raised in the Jewish tradition, traces of both reli-gions can be seen in his art. Initially following in the footsteps of his father, Kapoor began studying engineering, but after spending time in Israel, he decided to pursue a career in art. He left Israel in 1973 and immigrated to England, where he studied art first at Hornsey College of Art and later at the Chelsea School of Art. In his early works as a student like *Anthropomor-phic Ritual* (1977), his lifelong interest in mythology and religion is already evident. Germano Celant explains that, in this work, Kapoor

> establishes a balance or duality between opposite yet mutually attractive ele-ments. Maintaining the dialectic between divine and human, spiritual and physical, angelic and satanic; he makes forms fly and at the same time descend. He maintains a cyclical vision that rests on the meeting of earth and ether, low and high, dust and air. The archetype of the glorious body is transformed through the dialectical relationship between the volatile and the stable. . . . An opening requires a closing, a fullness wants a void, the limitless demands a limit.[12]

What is most characteristic of Kapoor's early work is his extraordinary use of vibrant colors. As we will see, these works are more similar to the joyful colors of Elsworth Kelly's Austin chapel than the somber tones of Rothko's Houston chapel. Kapoor has said that he discovered pigment on his return trip to India in 1979. But that is not all he learned in India; he also found the roots of his early artistic practice in his homeland. "I hadn't realized that the direction I had been working in was already there. I was only there for a month or so, but it was a real affirmation of my being. . . . The whole of the Indian outlook on life is about opposite forces. One thing I was fascinated by were the little shrines and temples by the roadside, which are all over India, and are specifically oriented towards this dualistic vision."[13] In India, Kapoor rediscovered what he once knew but had forgotten during his sojourn in foreign lands—vital religion and spirituality are not restricted to a separate time or domain of life, but pervade all life and experience. With this insight, Kapoor reached one of his most enduring convictions: "I do not want to make sculpture about form—it doesn't really interest me. I wish to make sculpture about belief, or about passion, about experience that is outside of material concern."[14] His vocation became bringing to others the truths he believes art has revealed to him.

Kapoor began this artistic quest with a work he started while still in art school and did not complete until 1985—*1000 Names*. Though this work was first exhibited in Paris and later shown at Coracle Press in London, he continued to develop variations of the multifaceted piece until 1985. From the walls of the temples to the streets of Mumbai, everywhere he looked, Kapoor saw bright colors. In Hindu mythology and cosmology, colors carry symbolic value, which he adapted to his own purposes. In *1000 Names*, he limits his palette to the primary colors red, yellow, and blue, and black and white. As his work became more refined, his color symbolism became more specific. The use of symbols was influenced by his deep appreciation for the writings of Carl Jung. "Red becomes a symbol of masculinity and the generative, while white refers to virginity and the feminine, and yellow corresponds to desire (the passional, solar part of red)."[15]

1000 Names, whose enigmatic title suggests the impossibility of naming anything properly, is neither painting nor sculpture, but something in between. Kapoor uses powdered pigments to create forms that are as malleable as they are fragile. Everything in this work is fleeting, transient, and ephemeral. Color creates forms that are always on the edge of being pulverized and returning to the prime matter from which they emerged. The proliferating forms and semi-forms are enclosed within a room that becomes "a magi-

cal environment born of the *conjuctio oppositorum* of conscious and unconscious, day and night, male and female, active and passive, life and death."[16] In contrast to Rothko's dark chapel and Bergman's black-and-white films, color overwhelms blackness, suggesting that life trumps death. In the bright sun of India, Kapoor found exorbitant fecundity that eventually was obscured but never completely extinguished by the northern gloom of dark, dank London days.

These forms range from basic solids—cubes, some open, some closed; cones, some erect, some wilting; pyramids, some with their tips knocked off, some pointing to the heavens; and spheres, some distorted with holes on top, others hollowed out like the dome of a dormant volcano—to more irregular forms including crescents, ascending spirals, ovals, boxes within boxes, even angled steps that lead not to the top of a pyramid but to a blank wall. Scattered seemingly randomly among these forms are objects indeterminately shaped, many of which are black or white. The overall effect of the work is a sense of dynamism that creates unending morphological and chromatic variation.

What is most suggestive about *1000 Names*, however, is not what is visible but what is invisible; not what is there but what is not there; not what is manifest but what is latent. All the forms are sitting on the bare floor or are attached to an empty wall. In many instances, the objects are half submerged, creating a sense of just having appeared from or just about to disappear into a ground that is never there. It is as if all colors and forms are manifestations of some thing or primal energy that shows itself by hiding. The relation between the visible and the invisible in this work can be interpreted cosmologically as the interplay of contending forces, or psychologically as the interaction of consciousness and the unconscious. The colorful forms seem to be the manifestation of processes that lie beneath the surface of conscious activity. I will return to this reading of the work of art in the next section. In the cyclical vision of Hindu cosmology, the world is the appearance of the play (*lila*) of the gods. Since what is most essential is always hiding, forms, images, and the words used to describe them are always incomplete because they imply something they can never express. This lack is the abyss (*Abgrund*) that is the groundless ground of everything that exists.

Unlike Kant, Kapoor does not turn away from the abyss, but, following Poe, plunges into it, seeking the silent origin of the work of art. With this leap of faith, his colors turn dark and his immaterial material becomes substantial. Responding to a question about the meaning of the title *1000 Names* in a 1990 interview, Kapoor commented on his transition away from his colorful pigment works.

ANISH KAPOOR: I've always felt that my work had to be about something else and that's what saved it, what made it be of any interest. I began to evolve a reasoning which had to do with things being partially revealed. While making the pigment pieces, it occurred to me that they all form themselves out of each other. So I decided to give them a generic title, "A Thousand Names," implying infinity, a thousand being a symbolic number. The powder works sat on the floor or projected from the wall. The powder on the floor defines the surface of the floor and the objects appear to be partially submerged, like icebergs. That seems to fit inside the idea of something being partially there. Now that's actually taken another turn. They're all about another place. They're all about something here, which is something inside, something not here. That process seems to happen with emptying things out, making things voided. That seems to actually fill them up. Emptying them out is just filling them up. And that's somewhere else. I don't know how else to say it.

AMEENA MEER: Filling them up with what?

AK: I suppose something inevitable. Something unspeakable, unknowable, unmeetable. Filling them up with fear. Fear in that they're all dark. Fear, I guess, is death.[17]

From this point on, all of Kapoor's art is *about* the void; for Kapoor, as for Poe, the void is *within*, which does not mean that it is personal. "Void is really a state within. It has a lot to do with fear, in Oedipal terms, but more so with darkness. There is nothing so black as the black within. No blackness is as black as that. I am aware of how the phenomenological presence of the void works but I am also aware that phenomenological experience on its own is insufficient. I find myself coming back to the idea of narrative without storytelling, to that which allows one to bring in psychology, fear, death and love in as direct a way as possible. The void is not something of which there is no utterance. It is a potential space, not a non-space."[18] Phenomenology is the study of the appearance of phenomena, but how does one study, ponder, reflect on what does not appear? How does one see what cannot be seen, speak what cannot be said, hear what remains silent? How is it possible to figure the void?

Kapoor begins with color and moves to form. To present the blackness within, he searches for the blackest black possible—absolute black. This might seem to be a surprising term for an artist who is best known for his bright shiny objects like *Cloud Gate*, affectionately dubbed "the Bean," in Chicago's Millennium Park. Even his most highly polished works, however, have a twist that renders them unsettling. Through the interaction of

the protrusion and intrusion of convex and concave surfaces, Kapoor creates folds that form pockets that are virtual holes. This inward turn reveals an opening that is the "pocket of silence" nourishing all reflection. For those patient enough to linger with these works, reflection becomes all absorbing.

The difference between white and black is the difference between reflection and absorption. Absolute black would have to be absolutely absorbing. Kapoor found the black he was looking for in the commercially produced Vantablack. The term "Vanta" is an abbreviation for "Vertically Aligned Nano Tube Arrays." Rather than reflecting light, Vantablack absorbs 99.965 percent of incoming light by trapping it in nanotubes and dissipating it as heat. This material was originally developed in England by Surrey Nano Systems, whose website describes the product.

> Vantablack is a super-black coating that holds the world record as the darkest manmade substance. It was originally developed for satellite-borne blackbody calibration systems, but its unique physical and optical properties have resulted in it finding widespread application. Vantablack absorbs virtually all incident light, making it ideally suited to addressing a host of light-suppression and light-management problems. It reflects so little light that it is often described as the closest thing to a black hole we'll ever see. With such exceptionally low levels of reflectance, Vantablack produces some startling optical effects; when it is applied to a three-dimensional object, Vantablack is so black that it becomes extremely difficult to discern any surface features, and three-dimensional objects appear to become two-dimensional.[19]

Kapoor created a scandal in the art world when he secured exclusive licensing rights for the use of Vantablack. In a 2014 interview with the BBC, he explained his attraction to the material. "It's so black you almost can't see it. It has a kind of unreal quality and I've always been drawn to rather exotic materials because of what they make you feel. Imagine a space that is so dark that as you walk in you lose all sense of who you are and what you are, and also all sense of time. Something happens to your emotional self, and in disorientation you have to reach inside you for something else."[20]

While exploring the artistic potential of black, Kapoor became preoccupied with the problem he described as "how to make an object, which is not an object, how to make a hole in space, to make something that does not exist."[21] In an effort to solve this problem, he developed a series entitled *Voids*. In *Mother as Void* (1988), *Mother as Ship* (1989), *Madonna* (1989–90) and *Eyes Turned Inward* (1993), he turns the void inside out in large convex objects mounted vertically on gallery walls.[22] These works create a force field

that threatens to absorb viewers. Indirectly recalling Poe's narrator at the edge of the abyssal whirlpool, Kapoor explains, "I have always felt drawn towards some notion of fear in a very visual sense, towards sensations of falling, of being pulled inwards, of losing one's sense of self."[23]

Kapoor develops his most effective explorations of the void by creating a complex interplay of emptiness and fullness in a series in which he uses stone. Celant notes the important role stone has played in religious myths and rituals. "In the history of religion, the greatest manifestations of the sacred have been lithic, from the Semitic bethels and the Arabian Kaaba to the black stone of Anatolia of Mithras, the Indo-Iranian lithic of light. In the legend of Deucalion and Pyrrha, even the human is symbolized by stone. For all these reasons, one might say that stone is the path from the human to the divine."[24] The *Void* series begins with a work entitled simply *I*, which is a limestone block with a hole in the middle that exposes a dark blue interior cavity. What initially appears to be solid and substantial is actually vacuous. Kapoor extends this theme with additional sculptures in which he carves precisely cut rectangles in large rough-hewn limestone rocks. He uses titles in a way similar to Newman to give specificity to his abstract objects or, in his own term, "non-objects." These sculptures are *about* the void. The opening of the void articulates the object that creates the space for what it cannot contain. In *Adam* (1988–89), the opening in the beige rock is black, and in *It is Man* (1988–89), it is a deep blue that is almost black. These works border on the didactic by explicitly suggesting that in the depths of human being, there is an emptiness that can never be filled. However, far from a mere lack, this void, like the silence between words, is what makes the articulation of all forms and appearances possible.

Once defined, the void and the silence it harbors proliferate. *Void Field* (1989) consists of sixteen large stones (241 × 127 × 114 cm) irregularly spaced in an empty room with white walls. Each stone has a black hole located approximately in its middle. While the large concave works turn everything inside out, *Void Field* turns the world outside in. Once again, Kapoor gives his work an unexpected twist. "'Void Field' is a work in which this kind of binary opposition that I've always been juggling with seemed to place itself in some very clear way. It's a work about mass, about weight, about volume and then at the same time seems to be weightless, volumeless, ephemeral; it's really turning stone into sky. The darkness inside the stones is the darkness of black night, the darkness of the sky."[25] This is not the first time that Kapoor attempted to create commerce between earth and heaven. In *Sky Mirror* (2006), he placed a massive concave/convex mirror (1067 cm in diameter) on Fifth Avenue in New York in the heart of Rockefeller Center. He repeated

this gesture in a series of works in which the mirror is situated in different locations. The effect is to create a hole in space that is an opening where, like in Alice's Wonderland, everything turns inside out and outside in. Kapoor explains, "Once I made 'Void Field,' this earth into sky, it occurred to me that it would be wonderful to attempt the opposite. In 'Void Field' we have the earth containing the sky, earth outside, sky within. To do the opposite was to have earth within, sky without. I just painted some stones.... And ... they became bits of sky. They became weightless and in a sense effortless."[26] This work, *Angel* (1989), consists of a collection of slate objects painted what appears to be Klein blue, placed horizontally on the floor.[27] By bringing the sky down to earth and raising the earth to the heavens, Kapoor creates a virtual *axis mundi* both joining and separating gods and human beings. These two trajectories come together in *Ghost* (1997), which is a stone measuring 195 × 140 × 120 cm with a large black rectangle carved in the center. Rather than leaving the void empty, Kapoor places in its middle a curved mirror in which the viewer can see his or her image reflected. When everything is inside out and outside in as well as inverted and reversed, opposites are conjoined but not necessarily united.

Kapoor develops his most extensive consideration of the void in two works that present what Celant aptly describes as "the architecture of the self." Moving from sculpture to architecture, he designs two complementary structures — *Building for a Void* and *Descent into Limbo* (both 1992). *Building for a Void*, which was created for the 1992 Seville Expo, is a 15′ tall cylinder that looks either like a screw entering the earth or an inverted whirlpool spinning toward heaven. There are two openings — one in the wall that lets light in from above, and one in the floor, which, like *Decension*, exposes the darkness of the groundless ground beneath. *Descent into Limbo* was first exhibited at Documenta IX in Kassel, Germany. It is a concrete cube measuring 6 × 6 × 6 m. In the center is a dark opening that is 3 m in diameter; "there is the illusion of a flat blue surface on the floor, but as one approaches, one realizes the sensation of standing at the edge of a precipice. The bottom is invisible, as though a fall might be infinite and eternal: Limbo. The effect creates an enormous tension, as though the earth's crust had ceased to exist and beneath it there was only an immense void, an absolute darkness."[28] As we have seen, Kapoor has always been intrigued by the prospect of falling into the void. When this work was exhibited at the Fundaco de Serralves Museum in Porto, Portugal, in 2018, a man gazing into an abyss that seemed to be bottomless actually fell into the hole in the middle of the floor, which fortunately was not bottomless but was only 8′ deep.[29] This incident was not

accidental—Kapoor intends his works to appear dangerous, creating a disturbing sense of unease that is both repulsive and strangely attractive. Commenting on his stone works, Kapoor unexpectedly invokes God and metaphysics.

> AK: They are spaces of wonder but they're also featureless, also, in a sense, nonexistent. It's the idea of making a sculpture that is actually not sculpture, just a hole in space that's a non-object, a non-physical thing. It's also futile because it's not possible. Grappling continually with this impossible thing seems to me to be a direct parallel for any ideas about God. It's totally intangible. One can't illustrate it, make it, or have it be. One can only remotely refer to it. I think that's worthy. That's the stuff, for me, art ought to be made of. And that's why it will always be incomplete. It's impossible to complete.
>
> AM: So art is about being and not-being.
>
> AK: Exactly, exactly.[30]

Being and not-being, that *is* the question. When art is a matter of life or death, the question becomes: Does black consume red, or does red overcome black?

As I have suggested, Kapoor is constantly searching for the origin of the work of art. Throughout his career, he has consistently associated this origin with the feminine and even the maternal. "To me," he confesses, "the notion of origin is very important, so I've made a number of works which have titles rather similar to that. It's trying to engage the place from which I emerge as an artist, which I feel to be feminine. I feel my creative self to be feminine. I feel that creativity is feminine. I think this is also very Eastern. One can speak of Western tradition, certainly in modern art, being basically phallic. Western sculpture is phallic art. My work seems to be the opposite. All the works I have here in the studio, they're all upright and in that sense, phallic, but they're all empty so it's an inversion of that phallic-ness. They're not toward the flat, but towards the concave. That's very important for me."[31] Not all of Kapoor's openings in rigid stones are hard-edged rectangles; many are soft curves that resemble a vulva. This motif is anticipated in pigment works like *Place* (1985), which is a cobalt-blue exposed box with a vulva-shaped opening on one side, and the bright red *Mother as Mountain* (1985), which is a pyramidal structure with gently sloped rippled sides with a vulval opening at the top. The title of another work, *L'origine du monde* (2004), makes direct reference to Gustaf Courbet's famous painting with the same

title. This work consists of a dark oval opening in a slanted wall in a purely white room. Taken together, these works suggest that all of Kapoor's abyssal openings can be understood as the generative maternal matrix.

Kapoor creates an explicit dialogue between the masculine and the feminine, which seems to have been influenced by Jung's distinction between the animus and anima archetypes. While this distinction reinscribes some of the traditional binaries that limit the understanding of both masculinity and femininity, what is most suggestive about Kapoor's work is his exploration of the generative potential of concealment. Birth and creation involve the complex interplay of withdrawal and emergence in which the hidden is the productive force. A series of sculptures with erect phallic stones are hollowed out by openings that are unmistakable representations of a vulva. (See, for example, *Three Witches* [1990].) Even the mirror in the opening of *Ghost* is shaped like a vulva, creating a reflection of the viewer that appears to be inside the sculpture. More recently, outside the Museum of Fine Arts in Houston, Kapoor has placed a bright shiny object shaped like a penis in which he has inserted a slightly concave vulva mirror that incorporates the image of the viewer by inverting and reversing it.

The return of color—not just any color, but especially red—in Kapoor's work is as important as these formal developments. Everywhere you turn when looking at his later work, you see red—the massive *Marsyas* (2002), *Pouch* (2006), *Inwending Volle Figur* (2006), *My Red Homeland* (2003), *Push-Pull, II* (2008–9). The list goes on and on. The most overwhelming work using red is *At the Edge of the World* (1998) in which a huge hemispheric dome filling the entire gallery hovers above viewers, threatening to suck them up into its empty center. It is impossible to dissociate red from blood, which can be a sign of violence and hence death, but can also be menstrual and, thus, a sign of birth and life. Kapoor's sculptures reverse Rothko's paintings and point toward Kelly's chapel. Rather than erasing red with black, the red abyss into which Kapoor asks us to plunge is more of a womb than a tomb. The artistic expression of birth is creativity, and the midwife of creativity is the imagination.

> The void has many presences. Its presence as fear is towards the loss of self, from a nonobject to a nonself. The idea of being somehow consumed by the object, or in the nonobject, in the body, in the cave, in the womb. I have always been drawn to a notion of fear, towards a sensation of vertigo, of falling, of being pulled inwards. This is a notion of the sublime which reverses the picture of union with light. This is an inversion, a sort of turning-inside-out. This is a vision of darkness. Fear is darkness of which the eye is uncertain, toward

which the hand turns in the hope of contact and in which only the imagination has the possibility of escape.[32]

Kapoor's work surfaces from the depths of an abyss like a MS. in a bottle that floats above depths that are unspeakably profound.

SECRETS

Noise is obscene—it invades, pervades, and permeates everything until there is no privacy, no interiority, no inwardness. Recording and surveillance technologies combine with big data, algorithms, and high-speed computers to create a world where no one can keep a secret. Secrets make us human, and the incessant bombardment of noise is destroying our humanity. When interiority is erased by programmed data and information, people are no longer themselves—they become completely transparent and totally superficial. Jean Baudrillard describes this condition as "obscene." "Obscenity," he writes, "begins when there is no more spectacle, no more stage, no more theater, no more illusion, when everything becomes immediately transparent, visible, exposed in the raw and inexorable light of information and communication. . . . Obscenity is not confined to sexuality, because today there is a pornography of information and communication, a pornography of circuits and networks, of functions and objects in their legibility, availability, regulation, forced signification, capacity to perform, connection, polyvalence, their free expression."[33] By erasing interiority, noise destroys the wellspring of creativity. Secrets secrete—their very hiddenness is the source of unexpected creativity. The unknown, perhaps even the unknowable, is what allows us to think what has not been thought and say what has never been said. If the origin of creativity could be known, it could no longer be creative.

Kierkegaard already knew this more than 150 years ago. In the very first paragraph in the very first book he published, he writes, "It may at times have occurred to you, dear reader, to doubt somewhat the accuracy of the familiar philosophical thesis that the outer is the inner and the inner is the outer. Perhaps you yourself have concealed a secret that in its joy or in its pain is too intimate to share with others."[34] The target of his criticism is Hegel according to whom the inner inevitably becomes the outer, and the outer becomes the inner. In this transparent world, there are no secrets. Hegel's speculative philosophy leads directly to the obscenity Baudrillard detects at the heart of what he describes as the society of the spectacle. When everything is sayable, knowable, and nameable, life is no longer marked by serendipity, novelty, and wonder, but becomes the eternal return of the same.

In many ways, Kierkegaard's whole life and entire *oeuvre* are a prolonged meditation on the enigma of the secret. I have already considered his analysis of silence in *Fear and Trembling*. In the final problem in that book, he addresses the relationship between silence and secrecy. He concludes by posing the question that haunted him throughout his life. "Was Abraham ethically defensible in keeping silent about his purpose before Sarah, before Eleazar, before Isaac?"[35] Kierkegaard begins his response by turning to Kant and Hegel. "The ethical as such is the universal; as the universal it is in turn the disclosed. The single individual, qualified as immediate, sensate, and psychical is the hidden. Thus his ethical task is to work himself out of his hiddenness and to become disclosed in the universal. . . . The Hegelian philosophy assumes no justified hiddenness, no justified incommensurability. It is, then, consistent for it to demand disclosure."[36] As we have seen, for Kierkegaard, unlike Kant and Hegel, religious faith cannot be reduced to universal ethical laws because the individual as individual is higher than the universal. Since language is general, if not universal, it cannot comprehend or express concrete existence—be it human or divine—which is irreducibly singular. In other words, the real remains forever silent because it eludes language in the very attempt to grasp it. The relation between the individual believer and the transcendent God is also radically singular, and, thus, is inexpressible and remains hidden in interiority. The transcendence of the Wholly Other God is mirrored in the inaccessible interiority of the self—*homo absconditus* is made in the image of the *deus absconditus*. Secret interiority defines the individual at the deepest level of human existence. What is most surprising about the knight of faith is that he looks just like everybody else. Johannes de Silentio is astonished and declares, "The instant I first lay eyes on him, I set him apart at once; I jump back, clap my hands, and say half aloud, 'Good Lord, is this the man, is this really the one—he looks just like a tax collector!'" This Quidam remains silent even when he speaks.

Kierkegaard realizes that his understanding of faith in terms of secrecy and inwardness raises endless questions. Most baffling, faith and the demonic are outwardly indistinguishable. "I always run up against the paradox," Kierkegaard admits, "the divine and the demonic, for silence is both. Silence is the demon's trap and the more that is silenced, the more terrible the demon, but silence is also divinity's mutual understanding with the single individual."[37] Though outwardly indistinguishable, the silence of the believer and the silence of the demonic are not inwardly the same. While the believer remains silent because he *cannot* speak, the demonic remains silent because he *will not* speak. Kierkegaard defines the demonic as *det In-*

deslutte (in + *slutte*, close), which means closed in, shut up, or locked up. In *The Concept of Dread*, he argues, "The demonic, is inclosing reserve [*det Indesluttede*] and the unfreely disclosed. The two definitions indicate ... the same thing, because inclosing reserve is precisely the mute [*det Stumme*], and when it is to express itself, this must take place contrary to its will." Demonic silence willfully conceals unspeakable transgressions. Having cheated, deceived, or abused others, speaking, revelation, and confession would offer relief and perhaps even make forgiveness possible. "Language, the word, is precisely what saves, what saves the individual from the empty abstraction of inclosing reserve."[38] But the demonic person refuses to speak and locks him- or herself up with a secret that will never be disclosed. Better to remain silent than to lose an identity that is no longer one's own.

Even this silence is not the most profound; there are other secrets even deeper than faithful or demonic silence. The deepest secrets are utterly enigmatic and raise questions that cannot be answered. Is it possible to unknowingly keep a secret from oneself? Is a secret that is not recognized as such really a secret? Is a secret that can be known still a secret? If a secret is shared, does it remain a secret? There is no telling for sure, but there are clues, hidden clues, which, like errant woodland paths, might lead nowhere.

The contrast between divine and demonic silence points to different dimensions of inwardness that create unavoidable faults that split subjectivity. The unspeakable outside inside the self can be either below or above consciousness and self-consciousness. For Freud, consciousness and self-consciousness float upon a bottomless sea that makes thought and language as fragile as Kapoor's brightly colored powder sculptures. Just as the visible world is the trace of an invisible underworld, so dis-course is the indirect saying of what can never be said. For Derrida, the navel of Freud's dream, which, we have seen, is the point of contact with the unknowable, is the crypt that is "an inner form ... (a) safe, an outcast outside inside the inside." In his patient reading of Nicholas Abraham and Mariana Torok's *The Wolf Man's Magic Word: A Cryptonymy*, Derrida asks, "What is a crypt? No crypt presents itself. The grounds [*lieux*] are so disposed to disguise and hide: something, always a body in some way. But also to disguise the act of hiding and to hide the disguise: the crypt hides as it holds.... The crypt is thus not a natural place, but the striking history of an artifice, an *architecture*, an artifact: a place *comprehended* within another but rigorously separated from it, isolated from general space by partitions, an enclosure, an enclave."[39] The architecture of the divided self is something like a crypt carved out of the rock of ages.

When considering the secret of the architecture of the self, it is instructive to note that in Danish, *"kierkegaard"* means cemetery. For Derrida, following Kierkegaard, the self is always duplicitous. "The Self: a cemetery guard. The crypt is enclosed within the self, but as a foreign place, prohibited, excluded. The self is not the proprietor of what it guards. He makes the rounds like a proprietor, but only the rounds. He turns around and around, and in particular it uses all its knowledge of the grounds to turn visitors away.... If he agrees to let in the curious, the injured parties, the detectives, it will be to serve them with false traces and fake tombs."[40] This tomb is the opening created by some *thing* that is introjected, but not incorporated, consumed, but not assimilated. This hidden crypt renders everyone and everything cryptic. In the crypt, "'Secrecy is essential,' whence the crypt, a hidden place, a disguise hiding traces of the act of disguising, a place of silence. Introjection speaks; 'de-nomination' is its 'privileged' medium. Incorporation keeps still, speaks only to silence or to ward off intruders from its secret place. What the crypt commemorates, as the incorporated object's 'monument' or 'tomb,' is not the object itself, but its exclusion.... A door is silently sealed off like a condemned passageway inside the Self, becoming the outcast safe."[41]

The silence of the crypt is not sterile, nor is this tomb empty. There is, in Frank Kermode's fine phrase, a "genesis of secrecy." Like everything else, the genitive is duplicitous. Secrets are not only generated by introjection and repression, but they are also generative of creative words and works that are always incomplete. As the Gospel according to Mark reveals, when the stone is rolled away or carved out from within, the tomb becomes a womb that gives birth to the infinite rebirth of the Word. Like a safe in a ghost ship where a wayward passenger "secrets" him- or herself, the crypt within the self is the silence tolling in every word and the fertile matrix of the most profound works of art. Those who know they do not know realize that the most effective way to silence the obscenity of noise is by continuously engaging in the impossible struggle to name the Unnamable.

Samuel Beckett once famously declared "there is nothing to express, nothing with which to express, nothing from which to express, no power to express, no desire to express, together with the obligation to express."[42] To speak or write while saying nothing would be to sound silence. But can language be self-erasing? How is it possible to speak and write yet say nothing? In all his plays, poems, and novels, Beckett struggles to speak silence—not speak *about* silence, but to speak and write silence by letting silence speak in, through, and between his words. Attempting to do the impossible, Beckett's language becomes simultaneously sparse and excessive. Paragraph and sen-

tence structure break down in opposite ways by contracting into brief fragments and exploding in sentences that run for pages and even entire books. At the same time that lapses and gaps proliferate, pauses become so long that it seems they will never end. To hear what Beckett says by not saying takes time and patience. His is a dark vision that *malgré lui* harbors a dim ray of hope.

Beckett was born into a Protestant family in Dublin in 1906. He studied French at Trinity College, and after graduation traveled to Paris, where he lectured at L'École Normale Supérieure (1928–29). While in Paris, he began to translate Joyce's *Finnegan's Wake*, but eventually abandoned the project to return to Dublin to pursue a master's degree.[43] Over the years, Beckett and Joyce developed a close but complicated relationship. Suffering from very poor eyesight, Joyce dictated part of *Finnegan's Wake* to Beckett. The "negative capability" of Beckett's mature work is the mirror image of Joyce's signature style. He once acknowledged to his biographer, James Knowlson, "I realized that Joyce had gone as far as one could go in the direction of knowing more, in control of one's material. He was always adding to it; you have only to look at his proofs to see that. I realized that my own way was impoverishment, in lack of knowledge and in taking away, subtracting rather than adding."[44] Though both Beckett and Joyce were preoccupied with the limits of language, they approached this boundary from opposite directions. The poverty of Beckett's language is inverse of the plenitude of Joyce's prose. Beckett's emptiness and Joyce's fullness meet in the abyss of silence.

While studying at Trinity College, Beckett concentrated on the writings of René Descartes. If modern philosophy begins with Descartes's *Discourse on Method* (1637), it ends with Beckett's *The Unnamable* (1953). From the seemingly firm foundation of self-certainty, Descartes attempted to reconstruct his world. Beckett was not convinced by Descartes's argument and countered by developing a literature of contraction in which he consistently withdraws from the surrounding world and even his own body, until he reaches an interior void that is utterly silent. He begins *The Unnamable* by responding to Descartes's confident self-certainty.

Where now? Who now? When now? Unquestioning. I, say I. Unbelieving. Questions, hypotheses, call them that. Keep going, going on, call that going, call that on. Can it be that one day, off it goes on, that one day I simply stayed in, in where, instead of going out, in the old way, out to spend the day and night as far away as possible, it wasn't far. Perhaps that is how it began. . . . I seem to speak, it is not I, about me, it is not about me. These few general

remarks to begin with. What am I to do, what shall I do, what should I do, in my situation, how to proceed? By aporia pure and simple? Or by affirmations and negations, invalidated as uttered, sooner or later?[45]

"I, say I. Unbelieving." For Beckett, Descartes did not carry his doubt far enough because he did not doubt his own doubting I. What is this I? Who is this I?

In attempting to answer these questions, Beckett begins by following Descartes—"one day I simply stayed in." Turning from the outer world to his inner self, Descartes is left with nothing but his own consciousness and self-consciousness. At this point, in this point, reflection becomes self-reflexive and, as Heidegger latter stressed, "everywhere man turns, he sees only himself." But Beckett discovers something beyond himself within himself. "I seem to speak, it is not I, about me, it is not about me."

> I'm in words made of words, others' words, what others, the place too, the walls, the floor, the ceiling, all words, the whole world is here with me, I'm the air, the walls, the walled-in one, everything yields, opens, ebbs, flows, like flakes. I'm all these flakes, meeting, mingling, falling asunder, wherever I go I find me, leave me, go toward me, come from me, nothing every but me, a particle of me, retrieved, lost, gone astray.... I'm something quite different, a quite different thing, a wordless thing in an empty place, a hard shut dry cold black place, where nothing stirs, nothing speaks. (139)

Beckett realizes the self-contradiction at the heart of self-knowledge. Just as the eye cannot turn around fast enough to see itself seeing, so the mind cannot turn around fast enough to understand itself understanding. The mind has a blind spot, and it is precisely what cannot be seen or known that makes seeing and knowing possible.

Self-knowledge presupposes self-objectification. In the effort to know itself, the subject (I) turns back on itself by objectifying itself (me). Who or what is this I that looks at itself in the mirror of what appears to be its own reflection? How is it possible to know the I that creates the object of self-knowledge? No matter how fast the I thinks or how deep it probes, the gap between the self as subject and the self as object can never be closed, and, therefore, at the deepest level, the I remains unknowable and unnamable. All nomination is de-nomination—the I can name itself only by unnaming itself. Edmund Husserl anticipated Beckett's insight when he wrote, "the experiencing ego is nothing that might be taken *for itself* and made

into an object of inquiry on its *own* account ... it has no content that can be unraveled, it is in and for itself indescribable: pure ego and nothing further."[46] *The Unnamable* is a solipsistic novel that traces the limits of solipsism. Beckett develops a negative anthropology that reflects a negative theology to demonstrate that the hidden I is as unknowable as the *Deus absconditus*. The secret of the I is that it is locked up in a crypt that is within consciousness and self-consciousness as a beyond that is as unfathomable as the abyss beneath them. This supra-consciousness is as inarticulate and hence silent as the unconsciousness.

If the I is silent, who or what speaks in *The Unnamable*? Basil, Worm, Mahood it seems. But no, these are surrogates or pseudonyms for the unnamable narrator who admits, "I invented them all" (36). The empty nameless I is the creator of its personae in the same way that the writer who creates characters through his words. Just as the world is created by the withdrawal of the transcendent God into the point of origin, so *The Unnamable* is created by the withdrawal of the I that allows the pseudonym "Samuel Beckett" and the characters he creates. Once the characters enter the world, they take on lives of their own and force the I/author/narrator to speak their language because he has no words of his own.

> It's of me now I must speak, even if I have to do so with their language, it will be a start, a step towards silence and the end of madness, the madness of having to speak and not being able to, except of things that don't concern me, that don't count, that I don't believe in, that they have crammed me full of to prevent me from saying who I am, where I am, and from doing what I have to do in the only way that can put an end to it, from doing what I have to do. (51)

Words betray the I by turning against it until the narrator becomes frustrated and declares, "it's the fault of the pronouns, there is no name for me, no pronoun for me, all the trouble comes from that, that, it's a kind of pronoun too, it isn't that either, I'm not that either, let us leave all that, forget about all that, it's not difficult, our concern is with someone or our concern is with something, now we're getting it, someone or something that is not there, or that is not anywhere" (164). During a time when pronouns have been absurdly politicized, Beckett offers wise advice, "no sense bickering about pronouns and other parts of blather. The subject doesn't matter, there is none" (102).

Though misleading, errant pronouns seem to have something to teach the inarticulate I.

First I'll say what I'm not, that's how they taught me to proceed, then what I am, it's already under way, I have only to resume at the point where I let myself be cowed. I am neither, I needn't say, Murphy, nor Watt, nor Mercier, nor—no I can't even bring myself to name them, nor any of the others whose very names I forget, who told me I was they, who must have tried to be, under duress, or through fear, or to avoid acknowledging me, not the slightest connexion.... There's no getting rid of them without naming them and their contraptions, that's the thing to keep in mind. (53)

A subtle but important shift occurs in this passage: not simply not, but neither/nor, whose implications unfold only gradually. Since the surrogates negate the I they claim to express, the I can affirm itself only by negating its own negations. I am neither this, nor that, nor anyone or anything else. Not even "A Thousand Names" can capture or express the I. Realizing the futility of naming the unnamable, Mahood, or is it the narrator—paragraphs and sentences are endless, leaving the speaker's identity unclear—contracts into a point by withdrawing from friends and family (if he ever had any), and even a body he does not believe is his own. Eventually, even his limbs disappear and the bodiless voice sinks to the bottom of a jar until it reaches something like a *punctum* that is the Degree Zero from which everything had begun. At this nul point, a strange twist in the narrative occurs. What had seemed to be a clear delineation between outside and inside, and exterior and interior, unravels, and it appears that there is neither an interior that is simply inside nor an exterior that is simply outside.

Perhaps that's what I feel, an outside and an inside and me in the middle, perhaps that's what I am, the thing that divides the world in two, on the one side the outside, on the other side the inside, that can be as thin as foil, I'm neither one side nor the other, I'm in the middle, I'm the partition, I've two surfaces and no thickness, perhaps that's what I feel, myself vibrating, I'm the *tympanum* [emphasis added], on the one hand the mind, on the other hand the world. I don't belong to either, it's not to me they're talking, it's not of me they're talking, no that's not it, I feel nothing of all that, try something else ... (134)

The tympanum is the "recessed ornamental space or panel enclosed by the cornices of a triangular pediment" that is the entrance to and exit from the sacred candle-lit space of cathedrals.[47] Neither inside nor outside the building proper, the tympanum marks the liminal site of passage that makes exchange and communication possible. The tympanum is also the membrane

that is the eardrum whose vibration makes hearing possible. This is the vibration felt at the edge of Kapoor's whirlpool named *Decension*. Neither inside nor outside the body proper, the tympanum is the boundary between the noise outside and the silence inside. This tain is the tympanum that foils obscene noise by opening a crack that makes it possible to see the silent abyss where language and art originate.

8.

. . .

9.

BETWEEN

NEITHER/NOR

In the early 1950s, Morton Feldman was an aspiring composer interested in experimental music when he attended a concert by the New York Philharmonic that featured the work of Anton Webern. During his youth, he had studied with Wallingford Riegger, who was a follower of Arnold Schoenberg, who, in turn, had been a pupil of Webern. Schoenberg's opera *Moses and Aron* remains one of the most eloquent testimonies to the unnameability of God that has ever been created. In an especially revealing twelve-tone series, Schoenberg writes,

> ARON: O shape of highest fantasy, how it thanks you that you charm it into an image!
>
> MOSES: No image can give you an image of the unimaginable.[1]

Commenting on the importance of Schonberg's work, Daniel Albright writes, "What this sort of art can do is to make absence explicit, manifest: to show the gap between what has been done and what is doable." The absence that is present everywhere in the opera repeated poignantly echoes in the refrain, "O Word, thou Word, that I lack!"[2]

A chance encounter changed the direction of Feldman's life and work. Distressed by the audience's negative reaction to Webern's work, Feldman left the concert hall early and in the lobby bumped into John Cage. The two composers immediately connected and quickly became good friends. Through Cage, Feldman met many of the leading artists of the era—Jackson Pollock, William de Kooning, Philip Guston, Mark Rothko, and, above all,

Robert Rauschenberg. As his relationship with these artists deepened, their work profoundly influenced his compositions. Feldman was especially impressed by Rauschenberg's White Paintings, which, we have seen, inspired Cage's influential *4'33"*. In an essay entitled "To Be in the Silence," Swedish pianist and composer Mats Persson reports that the first painting Feldman ever bought was one of Rauschenberg's Black Paintings.

> *Black Painting* became Feldman's companion for the rest of his life. By looking at and studying it, Feldman arrived soon at a new attitude, a desire to make something that was totally unique for him. He didn't see the painting as a collage, it was something more. It was neither life nor art. It was something in-between. Feldman states that it was now that he started to compose music that moved in this in-between state, music that erased the boundaries between material and construction and created a synthesis of method and application. A music between categories.[3]

Feldman's interest in the neither/nor of the in-between was deepened by his friendship with Philip Guston. Guston had been introduced to Zen Buddhism by Cage with whom he, like Newman and Merton, attended D. T. Suzuki's lectures on Zen. Guston persuaded Feldman that "Zen Buddhism offered an alternative to Kierkegaard's categorical either/or choice." Shortly after discovering Zen, Feldman wrote an essay entitled "Neither/Nor" in which he argued against the politicization of art through an unlikely comparison between the French composer Olivier Messiaen and Thoreau. "What I am really trying to say here is only that I feel we have been victimized. For centuries we have been victimized by European civilization. And all it has given us—including Kierkegaard—is an Either/Or situation, both in politics and in art. But suppose what we want is Neither/Nor? Suppose we want neither politics nor art? Suppose we want a human action that doesn't have to be legitimized by some type of holy water gesture of baptism? Why must we give it a name? What's wrong with leaving it nameless?"[4]

Feldman's most explicit exploration of the interstitial space of the neither/nor is a libretto entitled "Neither," based on a poem with the same title by Beckett.

> Neither
> to and fro in shadow from inner to outer shadow
>
> from impenetrable self to impenetrable unself
> by way of neither

as between two lit refuges whose doors once
neared gently close, once away turned from
gently they part again

beckoned back and forth and turned away

heedless of the way, intent on the one gleam
or the other

unheard footfalls only sound

till at last halt for good, absent for good
from self and other

then no sound

then gently light unfading on that unheeded
neither

unspeakable home[5]

Feldman met Beckett to discuss the possibility of setting his words to music, but Beckett was not interested. James Knowlson reports Beckett's account of the conversation.

> "He [Beckett] was very embarrassed—he said to me after a while: 'Mr. Feldman, I don't like opera.' I said to him, 'I don't blame you!' Then he said to me 'I don't like my words being set to music,' and I said, 'I'm in complete agreement. In fact it's very seldom that I've used words. I've written a lot of pieces with voice, and they are wordless.' Then he looked at me again and said, 'But what do you want?' And I said 'I have no idea!' ... I said that I was looking for the quintessence, something that just hovered."

Feldman then showed Beckett a few lines he had written for one of his works. Beckett was intrigued and responded by saying that there was only one theme in all his life and work. He then proceeded to write it down. "To and fro in shadow, from outer shadow to inner shadow. To and fro, between unattainable self and unattainable." He then added, "It would need a bit of work, wouldn't it? Well, if I get any further ideas on it, I'll send them on to you."[6]

In addition to Cage, Rauschenberg, and Guston, Feldman also had a long and deep relation with Rothko. As I have noted, Rothko did not live to see the completion of his Houston chapel. Knowing of their close relationship, a representative for the de Menils commissioned Feldman to write a piece to commemorate Rothko. The result was *The Rothko Chapel*, which premiered in the chapel in 1972. Feldman intended his composition to be a response to Rothko's paintings. "By the large canvases and their instructions to the viewer to stand close up to them," Persson explains, "Rothko is aiming at preventing the viewer from being able to survey the paintings, a survey that hinders a direct experience of them. Feldman sought a similar effect when composing his music, partly by not allowing the structural parts of the composition to stand in a simple symmetrical relation to one another or to the whole. In this way, he avoids predictability and overview."[7] The importance of chance is one of the most important lessons Feldman learned from Cage. Feldman, in turn, taught Cage something about chance. Responding to Feldman's innovations, Cage composed *Music of Changes* in which he used the *I Ching* to determine where notes were to be played in the work. Rather than attempting to control the work by programming its performance, both Feldman and Cage explore ways to create the conditions for the aleatory, which reveals what cannot be predicted or anticipated. The place or nonplace of the aleatory where novelty unexpectedly emerges is the neither/nor of the in-between.

At the same time Feldman was composing *Neither* and writing "Neither/Nor," Derrida was writing his extraordinarily innovative book or antibook *Glas*. The word "*glas*" means tolling, knell, and passing bell; "*glas funèbre*" means funeral-knell and death bell. In this work, Derrida charts the liminal space-time that is *neither* Kierkegaard's either/or *nor* Hegel's both/and. Instead of writing *about* this neither/nor, Derrida develops stylistic gestures that graphically perform or enact it. *Glas* consists of two columns that are further divided and subdivided by inserts cut into them. The larger column is devoted to Hegel's interpretation of the family, and the smaller to the thief, criminal, poet, and playwright Jean Genet. What is most important about this work is neither Derrida's analysis of Hegel nor Genet, but what *emerges* in the space in between. A year after *Glas* appeared (1971), Derrida published an essay that provides a capsule summary of his "monumental" work entitled "Tympan."

"Tympan" is the preface to a collection of essays entitled *Margins of Philosophy*. To underscore its marginal status, the preface has Roman numerals instead of Arabic numbers. Neither inside nor outside the work proper, "Tympan" is the margin of *Margins*, which marks the limit of this as well

as every other work. Like *Glas*, "Tympan" is divided into two unequal columns—the larger column is devoted once again to Hegel, and the smaller to Michel Leiris's book *Biffures*. *Biffer*, which derives from the Latin *bifida* (slit) means to cancel out, strike through, erase. Like all of Derrida's writings, "Tympan" concerns the relation between speech with its implicit metaphysics of presence, and writing with its implicit subversion of Western philosophy and theology epitomized by Hegel and, to a lesser degree, by Heidegger.[8] The title marking the border of the book is already double. Derrida repeatedly plays with the relationship between "tympan," which is "a padding of paper or cloth placed over the platan of a printing press to provide support for the sheet being printed," and "tympanum," which, as I have noted in a previous chapter, designates the eardrum as well as the opening between profane and sacred space marked by the recessed entrance to a temple or cathedral.[9] By using this title, Derrida locates his argument on the margin between the interiority and exteriority of his text. But the issue he probes is even more convoluted because of Derrida's repeated references to the ear.[10]

It is impossible to understand silence without considering the complexity of the organs that allow us to hear. The ears, of course, are already double; in addition to this, the ears are not simple boundaries between the outside and inside of the body proper, but are internally complex, thereby forming something like a boundary within a boundary, or a margin within a margin (of difference). Even when it is single, there is not one ear, but three—an outer ear, a middle ear, and an inner ear; and there are three membranes separating and connecting the three parts of the ear. The outer ear includes the pinna, which is the external part, and the ear canal that directs sound waves from the outer world to the eardrum, causing it to vibrate. The middle ear has three small bones—the anvil, stirrup, and hammer, which transmit the sound waves from the eardrum through another flexible membrane to the inner ear, which consists of a labyrinthine tube called the cochlea. At the end of this tube there is yet another membrane sensitive to different sound wave frequencies. The vibration of this basilar membrane triggers the release of neurotransmitters that convey patterns carrying information to the brain. What appears to be a simple boundary between outside and inside is actually an opening within an opening, a margin within a margin, and a limit within a limit. Where does outside actually end and inside begin? Is sound inside or outside? Where is silence? Is the world in itself silent? If so, how could we know? Might silence be neither in the world nor in the ear but somewhere in between?

Derrida begins "Tympan,"

> To tympanize—philosophy.
>
> *Being at the limit*: these words do not yet form a proposition, and even less a discourse. But there is enough in them, provided one plays upon it, to engender almost all the sentences in this book.[11]

The translator, Alan Bass, helpfully explains, "In French, '*tympansier*' is an archaic verb meaning to ridicule publicly." Philosophy, Derrida argues, can best be criticized at a limit that is no longer its own. Since philosophy has always sought to master every limit that might restrict its omnivorous gaze, Derrida's guiding question becomes, "If there are margins, is there still *a* philosophy, *the* philosophy" (xvi). The task of thinking at the edge of philosophy is to think a or *the* limit philosophy cannot comprehend. "And if the tympanum is a limit, perhaps the issue would be less to displace a *given* determined limit than to work toward the concept of limit and the limit of the concept" (xvii). To think this limit, Derrida argues, it is necessary to discern the middle of the middle (ear) by following Nietzsche's lead. "To philosophize with a hammer. Zarathustra begins by asking himself if he will have to puncture them, batter their ears (*Muss man ihnen erst die Ohren zerschlagen*), with the sound of cymbals or tympani, the instruments, always, of some Dionysianism. In order to teach them 'to hear with their eyes' too" (xii–xiii). I will return to a certain Dionysianism in chapter 11. For now, it is necessary to understand that to hear some works with your eyes is to see the silence of the invisible interval that makes all articulation possible. As Jabès writes in *The Book of Margins*,

> Silence is neither at the beginning nor at the end. It is
> *between*.
> Under the yoke,
> the word deserts the word.
> It labors not to be.[12]

The interval of between opens the space of desire that keeps life unsettled. As Merleau-Ponty explains, desire "is nowhere *in* the words. It is between them, in the hollows of space and time, and the significations they delimit, the way the movement in the film is between the immobile images that follow one another, or in the way the letters in some advertisements are made less by a few black lines than by white pages they vaguely indicate—blank but full of meaning, vibrating lines of force as dense as marble."[13]

Philosophy cannot tolerate silence and, therefore, tries to force everybody and everything that resists it to speak its own language. If the outer is the

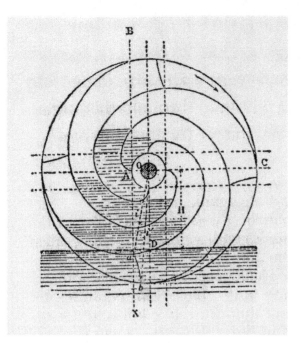

FIGURE 8. Hegelian version of Lafaye's tympanum
Source: Jacques Derrida, *Margins of Philosophy* (1982), xii

inner and the inner is the outer, reflection is caught in a house of mirrors that can be symbolized by a circle. Derrida identifies two versions of this circle. "These two kinds of appropriating mastery, hierarchy and envelopment, communicate with each other. . . . If one of the two types is more powerful here (Aristotle, Descartes, Kant, Husserl, Heidegger) or there (Spinoza, Leibniz, Hegel), they both follow the movement of the same wheel, whether it's a question finally, of Heidegger's hermeneutical circle or Hegel's onto-logical circle" (xx). Derrida finds both of these interpretive strategies lack-ing, and to illustrate this lack, he further divides his text between above and below with the white space of a gap separating the two parts of the text. The empty space of the intersecting margins creates a cross that resembles a chiasmus. In an extended footnote, Derrida explains that a tympanum is "also a hydraulic *wheel*, described minutely by Vitruvius" (xx). To clarify this point, he also provides an illustration of this wheel (xxi). This image (fig. 8) does not represent the closed circle of reappropriation that Derrida argues is characteristic of Western philosophy and theology, but suggests a swirling whirlpool resembling Kapoor's *Descension* and Poe's bottomless abyss. The empty center is as black as the Rauschenberg painting that inspired Feld-man's "Neither/Nor." This center, which is neither inside nor outside the

circle, recalls the words of Beckett's Unnamable, I am "the thing that divides the world in two, on the one side the outside, on the other side the inside, that can be as thin as foil, I'm neither on one side nor the other, I'm in the middle, I'm the partition, I've two surfaces and no thickness, perhaps that's what I feel, myself vibrating, I'm the tympanum."

Derrida adds one more meaning of "tympan" before he finally punctures philosophy's balloon. In manual printing presses, the tympan is material that is attached to a drum. A parchment or piece of silk is laid over the drum and is imprinted with ink that passes through the tympan. Entrance/exit to a temple, cathedral, chapel, head of a drum, eardrum, printing press, the list goes on. Derrida argues that the seemingly endless proliferation of meanings subverts philosophy's will to mastery and creates an opening no reflection can close. "Doubtless, philosophy will have sought the reassuring and absolute rule, the norm of this polysemia. It will have asked itself if a tympanum is natural or constructed, if one does not always come back to the unity of a stretched, bordered, framed cloth that watches over its margin as virgin, homogeneous, and negative space, leaving its outside outside, without mark, without opposition, without determination, and ready, like matter, the matrix, the *khora*, to receive and repercuss type" (xxvii). Philosophy's effort to secure its borders by negating what appears to negate it is self-subverting. Far from removing, incorporating, or assimilating its other, double negation includes what it seeks to exclude, thereby creating a crypt that is the matrix of every difference and all appearances. Derrida names this unnamable crypt the *khora* and this *khora* is what Michael Heizer (de)constructs in *Double Negative*. To get to *Double Negative*, it is necessary to pass through Las Vegas.

UNLEARNING LAS VEGAS

Approaching Las Vegas by air from the east, the earth appears to be an immense topographical map traced in colors no printing process can capture. From this angle of vision, the map no longer seems to exhaust the territory. As the western slope of the Rockies gives way to the Canyonlands of Utah, tones slowly shift from greens and grays to reds and browns. Craggy peaks flatten onto burnt plateaus and mesas whose smooth symmetry is broken by rough edges and deep gorges that look like trails left by ancient serpents winding their way ever deeper into the earth's surface. Dazzling reds and oranges fade into weathered flesh tones as contours fold and refold to create the semblance of long, skeletal fingers covered with veins that sometimes turn varicose. Countless fingers bend downward and dip into the cool azure

waters of Lake Mead that are rapidly receding, leaving a stark white margin between the blue of the lake and the red of the cliffs. The disappearing water is a timer ticking away the hours before there is a climatic disaster. Intricate lines worn into rock mix sculpture, drawing, and watercolors to create an earthwork no human hand could form and no museum could ever display. Beyond the border of the lake, an umber sand expanse spreads westward until it is breached by tiny green rectangles clustered so close that gridwork becomes gridlock. Moving from periphery to center, tarpaper roofs give way to red tiles that leave just enough space for garish aqua puddles where nature's most precious resource is irresponsibly being squandered. With a slight shift of the eyes, the Vegas Strip looms on the horizon.

Las Vegas is a pocket of noise in a sea of silence. When you fly into Vegas at night, the lights are overwhelming—electric lights, laser lights, neon lights. Inside and outside lights appear all the brighter because of the darkness of the surrounding desert. But it's not just the lights on the Strip, it's also the noise in the airport, taxis, hotels, elevators, shows, and casinos— above all the incessant clamor of slot machines everywhere. There is so much noise that it is impossible to hear yourself think, which, of course, is precisely the point. The noise is designed to keep players hooked by making them ignore the darkness at the edge of town.

The Las Vegas Strip is where postmodernism began, and the surrounding desert is where it ends. In 1968, Robert Venturi, Denise Scott Brown, and Stephen Izenor taught a seminar on Las Vegas at the Yale School of Architecture and, four years later, published *Learning from Las Vegas*, which launched postmodern architecture. What made Vegas so intriguing for Venturi and his colleagues was not just its architecture but their recognition that the Strip is a microcosm of post–World War II American culture. When Mies van der Rohe expressed the essence of modernism in his maxim, "less is more," Venturi countered, "less is a bore." Venturi realized that Vegas is a city of signs—signs of signs that point to nothing beyond themselves. Since this play of signs extended from the Strip to malls and high-end boutiques as well as the surging financial markets on Wall Street, postmodernism was a fitting aesthetic, if not ideology, for the emerging era of financial capitalism. Venturi embraced what others resisted. While modernists like Adolf Loss preached an ascetic gospel by declaring "ornament is a crime," Venturi called for an infinite proliferation of signs. The buildings on the Strip, he pointed out, disappear behind the signs they were built to display. The Strip, he concluded, "is virtually all signs." Indeed, "if you take the signs away, there is no place."[14]

The genius of Venturi's analysis was his prescient interpretation of Las

Vegas as a symptom of broader changes taking place during the latter half of the twentieth century. He saw the far-reaching implications of the shift from an industrial to a postindustrial economy before most other people. While an industrial economy involves the manufacture of material objects, a postindustrial economy traffics in images and information. In this new economy, the objects as well as the tokens of exchange are signs; we trade figures rather than things, representations instead of objects, bitcoins in place of metal coins or paper bills. This electronic and digital revolution is not limited, of course, to the economic sphere. As these technologies have become more sophisticated, they have become more pervasive, transforming all aspects of personal and social experience. In the years since *Learning from Las Vegas* was published, the changes Venturi foresaw have accelerated, leading to what can best be described as the dematerialization of the real and the virtualization of reality. With PCs, tablets, smartphones, video games, Internet, cable TV, electronic surveillance, and high-speed financial markets expanding globally, everything speeds up until reality itself seems to dematerialize and become virtual. This creates what Baudrillard aptly labels "the desert of the real itself."[15] But dematerialization and virtualization have a limit, and this limit cannot be mastered. Just when the real seems to have disappeared, it returns with a vengeance. The terrorism of 9/11, the financial crisis of 2008, and the ongoing and accelerating climate crisis mark the end of postmodernism. It has taken almost two decades for me to understand the lesson I began to learn on a winter night in 1990.

BEING-IN-BETWEEN

Desert within desert. Desert between desert. "Desert" is a verb as well as a noun. To desert is to withdraw, leave, forsake, or abandon. If you are not dazzled by the bright lights of the big city, another desert beckons. In the midst of this desert, the will to mastery is shattered by the approach of unmasterable forces held in tension by a void, gap, or tear that can be neither defined nor closed. To see this gap, it is necessary to hear the silence that teaches you to unlearn the lessons of Las Vegas.

I had come to Nevada to spend several days with Michael Heizer in preparation for writing an essay on his influential earthwork *Double Negative*, which the Los Angeles County Museum of Art had recently acquired.[16] Michael picked me up at the Las Vegas airport in his white pickup truck to drive the 130 miles north to Garden Valley, which is in the middle of the expansive basin-range territory. We did not linger on the Strip, but quickly headed into the darkness of the desert for the two-hour drive. As we drove,

Michael told me his version of his own story. He said that he had come to Nevada because his father, Robert Heizer, who was a distinguished archeologist at the University of California, Berkeley, had a lifelong interest in Native American culture. He had conducted extensive fieldwork in Mexico, South America, the American Southwest, and especially the Great Basin. When he was young, Michael accompanied his father on these trips and became intrigued by Olmec, Aztec, Mayan, and Incan art and architecture. Coming of age in the sixties, when the center of the art world was New York City, he quickly became dissatisfied with his studies at the San Francisco Art Institute. In 1965, he headed east, where he lived on Mercer Street in the heart of what was becoming SoHo. This was the time when abstract expressionism was beginning to fade and pop art and minimalism were on the rise. With Andy Warhol declaring that "business art is the step that comes after Art," art was becoming part of postwar consumer culture.[17] What most bothered Michael was the commodification of art and the commercialization of the art world. Though he had no trouble finding his way in this glitzy world, Michael still had dust on his boots, and he never felt at home in New York. He met Walter De Maria and Robert Smithson, whom he regarded as kindred spirits, but was distressed by what New York was doing to most artists and their work. Michael decided he had to leave the city and the European tradition that had been transplanted there to create his own city in the desert. In a 1968 interview with Julia Brown, he explained, "I was determined to be a contributor to the development of American art, to not simply continue European art. By European art, I mean painting on canvas and sculptures you walk around and look at like *Balzac* or *Moses*. I was intentionally trying to develop an American art, and the only sources I felt were allowable were American, South American, Mesoamerican, or North American. That might mean Eskimos or Peruvians. I wanted to finish off the European impulse. . . . Maybe I'm crazy, but I thought I'd actually contribute to creating an American identity."[18] Michael said that he could create this kind of art only in the West as far from New York's lofts, galleries, and museums as possible.

As we drove through the night, Michael repeatedly interrupted his narrative to explain why he chose Nevada. In addition to the memory of following his father around Garden Valley, he was also drawn to the deep geological time exposed in this vast land. Traces of human life extending back 11,000 years can be found in Garden Valley. "Sorta puts things in perspective," he wryly commented. He was fascinated by the numerous petroglyphs and, surprisingly, was intrigued by what he saw as the sculptural features of packrat nests and middens found all over the desert. He was also interested in the

sculptural properties of bones scattered everywhere. A couple of years later, he and I collaborated on a book we never completed about packrat nests entitled *Deserting Architecture*. We also created a sculpture from cattle and rat bones that hangs in my living room. The desert of Nevada is where my bone garden began.

Michael was quick to point out that Nevada is filled with contradictions characteristic of the precarious contemporary world. He had a keen sense of a looming apocalypse. "I knew I was doing something new and it had a vague relationship to other disciplines such as architecture. In my case, this sensibility was based on a feeling that we were coming close to the end of the world. The idea of living in a post-nuclear age informed everything, the clock was ticking—Vietnam had threatened everybody and it was time to get to the point."[19] He explained that signs of disaster were scattered everywhere in the desert—the nuclear test sight, hydrogen bombs stored in bunkers just outside Las Vegas, hidden military bases, war games on the 87 percent of the land the federal government owns in Nevada, and, of course, Area 51. As if to underscore this point, huge black B-52 bombers fly 300′ above the ground without making a sound. For Michael, the posthuman future was as important as the prehuman past. "Part of my art is based on an awareness that we live in a nuclear era. We're probably living at the end of civilization."[20] In addition to the impending technological apocalypse, Michael also stressed the physical dangers of living in the desert—the unbearable heat in the summer and cold in the winter, the incessant howling of the wind, sudden storms, losing your way and getting lost, and snakes, ever-present rattlesnakes. "Never go far into the desert without a pistol," he warned. I learned that Michael always packs heat.

These insights are essential for understanding Heizer's art, but it was something else he said that stuck with me. Knowing I am a student of religion, he asked, "You ever read *The Tibetan Book of the Dead*?" "Yeah," I responded. "That book saved my life. I was doing way too much acid—really messed up, when I found the book in my father's library. Gave me another way out." "And another way in," I said to myself. As I listened to Michael that night many years ago, it became clear to me that what drew him to the desert was a sense of danger that was inseparable from awe tinged with the aura of the sacred. Awe at the immensity, the age, the isolation, and, yes, the silence. This awe is what I wanted to experience, if not to understand.

We finally passed through Heiko, which you would miss if you blinked your eyes. At the edge of town, Michael stopped to open a gate with a big sign, "Keep Out." We drove through the gate and back a thirty-five-mile

Dematerialization → Materialization

Lightness → Gravity

Iconic → Aniconic

Visible → Invisible

Virtual → Real

Noise → Silence

FIGURE 9. Michael Heizer's "reverse" Las Vegas

dirt road that at times disappeared in ruts and drifting sand, until we came to his compound, which consists of several buildings made from sheet metal and cinderblocks. This is where Michael lived and worked with his two assistants, Mary Shanahan and Jennifer Meckiewicz. After brief greetings, we all went to bed to rest for the full day ahead. As I lay awake, I realized that Michael Heizer is a cowboy who lives like a monk.

When I awoke the next morning, Michael, Mary, and Jennifer were already up. Before heading to *Double Negative*, Michael wanted to show me his never-ending life's work, which he had come to Garden Valley to create. He refused to talk about it before I had seen it. As we approached, I saw nothing until we reached the edge of a wide opening. Looking down, I was astonished by what looked like a massive sunken Mesoamerican plaza prepared for ceremonies devoted to some unknown God. The central feature was a huge elongated structure that resembled a Mayan or Aztec sacrificial altar shaped like a pyramid with its tip knocked off. The carefully groomed red gravel sides of the plaza were angled at what appeared to be 45°, giving the sense of a vast inverted pyramid piercing the surface of the earth and opening a void beneath the ground. Michael explained that when the work was completed, it would be twice this size, making it even more immense that Turrell's Roden Crater. This project is not only artistically visionary but is also a technological marvel that is simultaneously primitive and futuristic.

Though he never said so directly, it was clear that Michael intended his art to reverse everything the world of Las Vegas stood for (fig. 9). By so doing, Michael was trying to reconnect art with what he regarded as the real world, and thereby to return to the Real itself.

The seeds for Heizer's mature vision can already be discerned in works he did while still in New York. As early as 1966, he completed a series entitled *Displaced Paintings*, which are actually 3D sculptures that hang on a wall.

Negative Painting (1966), for example, is an angled cut-out cross that creates a void in what had been a seamless surface. In other works, he actually made huge drawings on the floor of the desert using everything from pigments to his motorcycle. Commenting on these "paintings" and "drawings," Heizer explains, "I'm doing paintings here but I'm interested in sculpture, negative sculpture. I make something by taking something away. I think about earth strata building from nothing to something over millions of years. I mimic geomorphological time when I dig a hole that fills up in two years. Tomorrow I'm going to dig a trench that exactly imitates the outline of those hills."[21] In a characteristically illuminating essay on Heizer's early work, Germano Celant writes,

> His works of this period, called "Displacement Paintings," rather than aim at a formalization of relationships between primary elements such as color and surface, actually tend toward a dematerialization: they work toward the absence of the "displacement" of the material, dissolving the reality of painting in order to let us see its absence. What matters most in them is the vertigo of the void or the nothingness that takes place in the center of the painting, which is viewed *in the negative*. Compared to the formal dynamism and chromatic vivacity of the "Systematic Paintings," Heizer's works tend towards an absolute iconic silence. . . . They bring out into the open an inner spatiality, absent and immaterial, something that lies *elsewhere*.[22]

Heizer's work shows that this elsewhere is always near.

These *Displacement Paintings* became models for a series of experiments Heizer conducted in the California and Nevada deserts in the late 1960s. In these works, he defined what became the foundational axes of all his art: positive/negative, figure/ground, presence/absence, above/below, and fullness/emptiness. In his earliest efforts, he used picks, shovels, and even his feet to create tears in the earth's skin. Not satisfied with these superficial incisions, he soon graduated to heavy construction equipment to puncture the tympanum covering the earth. More interested in negative than positive space, Heizer labels these works as "negative sculptures" or "sculptures in reverse." He describes his first major effort with this kind of work. "The first object sculpture I built was 'Displaced/Replaced Mass,' which used granite blocks set inside three depressions in the ground which were lined with concrete. These materials were close to the existing materials of the region. The rock was gray, the concrete was gray, the entire work was colorless. The materials were chosen for their nature and application. What it would look like

was the issue. I hoped to find this as a surprise at the end of work rather than use known factors in a calculated manner to achieve predictable results."[23] Over the years, Heizer created repeated iterations of this work inside and outside, in the desert and in cities (New York and Los Angeles).

While *Displaced/Replaced Mass* sinks the work below ground, *Levitated Mass* raises it above ground. The first version of this work is on the northwest corner of Madison Avenue and 56th Street in New York City. A cleanly cut piece of granite, surrounded by a metal frame, appears to float above fast-rushing water. The effect of the work is as vertiginous as the rapid swirling water of Kapoor's *Descension*. On the surface of the granite, Heizer carves what appear to be hieroglyphs recalling ancient Egyptian pyramids. He explains the genesis and execution of this work.

> The concept dates from 1969. Originally I was going to use an uncut block of stone, but I encountered difficulties in the size and weight so I had to thin it down, I never wanted to lose the shape of the rock. I took the surface off, but kept the shape. I had difficulties due to the constraints of New York City, the characteristic of the plaza and having to tear through a substructural deck. I built the work by making the rock thinner, not for the purpose of reducing the weight, but the dimension. As soon as I cut the top grained surface off, I killed the rock so I had to put life back into it. It was an opportunity for me to do gravure in the rock based on my studies in rock gravure in Egypt. I engraved the cryptologic address on the top of the rock reinforcing the environmental concepts that I had been interested in for many years. The location of that object is cut into the top of that object. The cuts are a basic numerical cryptologic code. It gives the address. If you count the cuts it says 56 MAD (the rock is at 56th and Madison), it says five cuts for 5, and six cuts for 6 and thirteen cuts for M, one cut for A, four cuts for D.[24]

The madness of Madison Avenue is nothing compared to the madness of the Los Angeles version of this work.

In 2012, with the continuing support of Michael Govan, Heizer finally realized his original vision for *Levitated Mass* on the campus of the Los Angeles County Museum for Art. This work consists of a 21½′ tall boulder weighing 340 tons precariously balanced above a void created by a 456′ long flawlessly smooth and perfectly symmetrical concrete trench that gradually descends and ascends beneath the boulder. The work is surrounded by a barren 2½ acre expanse of decomposed concrete suggesting a desert terrain. Visitors can walk under as well as around the rock. Heizer found the rock he

wanted to use in the Jurupa Valley in Riverside County. In February 2012, the boulder was transported 106 miles on a 196-wheeled vehicle. The journey, which took eleven nights, became something like performance art that drew large crowds of onlookers. A feature-length documentary film of the transport and installation of the rock has been made. Once again, Heizer's work, like the massive rock, is balanced *between* opposites: desert/city, natural/artificial, organic/machinic, inside/outside, above/below, rising/falling, and weight/lightness. The scale of the work is what makes it so impressive. Walking under the suspended boulder, human beings are humbled by forces they can never master. For Heizer, rock is never merely rock but harbors a spirit he regards as holy. This spirit dwells in the Los Angeles work *Levitated Mass* in a way it does not in the New York version. "All the high-rises in New York are covered with imported rock, the only difference between the rock I bring in is that it is less finished, it's not killed off quite as much; it may be sawed and honed, but it's not completely killed. I try to leave spirit in the rock."[25]

Back in Nevada as we lingered in the desert city, Michael grew concerned about passing time and announced that we had to leave if we wanted to get to *Double Negative* before dark. Like most of his other work, it is difficult to get to *Double Negative*—pilgrimage is part of the experience. The most direct route is to drive from Las Vegas to Overton through eighty miles of desert, but we approached from the north. A hazardous switchback sand road without guardrails leads to the top of the Mormon Mesa, where the work is located on the far side eight miles away. The dirt road is so hard to find and partially hidden by sand that even Michael got lost. When we finally found the work, I was overwhelmed by its size and scale. As in his Negative Paintings, Michael creates by removing, allowing absence to reveal presence. In this work, he made two cuts on opposite sides of the mesa by removing and displacing 240,000 tons of sand and rock to form symmetrical voids 50′ deep and 30′ wide with 90° walls and a descending/ascending 45° ramp. End-to-end the work is as long as the Empire State Building is tall. In an interview, Michael explains,

> From my point of view, the totally negative works are phenomenological. There is no indication of why they are there, or what happened to the voided material. "Double Negative," due to gravity, was made using its own substance, leaving a full visual statement and an explanation of how it was made. In "Double Negative" there is the implication of an object or form that is actually not there. In order to create this sculpture, material was removed rather than accumulated. The sculpture is not a traditional object sculpture. The two

cuts are so large that there is an implication that they are joined in a single form. The title "Double Negative" is a literal description of two cuts but has metaphysical implications because a double negative is impossible. There is nothing there, yet it is still a sculpture.[26]

There is nothing there, yet there is—precisely this nothing is what fascinates Heizer. But where is this nothing? And how many voids are there? Where I saw two voids, Michael saw three. There are the two symmetrical voids, and there is the void between them, which is created by dumping the excavated material over the edge and letting gravity draw it into a hole whose bottom is invisible.

Michael said, "You can't understand it from up here, you gotta go inside." Turning away, he left me alone to enter the work of art. To enter the void, I had to descend the steep and uneven slope of rent earth. Only beneath ground level did the stunning proportions of this extraordinary work truly emerge. From the bottom of the cut, the precision of the lines, surfaces, and planes dissolves—the work is eroding. Its walls crumbling and its floor littered with refuse and debris from ancient eons, *Double Negative* is a ruin that is quietly being transformed by a silent artist. This work of art is not constructed to escape time, but to fold us into it ever more deeply. As I passed below the surface, I realized the profound truth of what I had long suspected—to dig down is to go back ... back through layers and layers of space and time to an *arche* that is, perhaps, older than the beginning of our world or any other world.

The walls of the tear display vast murals, rich collages, assemblages, and combines of unspeakable beauty. Colors and shapes, forms and figures too intricate and too complex to have been crafted by any human hand suggest a haunting anonymity, a terrifying impersonality, an inhuman intelligence. Enduring yet fragile sediments release a disturbing fossilized murmur. At the edge of the work, the ground grows more insecure. Loose sand and gravel fell from beneath my feet, adding to the ongoing work of art. Like a gift from some long-lost civilization, this overwhelming petroglyph cannot be decoded but must be read and reread without end.

The longer I lingered in the work of art, the stranger it became. *Double Negative* is not simply negative, nor does its duplicity negate negation. To the contrary, doubling negation opens the void of the neither/nor that simultaneously holds opposites apart and brings them together. To stand in the midst of these voids within voids is to dwell in the between that is the non-place where life and death take place. In this moment, the I actually becomes

a tympanum that is neither inside nor outside itself. Alternation, oscillation, vibration. *Fort ... Da. Da ... Fort.* The eternal return of what can never return because it can never be present.

As I have noted, "to sculpt" (from the Greek *sek*, to cut) is to open, puncture, carve, tear, rend. Subtraction adds—less is more. *Double Negative* is a work that is a nonwork, a work that works by not working. Heizer does not attempt to negate or sublate absence in order to affirm or re-present presence. His work presents and represents the impossibility of presence and thus the inevitable failure of re-presentation. This work of art (impossibly) *represents nothing*. To represent nothing without ceasing to represent, Heizer recasts the ground of figuration by refiguring the figure-ground relation. "Since the earth itself is thought to be stable and obvious as 'ground,'" Heizer explains, "I have attempted to subvert or at least question this."[27] His subversion of stable ground is not only figurative; it is also literal. As the ground withdraws and disappears, figure appears. With his penetration of the membrane of earth's surface, matter becomes *mater*, which is the origin of the work of art as well as the world in which we are destined to dwell. If you have enough faith to make the leap, Heizer plunges you into a void that is as much a womb as a tomb. This is the generative matrix from which everything emerges and to which all returns. Here the absence of ground is not a simple absence, but is the groundless ground that can only be seen by hearing silence.

With the hour growing late, it was time to leave the work of art. As I ascended the crumbling ramp, the late afternoon light of the gray winter day created a somber mood. In the distance, the Virgin River wound its way along the base of mountains marking the border between Nevada and Arizona. Turning away from the unsettling emptiness of space to the expansive corridors of time, silence unexpectedly rushed toward me. Not just any silence but an overwhelming silence that pressed palpably on my ears. I paused to linger with the Negative in the faint hope that I might become more silent than the silence around me. Emerging from the void, I understood what Michael had once said about *Double Negative*. "It is interesting to build a sculpture that attempts to create an atmosphere of awe. Small works are said to do this but it is not my experience. Immense, architecturally-sized sculpture creates both the object and the atmosphere. Awe is a state of mind equivalent to religious experience, I think, if people feel commitment they feel something has been transcended. To create a transcendent work of art means to go past everything."[28] I realized that being *in* the work of art was as close to the infinite as I had been.

That night Michael said that before I headed back east, there was one

more thing I had to do. Having been below, I had to go above to see *Double Negative* from the air. He had arranged for me to take a helicopter ride the next morning. The following day, I arrived early at the terminal on the edge of McCarran Airport. As the chopper slowly lifted off the ground, hotels and casinos sank beneath us. A sharp right turn to the northeast and we were quickly out of the city and over the desert. The flat expanse of sand and sage gradually gave way to massive rock outcroppings of sandstone hills among which wild burrows, mustangs, and bighorn sheep roam freely. The faces of the rocks and hills were etched with traces of ancient geological epochs. Seen from a height of 600′, the land stretched below like a taut canvas covered with subtle patterns painted in rich earth tones. Deeper into the desert, hills became mountains erupting like petrified waves out of some prehistoric sea. As the helicopter nearly brushed the top of the highest peak, the Valley of Fire burst before us in a stunning array of brilliant reds, oranges, ambers, and lavenders. Monumental memorials to the immemorial appeared awesome even from the sky. In the distance, Mormon Mesa rose from the valley floor. As we passed over the mesa and approached its far rim, the utter flatness, evenness, and horizontality of the land were broken by a torn edge. The chopper banked sharply to the left and began to follow the tattered margin of earth as it zigged and zagged, rose and fell as far as the eye could see.

Then suddenly, with an abruptness that was jarring, two cuts appeared on the surface of the mesa. It was as if they had been hiding and were waiting for someone to discover them. What I had missed on the ground, I saw from the air—two voids separated and joined a third void *between* them. Voids within voids removing the ground beneath your feet and taking your breath away. The nothing of this in-between allows everything to appear. I knew that this was what Michael wanted me to see and understand.

On the plane that night, I began to collect my thoughts by writing in my journal.

In the midst of the desert we suffer the interminable approach of a haunting inhumanity that forever tempers our apparent humanity. Traces of 11,000 years of human history cannot erase the disturbing anonymity that rustles endlessly in the desert. It is not just the inhospitability of the land. Whether traveling in a truck, on horseback, or on foot, danger is never far away. The course remains unclear and constantly threatens to disappear with the turn of the road, the twist of the path, or a fleeting gust of wind that covers the trail with sand. Unbearable heat, insufferable cold, sudden storms, venomous tarantulas, and deadly rattlesnakes pose unavoidable threats. If nature is a har-

monious organism, its vital signs disappear in the desert. The inhumanity of the desert, however, is not simply its evident violence; something else, something different, something more unsettling than any known threat is always stirring in the desert's open space. The only response to this something, which is really nothing, is awe — awe that can only be called religious. To experience this awe, you must let silence enter you.

Listen
Learn to listen
To the silence
That is not
Not our doing
But an undoing
That is not
Not our own

What I could not have known then was that *Seeing Silence* began that night.

PLACING (THE) BETWEEN

For almost three decades, I have been struggling with how to think about, talk about, write about what I saw and experienced in *Double Negative*. How can you see what is invisible, know what is unknowable, hear what is unspeakable? Though no words are adequate, some words are better than others. These are the words of poets who are philosophers and philosophers who are poets. "Being," Heidegger explains, "is the ab-ground, the cleft of the lighted 'in-between,' whose 'rocks' and 'bluffs' and 'pinnacles' keep themselves sheltered-concealed."[29] In an attempt to clarify this baffling claim, he offers the seemingly simple example of a jug in an essay entitled "The Thing." Twisting language to say what it usually does not say, he asks, "What in the thing is thingly? What is the thing itself?" The thing, he insists, is not an ob-ject (*ob*, toward + *jacere*, to throw) or *Gegen-stand* (*gegen*, against + *stehen*, to stand) that stands over against a sub-ject. Rather, the thing, Heidegger argues, is no-thing. "The emptiness of the void, is what does the vessel's holding. The empty space, this nothing of the jug, is what the jug is as the holding vessel." Heidegger knows his point is counterintuitive, so he continues to explain:

Sides and bottom, of which the jug consists and by which it stands, are not really what does the holding. But if the holding is done by the jug's void, then the potter who forms the sides and bottom on his wheel does not, strictly

speaking, make the jug. He only shapes the clay. No—he shapes the void. For it, in it, and out of it, he forms the clay into the form. From the start to the finish the potter takes hold of the impalpable void and brings it forth as the container in the shape of a containing vessel. The jug's void determines all the handling in the process of making the vessel. The vessel's thingness does not lie at all in the material of which it consists, but in the void that holds.[30]

The emptiness of the thing itself is not simply negative but is doubly negative, and this double negativity is the clearing that allows the articulation of determinate things. Just as the potter shapes the void by molding the clay, Heizer shapes the void that forms objects and subjects by removing the ground to expose the "*ab-grund*" (abyss). As we have seen, for Heidegger, this clearing (*Lichtung*) is the truth (*aletheia*) of the work of art. Truth as *aletheia* is a silent truth of art and the worlds it creates. "At the proper time"—but what time is "proper"—"it becomes unavoidable to think of how mortal speech and its utterance take place in the speaking of language as the peal of the silence of dif-ference. Any uttering, whether in speech or in writing, breaks the silence. On what does the peal of silence break? How does the broken silence come to sound in words? How does the broken silence shape the mortal speech that sounds in verses and sentences?"[31]

Words shape the silence from which they come like clay shapes the emptiness that gives it form. Clay and earth are the matter that mixes with the void to become the matrix of life and death, womb and tomb that is alpha and omega of creativity. Derrida, following Plato, names this unnamable matrix "*khora*." "Whether they concern the word *khora* itself ('place,' 'location,' 'region,' 'country') or what tradition calls by the figures—comparisons, images, and metaphors—proposed by *Timaeus* ('mother,' 'nurse,' 'receptacle,' 'imprint-bearer'), the translations remain caught in networks of interpretation."[32] And these networks are endless. Neither sense nor nonsense, neither sensible nor intelligible, the *khora* exceeds every polarity. As such, "the thought of the *khora* would trouble the very order of polarity, of polarity in general, whether dialectical or not. Giving place to oppositions, it would not submit to any reversal. And this, which is another consequence, would not be because it would inalterably be *itself* beyond its name but because in carrying beyond the polarity of sense (metaphorical or proper), it would no longer be on the horizon of sense, nor to that of meaning as the meaning of being."[33] This place that is no-place displaces every place, and, like *Displaced/ Replaced Mass*, unsettles every place that seemed secure.

Trying to speak *about* this place is like trying to speak *about* "the nothing that is not there and the nothing that is." In "*Comment ne pas parler:*

Dénégations—How to Avoid Speaking: Denials," Derrida argues that it is impossible both to speak and not to speak about the *khora*. In all speaking, we always speak *about* the Unspeakable; indeed, it is precisely what cannot be spoken that makes speaking possible. The *khora* that Derrida writes and Heizer inscribes is as unknowable, unimaginable, unnameable, and unspeakable as the *Deus absconditus*. Maybe more so. Words always imply a silence that simultaneously enables and frustrates them. To speak about or write about this no-thing, it is necessary to think neither positively nor negatively. This is the reason Derrida insists that neither kataphatic nor apophatic theology is adequate to express the inexpressible. What is required, he suggests, is something like a nonnegative negative theology that nonetheless is not positive. Neither theistic nor atheistic, such a "theology" would be a/theological.

> The *neither/nor* may no longer be converted into both ... and. ... [I]t is necessary to avoid speaking of *khora* as "something" that is or is not, that could be present or absent, intelligible or sensible, or both at once, active or passive, the Good ... or the Evil, God or man, the living or the nonliving. ... Radically nonhuman and atheological, one cannot even say that it gives place or that *there is* the *khora*. The *es gibt*, thus translated, too vividly announces or recalls the dispensation of God, of man, or even that of Being of which certain texts by Heidegger speak (*es gibt Sein*). *Khora* is not even *that* (*ça*), the *es* or *id* of giving, before all subjectivity.[34]

How to speak? How not to speak? How to speak Not? How to speak not without not speaking? A/theology neither speaks nor does not speak, but (impossibly) speaks while remaining silent.

Neither this nor that, but always something that is no-thing, the interval of the matrix has many improper names. For Isaac Luria, this placeless place is Makom, which is one of the names of God. To create the world, we have seen, God withdraws into the point of the Zim Zum. "Makom" is the name of both God and the withdrawal of the divine. Heizer's tear tips Newman's zip from vertical to horizontal and inscribes it into mother earth in a mimetic reenactment of the act of creation. For Meister Eckhart, the *khora* is the unknowable "Godhead" (*Göttheit*) that is neither within nor beyond God.

> I have sometimes said that there is a power in the spirit that alone is free. Sometimes I have said that it is a guard of the spirit; sometimes I have said that it is a light of the spirit; sometimes I have said that it is a spark. But now

I say that it is neither this nor that, and yet it is a something that is higher above this and that than heaven is above the earth. And therefore I now give it finer names than I have ever given it before, and yet whatever fine names, whatever words we use, they are telling lies, and it is far above them. It is free of all names, it is bare of all forms, wholly empty and free, as God in himself is empty and free. It is so utterly one and simple, as God is one and simple, and man cannot in any way look upon it. It is the same power of which I have spoken, in which God is verdant and growing with all his divinity, and the spirit in God.[35]

"Sometimes I have said that it is the light of spirit." This is the light Leonard Cohen glimpses when he croons.

> There is a crack, a crack in everything
> That's how the light gets in
> That's how the light gets in
> That's how the light gets in[36]

Like the void of *Double Negative*, the crack that lets the light get in is the horizon that draws us on by forever withdrawing from us.

IO.

TOWARD

The silence of the desert is a visual thing too. A product of the gaze
that stares out and finds nothing to reflect it. There can be no silence
up in the mountains, since their very contours roar. And for there to be
silence, time itself has to attain a sort of horizontality; there has to be
no echo of time in the future, but simply a sliding of geological strata
one upon the other giving nothing more than a fossil murmur.

JEAN BAUDRILLARD

DESERT VISIONS

You cannot learn about a place by flying over it; you must first drive and then
walk through it. Strangely, the French seem to know this better than Ameri-
cans; sometimes it takes a foreigner to reveal what is close to home. Perhaps
it is the scale of the space and the openness of the road that draws them.
Many visitors cannot complete the journey until they have written about
it. Jean Baudrillard presents a diary of his drive across the country in his
book entitled simply *America*. Few critics have understood the postmodern
world that Las Vegas represents better than he. Years before Google, reality
TV, Amazon, Microsoft, and Facebook, Baudrillard labeled the world that
is now our own "the desert of the real." He knew this virtual reality could
not last and tried to warn us about the looming disaster. In an effort to re-
cover the real, he drove into the desert—not the fake desert of the Strip with
its "Sands," "Dunes," and "Luxor" hotels, which are nothing more than a
"Mirage," but the real desert with real sand, dunes, and rock art much older
than the hieroglyphs etched on Egyptian pyramids. Here Baudrillard dis-

covered an ecstasy that was no longer human, an ecstasy that carries you to the elsewhere that is always near. "For the desert is simply that," he writes, "an ecstatic critique of culture, an ecstatic form of disappearance." This is not the noisy ecstasy of drugs and clubs, but the ecstasy that only silence brings. "When you emerge from the desert, your eyes go on trying to create emptiness all around; in every inhabited area, every landscape they see desert beneath, like a watermark. It takes a long time to get back to a normal vision of things and you never succeed completely. Take this substance from my sight! ... But the desert is more than merely space from which all substance has been removed. Just as silence is not what remains when all noise has been suppressed. There is no need to close your eyes to hear it. For it is also the silence of time."[1] This is the silence I had seen in *Double Negative* and have been searching for ever since. Looking for what I had seen and heard, I decided I had to return to the desert—not the desert in Nevada, but the desert in Texas.

Texas might seem like an unlikely place for an art road trip, but this reddest of red states is rich in art. Oil has made Texas rich and art, like everything else, follows the money. The course I plotted traced the art that interested me from east to west. Houston to Austin to Marfa; Mark Rothko and Barnett Newman to Ellsworth Kelly to Donald Judd and Robert Irwin. The beginning and end of this trip were anchored in oil—more precisely, the oil money of the de Menil family. As we have seen, John and Dominique de Menil created a foundation to establish a museum and fund the Rothko Chapel in Houston. In addition to this, Houston also boasts Kapoor's *Cloud Column*, which stands beside the entrance to the Houston Museum of Fine Arts, and Turrell's Live Oak Friends Meeting House Skyspace, as well as a Skyspace on the Rice University campus right next to Heizer's monumental sculpture *45° 90° 180°*. In 1974, the de Menils' daughter, Philippa, created the Lone Star Foundation, which later became the Dia Foundation. Dominique was an heiress to the Schlumberger oil fortunes. The Schlumberger Company was founded in 1926 in France as the Electric Prospecting Company. According to the company website, today Schlumberger is the world's leading provider of technology for the drilling, production, and processing to the oil and gas industry. The name "Dia," which derives from the Greek word meaning "through," was chosen to underscore the foundation's mission of supporting artists whose work is on such a grand scale that its completion is difficult, if not impossible. In 1987, the foundation established a museum in Chelsea, and twenty-two years later, under the imaginative leadership of Michael Govan, who was also instrumental in creating Mass MoCA, Dia Beacon opened. From the beginning Dia favored artists who

were developing the minimalist response to abstract expressionism and pop art. The initial list included Walter De Maria, Donald Judd, Dan Flavin, John Chamberlain, La Monte Young, and Marian Zazeela. Under Govan, the foundation extended support to Richard Serra, Robert Smithson, James Turrell, Michael Heizer, and Robert Irwin. Since leaving the Dia Foundation, Govan has continued to raise money to support the work of these artists. Though their art differs in important ways, De Maria (1935–2013), Smithson (1938–1973), Turrell (1943–), Heizer (1944–), Judd (1928–1994), and Irwin (1928–) were all drawn to the West.[2] The desert rather than the city was the preferred setting for their work. As post–World War II consumer culture heated up, these artists cooled on the city and, like monks fleeing the corrupt world, headed to the desert. But not all deserts are the same. The Texas desert differs from the Nevada desert, and both these American deserts differ from the Egyptian desert.

Leaving the buzz of Austin behind, I headed west on Interstate 10 for the 6½ hour, 430-mile drive to Marfa.[3] City gives way to suburbs draped on rolling hills with lush trees, shrubs, and flowering plants. Gradually, houses, malls, and trees shading green lawns disappear and the hills are covered with sagebrush and scrub oak. Occasionally tumbleweed blows across the road, while cattle scattered over the hills graze contentedly. In Nevada, there are fewer cattle than sheep, which are still shepherded by the Basques who settled in the Silver State many years ago. Beyond "Austin City Limits," the speed limit increases to 80 mph. At this speed the countryside rushes by like a video on fast-forward. Green morphs into brown, which then becomes different shades of amber and burnt umber. The greenish-gray of the sagebrush covers the earth tones of the desert floor. With no trees anywhere, there is no escape from the relentless rays of the blazing sun. The road is as straight as an arrow cutting through the land. But this territory is not as empty as the Nevada desert. The landscape is punctuated with oil derricks and pumps draining underground reserves dry. All along the highway, there are huge trucks much larger than oil tankers carrying precious water to newer wells used in fracking. Fading to a point that is always receding, the road seems to go on forever.

When engineers encounter an obstacle in Texas, they go *through* it rather than around it. One of the most interesting features of Interstate 10 is the roadside geology. At many places along the highway, high walls of sedimentary rock are exposed by cuts as precise as sliced layer cake. For those who know how to read them, these layers of cream-colored rock look like lines on a page of a book telling a story more ancient than human life. With gas stations as scarce as hen's teeth, you have to watch the fuel gauge carefully. When

you turn off the highway and find a town, it is so much like Wim Wenders's *Paris, Texas*, that you expect to meet Sam Shepard at the cash register.

As you get closer to the nearby border, the influence of Mexican culture can be seen in the small desert villages and towns. The farther I drove, the more I understood the difference between the Texas and the Nevada deserts. In Nevada, the desert is more desolate—fewer towns, people, and trucks. But the biggest difference is the sky and the light. The Nevada sky is dusty and often is tinged rose and pink from the reflection of the red earth below. In west Texas, the sky is clear and crisp—light is lighter and dark is darker. Even in the distance, outlines remain sharp and objects have a clarity that is almost surreal. In the heat of the noonday sun, the distant desert shimmers like ripples on a pond. At night, the sky is darker and the stars are brighter than I have seen anywhere else. It is so dark that in 2012 this area was named an international dark-sky park by the International Dark-Sky Association. This is one of only ten places in the world certified for dark-star gazing. What might Van Gogh have painted if he had seen this starry sky on a moonless night?

Closer to Marfa, the terrain changed—the Chisos Mountains, reaching a height of 7,832′, rose abruptly from the floor of the Chihuahuan Desert. The Rio Grande River, which is the third-longest river in the United States, stretches 1,900 miles from the Colorado Rockies to the Gulf of Mexico and forms the border between the United States and Mexico. A large sign read "Welcome to Big Bend National Park." In the park, the tall mountains with deep valleys and gorges erupted from the desert floor. For eons, the river has been carving deep cuts forming tall limestone cliffs, many of which are covered with ancient petroglyphs and pictographs. Today this process is slowing down because the Rio Grande is running dry.[4] The combination of ill-advised farming methods, obsolete treaties, misguided hydrotechnologies, and climate change have destroyed this vital resource that once sustained thousands of people. When the river is gone, there will no longer be a natural marker dividing the United States and Mexico.

Marfa is the most unlikely of towns; it has become an international art mecca in the middle of the Chihuahuan high desert (elevation 4,688′), fifty miles from the Mexican border. The Davis Mountains are to the north, the Cretaceous flats to the southwest, the Bofecillos Mountains to the south, the Chinati Mountains to the southwest, the Sierra Vieja Mountains to the west, and the Van Horn Mountains to the northwest.[5] This setting, the unforgettable sky, and the distinctive light give Marfa its unique identity. It is a small town with a population of only 1,800, 69 percent of whom are Hispanic or Latino. The nearest cities are Midland-Odessa and El Paso, which

are both three hours away. A single train track runs through the center of town, and train whistles break the desert silence day and night. The town was completely transformed when Donald Judd started buying property and land in 1971.

Judd was born in 1928 in Excelsior Springs, Missouri. He attended Columbia University, where he studied philosophy and received a master's degree in art history under the direction of Meyer Shapiro. In 1968, he bought a five-story building on Spring Street in SoHo, which he converted into his studio and residence. Like Heizer, however, he never really felt at home in New York City. "Too many people is the problem with New York," he complained.[6] But it wasn't just the crowds; it was also the lack of silence. "In general," he writes, "bright color adds to the bedlam. But then, just as the continuous noise in some cities, especially New York, is thoughtless, so is the use of color and materials."[7]

In many ways, it is hard to imagine artists more different than Heizer and Judd. One works with massive natural rocks and weighty material, the other works with industrial materials that are meticulously crafted. But both believe that with abstract expressionism and pop art, painting and the European tradition it represents had reached the point of exhaustion. They wanted to move beyond Europe to a distinctively American art, and they were convinced that the only place such art could be created was the western American desert.

Like many in his generation, Judd served in the military. In 1946, he and four of his fellow soldiers took a bus from Fort McClellan in Alabama to San Francisco, where they were deployed to Korea. This was the first time Judd had been in the Southwest, and it was love at first sight. He reported sending a telegram to his mother. "Dear Mom. Van Horn Texas. 1260 population. Nice town beautiful country mountains. Love Don. 1946 Dec. 17 5:45." He always remembered the beauty and tranquility of open spaces and small desert towns, and after the Korean War, when New York's noise and loud colors became too much for him, he decided to move to the Southwest. Judd was attracted to Mexico, but political tensions made it difficult to transport art across the border, so he decided to find a place as close to Mexico as he could. In 1985, he recalled, "I flew to El Paso in November 1971, and drove to the Big Bend of the Rio Grande in the Trans-Pecos. In addition to my developing idea of installations and my need for a place in the southwest, both due in part to the harsh and glib situation within art in New York and to the unpleasantness of the city, I had set a deadline for finding a place." Shortly thereafter, he discovered Marfa and in 1973 started buying land and buildings in and around the town. During World War I, Fort D. A. Russell

had been a base for training pilots. In the 1930s, the army moved two large hangars to the edge of town. During World War II, these buildings were used to hold prisoners of war. Judd pointed out that in one of the artillery sheds there is a sign that reads: "*Den Kopf Benutzen Ist Als Ihn Verliern.*"[8] Inside one of the hangars you can still see the faint letters of a message written by one of the prisoners. In the following years, Judd purchased more land and buildings as well as a compound on Main Street that he converted into working and living space. All of this was part of his vision of creating a setting in which artists could work and display their art in permanent installations. Judd was convinced that important art had to be contemplated slowly over a long period of time. His original plan of exhibiting Dan Flavin's neon light sculptures and John Chamberlin's sculptures made from debris left by car wrecks eventually expanded to include the work of nine more artists — Carl Andre, Ingolfur Arnarsson, Roni Horn, Ilya Kabakov, Richard Long, Claes Oldenburg, Coosje van Bruggen, David Rabinowitch, and John Wesley. He proposed a separate building devoted to each of these twelve artists.

In the late 1970s, Judd formed a partnership with Philippa de Menil, who had changed her name to Fariha Friedrich after marrying and converting to Sufi Islam. With the support of the Dia Foundation over the following years, Judd bought forty buildings and 340 acres of land. He eventually formed the Judd Foundation, which provided funds to restore and maintain his residences in Marfa and New York, both of which are now open to the public. Judd drew no distinction between work and living space. He felt it was important to live with the art he created so that he could better understand what he had actually done. The design for these spaces is as spare and precise as his sculptures. One of the most interesting parts of his Marfa residence is his extensive library. Ever the philosophy student, Judd's collection includes books by some of the most important modern philosophers — Kant's *Critique of Pure Reason*, Hegel's *On Art, Religion, and Philosophy*, and Heidegger's *Being and Time*. The lessons he learned from these writers were mostly negative. "Grand philosophical systems," he concluded, "are no longer credible."[9] Rather than Continental philosophy, Judd was more drawn to the British tradition of Locke and Hume, which led to his emphasis on the empirical experience of concrete works of art.

During the 1980s, the price of oil dropped precipitously, and the financial circumstances of the de Menil family changed for the worse. After a protracted legal battle, Judd severed his relationship with the Dia Foundation and was able to retain all the land, buildings, and art he had accumulated. In 1986, he created the Chinati Foundation, which he personally financed

until his untimely death from lymphoma in 1994.[10] Freed from the restrictions created by the foundation, Judd was able to develop his project as he had originally envisioned it. Today the campus of the Chinati Foundation is located on the edge of town next to the office of the US Border Patrol station responsible for covering 4,500 square miles, which is the largest territory in the country. During our troubled time, this office is a stark reminder of continuing tensions Judd spent his life trying to overcome. The two former artillery sheds form the center of the complex. In order to accommodate his art, he changed their flat roofs to semicircular roofs, creating a much greater sense of open space. He also replaced the garage doors along both sides of the building with gridded windows extending from ground level to the top of the walls. The elegant simplicity of the buildings is impressive. The windows function as semitransparent mirrors that both reflect the surroundings and allow visitors to view the art inside as well as see through the buildings to the mountains on the distant horizon. Around the sheds there are one-time barracks that now house the work of selected artists. Additional buildings displaying art are scattered throughout the town, making it difficult to distinguish the line between art and life.

In addition to creating important artworks and establishing a foundation and facilities to support his art as well as the work of other artists, Judd was a critic who wrote important essays on leading contemporary artists. He used these writings to develop the aesthetic principles that inform his art. He begins his influential 1964 essay "Specific Objects," "Half or more of the best work in the last few years has been neither painting nor sculpture. Usually it has been related, closely or distantly, to one or the other. The work is diverse, and much in it that is not painting and sculpture is also diverse."[11] Traditional—that is, European—art had been either painting or sculpture, and Judd is convinced that work following this trajectory implicitly or explicitly involves "anthropomorphic imagery," which represents nostalgic longing for a preindustrial past. He sees a third space opening where there is the possibility for art that is neither painting nor sculpture to emerge. "Oil and canvas," he argues, "are familiar and, like the rectangular plane, have a certain quality and have limits." Such familiarity and limitation violate the most basic principle of art.

Art should be new.
Art should be made with the widest knowledge possible.
Art should concern what you really know.
Art should resist all received information aesthetic or otherwise.[12]

Though artists ranging from Ed Kienholtz and Robert Morris to Tony Smith and Frank Stella were moving from two to three dimensions, Judd is not persuaded that they have broken sufficiently with their painterly pasts. Their work still bears representational and referential traces of earlier styles of painting he is trying to erase.

The most advanced work, Judd maintains, requires a revolution in materials as well as images and forms.

> The use of three dimensions makes it possible to use all sorts of materials and colors. Most of the work involves new materials, either recent inventions or things not used before in art. Little was done until lately with the wide range of industrial products. Almost nothing has been done with industrial techniques and, because of the cost, probably won't be done for some time. Art could be mass-produced, and possibilities otherwise unavailable, such as stamping, could be used.... Materials vary greatly and are simply materials— formica, aluminum, cold-rolled steel, plexiglass, red and common brass and so forth. They are specific. If they are used directly, they are usually aggressive. There is an objectivity to the obdurate identity of the material.

But for all his talk about the importance of materials, Judd's real preoccupation is space. One year before his death, he began an intriguing essay, "Some Aspects of Color in General and Red and Black in Particular." "Material, space, and color are the main aspects of visual art. Everyone knows that there is material that can be picked up and sold, but no one sees space and color. Two of the main aspects of art are visible; the basic nature of art is invisible."[13]

While Frank Stella famously declared, "What you see is what you see," Judd attempts to create conditions that make it possible to see what you do not see. "I think that I developed space as a main aspect of art.... Space is now a main aspect of present art, comparable only to color as a force." Judd's mature work is all *about* space—the task of the artist is to make space. Judd argues, "There has been almost no discussion of space in art, not in the present. The most important and developed aspect of present art is unknown. This concern, my main concern, has no history. There is no context; there are no terms; there are not any theories. There is only the visible work invisible. Space is made by an artist or architect; it is not found and packaged. It is made by thought."[14] To make space, Judd fabricates objects and arranges them precisely to reveal the interval that defines form. While Heizer removed hundreds of thousands of tons of material to create the opening of the work of art, Judd places hard-edged industrialized objects in precise

rectilinear designs to constitute the invisible matrix of vision. To make this space for others to see, Judd had to leave the noise of New York for the solitude of the desert.

Judd's two major works at the Chinati Foundation reveal space to be an event rather than a container. Space, in other words, is spacing. In a manner similar to several of the artists I have already considered, Judd's work is balanced on the border between polar opposites: repetition/variation, identity/ difference, simplicity/complexity, interiority/exteriority, and light/shadow. Like his contemporaries who are labeled minimalists, Judd attempts to dissolve referentiality and break down traditional hierarchies by creating serial works. What makes his version of seriality distinctive is his use of repetition to produce differences rather than an endless reiteration of the same. In *100 Untitled Works in Mill Aluminum* (1982–86), each object measures 41″ × 51″ × 72″ and is outwardly identical. However, the interior of each box differs in subtle ways that are not immediately obvious. There are fifty-two boxes in one building and forty-eight in the other. The arching ceiling and hushed atmosphere in the building gives the former artillery shed the aura of a cathedral filled with precious objects. The placement of the boxes in a grid creates a labyrinthian space through which visitors silently wander. The buffed sides of the boxes reflect changing light pouring through gridded windows with views extending to the distant mountains. Artist Kathleen Shafer describes the boxes and interior space as "magical."

> Viewing these pieces at different times of day allows them to further unravel themselves into objects that allow light and colors to constantly transform before my eyes. Although each piece is unique, to try to focus on any one is "like trying to focus on a word in a paragraph in a novel." Collectively, the reflections of the aluminum create colors and intensities of light that never seem to look the same. Installed in a simple alignment, the boxes seem to grow up and out of the floor, and yet at the same time, they hover. Where one box will have an open top, the interior space absorbing the light and looking dark to my eye, another box will have a closed top that sharply reflects light. The boxes' shiny and smooth surfaces contrast with the roughness of the red brick and beige concrete that forms the interior space of the buildings.[15]

As I pondered these arresting objects, my mind returned to Judd's interest in European philosophy. The boxes were carefully crafted and deliberately placed at the point of intersection of perpendicular lines in a way that reminded me of the precisely formulated, judiciously spaced, and sequentially numbered propositions in Wittgenstein's *Tractatus Logico-Philosophicus.*

Each box was posed as a proposition that demanded reflection, and when all these boxes and propositions were taken together, Wittgenstein's conclusion was the only appropriate response. "Whereof one cannot speak, thereof one must be silent."[16]

The site-specific work titled *15 Untitled Works in Concrete* (1980–84) shifts from inner to outer space. The piece consists of fifteen concrete units that were cast and assembled on the site. Each object is made of 2.5 m × 2.5 m × 2.5 m concrete slabs that are 25 cm thick. The concrete is seamless, but its finish is not as sensuous as the surfaces of Tadao Ando's work. The massive boxes are arranged in clusters of two to six along a north-south axis near the far edge of a plain separating them from the other buildings in the complex. A berm at the end of the series provides an overview of the work as a whole. While these objects are identical, their placement differs. Wandering between the boxes, Judd's understanding of space as spacing becomes clear. "Time and space," he argues, "don't exist; they are made by events, and positions. Time and space can be made and don't have to be found like stars in the sky or rocks on a hillside."[17] While *100 Untitled Works* reminded me of Wittgenstein, *15 Untitled Works* reminded me of Wallace Stevens, more particularly his poem "Anecdote of a Jar."

> I placed a jar in Tennessee,
> And round it was, upon a hill.
> It made the slovenly wilderness
> Surround the hill.[18]

The wilderness of the desert rises up between and around the concrete blocks, making the invisible visible. Judd did not place his concrete blocks in preexisting space; to the contrary, the blocks create the space they seem to occupy. As this insight slowly worked its way through my imagination, I realized that the real focus of this work of art is not the fifteen objects but the way they frame angles of vision from which to view the surrounding desert and distant mountains. The question, then, became one of frames and framing. How is frame-work to be understood?

Derrida addresses this question in an essay entitled "Parergon," which introduces his book *The Truth in Painting*.[19] In his discussion of Kant's Third Critique, which frames the First Critique and the Second Critique, Derrida writes, "Where does the frame take place. Does it take place. Where does it begin. Where does it end. What is its internal limit. Its external limit. And its surface between two limits." In a manner similar to the tympan, he

concludes, the frame is betwixt and between opposites it both sustains and subverts. Responding to his own question about the frame, Derrida writes,

> The first time I am occupied with folding the great philosophical question of the tradition ("What is art?" "the beautiful?" "representation?" "the origin of the work of art?" etc.) on to the insistent atopics of the *parergon*: neither work (*ergon*) nor outside the work [*hors d'oeuvre*], neither inside nor outside, neither above nor below, it disconcerts any opposition but does not remain indeterminate and it *gives rise* to the work. That which it puts in place — the instances of the frame, the title, the signature, the legend, etc. — does not stop disturbing the *internal* order of discourse on painting, its works, its commerce, its evaluations, its surplus-values, its speculation, its law, and its hierarchies.[20]

So understood, the frame is the spacing that opens gaps and creates holes in the philosophical tradition that has been the foundation of most Western aesthetic theory and much artistic practice. This is the tradition that Judd and the artists he supported wanted to subvert.

As I lingered in this work, the light continued to change, and as dusk began to fall, my eyes moved from the visible concrete objects to the invisible space between them. Constantly shifting shadows changed the quality of the light. When my attention shifted, the details of the foreground faded and the distant horizon came into sharp focus. This horizon joining and separating earth and sky is what Judd wanted me to come to this high desert to see. And this horizon, I now realized, is not only the origin but also the truth of the work of art.

APPROACHING HORIZONS

The controversial collector of minimalist and conceptual art Giuseppe Panza explained that his lifelong interest in religion and art was inspired by his memory of the silence in his family home in Varese, Italy. That silence, he recalled, "is in no way heavy, but on the contrary, carries me and makes me feel there is something both light and infinite in the air."[21] Panza first encountered the work of Irwin and Turrell in the late 1960s. The two southern California artists had been friends and collaborators since the Los Angeles County Museum's program in Art and Technology brought them together. Panza was sufficiently impressed by their work to commission installations for his villa in the Lombardy region of northern Italy. For Irwin, this early work would bear fruit years later in his design for Dia Beacon and his in-

stallation at Marfa. As Panza's collection grew, he eventually turned his villa into a museum. In 2014, the museum hosted an exhibition, *Aisthesis: The Origin of Sensations* devoted to the long relationship of Irwin, Turrell, and Panza. "*Aisthesis*" is the Greek word for feeling. The show included nineteen works created from 1963 to 2013. As in all of their work, Irwin and Turrell were less concerned with objects than with perception and the ability to apprehend the world anew. Irwin's and Turrell's sensitivity to silence was one of the things that drew Panza to their work.

Irwin's art actually originated in silence. In the 1950s, he was studying at the Chouinard Art Institute in Los Angeles, but he found the work being done there uninteresting. Searching for other approaches, he began visiting Europe. In 1954, while traveling from Paris to Morocco, he stayed on the Mediterranean island of Ibiza, which is off the eastern coast of Spain. He found the land and sea so seductive that he rented an isolated cabin on a barren peninsula where he stayed for eight months. During this entire time, Irwin lived in rustic conditions and did not talk to a single person. Years later he recalled this experience.

> It was a tremendously painful thing to do, especially in the beginning. It's like in the everyday world, you're just plugged into all the possibilities. Every time you get bored, you plug yourself in somewhere: you call somebody up, you pick up a magazine, a book, you go to a movie, anything. And all of that becomes your identity, the way in which you're alive. You identify yourself in terms of all that. Well, what was happening to me as I was on my way to Ibiza was that I was pulling all those plugs out. One at a time: books, language, social contacts. And what happens at a certain point as you get down to the last plugs, it's like the Zen thing of having no ego: it becomes scary, it's like maybe you're going to lose yourself. And boredom then becomes extremely painful. You really are bored and alone and vulnerable in the sense of having no outside supports in terms of your own being. But when you get all pulled out, a little period goes by, and then it's absolutely, serene, it's terrific. It just becomes really pleasant, because you're out, you're all the way out.[22]

By withdrawing to the island, Irwin attempted to return to point zero from which he could rethink his work as an artist. During long days and nights of contemplation and meditation, Irwin's artistic vision began to come into focus. "We have now arrived, to paraphrase Kasimir Malevich," he reflected, "in a place where there is no more likeness of reality, no idealistic images, no more things, nothing but a bare-bones desert. But here, in this desert we can now begin to question how it might be otherwise."[23]

Life on Ibiza was very different from Irwin's life in Los Angeles. While there were some similarities between Mediterranean and southern California light, everything else was different. Irwin represents his youth as "free from angst in the land of sun." In later years, he saw the laidback life in LA as important for the differences between East Coast and West Coast art. "I mean, people talk about growing up Jewish in Brooklyn, know what I mean? And they always dwell on the dark side. I hear all of that, and I grant that it makes for good drama, makes for good writing, and it makes good intellects, in a sense. Well, apparently this made for good artists, 'cause we didn't have nothing to do with all of that—no dark side, none of that struggle—everything was just a flow."[24] The purported lack of history and tradition in California left artists free to create new styles of expression.

By the late 1950s, some of the most promising young artists in southern California showed their work and gathered around the Ferus Gallery. Founded in 1957 by Walter Hopps and Edward Keinholz, this gallery brought New York art to LA in shows devoted to Warhol, Johns, Lichtenstein, and Stella. More important, Ferus also provided a venue for up-and-coming West Coast artists. Having hung out with Ferus artists Billy Al Bengston, Ed Moses, Kenneth Price, Larry Bell, and Ed Ruscha, Irwin goes so far as to claim, "my education began with my exposure to these people."[25] Beyond the art scene, LA popular culture was an important influence on Irwin during his formative years. His love of cars and driving made him susceptible to the burgeoning "hot rod aesthetic." In addition to fast cars, he dabbled in Zen Buddhism, which was popular among Ferus artists as well as on the beaches of southern California.

By the 1960s, Irwin's interests had shifted from the Ferus scene to the light and space movement that was emerging in the work of Larry Bell, Bruce Nauman, Marie Nordman, and others. This change in direction led to his collaboration with Turrell at LACMA and eventually to the Panza Villa project. The experiments he and Turrell conducted with anechoic chambers were especially important for Irwin. (See chapter 2.) As a result of this work, he concluded that art is not about *what* you see but is about *how* you see. With this insight, he transferred his attention from object to perception.

> Allowing people to perceive their perceptions—making them aware of their perceptions. We've decided to investigate this and to make people conscious of their consciousness.... If we define art as part of the realm of experience, we can assume that after a viewer looks at a piece, he "leaves" with the art, because the "art" has been experienced. We are dealing with the limits of an experience—not, for instance, with the limits of painting. We have chosen

that experience out of the realm of experiences to be defined as "art" because having this label is given special attention. Perhaps this is all "Art" means—this Frame of Mind.

With the focus on experience rather than object, Irwin began to move away from painting, which he now regarded as "second order." Rather than representation or abstraction, which both negate experience in different ways, he began to search for ways to provide the occasion for the apprehension of immediate presence. Responding to the work of other artists as well as critics, Irwin argues, "When they talked about a painting, they translated it into subject matter in a way, but it's not only about that. It's about presence, phenomenal presence. And it's hard: if you don't see it, you just don't see it; it just ain't there. You can talk yourself blue in the face to somebody, and if they don't see it, they just don't see it. But once you start seeing it, it has a level of reality exactly the same as the imaginary—no more, but no less. And basically, that's what I'm still after today. All my work since then has been an exploration of phenomenal presence."[26] In contrast to conceptual artists who, like Hegel, attempted to reduce the work of art to concepts or ideas, Irwin creates works intended to transport viewers to a preconceptual realm that can never be linguistically articulated.

Irwin did not immediately reject painting; rather, he began to develop a "nonobject art" through a patient reduction of images to the nul point he had discovered on Ibiza. In two series of works—*Dot Paintings* (1964–66) and *Disc Paintings* (1978–69), he gradually dissolved the painting (that is, object) into its context or environment. As images fade, the surface of the canvas becomes a play of shadows and "40, 60, 100 different shades of white" appear.[27] Walter Hopps recounted his experience of these ethereal works. "The virtually indescribable effect seems to be of light itself. If there is any way to describe this effect, perhaps it is as if a golden white area of light pulses somewhere in the silver white of the canvas."[28] As the work of art gradually dematerialized and the line between figure and ground dissolved, Irwin's medium became nothing other than light itself.

When the object disappeared and the work of art became the experience of the artist and the viewer, Irwin began what he describes as "site-conditioned/determined" art. Since the 1970s, he has created dozens of environments in gardens, parks, urban settings, and museums. In these works, Irwin listens and responds rather than attempting to program and control the setting. Site-conditioned/determined art differs from site-specific art and land art, which were emerging at the same time. Whereas Heizer imports heavy machinery and explosives into the desert to transform the en-

vironment to conform to his vision, Irwin's work has a lighter touch—he patiently attends to the setting in an effort to respond effectively.

> *Site-conditioned/determined.* Here the sculptural response draws all of its cues (reasons for being) from its surroundings. This requires the process to *begin* with an intimate, hands-on reading of the site. This means sitting, watching, and walking through the site, the surrounding areas (where you will enter from and exit to), the city at large or the countryside. Here there are numerous things to consider; what is the site's relation to applied and implied schemes of organization and systems of order, relation, architecture, uses, distances, sense of scale? For example, are we dealing with New York verticals or big sky Montana? What kinds of natural events affect the site—snow, wind, sun angles, sunrise, water, etc.? What is the physical and people density? the sound and visual density (quiet, next-to-quiet or busy)? What are the qualities of surface, sound, movement, light, etc.? ... A quiet distillation of all of this—while directly experiencing the site—determines all the facets of sculptural response.[29]

Two of Irwin's most successful site-conditioned/determined works were done for museums. He was commissioned to develop several gardens for the Getty Center, which is perched like an invincible fortress high on a hilltop overlooking LA. Irwin's lush gardens offer a stark contrast to Richard Meier's austere white buildings. The central garden has a path meandering through gardens with more than 500 varieties of plants, including many different kinds of cacti as well as plants selected from a desert terrain. On one of the stepping stones, Irwin has inscribed a phrase that captures the essence of his work—"Always changing, never the same." With panoramic views of LA on the distant horizon, the gardens offer a quiet place for reflection high above the noise of the traffic-clogged highway.

Longtime supporter of Irwin, Judd, Turrell, and Heizer, Michael Govan commissioned Irwin to design gardens for Dia's expansion from Chelsea to a vast factory space located in Beacon on the Hudson River. Irwin explains the genesis of his work: "I lived in a little town across the river for a year, and went there every day. I work experientially. I start in the space and walk through it a thousand times, just sort of running my hands over the whole thing."[30] The result is a garden that effectively integrates inside and outside as well as the industrial and the natural. The straight walkways and rectilinear plantings trimmed with the precision of Judd's aluminum boxes reflect not only the interior design of the museum but also the minimalist works on display. As if to underscore the interplay of the industrial and the natural, Irwin borders tree plantings with a curved steel border that has a patina

reminiscent of Richard Serra's *Torqued Ellipses*, which were first shown at Dia Chelsea. In developing these gardens, Irwin responds to Govan's challenge "to design our experience."

Looking back on Irwin's career, it becomes clear that the 1970s were a turning point. With his dissolution of painting and shift from object to non-object art, he was rethinking not only the function but also the origin of the work of art. To develop his ideas, Irwin made two important decisions: he started reading philosophy seriously, and once again he retreated to the desert. Although he was impressed by Wittgenstein's *Tractatus*, Irwin, unlike Judd, was more interested in Continental than in British philosophy. His philosophical self-education began by reading Descartes, Kant, and Hegel in depth. While British empirical and analytic philosophy is preoccupied with fragmentary parts, Irwin was impressed by Continental philosophy's willingness to ask big questions about the whole. "I'm touched by somebody who really puts it on the line in terms of making that kind of contribution and taking that kind of responsibility. When I first read Hegel that was my first take on the thing. I was really touched by the aspiration, *sentimentally touched* by the fact that somebody could aspire to something so huge. Or like Kant: I mean, what a spectacular effort!"[31] Irwin's ambition for art was as great as Hegel's was for philosophy. Rather than bringing the history of art, religion, and philosophy to their conclusive culmination, Irwin wanted to take art back to its origin and start all over. His guide for this grand undertaking was not Hegel's but Merleau-Ponty's phenomenology. As it did for many other artists of his generation, Merleau-Ponty's *Phenomenology of Perception* (French, 1945, English, 1962) left a deep impression on him. In this work, he found confirmation of his conviction that perception precedes and is a condition of conception. Perception, he concluded, is the incomprehensible but not inapprehensible origin of the work of art.

To confirm his conviction, Irwin once again retreated to the desert—not the distant desert on a Mediterranean island, but the desert near LA. He began taking morning drives into the Mojave Desert and eventually traveled as far as Arizona.

> The Southwest desert attracted me, I think, because it was the area with the least kinds of identifications or connotations. It's a place where you can go along for a long while and nothing seems to be happening. It's all just flat desert, no particular events, no mountains or tree or rivers. And then, all of a sudden, it can just take on this sort of . . . I mean, it's hard to explain, but it takes on an almost magical quality. It just suddenly stands up and hums, it becomes so beautiful, incredibly, the presence is *so* strong. Then twenty min-

utes later, it will simply stop. And I began wondering why, what those events were really about, because they were so close to my interests, the quality of phenomena.[32]

The beauty of this incredible presence became the focus of Irwin's art. He remained silent about what the desert taught him and let his works speak for themselves.

In 2016, the eighty-eight-year-old Irwin's desert dreams became a reality. Sixteen years earlier the Chinati Foundation invited him to create a permanent installation in what had been the hospital for Fort D. A. Russell. For years Irwin struggled to save the building's ruins, but the remains had deteriorated too much and eventually the site had to be cleared to make way for a precise replica of the original hospital structure. Bringing together elements Irwin has been developing for decades, this work is his culminating achievement. The installation is in a large 10,000-square-foot U-shaped building with an open courtyard where he placed a sculpture made from volcanic basalt from the state of Washington. The surrounding garden has Blue Grama grass and Palo Verde trees. A perfectly rectilinear concrete-and-gravel walkway marks a path through the garden. Soft rose stucco covers the outside of the building and provides an effective background for the interior garden.

On the outside as well as the inside, Irwin elaborates the framing methods Judd introduced in *15 Untitled Works in Concrete*. The building can be entered from either side—the entrances are framed by façades with rectangular openings that have the same dimensions as the doors. Once inside the building, frames proliferate. Two long corridors, joined by a third, are lined with perfectly symmetrical windows opening on the outside to the surrounding expanse of the desert and on the inside to the courtyard sculpture and garden. Scrims run down each corridor, creating a play of constantly changing shadows, which appear to be obscure figures in an old film. At the ends of both passageways, there is a series of scrims with openings that repeat the size and shape of the outer doors, creating frames within frames marking a transition to a space that remains invisible. The multiple scrims muffle sounds, leaving a hushed atmosphere that makes the space numinous.

The distinctive feature of the interior space is its color, or lack of color—everything is black, white, or gray. The corridor on the left side is black, the one on the right is white, and the hall connecting them is gray. Joining and separating the two vertical axes there are three black and three white scrims with an empty space in between. Entering from the left, you move from black, through gray, to white, and entering from the right, you move from

white, through gray to black. As you walk through the installation from left to right and from right to left, space is temporalized by repeating the diurnal rhythms that pattern our lives. The sense of time is deepened by the shadows of the window openings cast on the highly polished concrete floor. Moving with the sun, the rectangles create a sundial marking time's passage. It is important to visit this installation at different times of day and to walk through it from both directions. Far from static geometrical forms, this work of art changes constantly from hour to hour and season to season. Irwin's art provides a framework to apprehend events he can neither anticipate nor control. The eye-level windows that draw the light inside also turn the gaze of visitors outside. A thin gray film forms something like a tympan that subtly tints the desert landscape. As you walk along the corridor, the windows appear to be paintings carefully hung on a gallery wall. Commenting on his installation, Irwin remarks, "That's the main event, all the windows. People think they're looking for artwork, but what they're actually seeing is beautiful nature. I liked the architecture of the fort. All I did was to take that form and elaborate it—make the walls thicker, so you get a more substantial physicality to look out of. A real sense of the frame."[33]

Several critics have noted the similarities between Irwin's framed vistas and Dutch landscape artists like Jan van Eyck or, more recently, David Casper Friedrich. But that is not what I saw as I stared through rather than at these window frames. I saw the repetition and inversion of Rothko's black-on-gray paintings. The two geometric forms suggested an austere landscape with an expansive sky separated from earth by a perfectly linear horizon. While the colors were the same or almost the same, there were two important differences between Rothko's and Irwin's "paintings." In Irwin's work, gray is on top and black is on the bottom, and the big Texas sky crowds the dark land below to the edge or margin of the "canvas." What drew my attention was neither the gray above nor the black below but the vanishing horizon whose withdrawal allows sky and earth to appear. This is the horizon that beckons in all of Robert Irwin's art. What does it mean to follow this horizon?

PROMISE

The word "horizon" derives from the Greek *horizon*, to divide, separate, which, in turn, comes from *horos*, boundary, limit. The word "promise" comes from the Latin *promittere*, to send forth—*pro*, forth + *mittere*, to let go, send. The promise of the work of art sends us forth *toward* the horizon that marks and remarks the boundary or limit of experience by the approach of a future

that never arrives. How we respond to this always-outstanding-future determines how we dwell in the present. This is the point, or one of the points, of Irwin's telling comment on the horizon of his work.

> The wonder of it all is that what looked for all the world like a diminishing horizon—the art-object's becoming so ephemeral as to threaten to disappear altogether—has, like some marvelous philosophical riddle, turned itself inside out to reveal its opposite. What appeared to be a question of object/non-object has turned out to be a question of seeing and not seeing, of how it is we actually perceive or fail to perceive "things" in their real contexts. Now we are presented and challenged with the infinite, everyday richness of "phenomenal" perception (and the potential for a corresponding "phenomenal art," with none of the customary abstract limitations to form, place, materials, and so forth)—one which seeks to discover and value the potential for experiencing beauty in everything.[34]

Standing in the quiet of Irwin's installation contemplating the changing desert shadows and light, I realized that this work of art addresses the questions that had haunted me for many years. My mind wandered back to a conversation I had with Edmond Jabès in his Paris apartment on a late fall afternoon in 1989. Edmond was born in Cairo and lived in Egypt until the Suez crisis in 1956, when he moved to Paris. He told me that after he left Egypt what he missed most was the desert. When he was young, he recalled, "I would go into the desert alone for several days at a time." The Sahara desert is not the desert of the American West—there are no roads, no sagebrush, no scrub oak, no animals, no snakes. Only sand and more sand as far as the eye can see, and sometimes tracks left by camels carrying nomads passing through this vast wilderness. With dusk falling and light fading, Edmond approached a point—perhaps *the* point—that seemed to preoccupy him. Rising in his chair, he became agitated and spoke with an intensity I have rarely heard. "It is very hard to live with silence. The real silence is terrible. To approach this silence, it is necessary to journey into the desert. You do not go into the desert to find identity, but to lose it, to lose your personality, to become anonymous. You make yourself void. You *become* silence. You must become more silent than the silence around you. And then something extraordinary happens—you hear silence speak." This remark helped me to understand the *point* of all the empty space in his books. The design of his poetry stages the interplay of white and black that is the "stuff" of writing. In *El, or The Last Book*, Jabès writes,

Unimaginable encounter of what is on the point
Of becoming with what is about to be dispersed again.
 The tried word blossoms in an ordeal where it is
both hangman and victim.
 O recoil of all expectation where expectation is
tempered, as if action were only the desire not to
flower where death guards the gardens.
 Then the desert is a space where one step [*pas*, not] gives
way to the next, which undoes it, and the horizon
means hope for a tomorrow which speaks,
 where the pact is the point.[35]

What *does* it mean to become more silent than silence? What *does* it mean to become silence itself? What *does* it mean to hear silence speak? Is the point of the future dread and despair [Latin: *desperare*—*de-*, reversal + *sperare*, to hope] or hope?

From black to white through gray. From white to black through gray. Black-on-white. White-on-black. Black-on-black. White-on-white. From his *Black Square* to *Suprematist Composition: White on White*, Irwin recognizes the importance of Malevich's work for his own art.

> Malevich, of course, pared everything down to that empty white square. Everybody saw that and moaned, "Ooooh nooo, everything we love is gone." And instead he replied, "Ah, but we have found a desert of pure feeling!" Incredibly philosophical thing to say. One could easily have equated that empty square with the loss of God, the end of culture, the horror of death—and there's a whole artistic tradition that in effect does that: the existentialist tradition. But I'm convinced Malevich was drawing on the opposite tradition, the phenomenological. Instead of angst, he's telling you Wonder! Wow![36]

Pause. Pause once again to ponder. Ponder a lingering question: What color is silence? Perhaps white? Perhaps black? Perhaps something in between—something approximating infinite shades of gray?

For Herman Melville, white is the terrifying color of God's silence. In the memorable chapter "The Whiteness of the Whale," he writes,

> Though neither knows where lies the nameless things of which the mystic sign gives forth such hints; yet with me, as with the colt, somewhere those things must exist. Though in many of its aspects this visible world seems formed in love, the invisible spheres were formed in fright....

Is it that by its indefiniteness it shadows forth the heartless voids and immensities of the universe, and thus stabs us from behind with the thought of annihilation, when beholding the white depths of the milky way? Or is it, that as in essence whiteness is not so much a color as the visible absence of color, and at the same time the concrete of all colors; is it for these reasons that there is such a dumb blankness, full of meaning, in a wide landscape of snows—a colorless, all-color of atheism from which we shrink? ... [P]ondering all this, the palsied universe lies before us a leper; and like willful travelers in Lapland, who refuse to wear colored and coloring glasses upon their eyes, so the wretched infidel gazes himself blind at the monumental white shroud that wraps all the prospect around him. And of all these things the Albino whale was the symbol. Wonder ye then at the fiery hunt?[37]

Between belief and unbelief. Is this a-theism faithless, or is it the only faith that remains possible after the gods have fled?

It was, of course, Nietzsche's madman who most famously declared the death of God.

"Whither is God?" he cried; "I will tell you. *We have killed him*—you and I. All of us are his murderers. But how did we do this? How could we drink up the sea? Who gave us the sponge to wipe away the entire horizon? What were we doing when we unchained this earth from its sun? Whither is it moving? Away from all suns? Are we not plunging continually? Backward, sideward, forward, in all directions? Is there still any up or down? Are we not straying as though through an infinite nothing? Do we not feel the breath of empty space?"[38]

Who *did* give us the sponge to wipe away the horizon? If the death of God is the disappearance of the horizon that defines human finitude, then might the return of the horizon be the birth of a different God that reveals the infinite in the midst of the finite? A God who is not Beyond and Against the world and human beings, but Around, With, and In the quiet stillness of earth and everyday life? Extending his arms to embrace his work as well as the desert and sky surrounding it, Irwin confesses, "What would I want to get out of this thing? To make you feel that this is really a place worth taking care of. It's beautiful, it's wonderful, it's enlightening, it's thrilling—whatever word you want to put on it. No one else takes that role but the artist. That's what's unique to art."[39]

The desert has always been a place of temptation and hope. Forty days and forty nights in the wilderness with demons and strange voices clamoring in one's ears. The desert, however, is also the placeless place of an exodus to

a promised land that is not necessarily beyond but might always have been here-and-now hiding in plain sight. For sojourners in this desert of the real, it is a question of white and black, black and white; day and night, night and day. Are we moving from day to night or night to day? Despair and dread or hope? Or perhaps something in between that is neither debilitating despair nor blind hope. To try to answer this question, I had to return to Houston and once again drive to Austin to retrace the fourteen stations along the way from Rothko's black chapel to Ellsworth Kelly's white chapel.

II.

AROUND

I would only believe in a God that knows how to dance.
And when I saw my devil, there I found him earnest, thorough, deep,
somber: it was the spirit of gravity—through him, all things fall.

FRIEDRICH NIETZSCHE

AFFECTIONS

For Robert Irwin, the desert is a place of magic, awe, and wonder. When he
searches for words to suggest what he cannot explain, he sometimes waxes
poetic.

> Certainly the pure void of concept beckons the curious....
> Our posture (method) is that of philosophies—wonder, with its
> special ability
> to set aside, for the moment, the practical for the purely speculative.
> Pure wonder is that special state of mind—of enthusiasm and
> appreciation—
> that gives us the balance for such an ephemeral inquiry into the pure
> potential
> of our lives. First, because it gives us the means to suspend judgment,
> and second, because it does not require closure.[1]

"Pure Motive/Pure Method." "Wonder!" "Wow!" With the Owl of Minerva
circling and the twilight of the idols falling, who any longer has the cour-
age to speak and write about wonder, and, perhaps, even create wonderful

works of art that show light rather than darkness, glimmers of hope rather than clouds of despair?

Suffering intensely in the waning days of sanity before he fell into interminable silence, Nietzsche summoned the energy to write a fragmentary text he collected under the title "Dionysus-Dithyrambs" and signed it simply "Dionysus."

> Truly wonderful!
> Here I now sit,
> Near the desert and yet
> So far from the desert again,
> And in no way desolate....

From the edge of this desert, in the belly of an unnamable whale, Nietzsche sees silence and cannot resist its siren call.

> Hush!—
> From great things—I see a great deal!—
> One should keep silent
> Or speak greatly:
> Speak greatly, my delighted wisdom!
> Supreme star of being!
> Tablet of eternal forms!
> You come toward me?—
> Why hasn't anyone beheld
> Your mute beauty—
> Why doesn't it escape my gaze? ...
> Sign of necessity!
> Supreme star of being!—
> That no desire attains,
> That no No desecrates,
> Eternal Yes of being,
> Eternally I am your Yes:
> *For I love you, O eternity!*[2]

In the midst of unspeakable physical and psychological pain, Nietzsche beseeches readers, "Stay true to the earth and do not believe in those who talk of unearthly hopes."[3] Then a final "Yes!" "Yes" to the "Eternal Yes" of being. "Yes," which is "No to No." And finally, silence—eternal silence Nietzsche never broke.

The happy eras, Hegel once observed, are the blank pages of history. St. John of the Cross spends 180 pages recounting the travail of his "Dark Night of the Soul," and upon finally arriving at "the happy night," he falls silent. "In this happy night of contemplation God leads the soul by a manner of contemplation so solitary and secret, so remote and far distant from sense, that naught pertaining to it, nor any touch of created things, succeeds in approaching the soul in such a way as to disturb it and detain it on the road to the union of love."[4] Why this silence? Why has so much less been written on wonder, awe, and joy than on doubt, despair, and dread? Why is dissatisfaction so often embraced and contentment so often disparaged? Why is the sublime deep but beauty shallow? Why are so many writers and artists afraid of beauty?[5] Why does black suggest gravitas and white imply innocence? Why are so many modernists afraid of color? What makes color so threatening? Why is there so much suspicion about joy? Why is despair profound but joy superficial? Why is joy so often seen as naïve? Perhaps the preoccupation with darkness rather than light is a result of the obsession with death instead of birth.

Strangely, three of the writers who have the most profound things to say about wonder and joy are best known for the darkness of their vision — Nietzsche, Kierkegaard, and Jonathan Edwards. I will return to Nietzsche and Kierkegaard in the final section of this chapter; here I will focus on Edwards. Exiled to the wilds of western Massachusetts in a town — Stockbridge, which Norman Rockwell would make famous two centuries later, Edwards wrote what is one of the most important and least-read books on religion, *A Treatise Concerning Religious Affections* (1746). In the Berkshire Mountains, he became attuned to the beauty surrounding him. Edwards was a Calvinist, and Calvinists are best known for believing in an omnipotent God who seemingly arbitrarily elects some people for salvation and condemns others to eternal damnation. However, Calvin's God is, above all, the Creator whose power and glory can be seen in the beauty of creation. In the first book of his *Institutes of the Christian Religion*, Calvin writes,

> The Lord began to show himself in the visible splendor of his apparel, ever since in the creation of the universe he shows his glory to us, whenever and wherever we cast our gaze. . . . And since the glory of his power and wisdom shine brightly above, heaven is often called his palace. Yet, in the first place, wherever you cast your eyes, there is no spot in the universe wherein you cannot discern at least some sparks of his glory. You cannot in one glance survey the expanse, without being completely overwhelmed by the boundless force of its brightness.[6]

The austerity of Puritanism should not obscure the aesthetic sensibility at the heart of Calvinist theology.

For Edwards, as for Schleiermacher 150 years later, "true religion, in great part, consists in holy affections."[7] Just as Merleau-Ponty argues for the primordiality of perception, so Edwards insists that affections (feelings) are more rudimentary than thinking and willing.

> Such is man's nature, that he is very inactive, any otherwise than he is influenced by some affection, either love or hatred, fear or some other. . . . The affections of men are the springs of the motion: take away all love and hatred, all hope and fear, all anger, zeal and affectionate desire, and the world would be, in great measure, motionless and dead. . . . As in worldly things, worldly affections are very much the spring of men's motion and action, so in religious matters, the spring of their actions are very much religious affections: he that has doctrinal knowledge and speculation only, without affection, is never engaged with the business of religion.[8]

With the excesses of the First and Second Great Awakening swirling around him, Edwards is careful not to argue for anti-intellectual beliefs and irrational actions; rather, he insists that affections befall us and *color* everything a person knows and does.[9] More basic than language, the affections enable a person to apprehend what can be neither comprehended nor expressed discursively.

Written 250 years ago, it is remarkable how prescient Edwards's analysis appears today. He anticipates many of the most important insights of recent affect theory as well as some of the significant discoveries of contemporary neuroscience.[10] Antonio Damasio unknowingly echoes Edwards's account of religious affections when he writes in *The Feeling of What Happens: Body and Emotion in the Making of Consciousness,*

> The first basis for the conscious *you* is a feeling which arises in the re-representation of the *nonconscious proto-self in the process of being modified* within an account which establishes the cause of the modification. The first trick behind consciousness is the creation of this account, and its first result is the *feeling* (emphasis added) of knowing. . . . T. S. Eliot might well have been thinking of the process I just described when he wrote in the *Four Quartets,* of "music heard so deeply that it is not heard at all," and when he said "you are the music while the music lasts." He was at least thinking of the fleeting moment in which a deep knowledge can emerge—a union, or incarnation, as he called it.

In the final section of this chapter, we will see that "music heard so deeply that it is not heard at all" is the silent music Nietzsche hears in the joyous Dionysian revel that is the work of art.

Damasio makes two important additions to Edwards's theory. First, he establishes the necessary two-way interrelation between the affections and the body. On the one hand, somatic states influence affective dispositions, and, on the other hand, the affections condition the body. Second, as we discovered in our consideration of the reflexivity of the mind, there is always a lacuna in self-consciousness. Damasio admits, "What you do not ever come to know directly is the mechanism behind the discovery, the steps that need to take place behind the seemingly open stage of your mind in order for core consciousness of an object's image to make the image yours."[11] This unknowable mechanism constitutes the blind spot, which is the abyss where the imagination *presents* images that the mind eventually translates into concepts. Since the affective unconscious is not constituted by repression, the imagination can be creative in ways the Freudian unconscious cannot. Nowhere is this imaginative activity more evident than in the work of art.

Following Calvin, Edwards believes that religious affections are distinguished by their sensitivity to beauty. "Those affections that are truly holy," he explains, "are primarily founded on the loveliness of the moral excellency of divine things. Or (to express it otherwise), a love to divine things for the beauty and sweetness of their moral excellency, in the first beginning and spring of all holy affections."[12] In the course of his lengthy analysis, Edwards considers a broad range of affections, including fear, hatred, sorrow, desire, zeal, gratitude, compassion, love, and joy. Love and joy are the most important religious affections. In his fullest account of the joy that is beyond words, Edwards writes, "The nature of this joy, 'unspeakable and full glory.' 'Unspeakable' in the kind of it; very different from worldly joys, and carnal delights; of a vastly more pure, sublime and heavenly nature, being something supernatural, and truly divine, so ineffably excellent; the sublimity, the exquisite sweetness of which, there were no words to set forth. Unspeakable also in degree; it is pleasing God to give 'em this holy joy, with a liberal hand, and in large measure, in their state of persecution."

Their joy was "full of glory": although the joy was unspeakable, and no words were sufficient to describe it; yet something might be said of it, and now words more fit to represent its excellency, than these, "full of glory"; or as it is in the original, "glorified joy." In rejoicing with this joy, their minds were filled, as it were, with a glorious brightness, and their natures exalted and perfected . . .

it was a prelibation of the joy of heaven, that raised their minds to a degree of heavenly blessedness: it filled their minds with the light of God's glory, and made 'em themselves to shine with some communication of that glory.[13]

"Unspeakable joy" strikes one dumb—there simply is nothing to say that could adequately express this affection. Indeed, words break joy's magical spell. If Edwards is right, the pages Hegel regards as empty might actually be filled with joy no words can express.

It is important to stress that the joy Edwards describes is not a superficial happiness that overlooks or represses the undeniably dark moments of life. "In the saints," he stresses, "joy and holy fear go together."[14] Far from avoiding dread and despair, true joy surrounds and encompasses them to create a delight that is all the sweeter for having passed through darkness. Fear, even when it is holy, is a symptom of being-toward-death; joy, holy joy, is being-toward-birth, perhaps even rebirth.

In his classic work, *The Varieties of Religious Experience* (1901), William James develops the contrast between superficial happiness and profound joy through a comparison of what he labels "once-born" and "twice-born" believers. Once-born souls are "healthy minded." "If one were to ask the question: 'What is human life's chief concern?' one of the answers we should receive would be: 'It is happiness.' How to gain, how to keep, how to recover happiness, is in fact for most men at all times the secret motive of all they do, and of all they are willing to endure." For these people, religion is nothing more than a means to happiness. "With such relations between religion and happiness," James continues, "it is perhaps not surprising that men come to regard the happiness which a religious belief affords as proof of its truth. If a creed makes a man feel happy, he inevitably adopts it."[15] The once-born person is "childlike"; if questioned about apparently undeniable evil in the world, he or she denies it. When doubt, dread, and despair enter his or her mind, they are repressed. James gives numerous examples of the once-born from common people to well-known writers like Walt Whitman and Ralph Waldo Emerson. In contrast to this irrepressibly rosy view of life, sick souls are preoccupied with darkness and gloom. They ignore all good and, being subject to debilitating melancholy, have an "incapacity for joyous feeling."[16] "Now in contrast with such healthy-minded views . . . , if we treat them as a way of deliberately minimizing evil, stands a radically opposite view, a way of maximizing evil, if you please so to call it, based on the persuasion that the evil aspects of life are its very essence, and that the world's meaning most comes home to us when we lay them most to heart."[17] The two most promi-

nent examples of sick-souls James offers are Arthur Schopenhauer and Leo Tolstoy; I would add Hegel's unhappy consciousness.

James does not deny the realities these two varieties of religious experience affirm, but insists that either taken by itself is one-sided and, thus, is inadequate for negotiating the complexities of human experience. He identifies a third type of person—"twice-born," who does not deny life's darkness, but nonetheless believes it is subsumed within a more encompassing light. Through a process that the individual does not control, the two sides of experience are reconciled. This experience "may come gradually, or it may occur abruptly; it may come through new intellectual insights, or through experiences, which we shall later have to designate as 'mystical.' However it comes, it brings a characteristic sort of relief; and never such extreme relief as when it is cast into the religious mold. Happiness! Happiness! Religion is only one of the ways in which men gain that gift. Easily, permanently, and successfully, it often transforms even the most intolerable misery into the profoundest and most enduring happiness." James's analysis of the twice-born person focuses on Saint Augustine's *Confessions*. The most important point in James's argument is his insistence that "a solemn joy preserves a sort of bitter in its sweetness: a solemn sorrow is one to which we intimately consent."[18]

The most thoughtful elaboration of James's argument is developed in Richard R. Niebuhr's *Experiential Religion*. Drawing directly on the work of Edwards and Schleiermacher, Niebuhr rewrites Descartes's *Cogito ergo sum* as *"Patior ergo sum"*—I suffer therefore I am.

> We awaken to our being in suffering and being acted upon. . . . This is the original and encompassing experience that gives its form to all particular experiences, for neither thinking nor willing and acting on the environment are appropriate or conceivable human responses unless the field of surrounding forces disposes men toward thought and action in that field. Suffering is also the boundary of existence, an ever-present element of consciousness, and correspondingly our world appears to us to be a field of energies converging on us, shaping us, distending us, shattering us, and sending us on paths we have not chosen for ourselves.

Niebuhr borrows James's typology to identify two fundamental moods that determine contrasting orientations in life—fear and gladness. Weaving together Heidegger's account of *Stimmung*[19] and Edwards's analysis of affection, he argues "the attunement of the self is the basic and all-including

frame of mind that gives to the whole of personal existence its determinate quality, color, and tone."[20]

In fear, the individual feels set against the world, other selves, and even God. Isolated, purposeless, and powerless, the individual turns inward and withdraws even more. As alienation deepens, darkness grows strangely attractive and suffering becomes sweet. Niebuhr maintains that no one captures this mood more dramatically than Kierkegaard, who, during a particularly tumultuous time in his life, confided in his journal, "In addition to the wide circle of my acquaintances with whom I am, on the whole, on a very formal footing I still have an intimate, confidential friend — my melancholy, and in the midst of my pleasure, in the midst of my work, she beckons me, calls me aside, even though physically I remain where I am, she is the most faithful mistress I have known, what wonder then that I must be ready to follow her at any moment of the day."[21] Though melancholy may seem sweet for a while, it is a dead end from which there is, in Sartre's telling phrase, "no exit."

To describe the condition that is the polar opposite of fear and the melancholy it brings, Niebuhr borrows a term from Samuel Taylor Coleridge — "the gladness of joy." Just as James's solemn joy preserves the bitterness of "solemn sorrow," so gladness is more profound because fear is not repressed. Niebuhr quotes Swedish diplomat and former secretary-general of the United Nations, Dag Hammarskjöld. "To exist in the fleet joy of becoming, to be a channel for life as it flashes by in its gaiety and courage, cool water glittering in the sunlight in a world of sloth, anxiety, and aggression." Niebuhr then proceeds to explain, in the gladness of joy "the suggestion of motion, energy, power together with directionality of this energy as the felt content of the mood of rejoicing is unmistakable. There is another feature here also: the apparent dependence of the sense of 'fleet joy' upon the contrast with the 'world of sloth, anxiety and aggression'.... A third feature of the utterance only implied in the words 'to be a channel for life as it flashes by,' is that rejoicing discloses the sense and conviction of being part of something larger, in this case, the river of life."[22]

Left to his or her own devices, the despairing individual is impotent to escape imprisoning melancholy and leap into the stream of life. If deliverance is to come, it must arrive unexpectedly from elsewhere. Kierkegaard, like Augustine, identified the precise moment when joy miraculously cured his melancholy — it was a few days after his twenty-fifth birthday.

May 19. Half-past ten in the morning. There is an indescribable joy which enkindles us as inexplicably as the apostle's outburst comes gratuitously: "Rejoice I say unto you, and again I say unto you rejoice." — Not a joy over this or

that but the soul's mighty song "with tongue and mouth, from the bottom of the heart": "I rejoice through my joy, in, at, by, and with my joy"—a heavenly refrain, as it were, suddenly breaks off our other song; a joy which cools and refreshes us like a breath of wind, a wave of air, from the trade wind which blows from the plains of Mamre to the everlasting habitations.[23]

Such joy is an incomprehensible gift that leaves one speechless. Nietzsche pursues what Kierkegaard experienced in that moment in all of his writings.

> Deep is its pain—,
> Joy—deeper still than misery:
> Pain says: Refrain!
> Yet all joy wants eternity—
> Wants deep, wants deep eternity.[24]

The joyful light of this grace fills Ellsworth Kelly's Austin chapel.

LIGHT SHOWS

The distance between Rothko's chapel and Kelly's chapel is far greater than the 165 miles from Houston to Austin. In contrast to the dark, sober tones of Rothko's paintings, Kelly's chapel is a *riot* of light and color; indeed, his art is all about color. While many of his early paintings extended experiments of his predecessors and contemporaries in black and white, Kelly's signature works are exuberantly colorful. Several decades before Kelly began painting, Alexander Rodchenko responded to the black and white of Malevich's *Suprematism* by declaring that in constructivism, "I reduced painting to its logical conclusion and exhibited three canvases: red, blue, yellow. I affirmed it is all over. Basic colors. Every plane is a plane and there is no more representation."[25] What Rodchenko saw as the end of painting, Kelly saw as a new beginning. He uses multiple bright colors on canvases of all shapes—primary colors, but also oranges, purples, and greens of every imaginable shade on irregular and eccentric shapes. This gesture is more radical that it might first seem to be. Since the beginning of modernism, many writers and artists have been suspicious of color; indeed, some go so far as to argue that color appears to be dangerous and, therefore, should be restrained. While black and white were considered to be marks of modernity, maturity, sanity, and masculinity—in short, reason, truth, and honesty—color was regarded by many as primitive, infantile, mad, and feminine—in short, irrational, untruthful, and deceitful. From this perspective, maturity and historical progress can be

measured by the movement from the frivolity of color to the sobriety of black and white. In a section of the chapter on "The Whiteness of the Whale" that I omitted above, Melville rails at color's deceit. "And when we consider that other theory of the natural philosophers, that all other earthly hues—every stately or lovely emblazoning—the sweet tinges of sunset skies and woods; yea, the gilded velvets of butterflies, and the butterfly cheeks of young girls; all these are but subtle deceits, not actually inherent in substances, but only laid on from without; so that all deified Nature absolutely paints like the harlot, whose allurements cover nothing but the charnel-house within."[26] Here color is a dangerous sham intended to cover the inescapable horror of "nameless things."

For other artists, however, color is not demonic but actually appears to be sacred. Think of van Gogh, Monet, Renoir, and, above all, Matisse. Far from overcoming misgivings about color, lending it a sacred aura only deepened suspicions about it. It is precisely the sacred dimension of color that makes it so dangerous to the disenchanted world of modernity. In a characteristically insightful book, Michael Taussig points out that on January 8, 1938, with Europe on the brink of war, Michel Leris gave a talk at the College of Sociology in which he asked his fellow surrealists to consider the question, "What color is the sacred?"[27] The College of Sociology was established by Leris's friend and colleague, Georges Bataille, to explore three lines of inquiry: (1) the interpretation of religion presented by Emil Durkheim in *The Elementary Forms of Religious Life*; (2) the implications of Alexandre Kojève's idiosyncratic interpretation of Hegel's *Phenomenology of Spirit*; and (3) the importance of Nietzsche's reading of Dionysus in *The Birth of Tragedy* and other writings. The thread that draws together these three strands of inquiry is the question of the sacred. For Leris, Bataille, and other members of the college, the sacred does not delineate a sphere of order, meaning, and purpose; to the contrary, the sacred is the domain of transgression that threatens to overturn all organizing structures and laws designed to contain and constrain it.

Inverting the traditional binary in which the sacred provides the rules and regulations that bring order to the chaotic world and human experience, Leris and Bataille argue that the sacred is characterized by excesses that threaten to overturn all organizing laws and structures. In *Theory of Religion*, Bataille argues, "Undoubtedly, what is sacred attracts and possesses an incomparable value, but at the same time it appears vertiginously dangerous for that clear and profane world where mankind situates its privileged domain." Whereas the profane sphere of life sets the individual over against a transcendent God who isolates him or her from other individuals as well as

the surrounding world, the sacred shatters all boundaries. Bataille continues, "Religion, whose essence is the search for lost intimacy, comes down to the effort of clear consciousness which wants to be complete self-consciousness: but this effort is futile, since consciousness of intimacy is possible only at a level where consciousness is no longer an operation whose outcome implies duration, that is, at the level where clarity, which is the effect of the operation is any longer given."[28] Since the sacred eludes conscious articulation, the surrealists were convinced that it could be apprehended affectively only through works of art.

To Leris's question "What color is the sacred?," Taussig, in effect, responds that the color of the sacred is color—not any specific color, but color as such. Since the sacred is inherently transgressive, Taussig admits "color amounts to a crime." "Derived from the Latin *celare*, to conceal, *color* is another word for *deceit*."[29] This is the color of Melville's harlots whose "allurements cover nothing but the charnel-house within." Many artists, writers, and critics continue to share Melville's mistrust of color. This insight brings us back to the black-and-white photographs of my unidentifiable ghosts with which I began and have continued to ponder ever since. Gazing at the *punctum* of the photograph of his dead mother, Barthes reflects, "I am not very fond of Color.... I always feel (unimportant what actually occurs) that ... color is a coating applied later on to the original truth of the black-and white photograph. For me, color is an artifice, a cosmetic (like the kind used to paint corpses)."[30]

Colors are not always the mask of death. "True colors" do not deceive; rather, they reveal the unruly play of appearances, which Hegel famously described as "the bacchanalian revel in which no member remains sober."[31] Truth, Taussig explains, "comes in black and white for our philosophers as much as for us. Shapes and forms, outlines and marks, that is truth. Color, to tell the truth, is another world, a splurging thing, like a prancing horse or a run in a stocking, something, this thing, this formless thing that we need to fence in with lines and marks, the boundary-riders of thought." The effort to restrain color is futile because color is polymorphous and perverse. Exceeding every hard edge crafted to limit it, color flows freely and absorbs those who do not close themselves off from its incantatory rhythms. "Exaggerated, perhaps, but nevertheless the same sensation Nietzsche descried for the Dionysian meaning of absorption into the very being of the Other, as with music and ritual, as contrasted with the Apollonian, meaning controlled vision that holds the Other at arm's length."[32] In Dionysian wisdom, emptiness is fullness, absence is presence, and loss is gain. This is the promise of the colorful light show in Kelly's chapel; its fulfillment, if it comes, is beyond words.

For most of his life, Ellsworth Kelly avoided the city; for forty-five years he lived and worked in the country—Spencertown, New York, forty miles down the road from where I live and write.[33] Kelly grew up in New Jersey before it was overrun by developers. His grandmother, who was an amateur ornithologist, instilled in him a lifelong love of nature. Kelly traced his infatuation with color to the paintings of John J. Audubon his grandmother shared with him. In addition to a love of nature and color, his grandmother also taught Kelly how to draw. Drawing became a form of meditation for Kelly, and for his entire life, he drew almost every day. Most of these drawings were of plants. Though he drew with pen and ink, and did ink washes and water colors, his preferred drawing medium was a graphic pencil.[34] In these spare drawings, his lines are confident and flowing. The beauty of his curved lines reveals the empty space in which forms float as it withdraws around them. One of the most interesting things about these graceful drawings is the way they prefigure the changing shapes of Kelly's most interesting paintings. Looking back on his life's work in 1996, Kelly remarked, "In a sense, what I've tried to capture is the reality of flux, to keep art an open, incomplete situation, to get at the rapture of seeing."[35]

Kelly's formal education began at the Pratt Institute, where he met Albert Munsell, who developed a color system based on hue, value (lightness), and chroma (purity). To illustrate his theory, Munsell created color wheels and charts. His color wheels have five primary hues arranged in order: red, yellow, green, blue, and purple; intermediate hues fade into each other in between the primary colors. Colors opposite each other on the color wheel are interpreted as complementary. Throughout his career, Kelly experimented with different color grids, and eventually used two versions of his interpretation of Munsell's color wheel in his Austin chapel.

Like many in his generation, Kelly served in the army from 1943 to 1946. Unlike his fellow artists, however, his military experience actually advanced his artistic education. He was assigned to "the Ghost Army," which was responsible for developing camouflage for men and equipment. The training Kelly received in the theory and techniques of camouflage was modeled on courses developed at the Bauhaus.[36] In addition to his research on camouflage techniques, Kelly was responsible for designing propaganda posters similar to the ones Russian suprematists and constructivists produced. After the war, Kelly spent six formative years in Paris. During this time, he developed a deep interest in Cistercian, Romanesque, and Gothic architecture. What Kelly learned from countless visits to cathedrals and churches would prove decisive for the design of his chapel. He was also intrigued by the stained-glass windows and mosaics, which reminded him of Munsell's color

wheels and grids. Mark Rosenthal reports that Kelly found in these buildings inspiration for his own art. "He sensed that the people who made these works were filled with a religious feeling, which they conveyed in virtually every detail of their craftsmanship. To emulate this elusive process became Kelly's ambition: to imbue art with his own expressiveness, his own spirituality, not through the depiction of a narrative but through color and form only."[37]

While in Paris, he was friends with Brancusi, Calder, Hans Arp, and, most important, John Cage. In their discussions, Cage persuaded Kelly, who was obsessed with order, to explore the importance of chance in the work of art. Following Cage's advice in the early 1950s, Kelly produced a series of paintings to explore the importance of chance. *Spectrum Colors Arranged by Chance* (1952–53), for example, has a symmetrical grid of forty horizontal bars and forty vertical squares (a total of 1,600), plus 800 black squares. He determined the placement of colors on this grid by randomly drawing their locations out of a hat.[38] By giving up total control, Kelly allows the work to have an unpredictability that comes to fullest expression in the serendipitous play of light in his chapel.

His earlier work in Paris, which was influenced by Klee, Picasso, and Beckman, was figurative. According to Barbara Rose, this changed in 1949 with "the abruptness, inspiration, and finality of a religious conversion."[39] In the initial stages of his shift from figuration to abstraction, Kelly continued the black-and-white tradition of modernist painters. In *Black Square* and *White Square* (both 1953), for example, he refers explicitly to Malevich's black-and-white paintings. In "Malevich's paintings," John Coplans explains, "the viewer 'knows' he is observing a black square on a white ground. However, in Kelly's paintings, which consist of wood surrounded by painted wooden strips, it is the field itself, whether it be a white one or a black one that subjectively or objectively forces its substance or phenomenal existence on the perception of the viewer."[40] Perception rather than object increasingly became the focus of Kelly's work.

When Kelly returned to the United States, he predictably settled in New York City, where by 1957 he had undergone a second conversion—this time from black and white to color. Once again, there was a religious or spiritual dimension to this change. Reflecting on the purpose of his work, Kelly comments, "I want to capture some of that *mystery* in my work. In my paintings, I'm *not inventing*: my ideas come from constantly investigating how things look."[41] In the catalog for Kelly's 1996 Guggenheim retrospective, Diane Waldman goes so far as to suggest that Kelly used color "to create a near-mystical experience."[42] When Kelly fell in love with bright, almost gaudy

colors, the sober and somber atmosphere of black and white gave way to an effervescent *joi de vivre*.

In addition to his conversion to color, there were two other important developments around this time. First, like many other postwar artists, Kelly broke with the three-dimensional illusionistic space that had been characteristic of painting since the Renaissance—his works became flatter than flat. This change was an extension of his growing interest in perceptual experience created by the fleeting impressions of his paintings. Rather than suggesting clear ideas or rational forms, the colored works are directed to preconceptual modes of apprehension. Kelly's greatest innovation, however, was his move away from the rectilinear canvas in order to experiment with a variety of irregular shapes. Throughout the late 1960s and early 1970s, he began developing colorful monochromatic paintings in a variety of shapes and sizes ranging from diamonds, distorted triangles, and rhombi to more biomorphic shapes that recall his elegant drawings of plants. E. C. Goossen points out that "in the beginning he saw his subject matter as an object to be expressed in terms of shape, and ultimately shape itself became the subject."[43] Kelly was convinced that these shifting shapes suggest the flux of experience much more effectively than traditional square and rectangular canvases.

As Kelly's inquiry into the dynamics of color evolved, he moved away from the aleatory selection and placement of colors and toward the very deliberate design of his works. He consistently privileged primary colors and developed a modular system to pair colors in ways that maximize their effect. When these paintings are carefully considered, it becomes clear that color is a contrast effect and, therefore, changes with context. In some works, Kelly slightly separates modules letting the white space of the wall appear. John Coplans offers a helpful observation about this practice. Kelly "uses white as a buffer in the same way musicians use silence (the intervals between sounds in music being positive elements and scored as such). Through these paintings white is cast in a new or extended role to such an extent that its neutrality as ground is effectively destroyed."[44] With the erasure of the ground, figures morph. Instead of preexisting forms to which color is applied, forms seem to dematerialize and shapes appear to be created by the interplay of colors. The result is not a color field that is restricted to a painting hanging on the wall but is closer to a Turrell Ganzfeld that is totally absorbing. There is, however, one big difference—instead of a monochromatic Ganzfeld, the interaction of Kelly's paintings creates a multicolored atmosphere that elides the boundary between viewer and work or subject and object.

In a provocative essay entitled "Ellsworth Kelly's Oratorical Silence,"

David Hickey writes, "Kelly's paintings bestow upon us a tangible way of being alive that seems all too relevant, simply because it is a way of being in the world, not in our heads, or in the text, or in some virtual text-driven alternative."[45] Nowhere is this feeling of being alive more present than in "Austin." Critics, uneasy as always with religion, refuse to call this work a chapel and insist on calling it simply "Austin." While Kelly was an avowed atheist, we have seen that he freely admits that a certain mystery and spirituality inform his art. Furthermore, as I have suggested, atheism might be the most viable spiritual belief in a world mistakenly regarded as disenchanted and secular. Completed three years after his death in 2015, the chapel is Kelly's culminating work. Television producer Douglas Cramer, who brought us "memorable" works like *Dynasty* and *Love Boat*, originally commissioned what became the Austin chapel in 1986 for his vineyard in Santa Barbara. As the significance of the project grew for Kelly, he decided it should be located in a public rather than a private place. Thirty years later, the Blanton Museum of Art, located on the campus of the University of Texas, agreed to build the chapel exactly as Kelly had planned it three decades earlier.

Surrounded by museum and university buildings and open to a broad boulevard with the Texas state capitol building at the opposite end, Kelly's work appears to be discretely modest. The 2,715-square-foot building measures 60′ × 71′ × 26′ and is made of lush white limestone from Alicante, Spain, which is located on the Mediterranean coast. The design of the chapel reflects the influence of Cistercian and Romanesque architecture Kelly had discovered during his Paris years. Two barrel-shaped vaults, which are a smaller version of Judd's redesigned artillery shed, intersect to form a cross. In addition to the white limestone, the distinguishing features from the outside are a nine-square grid of colored glass above the entrance and on opposite ends of the east-west axis, and two versions of a twelve-tone color wheel.

The most obvious precedent for Kelly's work is Matisse's Chapelle du Rosaire in Vence, France (1949–51). Like Kelly's "Austin," Vence was Matisse's last work. Though Kelly visited Matisse's chapel in December 1964, he never acknowledged its influence on his chapel. Nevertheless, the similarities are undeniable. The extravagant use of color that had always drawn Kelly to Matisse's work is on vivid display in his Vence chapel. In many ways, Matisse's chapel actually provides the blueprint for Kelly's design. The bright and colorful atmosphere Matisse creates is all the more remarkable considering the political, social, and personal darkness from which it arose. Vence was the area of Nice that bombs destroyed during the Second World War. At the time Matisse began working on the chapel, his personal condition

was as desperate as the political situation. During the 1940s, he developed cancer and had to undergo surgery, which required a long and difficult recovery. A young woman, Monique Bourgeois, nursed him through his early convalescence, but in 1943, she informed him that she planned to enter the Dominican convent in Vence.[46] They had become quite close and when Bourgeois left to take her vows, Matisse followed her. After entering the convent, she learned that the Dominicans were planning to build a chapel. Bourgeois asked Matisse if he would design the building. Though he had never done anything like this before, he agreed and spent the last years of his life working on the chapel. As time passed, the chapel became ever more important for Matisse. "This work took four years of intensive labor, to the exclusion of all else," he explained, "and it is the culmination of my whole working life. In spite of its imperfections, I regard it as my masterpiece."

In his youth, Matisse had been baptized a Catholic, but he had never practiced the faith. And yet, he freely acknowledged the importance of religion for his work. "All art worthy of the name is religious," he insists. "Any work created from lines and colors: if the work is not religious it does not exist." This conviction grew deeper with the passing years. Looking back on his work in the twilight of his career, Matisse detected a clear trajectory. "I began with the profane and now, in the evening of my days, I am ending quite naturally with the divine."[47] Like Kelly's chapel, the Vence chapel is modest in size—it measures merely 15 m × 6 m. Matisse was involved in the design of every detail from the blue-and-white tile roof outside to the altar and priests' vestments inside. The interior of the chapel is bursting with Mediterranean light filtered through floor-to-ceiling yellow, blue, and green stained-glass windows. Three large murals adorn the walls: *Saint Dominic, The Virgin and the Child*, and *Stations of the Cross*. These works are executed in a calligraphic style with light black lines on white tiles. Matisse's *Stations of the Cross* differs from its predecessors in significant ways. Unlike Newman's and especially Rothko's dark canvases, Matisse's light lines represent the stations in a sequential but nonlinear way with drawings that depict what actually took place at each stage of the journey. The graphic representations of the stages are collaged and numbered around the central image of the crucifixion. The most distinctive feature of this "painting" is the way colors from the light streaming through the windows play over the black-and-white surface of the passion narrative. The light and colors create a space that is alive and constantly changing. Matisse explains, "Within a very restricted space, as the width is only 5 meters, I wished to establish (as I had previously established in paintings measuring only 50 centimeters) a spiritual space, by which I mean a space whose dimensions are not limited by the exis-

tence of the objects represented." He believed his chapel realized his original vision by creating "a church full of gaiety—a space that makes people feel happy. . . . The forms will be of pure color, very bright. No figures, only the outline forms. Imagine the sun streaming through the window—it will cast color reflections on the floor and white windows."[48] I suspect he would have said the same about Kelly's chapel.

I first saw Kelly's chapel shortly after visiting Rothko's Houston chapel and on my way to Marfa to see Judd's and Irwin's work. Passing through the heavy oak doors under the colored glass grid, you enter a magical space created by a kaleidoscopic light show that takes your breath away. At the far end of the north-south axis, opposite to the door, there is a graceful 18′ sculpture carved from a California redwood tree. Each side of the sculpture is slightly curved, creating an interplay of concave and convex. The walls and ceiling, which are as white as the limestone blocks on the outside, form a screen for the display of colors created by sunlight passing through the color grid above the door and the adjacent color wheels on opposite ends of the east-west axis. These color wheels derive directly from Munsell, who, recall, was Kelly's teacher at Pratt. Kelly had been interested in the relationship of different shades in the spectrum since his student days. In works extending from *Study for Spectrum IV* (1967) to *Spectrum IX* (2014), he develops the design and relationship for colors that he uses in the chapel windows. One of the color wheels consists of twelve squares, the other of twelve spokes *around* an empty circular center. The order of the colors is the same in both windows. Moving clockwise, there is a progression from light yellow through green and blue to dark red, and then through lighter red fading to orange, and back to yellow. The trajectory is clear: from light through darkness, and back to light. The squares are separated and joined by the silence of white space. In these color wheels, there is no black to swallow the rosy red. The nine-square grid above the door suggests a similar pattern. Each of the three primary colors—red, yellow, and blue—is accompanied by two intermediate shades that fade into each other.

What no photograph can capture is the dynamism of these colors as they appear on the white walls and gray granite floor. If you are patient enough to spend enough time *in* this work of art, it actually changes before your eyes. As the sun moves across the sky, the color wheels become sundials turning as they mark the passing hours. In addition to this, the intensity of the colors changes with the time of day, the seasons, and the conditions of the sky. A final interior feature completes Kelly's work. Like Newman, Rothko, and Matisse, Kelly has created his version of the Stations of the Cross. His interpretation could not be more different than Rothko's moody paintings.

Kelly's work is closer in tone to Matisse's Stations whose slender lines recall Kelly's plant drawings. However, while Matisse's images are explicitly representational and his collage of the Stations is nonlinear, Kelly's interpretation of the Stations is at first glance abstract and maintains the narrative line of Jesus's passion. He depicts each station with an identically sized relief panel made from black and white marble. The reliefs are displayed in a straight line that runs along both walls on both axes. When you study these reliefs carefully, you realize that even though they are abstract, they are implicitly representational. Each abstract form suggests what occurred at each particular station of the cross. This creates a narrative line that involves a different temporality than the revolving color wheels reflecting the rotating sun. What is most distinctive about Kelly's Stations is that the black-and-white reliefs are overwhelmed by colorful light that plays over them. It is as if the stations were the backdrop, perhaps even the pretext for the uplifting light show Kelly stages.

Though there is no evidence Kelly ever studied Kierkegaard, he understood *Fear and Trembling* better than Rothko for whom the text was virtually sacred. Rothko was Kierkegaard's "tragic hero" who made the first movement of faith, infinite resignation, in which he felt "pain in renouncing everything, the most precious thing in the world." The "knight of faith," by contrast, does not stop with infinite resignation but makes a second move in which he recovers what he had given up. This double movement completely transforms life. For Rothko, the walls were closing in; for Kelly, they were opening out. Rothko could make only the first move and gave up everything by killing himself; Kelly makes both moves and ends by affirming life. To read Kierkegaard merely as the prophet of doubt, dread, and despair is to miss or ignore the second movement of faith. Commenting on the knight of faith in one of the most important passages in Kierkegaard's entire *oeuvre*, Johannes de Silentio writes,

> The whole earthly figure he presents is a new creation by virtue of the absurd. He resigned everything infinitely and then he grasped everything again by virtue of the absurd. He is continually making the movement of infinity, but he does it with such precision and assurance that he continually gets finitude out of it, and no one ever suspects anything else.... The knights of infinity are ballet dancers and have elevation. They make the upward movement and come down again, and this, too, is not an unhappy diversion and is not unlovely to see. But every time they come down, they are unable to assume the posture immediately, they waver for a moment, and this wavering shows that they are aliens in the world.... One does not need to see them in the air; one needs

only to see them the instant they touch and have touched the earth—and then one recognizes them. But to be able to come down in such a way that instantaneously one seems to stand and walk, to change the leap into life into walking, absolutely to express the sublime in the pedestrian—only that knight can do it, and this is the one and only marvel.[49]

The sublime in the pedestrian, the beautiful in the ordinary, the sacred in the profane, light in darkness—this is what Kelly's chapel reveals. In this space, the *Via Dolorosa* becomes the *Via Jubilosa*. Neither beyond nor within, neither above nor below, neither circumscribed nor limited to a place set apart, the sacred is all *around* us. To follow the stages on life's way Kelly charts is to come through the dark night of the soul and to discover gaiety, gladness, joy—perhaps even hope. Matisse might well have been thinking of Kelly's chapel as well as his own when he wrote, "The lightness gives a feeling of release, of freedom; to the extent that my chapel does not say: Brothers"—and I would add, Sisters—"you must die. It says the reverse: Brothers" and Sisters "you must live."[50]

THE BIRTH OF ART

He suffered so much—isolation, loneliness, migraines, fainting spells, seizures, and finally silence: silence year after year until the final silence took him. And yet, he danced, he loved to dance. In *The Joyful Science* [*Die Fröliche Wissenschaft*],[51] Nietzsche writes, "When the proper tension and harmony of the soul had been lost, one had to *dance*, following the singer's beat: that was the prescription of this therapy." Nietzsche followed this therapy by dancing every day, yes, *every day*. With whom did he dance? Could he really dance alone? Where did he dance? Why did he dance on and on *through the night*? Though he spent his days feverishly reading and writing, Nietzsche disdained scholars as feeble in body, mind, and soul. *"Faced with a scholarly book.*—We do not belong to those who have ideas only among books, when stimulated by books. It is our habit to think outdoors—walking, leaping, climbing, dancing, preferably on lonely mountains or near the sea where even the trails become thoughtful. Our first questions about the value of a book, of a human being, or a musical composition are: Can they walk? Even more, can they dance?"[52] How would Nietzsche have responded to Kelly's chapel? Would he have heard its music? Would he have understood it to be a temple to a dancing god?

I suspect Nietzsche would have focused on two details about the color grid and the redwood sculpture I failed to mention. Taken together, these

details infinitely expand the work of art. The fascination with grids was wide-spread among modernists. As Rosalind Krauss argues in her classic essay, grids function either restrictively or expansively in myths and science as well as in works of art. On the one hand, when subjected to a structuralist analysis, the oppositional either-or logic of the grid restricts because it *excludes* whatever disrupts rational order; on the other hand, the grid can function *inclusively* and expansively. "Logically speaking," Krauss argues, "the grid extends, in all directions, to infinity. Any boundaries imposed upon it by a given painting or sculpture can only be seen—according to this logic—as arbitrary. By virtue of the grid, the given work of art is presented as a mere fragment, a tiny piece arbitrarily cropped from an infinitely larger fabric. Thus the grid operates from the work of art outward, compelling our acknowledgment of a world beyond the frame."[53] The same expanding and contracting operation is at work in the sculpture that stands in the place of the traditional altar. On the one hand, the circles form an enclosure that circumscribes and contains, thereby excluding what lies beyond their edge. On the other hand, the curves that delineate the two sides of the sculpture are sections of two large circles whose radii extend far beyond the interior of the chapel. These curves are close to each other but do not touch. The sculpture emerges in the negative space between the two. Alternatively, the sculpture delineates circles that expand the work of art beyond what appear to be any confining limits. Though the squares and grids, and circles and wheels are opposite forms, they display the same rhythm of expansion and contraction. The infinitely expanding grid and circles carry the sacred space of the chapel out into the profane world and bring the profane world into the chapel, thereby transforming both. Not one, not two, but one-in-two and two-in-one.

For all the diversity of Nietzsche's fragmentary writings, his work has a remarkable consistency that revolves around the Greek god Dionysus. From his first to his last works, Nietzsche's vision is shaped by his idiosyncratic interpretation of Dionysus. As I have noted, Nietzsche signed the last fragments he wrote before slipping into terminal silence "Dionysus." Dionysus is also the focus of his early work—*The Birth of Tragedy*. Though Nietzsche was trained as a philologist, he was too imaginative and creative to be constrained by the rules and regulations of the university. The ostensible topic of his qualifying dissertation was tragedy, but his true subject was the birth of art. *The Birth of Tragedy* is a philosophy of art that is a philosophy of life. Nietzsche's most enduring conviction was that "this world can be justified only as an aesthetic phenomenon." The Madman's declaration of the death of the transcendent God is at the same time the announcement of the birth of

an immanent God, who is "the supreme artist amoral, recklessly creating and destroying, realizing himself indifferently in whatever he does or undoes, ridding himself by his acts of the embarrassment of his riches and the strain of his internal contradictions."[54] The internal contradictions of the work of art are a function of the contending drives Nietzsche labels Apollonian and Dionysian. Apollo, Nietzsche argues, is "the observer of limits," who "demands self-control." By establishing the boundaries within the self as well as between self and world, Apollo becomes the "apotheosis of the *principium individuationis*." Dionysus, by contrast, is the principle of "de-individuation" that overflows every limit designed to contain it. While neither Apollo nor Dionysus can exist apart from the other, Nietzsche does not value them equally. He privileges Dionysus, who is the destructive-creative "vortex" of the "primordial Being" whose infinite restlessness issues in the "constant proliferation of forms pushing into life." This is the principle through whose "extravagant fecundity" the world is created. To name God an artist is to declare creativity divine and to deem the world a work of art. "The Dionysian element, as against the Apollonian, proves itself to be the eternal and original power of art, since it calls into being the entire world of phenomena." To participate in this creativity is to become nothing less than a moment in the life of the divine. Zarathustra, who, like the knight of faith, "moves like a dancer," comes down from the mountaintop to declare this gospel. "I tell you: one must harbor chaos if one would give birth to a dancing star. I tell you: you still harbor chaos within you."[55] This birth is the most profound joy. After saying "Yes!" to this overwhelming joy, Nietzsche fell into eternal silence. Is it possible to live *with*, perhaps even *in* this silence?

12.

. . .

13.

WITH

The calculations necessary to right placement of stone are not performed in the mind but in the blood. Or they are like those vestibular reckonings performed in the inner ear for standing upright. I see him standing over his plumb bob which never lies and the plumb bob is pointing motionless to the unimaginable center of the earth four thousand miles beneath his feet. Pointing to a blackness unknown and unknowable both in truth and in principle where God and matter are locked in a collaboration that is silent nowhere in the universe and it is this that guides him as he places his stone one over two and two over one as did his fathers before him and his sons to follow and let the rain carve them if it can.

CORMAC MCCARTHY

TENDING GARDENS

Everything begins in a garden. I have been tending gardens my whole life, sometimes the gardens of others, sometimes gardens I realize are never really my own. Vegetable gardens and flower gardens—practical and decorative, utilitarian and nonutilitarian. When I was young, my education began outside classrooms by the side of my father, who had been raised on a Pennsylvania farm with no electricity, running water, or mechanized equipment to plow the fields and tend the apple and peach orchards. Though he eventually became a science teacher in a suburban New Jersey high school, the most important lessons he taught me could not be found in books. His pedagogy began in our flower and vegetable gardens. He did not explain what he was trying to accomplish but taught by making me imitate what he was doing.

When he thought I had learned enough, he sent me first to neighbors and then all over town to tend gardens for people who thought they didn't have time to do it themselves. My father was a strict taskmaster, and I didn't always enjoy working while my friends were playing. But even at an early age, I somehow knew that he was trying to teach me something important that could not be put into words.

It has taken me many years to begin to understand those early lessons. He was teaching me how to see, feel, smell, touch, and hear differently. This lifelong science teacher was convinced that education does not begin and end with ideas, but requires something deeper, something more profound that can be taught only through physical labor and bodily discipline. This discipline, he showed me, cultivates important values that are sorely lacking in today's noisy high-speed world—patience, concentration, attentiveness, care, tact, openness, and wonder. He never read Nietzsche but surely would have agreed with his admonition to "stay true to the earth"; he too distrusted people who spend their days sitting behind a desk and looking at the world through a window. "*Humus*," Robert Pogue Harrison reminds us, "grounds the human."[1] In his marvelous book, *Dirt: The Ecstatic Skin of Earth*, William Bryant Logan writes, "Hospitality is the fundamental virtue of the soil. It makes room. It shares. It neutralizes poisons. And so it heals. This is what the soil teaches: If you want to be remembered, give yourself away."[2] People who do not get their hands dirty by digging in the earth are less than human.

For all his love of earth, my father did not appreciate rocks. Trudging behind his mule-drawn plow while cultivating 12-acre fields, rocks were obstacles that had to be removed. As I helped him spade by hand our 60′ × 80′ vegetable garden every year, I too found rocks a nuisance. No matter how many we hauled away, each spring the earth spit up more. My father never taught me to pause and listen to stones. That lesson I had to learn from my geologist son, Aaron. While he was doing fieldwork in the Wind River Canyon in Wyoming, he found a large beautiful piece of petrified wood and somehow managed to bring it home to give me as a gift. I designed a steel stand to display it in my study. For many years, it stood silently near the desk where I write, but I did not take time to listen to what the stone was saying. To learn the lesson stones teach, I had to travel to the other side of the world.

In the spring of 1992, I received an email from Cynthia Davidson that read simply: "Meet at Frank Gehry's Fish Restaurant in Kobe on . . . at . . ." During the 1990s, Cynthia and her husband Peter Eisenman ran a series of an-

nual conferences in a different city each year under the auspices of their corporation, Architecture New York (ANY). These meetings brought together architects, artists, writers, philosophers, and critics from all over the world to consider architecture at the end of the millennium. The conversations and debates were not limited to architecture but ranged over broader cultural, social, political, and economic questions. The group that met in Kobe included Rem Koolhaas, Daniel Libeskind, Elizabeth Diller, Jeff Kipnis, Frederick Jameson, Jacques Derrida, and an architect I had never met—Tadao Ando. The conference that year was organized by the well-known Japanese architect, Arata Isozaki, and was held on the island of Kyushu, which is known for its natural beauty and exceptional hot springs. After dinner at the Fish Restaurant, everyone took an overnight ferry to the island. Over the course of the next three days, I became increasingly intrigued by Ando not because of what he said but because of what he did not say. He never broke his silence by uttering a single word. Though others explained that this was because he didn't know English, I suspected something else was going on. Several decades later, I unexpectedly heard Ando's silence again.

Having never been to Japan, I spent the weeks before and after the conference visiting Tokyo and Kyoto. What I found most memorable about this trip was the rock garden in the Kyoto Ryōanji Temple. In the early 1990s, everyone was reading French philosophers and critics, many of whom were arguing that all culture could be interpreted through an expanded notion of writing. Twenty years earlier, Roland Barthes had published his influential book on Japan, *The Empire of Signs*, which was, in effect, required preconference reading. In the first chapter, "Faraway," Barthes muses, "Writing is, after all, in this way, a *satori*: *satori* (the Zen occurrence) is a more or less powerful (though in no way formal) seism which causes knowledge, or the subject, to vacillate: it creates *an emptiness of language*. And it is also an emptiness of language which constitutes writing; it is from this emptiness that derive all features with which Zen, in the exemption from all meaning, writes gardens, gestures, houses, flower arrangements, faces, violence."[3]

If gardens are a form of writing, the question becomes, How are they to be read? François Berthier develops a thoughtful response to this question in *Reading Zen in the Rocks*.

Is there a language of stone? A few unhewn rocks distributed on an expanse of gravel—could they be delivering a message? This is ultimately the question posed by the garden at Ryōanji in Kyoto. This garden is disconcerting through its not really being a garden: there is no green of trees to be seen, no scent of

flowers to be caught, nor any birdsong to be heard. This desertlike space is enigmatic, an arid area where just fifteen rocks measure themselves against the immensity of the void. Five centuries old, the garden of Ryōanji is a surprisingly modern work of art. It is also a place where the human being can read in the dark mirror of stone, the mystery that he carries within.

The writing in Barthes's cryptic texts and Berthier's enigmatic gardens does not involve the transcription of ideas and concepts into verbal representations. Rather, the notion of writing they discuss is performative or, in different terms, a form of practice. Berthier quotes the fourteenth-century Zen monk Musō Soseki's *Dream Dialogues*: "He who distinguishes between the garden and practice cannot be said to have found the way." "What the great monk meant," Berthier explains, "was that to create a garden is a way of practicing Zen. Such an assertion implies close connections between the art of the garden and the search for truth."[4]

Ever since Neolithic times, rocks have been regarded as sacred in Japan and China. In his twelfth-century *Stone Catalogue of Cloudy Forest*, Du Wan writes, "The purest energy of the heaven-earth world coalesces into rock. It emerges, bearing the soil. Its formations are wonderful and fantastic.... With the size of a fist can be assembled the beauty of a thousand cliffs."[5] The energy rocks were believed to possess made them the focus of ritual and meditative practices. In Zen Buddhism, according to Berthier, the art of rock gardens goes back to the fifth century. In many early gardens, water, whether in ponds, lakes, streams, or waterfalls, was an essential element. The father of the Zen rock garden was Musō Soseki (1275–1351).[6] While some of Musō's designs involve elaborate water features, he also made original contributions to dry landscape gardens. In these gardens, water usually is represented with white gravel or sand, which is carefully raked to suggest ripples or small waves surrounding rocks that appear to be islands or mountains emerging from the liquid expanse.

Ryōanji Temple was founded in 1450 by then prime minister Hosokawa Katsumoto, but it burned down during a period of civil war.[7] The current garden, which dates from 1507, is 2,670 square meters and is bordered on three sides by a low wall with a tile overhang. On the fourth side, there is an open wooden pavilion with an elevated viewing platform. The garden is surrounded by pine, maple, and flowering trees that add a touch of color in spring and fall. The central feature of the garden is a large expanse of carefully raked white gravel, interrupted by fifteen rocks arranged in five groups each of which is encircled by a narrow border of green moss. Mov-

ing from east (left) to west (right), these groups have different numbers of rocks: five, two, three, two, three. Number symbolism is very important in Zen. Odd numbers and asymmetry (*Fukinsei*) create dynamic tensions and are privileged over even numbers whose balance is regarded as entropic. In this scheme, Berthier explains, the number five "is accorded special significance: situated in the middle of the first nine numbers, it is the symbol of the center. Hence the theory of the five primordial elements: wood (east), fire (south), earth (center), metal (west), water (north). This originally Daoist schema gave rise to the cosmic diagram of the central mountain surrounded by four others situated at the cardinal points. Thus 5, as the pivotal number, marks the axis of the world around which the four directions are arrayed."[8] My colleague Michael Como elaborates this point. "Understanding how the Five Phases of matter interact allows one to pattern one's life in an enormous number of areas, which can be grouped in terms of five—there are five colors, five tastes, five visible planets in the sky, five sense organs in the human body, even five directions, including the center as the most fundamental direction. Five is really the basic template for Chinese aesthetics, cooking, astrology, and medicine."[9]

In addition to the significance of the groupings, each rock is positioned to indicate a distinctive vector of force that creates a sense of movement among seemingly inert objects. David Slawson uses the analogy of dancing to explain this unexpected feature of rock gardens. "Rocks and trees can move as well as move the viewer. In the choreography of a modern dance or ballet, it is the specific quality of the feeling or sensation being expressed by the dancers that determines the force and direction of their movement. For example, a broad, upward-sweeping gesture of the arm raised to the oblique, with the dancer's eyes cast in the same direction, can suggest aspiration. The classical Japanese garden designer is in this sense a choreographer, with rocks and trees as his chosen dancers." He cites a garden manual entitled *Sakuteiki*, written by Tachibana no Toshitsuna (1028–94), to elaborate his point. "You should set rocks bearing in mind the three forces—horizontal, diagonal, and vertical.... These three are equivalent to the triad, Heaven, Earth, and Man. First of all, set these three together at one spot that is to be the focal point. Once you have set the triad—Heaven, Earth, and Man—and then planted an upright tree to complement it, the result is a flawless gem fit for a king. ... It is said that when you compose the garden next to the residence in this way, the occurrence of misfortune is avoided by virtue of the garden."[10] In this scheme, human beings are suspended between heaven (vertical forces) and earth (horizontal forces). The rocks not only suggest motion but be-

come virtually animate. The instruction manual repeatedly warns that when determining proper placement, the gardener must "follow the request [of the rock]."[11] It is important never to place vertically a rock that had been horizontal or to place horizontally a rock that had been vertical.

Two additional interrelated principles inform the design of rock gardens. The first is framing. In addition to the surrounding walls, the Ryōanji garden is framed with a border consisting of two perfectly rectilinear rows of light gray stone separated by dark gray and black rounded stones randomly placed between them. This creates the effect of a picture frame around a painting that is reminiscent of an ethereal Japanese ink drawing in which emptiness and form figure and refigure each other. A second framing device results from arranging the rock groupings to be ideally viewed from a sitting position located in the center of the veranda on the open side of the garden. The pavilion functions like one of the windows in Irwin's installation in Marfa. This framing strategy is directly related to the final design principle—*Miegakure*, which means "hide and reveal." The five clusters of rocks are arranged to make it impossible to grasp the whole garden from any one perspective. Every line of sight simultaneously reveals and conceals different rocks. Once again the *Sakuteiki* manual is illuminating. *Miegakure* "relies heavily on the principle of overlapping perspectives and involves making only part of an object visible, rather than exposing the whole. The purpose is to make the viewer imagine the invisible part and thus create not only an illusion of depth but also the impression that there are hidden beauties beyond. *Miegakure* is, in short, a means of imparting a sense of vastness in the small space."[12] This sense of vastness makes it possible to apprehend the macrocosm in the microcosm and the infinite in the finite.

When the subtlety and complexity of the Ryōanji rock garden are understood, it becomes clear that the temple is a sacred space that provides the setting for ritual processes. To maintain the aesthetic effect of the garden, monks must carefully rake the white gravel every day. This raking is a form of meditation that is done rhythmically and silently. Physical activity changes one's frame of mind by engendering an affection that colors thinking and shapes action. The proper maintenance of the garden creates the condition for a second ritual practice—Zazen. The garden becomes, in effect, a zendo, which serves as a meditation hall. Berthier imagines what rocks in a dry landscape rock garden might be saying. "I am nothing but blocks of stone on pieces of gravel. I am nothing but weight and silence, inertia and density. Nothing will ever learn my secret, or even whether I contain one. The only thing that can penetrate me is the strident cry of the cicada that pierces the

heart of summer. Be content to taste the raw beauty of my opaque flesh; look at me without saying a word and ask me nothing; be silent and try, through my hermetic body, to find yourself."[13] This is the silence that echoes in what one visitor aptly described as this "garden of emptiness."

Set off from the noise of the city, the Ryōanji rock garden functions like a haiku. "All of Zen, of which the haiku is merely the literary branch," Barthes explains, "appears as an enormous praxis destined to *halt language*, to jam that kind of internal radiophony continually sending in us, even in our sleep ... to empty out, to stupefy, to dry up the soul's incoercible babble."[14] When the incessant noise ends, true silence begins. The Zen master Tōzan Ryō-kai is reported to have told his followers, "If we hear the sound through the eyes, we are able to know it."[15] The sound you hear through your eyes in the Ryōanji rock garden is the silence that tolls in the white space between the rocks.

The most memorable feature of the Kyoto temple is not what is there but what is not there — not the islands of stone, but the vast white sea upon which they float. In a manner similar to Heidegger's *aletheia* and Derrida's *khora*, emptiness and form are not opposite but actually coincide. In the well-known words of the *Heart Sutra*, "Form is Emptiness and Emptiness is Form."[16] The name of this unnamable void is *"Ma."* *Ma* is the interval or clearing that allows everything that exists to be articulated. It can refer to gaps in Japanese music, pauses in dance, and the distance between host and guest in the tea ceremony. Nishida Kitarō maintains that *Ma* is also the central philosophical "concept" in Zen. Like the void of Heidegger's jug and the interval between the two infinite circles that allows Kelly's redwood sculpture to emerge, this gap is no-thing — no determinate thing; rather, it is the "self-transforming matrix" of all things.[17] In this interval, the substance of things dissolves in an effervescent event. "This nothingness," Kitarō argues, "is grounded in the contradictory identity of the creative world, which is self-transforming through the dialectic of its own negation and affirmation. At the ground of the self, therefore, there must be that which, in its own absolute nothingness, is self-determining, and which, in its own absolute nothingness, is being. I believe this is the meaning of the ancient Buddhist saying, 'Because there is No Place in which it abides, this Mind arises.'"[18] The place that is no place is everywhere as the unnamable groundless ground of all presence and every present.

In *Religion and Nothingness*, Itiaro's student, Keiji Nishitani, elaborates this insight by the notion of *Ma* as "interval, gap or space." Endless chatter and incessant noise mute the silence of the absolute void at the heart of

existence. The rhythmic pulsation of this interval is *neither* the both/and of unifying identity *nor* the either/or of oppositional difference. In Nishitani's words, "we do not presuppose a separation of subject and object and then work toward their unification. The unity of the absolute near side is not the result of a process but rather the original identity of absolute openness and absolute emptiness. Its standpoint is neither a monism nor a dualism of any sort." When negation is doubled in the nihility of neither/nor, nihilism is sublated, and, in a manner similar to Nietzsche, "No" becomes "Yes."

> Emptiness is the field on which an essential encounter can take place between entities normally taken to be most distantly related, even at enmity with each other, no less than between those that are most closely related. This encounter is called "essential" because it takes place at the source of existence common to the one and the other and yet at a point where each is truly itself. . . . Indeed, it is even inadequate to speak any longer of an "encounter." Just as a single beam of white light breaks up into rays of various colors when it passes through a prism, so we have here an absolute self-identity in which one and the other are truly themselves, at once absolutely broken apart and absolutely joined together.[19]

Colors mingle without melding in the white light at the limit of Irwin's horizon, on the surface of Kelly's walls, and in the finely raked gravel between Ryōanji's rocks. To see this light is to hear the silence that is vital for life. At the end of his journey through the temple garden, Berthier reflects, "But all one has to do is to sit at the edge of the garden and stop up one's ears. Then the miracle happens. In the great silence that is thereby regained, the spontaneous beauty of these rough rocks surges forth, and their immortal chant ensues, the substance of which is this: Beyond the weight of matter there resides Spirit, without which one can never truly live."[20] John Cage heard this silence when he visited the Ryōanji temple for the first time in 1962.

An avid gardener most of his life, Cage drew lessons for composing from gardening. Whether a rock garden or a musical score, the work of art is a matter of spacing and timing, rhythm and pace, sound and silence. These are the principles Cage saw in Ryōanji. In his informative article "Digging in John Cage's Garden: Cage and Ryōanji," Stephen Whittington writes,

> "Empty" space is important in gardens; one might say that in a garden the stones and plants are there to articulate or energize the space, rather than

space being merely a blank canvas for the arrangement of objects. A careful balance is maintained between "empty" space and the things that (often sparsely) occupy that space. For Cage "empty" space equaled silence, a relative rather than an absolute concept, a field in which sounds can occur. A figure-ground shift can occur in a garden if one contemplates the space between the rocks, rather than the rocks themselves; in a similar way, Cage's music invites the contemplation of the "silence" between sounds as much as the sounds themselves.[21]

Cage was always interested in the relationship between audio and visual experience in art. As we have seen, his ode to silence, *4'33"*, was inspired by Rauschenberg's White Paintings. In the later years of his life, Cage became increasingly preoccupied with the interrelationship of audio and visual aspects of experience in the work of art. He became so intrigued by the temple rock garden that he did a series of fifteen pencil drawings entitled *Where R = Ryōanji*, which he created by tracing the edges of different stones. Some of these drawings look like Cy Twombly's scribbles and others like Kelly's delicate plant drawings. The main difference between Cage's drawings and the design of the Ryōanji garden is the role he gives to chance. While the creators of Zen gardens expressed their creativity by responding to the requests of the rocks in the context of the site, Cage let chance determine which stones to use, their positions, and the hardness of the pencils with which he drew.

Applying the lessons learned in gardening to composition, Cage used his drawings to create a musical work he named *Ryōanji* (1983–85). "The scores of the 'Ryōanji' were made by drawing around paper templates of the stones placed at chance-determined points in the total garden, using different kinds of lines (straight, dash, dotted, and dash-dot) drawing from left to right." Each of the twenty orchestra members selected a single sound that he or she used for the whole performance. Cage insists that the visual appearance of the score reflects the audio experience of the performance. He explains, "I think of the garden or the space for the fifteen stones as being four staves, or two pages—each page having two staves. And the staves are actually the area of the garden. . . . I think that with proportional notation, you automatically produce a picture of what you hear. Perhaps more so in 'Ryōanji.' The solo instruments correspond to the rocks, while the percussion parts 'are the raked sand' of the garden."[22]

More than twenty years earlier in his "Lecture on Nothing," Cage had written,

```
                                                       But
now        .                   there are silences                      and the
words      make                help make                               the
silences   .                                      the
                                   I have nothing to say
       And I am saying it                                and that is
             This space of time                               is
organized
                           We need not fear these          silences, —
       We may love them.²³
```

As we have been discovering, there are many silences that engender different affections and reflect various dispositions. Furthermore, people in different religious traditions hear alternative sounds of silence. Japanese philosopher Shizuteru Ueda identifies three levels of silence in Zen Buddhism.

1. The first silence is called *damaru* and means Not speaking, to say nothing in the world of language, i.e., to say nothing during a meeting.

2. The second term is *chin-moku*—*chin* for sinking; *moku* for silence—meaning silently to sink to the bottom through silence. In a pensive silence related to the world of language, but with an inkling of the absolute silence of infinite openness.

3. The third silence is called *moku*; this is originally a Buddhist term and implies "silence per se." The idea is silently to enter the absolute realm of infinite stillness, which is not disturbed by speaking and cannot be broken, but rather endows speaking with a depth of meaning.²⁴

Cage sought *moku* in his life and art; by living *with* silence, he believed he might find "the realm of infinite stillness." His drawings and music are audiovisual aids intended to teach others to see the silence he saw in the Ryōanji rock garden.

DIGGING DEEPER

In the years following the ANY conference, I thought about Ando's architecture from time to time but did not undertake an investigation of it. The title of the conference that year was "Anywhere." Over the course of three days, participants presented thoughtful explorations of the significance of the interrelated themes of mobility and place for modern and postmodern architecture. When modern architecture was imported from Europe in

Philip Johnson's 1932 exhibition at the Museum of Modern Art, he labeled it "International Style." As this name implies, modern architecture privileges generality and universality over particularity and locality. This led to the deterritorialization of architecture, which reflected modern life. The digital revolution accelerated processes of the dematerialization of culture and the economy in emerging global networks. While modernism and postmodernism differ in many ways, they both regarded these developments positively and were committed to promoting them. Modernists sought to create uniform designs that were flexible enough to be located *anywhere*. Postmodernists rejected modernists' Puritanism that stripped buildings bare, but accepted the delocalization of architecture by appropriating images *anywhere* they could find them and applying them like stickers on bare surfaces. Both of these movements directly opposed site-specific art and land art like the work Turrell and Heizer began in the late 1960s.

As I continued my exploration of the postmodern culture of simulacra, emerging network culture, and global financial networks, I began to have reservations about the way these technologies transform minds and bodies and literally change the face of the earth. As a result of these misgivings, I began an intensive inquiry into the abiding importance of place. In addition to researching and reading about the interrelated issues of space and place, I decided to take philosophy off the page by beginning to create art on Stone Hill, where I live in the Berkshires. The direction of this work was determined by chance. In August 2006, I decided to clear a wooded area that I had looked over from my study window for years. I had no plan, and I really did not understand why I felt compelled to begin what would become an endless project. I cut down many big trees and cleared thick undergrowth. When I hauled away the brush, I discovered a beautiful rock outcropping. After thinking about what to do with this rock for several days, I finally decided to create a Japanese rock garden similar to the one I had seen in Kyoto. In preparation for this work, I researched the tradition of rock gardens in China and Japan, and read more deeply in Buddhist philosophy. I had always suspected that there are deep continuities between certain strands of Buddhism and the philosophers who are most important for me—Hegel, Kierkegaard, Nietzsche, Heidegger, and Derrida. For the past twelve years, these aesthetic and philosophical ideas have shaped my work on Stone Hill as it has expanded from cultivating gardens of earth and stone to creating steel, stone, and bone sculptures. Four of the books I wrote during this period are related to the art I was creating: *Grave Matters*; *Mystic Bones*; *Refiguring the Spiritual: Beuys, Barney, Turrell, Goldsworthy*; and *Recovering Place: Reflections on Stone Hill*. This art and these books have led to two art exhibitions:

Grave Matters (2002) at the Massachusetts Museum of Contemporary Art and *Sensing Place: Reflections on Stone Hill* (2016) at the Sterling and Francine Clark Institute.[25]

As my work progressed, seemingly unrelated strands began to come together in unexpected ways. In the fall of 2001, the Clark Art Institute announced that Ando had been hired to design an addition to the museum. Disagreements about the program and financial difficulties delayed the project. By the time I had created my first rock garden and was exploring ways to expand the work, Ando's design was becoming a reality. The Clark, which is on the north end of Stone Hill, and my place, which is on the south end, are connected by a woodland path that, unlike Heidegger's *Holzweg*, does not lead nowhere. Recalling my encounter with Ando in Japan, I began researching his work and was surprised by two discoveries. First, Ando insists that place matters not just for architecture but also for life. All of his work involves an indirect or direct criticism of the modernist preoccupation with universality, homogenization, and placelessness, and the postmodern cult of floating signs and images. Second, though Ando does not flaunt his interest in philosophy, his work resonates with Kyoto school philosophers. His aesthetic is deeply informed by the Zen principles of design on display in Kyoto's Ryōanji rock garden. I began by turning to a major catalog of his work, where, much to my surprise, I found that Ando devoted his brief introduction to the idea in Zen that I found most interesting. Ando's work, Tom Heneghan suggests, "is an architecture reduced to extremes of simplicity, and an aesthetic so devoid of actuality and attributes that it approached ... 'nothingness.'"[26] In an essay entitled "Thinking in *MA*," Ando writes,

> I want to nurture space into being with care, attentive to craftsmanship. That same space, however, I am resolved to pry open using the harshest force. The delicacy that is distinctive of Japanese, and of Eastern, sensibility I seek to infuse with intense originality. Japan's traditional architecture is marked by subtle coloring, obtained in the vertical and horizontal lines of its wood structure by assiduous handling of fragile substance, like natural wood, paper, and earth; and by the depth achieved through artful arrangement of sequence. Within it, there is gentleness in the meeting of parts, in the merging of orchestrated views, and the transition between inside and outside flows. The resulting space attains the fineness of silk cloth.... The gap between elements colliding in opposition must be opened. This gap—the *ma* concept peculiar to Japanese aesthetics is just such a place. *Ma* is never a peaceful golden mean, but a place of the harshest conflict. And it is with *ma* thus informed with harshness that I want to continue and to provoke the human spirit.

Ando's statement is fraught with contradictions: nurture, care, delicacy, fragility, gentleness, the fineness of silk cloth, and yet, "elements colliding in opposition," prying open space "using the harshest force" to find the "place of harshest conflict." Far from avoiding such contradictions, Ando cultivates them because he is convinced they vitalize architecture. "They are ... contradictions," he continues, "I seek not to avoid, but always to meet head on in my pursuit of architecture within actual architectural practice. For it is such conflicts as these that promise to liberate Japanese architecture from its imprisonment in the *museum of tradition* and temper it anew."[27] By meeting these contradictions head on, Ando attempts to negotiate the oppositions that tear apart self and world. "For me," he writes, "architecture is the reconciliation or synthesis of opposing concepts; it arises from the subtle interstices of conflicting ideas. In other words, it is the sublimation of polar opposites—inside and outside, east and west, part and whole, history and the present, art and reality, past and future, abstract and concrete, simple and complex."[28]

With this twist, the path I had been following unexpectedly returned to the beginning, which, I realized, I had never left behind. From origin to end, and end to origin; from Turrell and Ando to Ando and Turrell, and back again; from religion to art to religion; from birth to death to rebirth; from living without silence to living with silence to living and dying in silence. As we have seen, Georges Bataille argues in *Lascaux, or The Birth of Art* that both art and humanity originate in a cave. "Lascaux provides our earliest *tangible* trace, our first sign of art and also of man."[29] Though Ando never mentions Bataille, he shares his preoccupation with origins and traces the origin of both architecture and his personal interest in architecture to caves.

> In the forty years since I decided to become an architect, I have been looking for my own "matrix of space," which in my imagination is an obscure place like a cave surrounded by thick, heavy walls of earth, or a space in the darkness lit only with a dim ray of light.
>
> These images do not derive from a phenomenology of space, but rather from physical—and unconscious inclinations of my own. In search of their origin, places from the past come to mind: such memories as dusky rooms of the house I lived in as a child; subterranean labyrinths of cave houses in Cappadocia I saw on a journey in my youth; a passage of descending steps leading to an underground well in Ahmadabad....
>
> I am deeply imbued with, and influenced by, the feeling of space embracing life, a feeling you might get looking up at the sky from the depths of earth.... It has been my desire to return to the origin of architecture and contemplate light from the side of darkness.[30]

The preoccupation with origins leads Ando to a profound respect for the specificity of particular places. This is one of the primary reasons he resists most modern and postmodern architecture. Two years after the conference where I first met Ando, he gave a presentation at another ANY conference in which he offered a poem and gave a talk in which he argued that as a result of the preoccupation with universal forms and virtual technologies, architecture is losing touch with the natural, material, and bodily conditions of life. Ando, like Nietzsche, wants "to stay true to the earth," and to do this, again echoing Nietzsche, he seeks to create an architecture that allows primal elements to *dance*. "Architecture's break with the earth, with history, will lead to the extinction of the genius loci.... In such a context, I seek to reattach architecture firmly to the earth.... Through architecture, I want to make the wind dance, to make the sky and the earth vibrate. In this way, it is possible to render life to the movements of the genius loci, to resuscitate it."[31] Rather than shaping earth to conform to human designs, Ando admits, "I always listen to that whispering voice of a given place. I think of it comprehensively with all of its forces—the visible characteristics as well as the invisible memories to do with the interaction between a locality and humankind."[32] In Japan, part of what it means to listen to the whispers of a particular is to respect the importance of gardens for traditional architecture. "Those monuments," Ando maintains, "are in a sense a version of Land Art before the time of Land Art."[33]

Ando's architecture can be understood as an extended effort to recover place in a world where the local is increasingly absorbed by the forces of globalization. He is deeply concerned about the way modern industrialization and urbanization, and postmodern digitalization and virtualization are isolating people from the natural world and repressing sensuous bodily experience. Architects, he believes, should first listen and then respond to the natural environment. "A site always has a distinct field of force that affects man. The field is a language, yet not a language. The logic of nature affects one subjectively, and it is made gradually clear only to those who seriously attempt to perceive it. Architecture is ultimately a question of how one responds to these demands made by the land. To put it another way, the logic of architecture must be adapted to the logic of nature."[34] Since Ando rejects every form of dualism between mind and body as well as self and world, this response must be bodily and, by extension, emotional and affective. To cultivate these affections, Ando returns to the origin, which we can never leave if we are to survive. His entire *oeuvre* represents an effort to see light in the midst of darkness, which, we have seen, began in his childhood.

To bring this long argument about religion and art full circle without

closing the loop, I will consider two chapels and two art museums designed by Ando. All of these works are informed by the elegant simplicity characteristic of Zen aesthetics. Like so many of the artists I have considered, Ando is preoccupied with the interplay of light and darkness. Church of the Light (1989) and Church on the Water (1988) are not really two different structures, nor are they exactly one. Conceived and designed at the same time, they are two-in-one and one-in-two. Ando's sensitivity to nature is reflected in the materials he uses. In a manner similar to Irwin's Marfa installation, Ando's buildings are constructed to sculpt light with shadows that reveal its interplay with darkness. "Light is the origin of all being," Ando claims. "Light gives, with each moment, new form to being and new interrelationships to things, and architecture condenses light to its most concise being. The creation of space in architecture is simply the condensation of the power of light."[35] The light in Ando's churches is different from the melancholy darkness of Rothko's chapel and the cheerful brightness of Kelly's chapel. He creates a play of fleeting shadows that is neither dark nor light, but something in between.[36]

While his signature materials are concrete, wood, and glass, his palette is much more expansive. "I believe that 'architectural materials' are not limited to wood or concrete that have tangible forms, but go beyond to include light and wind—which appeal to our senses."[37] The concrete Ando uses to sculpt light is unlike any other; he takes a common industrial material and transforms it into a work of art. The use of handmade wooden frames and a unique fabrication technique lend the concrete a density that creates a luminosity on its rippling surface. Architectural historian Kenneth Frampton explains the surprising effect of this construction method. "It is hard to imagine anything more materialistic in construction than reinforced-concrete. Yet as was evident in Tadao Ando's earliest works, it is exactly this element that under certain conditions is susceptible to dematerialization through the impact of light. . . . It is the very unevenness of the cast concrete that makes the wall appear as though it were a light fabric hung against an invisible plane. Here the passage from material to immateriality is inseparable from the movement of the sun. It is a transformation that embodies the essential paradox of Ando's architecture, namely the dematerialization of form through a perceivable passage of time."[38]

Church of the Light is a small building (1216 sq ft) located in the foothills of the Yodo valley. The church consists of three concrete cubes (5.9 m × 15.7 m × 5.9 m). A wall cutting through these cubes at a 15° angle sets the church off from the street and forms the entrance. The use of walls as a framing device is one of the distinctive features of Ando's architecture. Heneghan

observes, "The intensity of meaning embodied in Ando's walls is, perhaps paradoxically, due to their abstinence from customary means of architectural expression. In their absolute plainness, they deny symbolism. They are mute, and it is in this very silence that their expressiveness lies."[39] The silence of Ando's walls not only separates and divides, but also, more importantly, connects and creates the possibility for passage and exchange. In Church of the Light, he uses the wall to create a liminal transitional space from outside to inside and from light to darkness. On the interior, the concrete walls are punctuated by points, which are small holes that create a grid on the surface of the concrete. The dark wooden floor gradually slopes down to the far wall where there is a glass cross stretching from floor to ceiling and side to side. Light from this cross illuminates the interior, creating a mysterious effect. Entering from the back and gazing down the central axis between perfectly straight rows of wooden pews, the diffused light of the cross forms open arms drawing congregants into its embrace. Ando's church is not as dark as Rothko's chapel and not as light as Kelly's chapel; nor does black overshadow color, or color overwhelm black. Colors from the outside show through the opaque glass of the cross to offset the gray and brown of the interior. The restraint of Ando's design creates a seminal emptiness that is uplifting rather than depressing.

Church on the Water, located in the Yuhari Mountains, is larger and more complex than Church of the Light. Here Ando introduces two additional elements that are crucial for his architecture—air and water. The structure consists of two overlapping cubes—one above ground (10 m square) and one below ground (15 m square). Once again Ando uses a freestanding wall to frame the building and mark the entrance. In contrast to the downward slant of the Church of the Light, the entrance to the Church on the Water slopes gently upward and leads to an elevated area enclosed on four sides by glass with large symmetrical crosses. In this space, light envelops visitors as they peer through the crosses to the surrounding forest and mountains. The multileveled structure is surrounded by a large manmade tiered lake, making it appear that the church defies gravity and is floating on water. The entrance to the church is a staircase curving downward to a cylindrical antechamber. A surprise awaits visitors as they enter the sanctuary proper. At the far end behind where the altar traditionally is located, there is a retractable glass wall that opens onto the lake in the middle of which there is a large white cross made of steel. It is as if you are gazing through the surface of a painting to a third, perhaps even a fourth dimension. Opening the interior to the elements as well as the surrounding environment, Ando brings outside light and color

inside to fill space that had appeared to be empty. Here art and nature become one-in-two. "Nature in the form of water, light, and sky restores architecture from a metaphysical to an earthly plane and gives life to architecture. A concern for the relationship between architecture and nature inevitably leads to a concern for the temporal context of architecture. I want to emphasize the sense of time and to create oppositions in which a feeling of transience of the passing of time is part of the spatial experience."[40] Church on the Water is an invitation to follow Ando on his journey from light through darkness to light. The stages along this way extend from church to art and eventually the museums that house works of art.

In many ways the Chichu Art Museum (2004) is Ando's master work. The word "*chichu*" in Japanese means "underground," and the proper translation of the museum's name is "art museum in the earth." This work fulfills Ando's "desire to return to the cave that is the origin of architecture and contemplate light from the side of darkness." Explaining his goal in Chichu, he writes,

> It is possible to create almost any form underground as there are no axes or directions as exist above ground, on earth. But this formal freedom made me all the more committed to primal geometrical forms. The outer expression of an underground building is invisible, and, therefore, the obvious issues of form were not an issue. My challenge was to achieve a highly complex and varied sequence of "lightscapes" with a configuration of simple geometrical forms. . . . I examined every detail of the amount and quality of light penetrating the darkness and highlighting the individual spaces, making each distinctive. The museum was intended, holistically, to be visited with light as the guide.[41]

Chichu is located on the southern end of the island of Naoshima on cliffs overlooking the Seto Inland Sea. It is a unique museum devoted to the work of only three artists: Claude Monet, Walter De Maria, and James Turrell.

Ando had a working relationship with Turrell dating back to their 1999 collaboration on Minamidera, which is part of the Art House Project intended to make art a part of everyday life. Ando designed a 1754-square-foot wooden building for Turrell's *Backside of the Moon*. This work is a variation of Turrell's Dark Space at Mass MoCA, which I considered in the second chapter. Visitors are led into a dark room where initially *nothing* is visible. As eyes adjust, a purple glow first begins to emerge and then an ultraviolet rectangle appears to hover in space. Gradually, the awareness dawns that this light had been there all along, but you had not been able to see what

was there before your eyes. In a conversation entitled "When What Was Darkness Becomes Light," Ando and Turrell discuss the result of their collaboration.

> ANDO: This is a space I've surely never experienced before. Although it is a very small box, I feel that it extends infinitely.... I think I could stay here even for an hour. I feel that the spirit inside of me has been gradually raised.
>
> TURRELL: I think this space, this architecture that we make, really has the feeling of spirit. When you are in some temples alone or with not too many, you can sense this kind of feeling too. This belongs to the history of these kinds of places. It certainly is that kind of situation where we meet the imagination, the things that we have hoped for.
>
> ANDO: Originally, I think religion offered this. Japanese people have really forgotten such feelings. But I believe that here people will be able to retrieve and restore those kinds of feelings.[42]

Chichu is a grand earthwork on the scale of Heizer's *Double Negative* and Turrell's Roden Crater. With all the galleries underground, the museum is a cave with openings to the heavens. From outside and above ground, the museum is invisible and the square, triangular, and rectangular openings look like abstract sculptures carefully placed across the island landscape. The intricately designed underground spaces are connected by corridors with walls radiating natural light on the shimmering surface of concrete. In spaces between the galleries, there are stone and grass courtyards open to the sky. In this labyrinth, there is no center, and it is easy to become disoriented. This unsettling feeling is exacerbated by the walls of the passageway leading to the museum interior, which are tilted at a 6° angle. "The aim," Ando explains, "was to give the visitors a feeling that they are going into the center of the earth, perhaps to its very center. Six degrees represents one-sixtieth of a full 360-degree circle that might be seen as a portion of the earth's sphere."[43] By returning to the material matrix of life, it becomes possible to get back in touch with the humus that makes us human.

The three artists whose work appears in Chichu have a profound respect for the natural world and implicitly or explicitly share Ando's belief that art can help to heal the rift between humanity and nature. Nonetheless, Ando's architecture shares more with Turrell than with Monet or De Maria. Ando's geometric openings, like Turrell's Skyspaces, capture light and bring heaven down to earth. Turrell might well be quoting Ando rather than commenting on his own art when he writes, "My work is first of all art, not religion, but

that isn't to say that religion isn't within the realm of the Artist. So come on, I am not going to give that area up! Besides I find the inscription on the [Berlin] Buddha Amitaba very compelling: The highest truth is without image/Yet if there were no image there would be no possibility of truth/ The highest principle is without words/Yet if there were no words how could principle be known."[44] To discover in Ando's architecture that "the highest principle is without words" is to see silence.

The success of these works made Ando the ideal choice to design the addition to the Clark whose distinguishing feature is its beautiful natural setting. The 140-acre campus is located in the Berkshires in a valley nestled between the Taconic Range in New York and the Green Mountains in Vermont. The Clark was created in 1955 by Sterling and Francine Clark. Sterling inherited a fortune from his grandfather, who had been the lawyer for the Singer Sewing Machine Company. After spending many years in the Far East, he settled in Paris in 1911 and began collecting art. By the middle of the twentieth century, his collection included American and European paintings (especially French impressionists), sculptures, prints, photographs, and decorative arts. During the early years of the Cold War, the Clarks decided they wanted to establish a museum far from cities in a place they thought would be unlikely to suffer a nuclear attack. After a prolonged search, they settled on Williamstown, Massachusetts.

The architecture of the original building was ill suited for its natural setting. The white marble building (1955) looks more like Heidegger's Greek temple or a mausoleum, which it actually is since the Clarks are buried beneath the entrance. In 1973, a research institute was established, and once again the architecture was problematic. The brutalist structure, built using red granite, clashed with the classical style of the original museum and was also at odds with its surroundings. Both buildings are oriented toward the street and turn their back on Stone Hill. These two mistakes created a considerable challenge for Ando. He had to find a way to connect the existing buildings and to integrate the entire complex into its surroundings. Realizing that the natural setting of the Clark is as important as its architecture, Ando developed a twofold solution. First, he devised a way to get people into the natural surroundings by designing a space for exhibitions and the conservation laboratory in a new structure located in the woods halfway up Stone Hill. The Lunder Center can be approached either through a circuitous woodland path or on a gently curving drive lined with native grasses and birch trees that glow golden yellow on fall days. The most memorable feature of the concrete-and-wood building is a large angular terrace facing north with a spectacular view of the Green Mountains. There is one detail

that is also significant. In the Lunder Center, as in several other buildings, including Church of the Light, the freestanding wall outside the structure is shaped like the number seven. As we have seen, numbers bear significant symbolic weight in Japan and China. Michael Como's explanation once again is helpful. "The number 7 is of primary importance because from a very early period, the pole Star, which is fixed and around which all other stars revolve, became a symbol of kingship. From there, it is a short step to include the Big Dipper, which is composed of seven stars. In many forms of astrology, these seven stars control human fate to a large degree."[45] Ando's use of walls shaped like sevens is a quiet gesture aimed at connecting the heavens and the earth.

The second and more important part of Ando's plan was the creation of a new 11,000-square-foot building to accommodate special exhibitions, lectures, dining, and retail. His most radical innovation was to reorient the museum by turning the building away from the street and toward the sloping meadow the previous building obscured. Landscape architect Reed Hilderbrand redesigned the campus by planting more than 1,000 trees and revamping trails leading from the museum across fields and into the woods. With the reorientation southward, the museum now points visitors to the trail that leads toward the far end of Stone Hill, where my sculpture garden is located.

The new Clark addition includes all of Ando's characteristic elements: concrete, wood, glass, water, air, and wind. Recognizing the importance of not blocking the natural setting, Ando resists any vertical structures and uses a horizontal orientation typical of traditional Japanese architecture. As in his other buildings, he uses freestanding walls to define the entrance and frame the buildings and their surroundings. He joins the original white marble building to the new center with a linear gallery that has one wall made of glass and the other made of red granite matching the façade of the research center. A long red granite wall leading from the parking lot to the entrance passes by a lily pond that looks exactly like the one depicted by Monet in the paintings on display in the Chichu Art Museum. At the entrance, granite gives way to concrete and glass—two glass doors open automatically, revealing a beautiful three-tiered shallow reflecting pond with water covering glistening round gray stones and surrounded by a terrace with willow trees, benches, and chairs for visitors to pause and reflect on the surroundings. The spectacular view of Stone Hill rising from the reflecting pool toward the sky takes your breath away. Art, architecture, and nature have rarely come together to create such a stunning vista.

In the design of the Clark, as in Ando's other projects, what is most im-

portant is located underground. The new galleries, conference room, and café are all located beneath ground level. Access to the lower level is by way of stairs that pass through a trapezoidal opening with a slim concrete column connecting surface and depth. The submerged galleries are reminiscent of the exhibition spaces in the Chichu Museum. Natural light streams into the interior through two courtyards with reflecting pools open to the sky. In the Clark Center, Ando creates a more effective interplay between volume and void than in his other works. Here voids are not merely negative space but function like the emptiness of Heidegger's jug and Derrida's *khora* to let forms emerge. In addition to this, there is another important difference between the Clark Center and the churches and museum I have considered. The ambiance of the Clark is brighter and lighter. Whereas in Church of the Light and Church on the Water, Ando seeks "to return to the origin of architecture and contemplate light from the side of darkness," in the Clark he seems to contemplate light from the side of light. The atmosphere is literally and figuratively lighter. Gone are the dark wooden floors and concrete stairs, and in their place are light white oak floors and an open-air staircase. Interior walls are designed to reflect rather than absorb incoming natural light. Darkness has not been erased; rather, it has been muted in an endless play of shadows. Ando once confessed that he is seeking a "'shelter for spirit' born of a 'quest for the relation between light and shadow.'"[46] The space he has created in the Clark is reminiscent of the space of Japanese rooms described by the well-known writer Jun'ichiro Tanizaki in his meditation *In Praise of Shadows.*

Wherever I see the alcove of a tastefully built Japanese room, I marvel at our comprehension of the secrets of shadows, our sensitive use of shadow or light. For the beauty of the alcove is not the work of some clever device. An empty space is marked off with plain wood and plain walls, so that the light drawn into it forms dim shadows within emptiness. There is nothing more. And yet, when we gaze into the darkness that gathers behind the crossbeam, around the flower vase, beneath the shelves, though we know perfectly well it is mere shadow, we are overcome with the feeling that in this small corner of the atmosphere there reigns complete and utter silence; that here in the darkness immutable tranquility holds sway. The "mysterious Orient" of which Westerners speak probably refers to the uncanny silence of these dark spaces. And even we as children would feel an inexpressible chill as we peered into the depths of an alcove to which sunlight had never penetrated. Where lies the key to this mystery? Ultimately it is the magic of shadows. Were the shadows to be banished from its corners, the alcove would in that instant revert to mere void.[47]

Ando's architecture creates a quiet atmosphere where it is possible to see a silence that is more about serenity than dread or exuberance. Here one discovers that silence reveals what cannot be revealed. Werner Blaser goes so far as to suggest that Ando's work is "an architecture of silence." "The subtle modulations of sharp edges, clean lines, and smooth surfaces are what stimulate us. These are the loci of spiritual exchange. Moments of silence are gifts. In silence we feel at home."[48] The question that remains is how to live *with* this silence.

LISTENING TO STONES

In 1983 while I was at the National Humanities Center writing *Erring: A Postmodern A/Theology*, I met Toshihiko Izutsu, who was a distinguished Japanese interpreter of Islam and Zen Buddhism. He knew nothing about deconstruction and was interested in learning as much as he could about the philosophical and critical movement that was sweeping across America at that time. Over the course of the next several months, we met often and I explained my interpretation of Derrida's writings to him. As our conversation deepened, Izutsu explained to me that he saw interesting similarities between deconstruction and Zen. In an effort to demonstrate this connection, he introduced me to the writings of Kitarō and Nishitani and emphasized the importance of the Kyoto school. As his stay at the center drew to a close, he expressed a desire to meet Derrida, and I arranged a meeting when he stopped in Paris on his way back to Japan. Since Derrida's work was not known in Japan at that time, their conversation was mutually productive. Izutsu told Derrida that he planned to introduce his work in Japan, but had understandable concerns about translation problems. A few weeks after their conversation, Derrida wrote Izutsu a letter dated July 10, 1983, in which he discusses how he had chosen the word "deconstruction" and some of the nuances any adequate translation would have to convey. He later published this letter with the title "Letter to a Japanese Friend."[49] This brief text remains Derrida's clearest explanation of deconstruction.

Derrida's choice of title is a direct reference to a seminal essay by Heidegger entitled "Dialogue on Language between a Japanese and an Inquirer," which was first published in his 1959 book *On the Way to Language*. It is important to note this title stresses Heidegger's intent to explore the prelinguistic terrain from which language emerges rather than to discuss language as such. As I pondered Ando's architecture and its relation to the Ryōnani temple as well as the work I was doing on the other end of Stone Hill, my thoughts drifted back to what Izutsu had taught me. I returned to Derrida's

letter and Heidegger's dialogue that had inspired it.[50] In response to a question about how the word *Iki* should be translated, the Japanese responds,

JAPANESE: *Iki* is the breath of silence of luminous joy.

INQUIRER: You understand "joy" literally, then, as what attracts and carries away into silence.... The joys of the same kind as the hint or sign that calls on in the to and fro, and beckons to and fro.

JAPANESE: The sign, however, is the message of the veiling that opens up or lights.

INQUIRER: Then all presence would have its origin in grace in the sense of the pure joy of the beckoning silence.

The notion of a veiling that clears or opens up leads to the question of language. As we have seen, Heidegger argues that language clears the way for whatever exists through a presencing that is a revealing withdrawal. Once again the exchange turns on a question of translation.

INQUIRER: And what does *Koto* say?

JAPANESE: This is the question most difficult to answer. But it is easier now to attempt an answer because we have ventured to explain *Iki*: pure joy of the calling silence. The breath of silence that makes calling joy come into its own in the reign under which that joy is made to come. But *Koto* always also names that which in the event gives joy, itself, that which uniquely in each unrepeatable instant comes to appearance in the fullness of its grace.

INQUIRER: *Koto*, then would be the event of the lighting message of grace.[51]

These tangled words convey the insight toward which I had unknowingly been moving for many years. *Grace is the gift of life that occurs in each unrepeatable instant, even in times of darkness.* Fleeting grace-full presence brings joyful delight that can be experienced only in the silence that is its origin. This is the silence that has been calling to me on Stone Hill.

For almost three decades, I have been running, skiing, and walking along the woodland path that leads from my house to the Clark Art Institute. Along the trail, the forest opens to reveal fields planted with corn and hay where, with Annie Dillard, "I saw the silence heaped on the fields like trays. That day the green hayfields supported silence evenly sown; the fields bent just so under the even pressure of silence, bearing it, palming it aloft: cleared fields, part of a land, a planet, that did not buckle beneath the heel of silence,

nor split up scattered to bits, but instead lay secret, disguised as time and matter as though that were nothing, ordinary—disguised as fields like those which bear the silence only because they are spread, and the silence spreads over them, great in size."[52] It is not only the woods and the fields, but, more important, the rocks and stones that make Stone Hill sacred. To see their silence, you must learn to listen differently.

Everything ends in a garden. As I have explained, when I began clearing the woods nearby my study, I had no clear plan. Indeed, I did not really know why I was doing it. It was a year after I had suffered several serious illnesses during which I had, in Blanchot's memorable words, "died without dying." Perhaps recalling lessons my father had taught me, I suspected that cultivating the earth would help me recover from wounds that were more than physical. When I created my first Zen rock garden, I never anticipated it would be the first step in an ongoing project that has expanded to a sculpture garden covering five of the eight acres of our land. Ponds now punctuate the hillside, and a rock-strewn stream flows between sculptures made of steel, bone, and stone. I have designed these works and fabricated them with local craftsmen including landscape designers, masons, metal workers, and heavy machinery operators whose knowledge and creativity are remarkable. These people do not sit behind desks talking about materiality and writing about the body; they understand materials and have a bodily knowledge etched in their hands and muscles. In their work, the line between craft and art disappears. Laboring for long hours side by side with these artists, I have learned many lessons words cannot convey. In a way similar to the monks raking gravel in the Ryōanji rock garden, maintaining what we have created tunes my body and attunes my mind to rhythms that elude language. Michel Serres is the rare contemporary philosopher who appreciates the importance of such ritual labor. In his rich book *The Five Senses: A Philosophy of Mingled Bodies*, he writes,

> So, do we learn how to die, how to survive alone through suffering, to sing joyfully when our child recovers from illness, to prefer peace to war, to build our home over time? Or do we take our education in the direction of serenity? In dictionaries, codes, computer memory, logical formulae; or quite simply at the banquet of life? I don't believe, says the beggarly phantom behind the machine, that if there is any sense to life, it lies in the word *life*; it rather seems to me that it arises in the senses of the living body. Here, in the sapience cultivated by fine wine [perhaps provided by Dionysus], with as few words as possible; in the sagacity mapped out by scents enhancing our approach to

others; there, through vocalizing, sobbing, and what our hearing perceives beneath language; through the aromas that rise up out of the indescribable earth and landscapes; from the beauty of the world that leaves us breathless and speechless; from dancing, where the body alone dives freely into deaf and mute senses; from kisses which prevent us from even whispering ... from the banquet we will have to leave.[53]

The most important lessons gardening on Stone Hill has taught me I have learned from rocks, which I have used to create sculptures: a stone bench, carved granite rocks weighing ½ to 2½ tons, natural rocks delicately balanced on a carefully cut inverted pyramidal piece of gray granite, striated streams and rivers of gravel, and a large 14′ in diameter dry stone fire pit oriented on the summer and winter solstice axes. In addition to these works, there were massive rocks hiding, like Poe's purloined letter, in plain sight. What I thought were bumps in overgrown fields turned out to be an undulating ridge of rock dipping below and breaking through the surface of the earth. When the weeds and dirt were stripped away, I discovered three large outcroppings that looked like the edges of tattered pages of a book. Far from static, these rocks appear to be waves rising toward the sky. My geologist friends confirmed this impression when they told me that four million years ago, these rocks were on the ocean floor off the coast of Nantucket, where the *Pequod* once was anchored. They also told me that the rock is Stockbridge marble, named for the town where Jonathan Edwards wrote his most important works. This is the same marble Hawthorne's Ethan Brand burnt in his lime kiln on nearby Mount Greylock, where Thoreau hiked and that inspired Melville as he gazed at the snow-covered mountain and saw the white hump of Moby-Dick. These astonishing rocks, which are works of art no human hand could craft, harbor ancient lithic memories of the silent origin that is our end. Once again, Dillard sees what others overlook. "Geography is life's limiting factor. . . . If you dig your fists into the earth and crumble geography, you strike geology. Climate is the wind of the mineral earth's rondure, tilt, and orbit modified by local geological conditions. The Pacific Ocean, the Negev Desert, and the rain forest in Brazil are local geological conditions. So are the slow carp pools and splashing trout riffles of any backyard creek. It is all, God help us, a matter of rocks."[54] If, in the end, it's all a matter of rocks, we need to learn to listen to what rocks are saying.

One of the most pressing problems is that in today's high-speed, noisy world, people have forgotten how to listen. Mindless chatter silences mindful reflection. Always being the first to speak and refusing to stop talking

is a strategy of avoidance, control, mastery, and domination. To listen truly, you must remain silent, and silence, as Heidegger explains, requires modesty and reticence.

> *Keeping silent* is another essential possibility of discourse, and it has the same existential foundation. In talking with one another, the person who keeps silent can "make one understand" (that is, he can develop an understanding), and he can do so more authentically than the person who is never short of words. Speaking at length about something does not offer the slightest guarantee that thereby understanding is advanced. On the contrary, talking extensively about something, covers it up and brings what is understood to a sham clarity—the unintelligibility of the trivial. . . . Keeping silent authentically is possible only in genuine discoursing. . . . In that case, one's reticence or secrecy [*Verschwiegenheit*] makes something manifest, and does away with "idle talk" [*Gerede*]. As a mode of discoursing, reticence articulates the intelligibility of Dasein in so primordial a manner that it gives rise to a potentiality-for-hearing which is genuine, and to a Being-with-one-another which is transparent.[55]

Self-assertive speech creates an echo chamber; reticence, by contrast, lets go of self-assertion in order to be open to what can be neither anticipated nor controlled. Letting go is letting be; this release *from* self is the release *of* the other. To describe this letting go, Heidegger borrows a term from Meister Eckhart—"releasement [*die Gelassenheit*]." In his delightful book *Wandering Joy: Meister Eckhart's Medieval Philosophy*, Reiner Schurmann explains Heidegger's point by referring to Eckhart. "The openness in which beings appear is freed from the dominance of representation and possession. Meister Eckhart would say the breakthrough is accomplished when the Godhead in which beings appear is freed from the dominance of attachment and possession."[56]

True listening is the openness to others *as other* rather than the closure that transforms others into a mirror image of one's own desires and interests. Such listening requires quiet patience, which is impossible apart from a certain passivity. To listen, it is necessary to learn how to remain silent and wait for the call of the other. Waiting is not the same as awaiting; just as fear always involves a determinate something and dread has no object, but is always provoked by nothing, so awaiting knows what is expected, while waiting is the unknowing openness to whatever arrives. In their "conversation on a country path," Heidegger's Scholar, Scientist, and Guide consider what it means to wait.

GUIDE: Perhaps we are just now close to being let into the essence of thinking.

SCHOLAR: In that we are waiting upon its essence.

GUIDE: Waiting, all right; but never awaiting; for awaiting is already involved with representing and latches onto what is represented.

SCHOLAR: Waiting, however, lets go of that; or rather I should perhaps say: Waiting does not at all let itself get engaged in representational setting-before. Waiting has properly no object.

SCIENTIST: And yet if we wait, we always wait upon something.

SCHOLAR: Certainly; but as soon as we represent to ourselves and bring to a stand that for which we wait, we are no longer waiting.

GUIDE: In waiting we leave open that upon which we wait.

SCHOLAR: Why?

GUIDE: Because waiting lets itself be involved in the open itself.[57]

The open is the clearing where Being is given. Being can never be possessed—it is always a gift, a temporary gift. Since it is not forever, the gift of life is at the same time the gift of death, and the gift of death is simultaneously the gift of life. Grace is the astonishing gift of life that is the gift of death, and the gift of death that is also the gift of life. Silence is the opening to the wonder of this grace. As Johannes de Silentio reminds us, the second movement of faith is the acceptance of all Being as Being-given. To abide by this faith is to be committed to a transvaluation of all values. Instead of calculation, manipulation, domination, and control, virtues to be thoughtfully and quietly cultivated become reflection, deliberation, attentiveness, care, cooperation, concentration, compassion, empathy, hospitality, humility, stewardship, and generosity. To live these values truly without any expectation of return brings "the supernatural peace of the countryside at the end of September, a plenitude in which divinities, tangible, come down to earth, between the not-yet and the already-over—dense minutes when the body understands more than the mind does—is there any sentence to equal the delights of the given?"[58]

As I became convinced that there are things we can apprehend but cannot comprehend, I had begun experimenting with ways of using design to convey thoughts and ideas. I started by using images in books to make arguments rather than merely illustrate ideas. I tried to bring these images alive by creating a video game, however as electronic media began to take over people's lives, I came to have misgivings about the virtualization of reality.[59] Eventually, I became dissatisfied with appropriated images of others and

started creating my own by taking photographs. I soon learned the limitations of the two dimensions of the page and slowly began to explore the possibility of moving into the third dimension by making sculpture. I started by fashioning a sculpture with the dirt collected from the grave sites of my ghosts. While it was effective, I still was not satisfied. Just as I had felt the need to move philosophy off the page and into the third dimension, now I wanted to move sculptures from inside to outside where it would be possible to literally get people into the work of art. My first sculpture that was designed for the outdoors was inspired by an essay entitled "The Pit and the Pyramid: Hegel's Semiology" in which Derrida invokes Poe's "The Pit and the Pendulum" to develop a critical reading of the *Phenomenology of Spirit* through an analysis of Hegel's use of a "pyramid with its tip knocked off." I first used this image in several books and then translated it into a steel sculpture. Recalling lessons I learned standing in the middle of Heizer's *Double Negative*, I decided the work was incomplete without the pit, so I created an inverse image that was the precise size of the pyramid and placed it in a hole 4½' deep. Both the positive and the negative sculptures are placed in adjacent equilateral triangles that form one of the lines of vision in the garden.

With the sculptures proliferating and the garden growing, I realized I needed to frame the work more effectively. As I considered how this might be done, my thoughts once again drifted back to the Ryōanji rock garden that had inspired my initial efforts. I decided I needed a place where a person could sit and quietly contemplate the overall effect of the garden. A dark wooden pavilion with an elevated veranda like the one in Kyoto wouldn't work. As I considered this problem while walking along the path leading to the Clark, I noticed what I had seen countless times—the crumbling remains of one of the many stone walls that line the trail. Like fading photographs of unknown faces, these walls are quiet reminders of voices that have long fallen silent. Stone walls are, of course, an integral part of the New England landscape. Farmers who had cleared the rocky soil made these walls to keep livestock from roaming away. Some of these walls are almost as old as the United States. Susan Allport reports, "In 1633, the Plymouth court finally made crop growers responsible for fencing, and nine years later the Massachusetts court reversed a previous ruling and declared that 'every man must secure his corne and meadowe against great cattell.' Thus began the body of laws and customs requiring farmers to enclose their crops." By 1871, Massachusetts had 32,960 miles of stone walls; Connecticut, 20,505; and Rhode Island, 14,030.[60] Suddenly, the solution was obvious, I would complete this stage of the garden by building a stone wall that would surround a stone where a person could sit to meditate.

I realized that this would have to be a special wall that would subvert walls' traditional function of dividing and separating. This garden wall would function as a border, margin, limit, tympan, and horizon that creates a sense of simultaneously merging with and emerging from the earth. As the site of contraction and expansion, the wall would be reminiscent of both a womb and a tomb.[61] Since I wanted to reinforce the intimate relation between human being and the ground that gives it sustenance, the wall would have to be *in* and not *on* the earth. As always, I would respect the contours of the earth and make the wall move with rather than against its curves. Moreover, the wall had to look like it belongs in this particular place and nowhere else. I did not have enough stones to build the wall and would have to find more. To preserve the genius loci, I would have to integrate stones I collected from the garden and surrounding woods with stones I brought in from elsewhere. In addition to this, I wanted to create a wall that would mark the temporal rhythms of the garden.

Seeking help to develop a design that would integrate all of my ideas, I turned to the work of the most imaginative and creative waller I know—Dan Snow, who lives and works in nearby Vermont. Snow is a visionary artist who not only builds beautiful walls precisely adapted to the specificities of each particular place, but also writes about his craft in very illuminating ways. His books *In the Company of Stone: The Art of the Stone Wall* and *Listening to Stone* are implicitly a response to Annie Dillard's *Teaching a Stone to Talk*. Snow begins *In the Company of Stone* by reflecting on silence.

> I could say that drystone walling is a silent and solitary pursuit. In the text of this book there is plenty of evidence to support such a claim. But that's just not the way it is. Throughout a day of walling, as the light of the sun comes from below the horizon or is subdued from above by clouds, crickets bow their wings in symphonic harmony. When the sun breaks out, the day is further brightened by songbirds in solo performances. The importance of these subtle additions to a waller's "soundscape" needs cannot be overstated. The air is infused with the music of these tiny creatures.

Just as Cage's absence of music makes silence audible, so some forms of music make it possible to hear silence. Though Snow never says so directly, walling is for him a form of meditation. "Walling puts back what has come apart. I spend my days close to the ground. My shoes are scuffed from stamping in the dirt. The palms of my hands are burnished from grabbing stone. I bend so low my head dips below my heart. I'm always trying to get a little closer to the land and its boundless bounty."[62] Snow's art always remains

open to these gifts, which he receives gratefully. He expresses his gratitude with designs that are never intrusive and are always responsive to what the land gives.

As a person who has spent most his life in the company of books rather than stones, it has been fascinating to discover that wallers read stone and rock as carefully as I read books. They see, feel, and hear what I do not. Experienced wallers read a line etched in stone and know exactly what it says and how to split it. This knowledge is tactile as much as mental. "Touch is the sense," Snow explains, "that informs me most generally about stone. My eyes urge on my hands, but the touching and gripping is the handshake of agreement for us to begin working together." Even when hammering and chipping, Snow always works with and never against stone. The waller's sensual knowledge comes through his ears as well as his hands. The accomplished waller knows how to listen to stone. "'Mute as a stone,' the old saying goes. I suppose that's true if the stone is in repose. Strike it, though, and it will begin to jabber. Flip it across a stockpile and it will talk to every stone it meets along the way. It will rattle and clatter against small ones, grind and rumble over large one. Stones already in a wall talk back."

For Snow, the labor that gives birth to the wall is a ritual repetition of the act of creation. "For me," he confesses, "part of the allure of walling is in making something from nothing. Collecting what has been overlooked or underappreciated and creating something useful with it feels like an alchemist's trick. To make the most of not much is the waller's magic."[63] The magic of creation results in walls whose beauty emerges from the interrelation of stones that transforms static objects into flowing rivers whose curves bend with the land. Snow realizes that stones alone do not create this beauty. Like the potter shaping Heidegger's jug, Snow's crafty hands shape the void that forms the wall. "To watch me, you might think I'm building a wall of stone, but my focus actually is on building negative spaces. If I can create spaces that absorb loose stone into the shape of a wall, then when there are no more spaces left, the wall will be finished. Spaces are really the stuff that walls are made of."[64]

In Snow's eloquent account of walling, I saw the way threads of my writing, sculptures, and garden could be woven together in a stone wall. His most important lesson was the least expected. If my wall were to be successful, it could not be only my design; I would have to let go of my determination to control by letting stones be what they are and letting them do what they, not I, wanted to do. If I could do this, Snow promised a miracle might occur.

My surprise is in how my perception is changed as stones enter into relationships with one another on their way to becoming a wall. When now and again a stone falls into a place that is utterly inevitable, I feel I am suddenly standing under a shower of grace. For an instant I become inevitable, too. I share the compatibility that the stone finds with the stone. If I'm lucky, it happens a lot. Then again, some days it doesn't happen at all. Grace may fall in the next moment or never again. I know only that if I put myself with stone, it may happen again, so I keep on walling.[65]

And I keep writing and digging.

After absorbing the lessons Snow teaches, I sketched an outline of the wall but left the details for the stones to determine. I then called Valerie and Josh, with whom I have worked for many years, and explained what I wanted to do. Valerie sent me to a building supplier to select the color, shape, and size of the stones to be used. Two days later three tons of fieldstones arrived and I spread them out on the grass beside the gentle hill I had selected as the site of the wall. Shortly thereafter Josh and I began excavating the site I had selected on the slope at the edge of the garden. Over the course of the next three weeks, we worked together to build the wall. The days were long and hot, and the labor was hard. Josh knew about Snow's work but had not read his books. I gave him an excellent documentary film about Snow, so he would have a better idea of what I was thinking.[66] As we worked side by side, Josh explained what he was doing and his personal philosophy of walling. I was interested in how similar his and Snow's ideas were. Having once built a far less complex stone wall by myself, I was surprised by the intricacy of Josh's construction process. Since we were building this wall into a hillside rather than freestanding, we had to make it in a way that would allow drainage and movement with the freezing and thawing earth. To ensure stability, we created an invisible interior and a visible exterior wall that tilted slightly inward and were separated by about 8″. We filled an 8″ gap between the earth and the inside wall and between the two sides of the wall with gravel and stone chips. To create a sense of incompletion, I designed the wall as an ellipse that opens to the garden. The length of the wall is 36′, which is, of course, precisely one-tenth the number of degrees in the circumference of a circle. In accordance with the Japanese principle of *Miegakure*, the wall is not immediately obvious as you approach the garden—it disappears from certain angles of vision, thereby creating an interplay of appearing and concealing, or emerging and withdrawing.

Constructing a sturdy wall that expresses philosophical ideas and is aes-

thetically appealing is far from easy, but Josh was up to the task. The stones we used had been randomly collected from fields in nearby upstate New York. They were oddly shaped and each one had to be chiseled or split before they could be fit together to form the wall. Like Snow, Josh reads stones carefully and listens to what they say. He repeatedly said to me, "You have to listen to stones, they will tell you where they want to be. Gotta go with them." After finding the exact stone needed for a particular place, he would read its lines; if it needed to be shaped, he would predict how it would split when he hit it with his hammer and chisel—he was never wrong. Sometimes Josh would say "just let 'em stay where they lay." It took a while to train my eyes and ears to find the next stone I thought Josh would need, but he accepted what I brought him less than half the time. Finding the right stone for a wall is, like finding the right word for a sentence, a combination of experience and chance. As I watched Josh work, I noticed that there were times when he would fall silent and seemed to slip into a trance. Like a basketball player in the zone, the right rock would fall into his hands and effortlessly find its place in the wall. Attentive to every detail, Josh was surprisingly sensitive to the importance of light. When positioning stones, he carefully calculated how the light would cast shadows on the surface of the wall as it moved across the sky. He would set the stone, step back and stare at it, and then proceed to nudge it slightly this way or that until it caught the light exactly the way he wanted. For anyone with enough patience to attend to the subtle changes, the wall is a sundial. To integrate the field stones with the rocks on the property, I collected seven—precisely seven—stones, and Josh found a way to work all of them into the design of the wall. We used the largest stone I had uncovered to create the focal point of the wall slightly off center. When the wall is viewed from a distance, the eye is drawn to this stone and the wall unfolds around it (fig. 10).

A final detail remained before the wall was complete—we had to find the stone where one could sit while reflecting. I had imagined a piece of gently furrowed dark gray Goshen stone that would rest on a bed of light gray gravel. Once again, chance intervened. Josh and I drove to Goshen to select a stone, but on the way took a wrong turn and ended up in Ashland. While the quarry had Goshen stone, the owner showed me a remarkably beautiful piece of Crowsfoot Schist that looked more like a painting than a rock. The design is so intricate that it is hard to believe an artist had not created it. When I asked about this rare stone, the owner of the quarry gave me a sheet explaining its history.

Crowsfoot Schist has its origins over 500 million years ago in the Ordovian era, as the cooled and hardened magma of ancient volcanos that lined the

FIGURE 10. Keystone

shore of a long extinct ocean. These venerable, volcanic mountains were held up by their basalt cores as Africa slowly and inexorably drifted across that old ocean and folded and shifted everything in its path in the action we know as plate tectonics. The basalt cores were then crushed, pressed, folded, and heated in this building/mountain crushing process and the resulting metamorphosis brought on by that heat and pressure created the schist we know as Crowsfoot. Just looking at the bundles of black hornblend crystals (the "Crowsfeet") you can imagine the forces that pressed and splayed them. . . . This is a very rare schist found only in a small location in the Berkshires and some geologists report that it can also be found in a small location in Venezuela where we once shared landmass.[67]

So many issues come together in this remarkable stone. Its design is stunning—the crowsfeet could just as well be exploding stars, tracks of ancient animals, or hieroglyphs from a lost tribe. The colors are from a palette that seems infinite—black, white, gray, blue, yellow, orange, burnt umber, and pink. As I placed the stone in the middle of the enclosure of the elliptical wall, I knew the work was done. Looking at the Crowsfoot Schist, there can be no doubt that the world is, indeed, a work of art (fig. 11).

This work of art is always changing and requires constant attention. By any reasonable measure, my obsession with details is excessive and makes

FIGURE 11. Crowsfoot Schist

no sense because almost no one ever sees what I have done. Creating and maintaining this garden is like writing a long book that nobody takes time to read in today's noisy world. While an expensive and useless folly in the eyes of many, for me the garden is its own reward. Labor is not work but is a form of meditation. Creating art and tending a garden are ways of attending that attune mind and body to the gift of the earth's extraordinary fecundity, which is an infinite resource for renewal.

Resting on the sitting stone, you look north toward Ando's addition to the Clark one and a half miles away. In front of you is the pyramid with its tip knocked off and the pit that is its negative image. The gap joining and separating them frames ponds and wetlands connected by a meandering stream. Just beyond the stream there is the drystone fire pit whose arms extend to the sky to welcome the approaching solstice. On the horizon of the garden at the edge of the woods there are three 18′ steel sculptures designed after the initials of the three ghosts who have inspired me since the beginning. On the left, there is the K of Kierkegaard, on the right, the H of Hegel, and in between, always in between, there is the D of Dionysus, with which Nietzsche signed the last words he wrote before slipping into eternal silence. I know that silence soon awaits me, as, indeed, it awaits us all (fig. 12).

The wall opens a space that invites contemplation. To enter this space, it is necessary to learn to live *with* silence by letting go of the noise of the world. Letting go is a letting be, which, paradoxically, requires the willing of

FIGURE 12. The Pit and the Pyramid

nonwilling. Rather than shaping the world in your own image, contemplation opens you to receiving the boundless gift of life, which is also the gift of death. The wonder is that the acceptance of death creates new possibilities for life. This is the Dionysian wisdom that left Nietzsche speechless. Midnight is also midday, and midday is also midnight.

> Did you ever say Yes to a single joy? Oh, my friends, then you said Yes to *all* woe as well. All things are chained together, entwined, in love—
>
> —if you ever wanted one time a second time, if you ever said "You please me, happiness! Quick! Moment!" Then you wanted it *all* back!
>
> —All anew, all eternity, all chained together, entwined, in love, oh then you *loved* the world—
>
> —you eternal ones, love it eternally for all time: and even to woe say Be gone, but come back! *For all joy wants—Eternity!*[68]

<p style="text-align:center">"Then the miracle happens."
"Wonder!"
"Wow!"</p>

The wall is complete, but the work of art goes on; art I once thought was my own is but a passing moment in the infinite work of an artist that forever remains unnamable. The last station along the *Via Dolorosa* that is a *Via Jubilosa* is always deferred and, thus, the future remains open. I realize, of course,

that the day will come when my wall will crumble like those along the Stone Hill trail, and the woods will reclaim the garden that has never been my own. In the meantime, I hope that the space I have cleared with the books I have written and the garden I have created might be a quiet place where people who care might for a fleeting moment see silence.

14.

IN

•
•
•

Without
Before
From

•
•
•

Beyond
Against
Within

•
•
•

Around
Between
Toward

•
•
•

With
In

•
•
•

FIGURE 13. Hearing Stone Speak

ACKNOWLEDGMENTS

The voices of many others sound silently throughout these pages. I express my sincere appreciation to the following friends and colleagues: John Chandler, for his continuing support; Jack Miles, for always keeping me honest; Jennifer Banks, for many rich exchanges; Clemence Bouloque and Michael Como, for their thoughtful explanations; Linda Shearer, for guiding me through the Texas art world; David Leslie and Ashley Clemmer, for opening the Rothko Chapel in Houston to me; Veronica Roberts, for her tour of the Kelly Chapel in Austin; Hiram Butler, for getting me access to Turrell's Live Oak Friends Meeting House; Michael Conforti, for his architectural insights; Michael Govan, for our ongoing conversation; Ray L. Hart, Graham Parkes, and Jeffrey Kosky, for their exceptionally insightful and helpful readings; Lisa Wehrle and Grace Laidlaw, for keeping me from making embarrassing mistakes; David Robertson, for his indexing skill; Randy Petilos, for his endless patience; Alan Thomas, for years of editorial wisdom; Margaret Weyers, for her alchemical magic; and, as always, Dinny, who has always been there since the beginning. Finally, I dedicate this work to my daughter, Kirsten, and son, Aaron; and my grandchildren, Taylor, Jackson, Elsa, and Selma.

Stone Hill
March 12, 2019

NOTES

CHAPTER ZERO

1 Friedrich Nietzsche, *The Gay Science*, trans. Walter Kaufmann (New York: Random House, 1974), 1981.
2 Roland Barthes, *Camera Lucida*, trans. Richard Howard (New York: Hill and Wang, 1981), 96.
3 Karl Ove Knausgaard, *Autumn*, trans. Ingvild Burkey (New York: Penguin, 2017), 78.
4 Julian Bell, "The Perennial Student," *New York Review of Books*, July 13, 2017, 23.
5 Walter Benjamin, "The Work of Art in the Age of Mechanical Reproduction," in *Illuminations*, trans. Harry Zohn (New York: Schocken Books, 1969), 226.
6 Plato, *Phaedrus*, sec. 275 D-E, quoted in Dennis Schmidt, *Between Word and Image: Heidegger, Klee, and Gadamer on Gesture and Genesis* (Bloomington: Indiana University Press, 1981), 99.
7 Blaise Pascal, *Pensées*, "The Eternal Silence of These Infinite Spaces Terrifies Me," eNotes.com, accessed May 4, 2019, https://www.enotes.com/topics/pensees/quotes/eternal-silence-these-infinite-spaces-terrifies.
8 Martin Heidegger, *Kant and the Problem of Metaphysics*, trans. Richard Taft (Bloomington: Indiana University Press), 66.
9 Maurice Blanchot, "Literature and the Right to Death," *The Gaze of Orpheus and Other Essays*, trans. Lydia Davis (Barrytown, NY: Station Hill Press, 1981), 43, 49.
10 Barthes, *Camera Lucida*, 15, 67.
11 Barthes, *Camera Lucida*, 51, 27. Freud makes this observation appropriately in a footnote in *The Interpretation of Dreams*. I will consider this text in chapter 7.
12 Barthes, *Camera Lucida*, 4-5, 72.
13 Jean-Luc Nancy, *The Ground of the Image*, trans. Jeff Fort (New York: Fordham University Press, 2005), 94.
14 Susan Sontag, *On Photography* (New York: Farrar, Straus, and Giroux, 1977), 102.
15 Maurice Blanchot, *The Sirens' Song*, trans. Sacha Rabinovitch (Brighton: Harvester Press, 1982), 38.
16 Edmond Jabès, *The Book of Margins*, trans. Rosmarie Waldrop (Chicago: University of Chicago Press, 1993), 127.
17 Edmond Jabès, *The Book of Questions: El, or The Last Book*, trans. Rosmarie Waldrop (Middletown, CT: Wesleyan University Press, 1984), 3, 15.
18 Ludwig Wittgenstein, *Tractatus Logico-philosophicus*, trans. C. K. Ogden (Mineola, NY: Dover Publications, 1999), 108, 107.

19 Wittgenstein, quoted in Erling Kagge, *Silence in the Age of Noise*, trans. Becky L. Crook (New York: Pantheon Books, 2017), 91–92.

20 Ray Monk, *Ludwig Wittgenstein: The Duty of Genius* (New York: Free Press, 1990), 94.

21 Samuel Beckett, *The Unnamable* (New York: Grove Press, 1958), 28.

22 Ihab Hassan, *The Literature of Silence: Henry Miller and Samuel Beckett* (New York: Knopf, 1968), 22.

23 Susan Sontag, "The Aesthetics of Silence," in *Styles of Radical Will* (New York: Picador, 2002), 32–33, https://sciami.com/scm-content/uploads/sites/9/2016/11/s-sontag-the-aesthetics-of-silence.pdf.

24 Gerard Manley Hopkins, "The Habit of Perfection," in *Poems* (London: Humphrey Milford, 1918; Bartleby.com, 1999), https://www.bartleby.com/122/3.html.

25 Beckett, *Unnamable*, 110.

26 Georges Bataille, *L'expérience intérieure* (Paris: Gallimard, 1959), 28.

27 Martin Heidegger, "The End of Philosophy and the Task of Thinking," in *On Time and Being*, trans. Joan Stambaugh (New York: Harper and Row, 1972), 64. Male pronouns reflect Heidegger's original language.

28 Maurice Blanchot, *The Infinite Conversation*, trans. Susan Hanson (Minneapolis: University of Minnesota Press, 1993), 207.

29 Quoted in Steffi Hobuss, "Silence, Remembering, and Forgetting in Wittgenstein, Cage, and Derrida," in *Beyond Memory: Silence and the Aesthetics of Remembrance*, ed. Alexandre Dessingue and Jay Winter (New York: Routledge, 2015), 103.

30 John Cage, *Silence* (Middletown, CT: Wesleyan University Press, 1961), 109, 136.

31 I have drawn the details of this performance from Toby Kamps's "(. . .)," introduction to *Silence* (Houston: Menil Foundation 2012), 63–64.

32 Kamps, introduction to *Silence*, 84.

33 Cage, *Silence*, 108.

34 Morgan Falconer, *Painting Beyond Pollock* (New York: Phaidon Press, 2015), 166.

35 Quoted in Kamps, introduction to *Silence*, 63.

36 See Jacques Derrida, "The Pit and the Pyramid: Introduction to Hegel's Semiology," *Margins of Philosophy*, trans. Alan Bass (Chicago: University of Chicago Press, 1982), 69–108.

37 Josef Helfenstein and Lawrence Rinder, *Silence* (Houston: Menil Foundation, 2012), 7.

38 Kamps, introduction to *Silence*, 74.

39 Roberta Smith, "A Year in a Cage: A Life Shrunk to Expand," *New York Times*, February 18, 2009.

40 Blanchot, *Sirens' Song*, 41.

CHAPTER ONE

1 Pascal, *Pensées*.

2 Henry David Thoreau, *Walden* (Princeton, NJ: Princeton University Press, 1988), 52.

3 *American Heritage Dictionary* (New York: Houghton Mifflin, 1970).

4 Michel Serres, *The Five Senses: A Philosophy of the Body*, trans. Margaret Sankey and Peter Cowley (London: Continuum Books, 2008), 200–201.

5 Aldous Huxley, *The Perennial Philosophy* (New York: Harper and Row, 1945).

6 Jacques Attali, *Noise: The Political Economy of Music*, trans. Brian Massumi (Minneapolis: University of Minnesota Press, 1987), 5.

7 Filippo Tommaso Marinetti, "The Futurist Manifesto," *Le Figaro*, February 20,

1909, https://www.societyforasianart.org/sites/default/files/manifesto_futurista.pdf.

8 Stephen Kern, *The Culture of Time and Space, 1880–1918* (Cambridge, MA: Harvard University Press, 1983), 259–60.

9 Barclay Brown, introduction to *The Art of Noises*, by Luigi Russolo (New York: Pendragon Press, 2005), 1.

10 Russolo, *Art of Noises*, 23, 25.

11 Brown, introduction to *Art of Noises*, 4. The contemporary artist Ken Butler continues the tradition Russolo began by creating experimental sculptural instruments with different everyday materials including tools, sports equipment, and household objects. He has made violin bodies out of boots, used floor mops and sleds to create cellos, and made spotlights for interactive musical light out of recycled wire. His work "explores the interaction between, and transformation of, common objects, altered images, sounds, and silence." His work has been the subject of an exhibition at the Massachusetts Museum of Contemporary Art. *The New Sound of Music: Hybrid Instructions by Ken Butler*, March 30–September 4, 2006, https://massmoca.org/event/the-new-sound-of-music/.

12 Brown, introduction to *Art of Noises*, 3–4.

13 Don DeLillo, *White Noise* (New York: Penguin Books, 1985), 12.

14 DeLillo, *White Noise*, 36.

15 For a more complete discussion of the rise of American advertising, see my book, *Speed Limits: Where Time Went and Why We Have So Little Left* (New Haven, CT: Yale University Press, 2014), chap. 4, "Windows Shopping."

16 "Global Advertising Spending 2010 to 2019," Statista.com, accessed July 15, 2018, https://www.statista.com/statistics/236943/global-advertising-spending/.

17 "Muzak," Wikipedia, accessed July 15, 2018, https://en.wikipedia.org/wiki/Muzak.

18 Lucy Lippard, "Constellation by Harsh Daylight: The Whitney Annual," *Hudson Review* 21, no. 1 (Spring 1968).

19 George Prochnik, *In Pursuit of Silence: Listening for Meaning in a World of Noise* (New York: Anchor Books, 2011), 112.

20 Douglas Van Praet, LinkedIn, accessed July 17, 2018, https://www.linkedin.com/in/dvp3k.

21 Prochnik, *In Pursuit of Silence*, 100.

22 Marina Murphy, "'Silence Machine' Zaps Unwanted Noise," *New Scientist*, July 15, 2018, https://www.newscientist.com/article/dn2094-silence-machine-zaps-unwanted-noise/.

23 John Biguenet, *Silence* (New York: Bloomsbury Academic, 2015), 12, 10.

24 I will consider *Fear and Trembling* in chapter 7.

25 St. John Climacus, *The Ladder of Divine Ascent*, trans. Archimandrite Lazarus Moore (London: Farber and Farber, 1959), 134–35.

26 Søren Kierkegaard, *The Present Age*, trans. Howard and Edna Hong (Princeton, NJ: Princeton University Press, 1978), 104.

27 Søren Kierkegaard, *Two Ages: The Age of Revolution and the Present Age*, trans. Howard and Edna Hong (Princeton, NJ: Princeton University Press, 2009), 97.

28 Søren Kierkegaard, *Journals and Papers*, trans. Howard and Edna Hong (Bloomington: Indiana University Press, 1970), vol. 2, no. 2061.

29 Herbert Marcuse, *One-Dimensional Man* (Boston: Beacon Press, 1991).

30 Martin Heidegger, *Being and Time*, trans. John Macquarrie and Edward Robinson (New York: Harper and Row, 1962), 167. The influential contemplative Thomas Merton, whose work I will consider below, was deeply influenced by Heidegger's account of Das Man. In *New Seeds of Contemplation*, he expresses Heidegger's point in less convoluted language. "When men live huddled together without true com-

munication, there seems to be greater sharing, and a more genuine communication. But this is not communion, only immersion in the general meaninglessness of countless slogans and clichés repeated over and over again so that in the end one listens without hearing and responds without thinking. The constant din of empty words and machine noises, the endless booming of loudspeakers end by making true communication and true communion almost impossible. Each individual in the mass is insulated by thick layers of sensibility. He doesn't care, he doesn't hear, he doesn't think. He does not act, he is pushed. He does not talk, he produces conventional sounds when stimulated by the appropriate noises." *New Seeds of Contemplation* (New York: New Directions, 2007), 54–55.

31 Quoted in John Biguenet, *Silence (Object Lessons)* (New York: Bloomsbury Academic, 2015), 208.

32 Biguenet, *Silence*, 208.

33 Susan Sontag, *Styles of Radical Will* (New York: Farrar, Straus, Giroux, 1969), 23.

34 Serres, *Five Senses*, 340.

35 Paul Simon and Art Garfunkel, "The Sound of Silence," *Sounds of Silence*, Columbia Records, 1964.

36 DeLillo, *White Noise*, 198–99.

37 Norman O. Brown, *Love's Body* (New York: Random House, 1966), 258.

CHAPTER TWO

1 Robert Whittaker, "Greeting the Light: An Interview with James Turrell," *Works and Conversations*, March 22, 1999, http://www.conversations.org/story.php?sid =32.

2 Michael Govan and Christine Y. Kim, *James Turrell: A Retrospective* (New York: Prestel Verlag, 2013), 39.

3 I will consider Irwin's work in chapter 11.

4 Maurice Tuchman, *A Report on the Art and Technology Program of the Los Angeles County Museum of Art, 1967–1971* (Los Angeles: Los Angeles County Museum of Art, 1971), 127.

5 Tuchman, *Art and Technology*, 130.

6 Govan and Kim, *James Turrell*, 208.

7 Tuchman, *Art and Technology*, 133.

8 Tuchman, *Art and Technology*, 138.

9 Whittaker, "Greeting the Light."

10 Turrell, quoted in Govan and Kim, *James Turrell*, 13.

11 Pierre Lacout, *God is Silence* (London: Quaker Books), 5–6.

12 Turrell, "Speaking for the Light," quoted in Govan and Kim, *James Turrell*, 49.

13 Turrell, "Speaking for the Light," 43.

14 Count Giuseppe Panza di Biumo, unpublished, undated notes held by the Getty Research Institute, Los Angeles.

15 I have discussed Roden Crater at length. See "Creation of the World," in *Refiguring the Spiritual: Beuys, Barney, Turrell, Goldsworthy* (New York: Columbia University Press, 2012), 103–45.

16 Turrell, quoted in Govan and Kim, *James Turrell*, 40.

17 Quoted in Whittaker, "Greeting the Light."

18 Jonathan Griffin, "James Turrell Interview," *Financial Times*, May 24, 2013.

19 Quoted in Henri Neuendorf, "James Turrell Almost Stole a Painting by Juan Gris," *Artnet News*, May 2, 2016, https://news.artnet.com/market/james-turrell-interview -pace-exhibition-483563.

20 Turrell, quoted in Govan and Kim, *James Turrell*, 132.

21 Derrida prefaces *Margins of Philosophy* with a brief supplement entitled "Tympan," which I will consider in chapter 10.

22 Turrell, quoted in Govan and Kim, *James Turrell*, 47.

23 Nietzsche, *Gay Science*, 181.

24 Turrell, quoted in Govan and Kim, *James Turrell*, 249.

25 Quoted in Thomas Merton, *Contemplative Prayer* (New York: Image 2014), 60.

26 Maurice Merleau-Ponty, *Phenomenology of Perception*, trans. Colin Smith (London: Routledge and Kegan Paul, 1978), 283.

27 I will examine this account of the imagination in more detail in chapter 7.

28 Maurice Merleau-Ponty, *The Visible and the Invisible*, trans. A. Lingis (Evanston, IL: Northwestern University Press, 1968), 33–34.

29 Merleau-Ponty, *Phenomenology of Perception*, 61–62.

30 Merleau-Ponty, *Phenomenology of Perception*, 274, 298, 254.

31 Merleau-Ponty, *Visible and the Invisible*, 247.

32 Merleau-Ponty, *Visible and the Invisible*, 49.

33 Tuchman, *Art and Technology*, 132.

34 Govan and Kim, *James Turrell*, 31, 15.

35 William James, *The Principles of Psychology* (London: Macmillan, 1891), 288–89.

36 Simon Ings, *A Natural History of Seeing: The Art and Science of Vision* (New York: Norton, 2007), 125.

37 George Lakoff and Mark Johnson, *Philosophy in the Flesh: The Embodied Mind and its Challenge to Western Thought* (New York: Basic Books, 1999), 18.

38 Quoted in Craig Adcock, *James Turrell: The Art of Light and Space* (Berkeley: University of California Press, 1990), 20.

39 Wallace Stevens, *Opus Posthumous*, ed. Samuel French Morris (New York: Knopf, 1982), 174.

40 Annie Dillard, *Holy the Firm* (New York: Harper and Row, 1977), 62.

41 Mircea Eliade, *The Sacred and the Profane: The Nature of Religion*, trans. Willard Trask (New York: Harper and Row, 1959), 57–58.

42 I will consider Ando's work and his relation to Turrell in chapter 13.

43 Martin Heidegger, *Poetry, Language, Thought*, trans. Albert Hofstadter (New York: Harper and Row 1971), 41, 32. In a fine essay entitled "The Man Who Walked in Color," Georges Didi-Huberman also associates Turrell's Skyspaces with temples. The most important part of his analysis is his interpretation of Turrell's work through the notion of the *khora* developed by Plato and expanded by Derrida. While suggestive, I think this analysis is misguided for reasons that will become apparent in my discussion of the *khora* in relation to Michael Heizer's work in chapter 10. *The Man Who Walked in Color*, trans. Drew Burk (Minneapolis: Univocal, 2017).

44 Georges Bataille, *Visions of Excess: Select Writings 1927–1939*, trans. Allan Stoekl (Minneapolis: University of Minnesota Press, 1985), 216.

45 As I have noted, Derrida examines this image in his essay "The Pit and the Pyramid: Introduction to Hegel's Semiology." I will consider Derrida's argument in chapter 10.

46 Govan and Kim, *James Turrell*, 211–12.

47 Yulia Ustinova, *Caves in the Ancient Greek Mind: Descending Underground in the Search for Ultimate Truth* (New York: Oxford University Press, 2009), 215. This is an excellent survey of the importance of caves in the Western tradition.

48 I will consider negative theology in the following chapters.

49 Georges Bataille, *Lascaux, or The Birth of Art*, trans. Austryn Wainhouse (Geneva, Switzerland: Skira, n.d.), 11. Bataille's denial that Neanderthals created art has been called into question by recent scientific findings. See Carl Zimmer, "Neanderthals, the World's First Misunderstood Artists," *New York Times*, February 22, 2018.

50 Bataille, *Lascaux*, 11, 49.

51 Georges Bataille, *Inner Experience*, trans. Leslie Anne Boldt (Albany: State University of New York Press, 1988), 52, 36.

52 Blanchot, *Infinite Conversation*, 209.

53 Nicholas of Cusa, *Selected Spiritual Writings*, trans. H. Lawrence Bond (New York: Paulist Press, 1997), 213.

CHAPTER THREE

1 G. W. F. Hegel, *Phenomenology of Spirit*, trans. A. V. Miller (New York: Oxford University Press, 1968), 49. Translation modified.

2 Derrida organizes his monumental study of Hegel around the image of *glas*, which is the death knell sounded by church bells as the funeral procession passes. *Glas*, trans. J. P. Leavy and R. A. Rand (Lincoln: University of Nebraska Press, 1986).

3 Hegel, *Phenomenology*, 59–61.

4 Yve-Alain Bois, "Two Paintings by Barnett Newman," *October* 108 (Spring, 2004): 4.

5 Barnett Newman, *Barnett Newman: Selected Writings and Interviews*, ed. John P. O'Neill (Berkeley: University of California Press, 1992), 140.

6 Thomas Hess, *Barnett Newman* (New York: Museum of Modern Art, 1971), 22–23. I have drawn most of the details about Newman's life from Hess's study.

7 Newman, *Selected Writings*, 178.

8 Quoted in Hess, *Barnett Newman*, 24–25. The biographical details in the preceding paragraphs are gathered primarily from Hess's essay.

9 Newman, *Selected Writings*, 174–75.

10 Quoted in Hess, *Barnett Newman*, 73.

11 Ann Temkin, *Barnett Newman* (Philadelphia: Philadelphia Museum of Art, 2002), 158.

12 Jean-François Lyotard, "The Sublime and the Avant-Garde," in *The Lyotard Reader*, ed. Andrew Benjamin (Cambridge, MA: Basil Blackwell, 1989), 197.

13 Immanuel Kant, *Critique of Judgment*, trans. James Meredith (New York: Oxford University Press, 1973), 97–98.

14 Kant, *Critique of Judgment*, 100.

15 Quoted in Govan and Kim, *James Turrell*, 30.

16 Quoted in Govan and Kim, *James Turrell*, 100.

17 Newman, *Selected Writings*, 171.

18 Newman, *Selected Writings*, 173.

19 Temkin, *Barnett Newman*, 1978.

20 Alain Corbin, *Historie du Silence: De la Renaissance à nos jours* (Paris: Editions Albin Michel, 2016), 9. I would like to express my appreciation to my colleague Clemence Bouloque for translating this passage. For a thoughtful meditation on silence, see her work, *Mort d'un silence* (Paris: Gallimard, 2015).

21 *American Heritage Dictionary*.

22 Hess, *Barnett Newman*, 55.

23 Hess, *Barnett Newman*, 71.

24 Wassily Kandinsky, *Point and Line to Plane* (New York: Dover, 1979), 25, 57.

25 For an elaboration of this distinction, see my book, *Erring: A Postmodern A/Theology* (Chicago: University of Chicago Press, 1987).

26 Gershom Scholem, *Major Trends in Jewish Mysticism* (New York: Schocken Books, 1941), 261. "En-Sof" also refers to something without end.

27 Eliot Wolfson, "The Holy Cabala of Changes: Jacob Boehme and Jewish Esotericism," *Aries—Journal for the Study of Western Esotericism* 18 (2018): 35. While Scholem's study of Jewish mysticism has long been accepted as normative, Wolfson's work is much more sophisticated philosophically. No one has a better understanding of the relation between the Kabbalah and Heidegger's philosophy.

28 I will return to the figure of the horizon in chapter 11.

29 Eliot Wolfson, *Language, Eros, Being: Kabbalistic Hermeneutics and Poetic Imagination* (New York: Fordham University Press, 2005), 293–94.

30 I will consider Kierkegaard's *Fear and Trembling* in the discussion of Rothko in chapter 6.

31 Hess, *Barnett Newman*, 110. While the titles of many of Newman's paintings offer ample evidence of the importance of the Jewish religious tradition for his work, Hess was the first to draw a connection between his paintings and the Kabbalah.

32 Hess, *Barnett Newman*, 111–13. The titles in this text are the names of additional paintings related to the synagogue and "Zim Zum." In chapter 10, I will consider Derrida's elaboration of the notion of *Makom* or place.

33 Gen. 1:1–5 (*The New English Bible* [New York: Oxford University Press, 1970]).

34 Martin Heidegger, *Mindfulness*, trans. Parvis Emad and Thomas Kalary (New York: Bloomsbury, 2016), 47. Two other works are noteworthy in this context: Dennis Schmidt, *Between Word and Image: Heidegger, Klee, and Gadamer on Gesture and Genesis* (Bloomington: Indiana University Press, 2013); and David Norwell Smith, *Sounding/Silence: Martin Heidegger at the Limits of Poetics* (New York: Fordham University Press, 2013).

35 Heidegger, *Poetry, Language, Thought*, 207–08. Translation modified.

36 Martin Heidegger, *Contributions to Philosophy (From Enowning)*, trans. Parvis Emad and Kenneth Malay (Bloomington: Indiana University Press, 1999), 359.

37 Thomas J. J. Altizer, *The Self-Embodiment of God* (New York: Harper and Row, 1977), 27.

38 Martin Heidegger, *On the Way to Language*, trans. Peter D. Hertz (New York: Harper and Row, 1971), 126.

39 Martin Heidegger, *What is Called Thinking?*, trans. J. Glenn Gray (New York: Harper and Row, 1968), 9.

40 Ferdinand de Saussure, "Course in General Linguistics," *Deconstruction in Context*, ed. Mark C. Taylor (Chicago: University of Chicago Press, 1986), 167.

41 Martin Heidegger, *Early Greek Thinking*, trans. David Farrell Krell and Frank A. Capuzzi (New York: Harper and Row, 1975), 76–77.

42 Emmanuel Levinas, *Otherwise than Being or Beyond Essence*, trans. Alphonso Lingis (Boston: Martinus Nijhoff, 1974), 5. Translation modified.

43 Heidegger, *Poetry, Language, Thought*, 190.

44 Levinas, *Otherwise than Being*, 45.

45 Levinas, *Otherwise than Being*, 48, 45.

46 *Oxford English Dictionary* (New York: Oxford University Press, 1971).

47 Levinas, *Otherwise than Being*, 6.

48 I will consider important insights of psychoanalysis for the issue of silence in chapter 7.

49 Julia Kristeva, *Desire in Language: A Semiotic Approach to Literature and Art*, trans. Leon Roudiez (New York: Columbia University Press, 1980), 136.

50 Julia Kristeva, *Powers of Horror: An Essay on Abjection*, trans. Leon Roudiez (New York: Columbia University Press, 1982), 61.

51 Kristeva, *Desire in Language*, 221.

52 Heidegger, *On the Way to Language*, 134–35.

53 Heidegger, *On the Way to Language*, 134–35, 120.

54 Heidegger, *On the Way to Language*, 47.
55 Martin Heidegger, *Being and Time*, trans. John Macquarrie and Edward Robinson (New York: Harper and Row, 1962), 261.
56 Heidegger, *Poetry, Language, Thought*, 60–61.
57 Heidegger, *Poetry, Language, Thought*. Translation modified.
58 Wallace Stevens, *The Collected Poems of Wallace Stevens* (New York: Knopf, 1981), 10.

CHAPTER FIVE

1 For an elaboration of this point, see my book, *Disfiguring: Art, Architecture, Religion* (Chicago: University of Chicago Press, 1992).
2 Clement Greenberg, "Modernist Painting," *The Collected Essays*, ed. John O'Brian (Chicago: University of Chicago Press, 1993), 4:85.
3 Quoted in Alec R. Vidler, *The Church in an Age of Revolution* (Baltimore: Penguin, 1971), 31.
4 Friedrich Schleiermacher, *On Religion: Speeches to Its Cultured Despisers*, trans. John Oman (New York: Harper and Row, 1958), 39.
5 Schleiermacher, *Speeches*, 41–42.
6 Schleiermacher, *Speeches*, 41–43.
7 Schleiermacher, *Speeches*, 136.
8 Hegel, *Phenomenology of Spirit*, 6.
9 *Last Paintings* (Bottrop, Germany: Josef Albers Museum Quadrat, September 26–January 9, 2009) (exhibition).
10 Blavatsky and Stiener influenced other leading artists, most notably Mondrian, who, like Kandinsky, was a theosophist, and Joseph Beuys, who was an anthroposophist. For a more detailed discussion of these relationships, see *Disfiguring*, chap. 3; and *Refiguring the Spiritual*, chap. 2.
11 Wassily Kandinsky and Franz Marc, *The Blaue Reiter Almanac*, ed. Klaus Lankheit (New York: Viking Press, 1974), 250.
12 Wassily Kandinsky, *Concerning the Spiritual in Art*, trans. M. T. H. Sadler (New York: Dover, 1977), 12.
13 "Sublimation" is, of course, the name Freud gives to the process through which art emerges from base instincts. Though rarely noted, the roots of psychoanalysis can be traced to rituals associated with mining and metallurgy. See Mircea Eliade, *The Forge and the Crucible* (Chicago: University of Chicago Press, 1979). It is also instructive to note in this context that some translators render Hegel's pivotal terms *"aufheben"* and *"Aufhebung"* as sublimate and sublimation. I prefer the more common translation "sublate."
14 Renato Poggioli, *The Theory of the Avant Garde*, trans. Gerald Fitzgerald (Cambridge, MA: Harvard University Press, 1968), 201.
15 Donald Kuspit, "Concerning the Spiritual in Contemporary Art," in *The Spiritual in Art: Abstract Painting 1890–1985*, ed. Maurice Tuchman (New York: Abbeville Press, 1986), 314.
16 Kuspit, "Concerning the Spiritual," 314.
17 Quoted in Roger Lipsey, *An Art of Our Own: The Spiritual in Twentieth-Century Art* (Boston: Shambhala, 1988), 143.
18 Roland Barthes, *Writing Degree Zero*, trans. Annett Lavers and Colin Smith (New York: Hill and Wang, 1977).
19 Quoted in Linda Henderson, *The Fourth Dimension and Non-Euclidean Geometry in Modern Art* (Princeton, NJ: Princeton University Press, 1983), 288.
20 Kasimir Malevich, *The Non-Objective World*, trans. Howard Dearstyne (Chicago: Paul Theobald, 1959), 68.

21 Malevich, *Non-Objective World*, 76.
22 Kazimir Malevich, *Essays on Art, 1915–1928*, trans. X Glowacki-Prus and A. McMillan (Copenhagen: Borgen, 1968), 1:127.
23 Quoted in Camilla Gray, *The Russian Experiment in Art, 1863–1922* (New York: Henry Abrams, 1962), 249.
24 Quoted in Stephanie Rosenthal, *Black Paintings* (Munich: Hatke Camtz, 2007), 40.
25 Ad Reinhardt, *Art-as-Art: The Selected Writings of Ad Reinhardt*, ed. Barbara Rose (New York: Viking Press, 1975), 113–14.
26 John Keats, "To Homer," Poetry Foundation, accessed May 27, 2019, https://www.poetryfoundation.org/poems/44485/to-homer.
27 Friedrich Nietzsche, *Thus Spoke Zarathustra*, trans. Marianne Cowan (Chicago: Henry Regnery, 1957).
28 Reinhardt, *Art-as-Art*, 86.
29 Rosenthal, *Black Paintings*, 14.
30 Reinhardt, *Art-as-Art*, 86.
31 Quoted in Kuspit, "Concerning the Spiritual," 317.
32 Rose, *Art-as-Art*, 82.
33 Quoted in Rosenthal, *Black Paintings*, 13. Disagreements and conflicts eventually drove the artists apart. A lawsuit asserting plagiarism involving the Black Paintings ruptured the relation between Newman and Reinhardt, and Reinhardt's misgivings about Rothko's contribution to the de Menils' Houston chapel, which I will consider in the next chapter, led to tensions. Reinhardt actually went so far as to declare, "What's wrong with the art world is not Andy Warhol or Andy Wyeth but Mark Rothko. The corruption of the best is the worst." (Quoted in Yve-Alain Bois, "The Limit of Almost," in *Ad Reinhardt* [New York: Rizzoli, 1991], 21.)
34 The writings of Jacob Boehme are the bridge that joins these medieval mystics and Luther's theology with the Jena idealists and romantics. For a consideration of the importance of Boehme's writings, see Alexandre Koyré, *La Philosophie de Jacob Boehme* (New York: Burt Franklin, 1929/1968); Ray L. Hart, *God Being Nothing: Toward a Theogony* (Chicago: University of Chicago Press, 2016); Wolfson, "Holy Cabala of Changes."
35 Quoted in Merton, *Contemplative Prayer*, 53–54.
36 Quoted in Michael Corris, *Ad Reinhardt* (London: Reaktion Books, 2008), 87, 88.
37 Thomas Merton, *New Seeds of Contemplation* (New York: New Directions, 2007), 131. Emphasis added.
38 David Sylvester, *About Modern Art: Critical Essays 1948–96* (New Haven, CT: Yale University Press), 397. In addition to Newman and Rothko, other midcentury artists who worked extensively in black included Robert Rauschenberg, Frank Stella, Willem de Kooning, Clyfford Still, Franz Klein, and Cy Twombly.
39 Quoted in Rosenthal, *Black Paintings*, 26.
40 Reinhardt, *Art-as-Art*, 102.
41 Quoted in Rosenthal, *Dark Paintings*, 38.
42 Reinhardt, *Art-as-Art*, 90.
43 Ad Reinhardt, "Autocritique de Reinhardt," in *Iris-Time* (Paris, 1963), 1.
44 Reinhardt, *Art-as-Art*, 93.
45 Susan Sontag, *On Interpretation* (New York: Farrar, Straus, Giroux, 2013), 35.
46 For instructive discussions of figures, see Thomas A. Carlson, *Indiscretion: Finitude and the Naming of God* (Chicago: University of Chicago Press, 1999); *The Indiscrete Image: Infinitude and the Creation of the Human* (Chicago: University of Chicago Press, 2008).
47 Pseudo-Dionysus, *The Divine Names and Mystical Theology*, trans. John Jones (Milwaukee: Marquette University Press, 1980), 211.

48 Cusa, *Spiritual Writings*, 107.

49 Cusa, *Spiritual Writings*, 90, 94, 121.

50 Cusa, *Spiritual Writings*, 93.

51 This is not to deny that in Christian theology, God is believed to be triune. Though the explanations are often confused, the threeness of God does not negate the oneness of God.

52 Cusa, *Spiritual Writings*, 210.

53 For further analysis of this important point, see Kevin Hart's thoughtful discussion of the relation between poetry and negative theology. *Poetry and Revelation: For a Phenomenology of Religious Poetry* (New York: Bloomsbury, 2018).

54 Reinhardt, *Art-as-Art*, 93. Emphasis added.

55 I will consider the other part of Kierkegaard's argument in *Fear and Trembling* in chapter 13.

56 Sigmund Freud, *Beyond the Pleasure Principle*, trans. James Strachey (New York: Norton, 1961), 13–14.

57 See Plato's *Phaedrus*, sec. 246 B.

58 Freud, *Beyond the Pleasure Principle*, 15.

59 See Jacques Lacan, *Feminine Sexuality: Jacques Lacan and the école freudienne*, ed. J. Mitchell and J. Rose, trans. J. Rose (New York: Norton, 1982).

60 Bois, "Limit of Almost," 29. I will return to this comment by Derrida in chapter 10.

61 Quoted in Lucy Lippard, *Ad Reinhardt* (New York: Harry Abrams, 1981), 63.

CHAPTER SIX

1 In the Christian tradition with which Kierkegaard identifies, the most extreme form of this dualistic tendency is the Gnosticism that was widespread in the eastern Mediterranean world during the early years of Christianity. Much of our knowledge about Gnosticism comes from the early Christian writer Irenaeus's (130–202) "*Against Heresies.*" According to Irenaeus's description of the writings of Valentinus, who was one of the most important Gnostics, silence played a crucial role in Gnostic theology and cosmology. Describing the hierarchy within the divine Pleroma from which the world derives, Irenaeus writes, "The first of these [dyadic deities], Valentinus, who adapted the principles of the so-called Gnostic heresy to the individual character of his school, thus expounded it, defining that there is an unnamable Dyad, of which one is called Ineffable and the other Silence. Then from this Dyad a second Dyad was produced, of which he calls one part Father and the other Truth. From the Tetrad were produced Logos and Zoe, Anthropos and Ecclesia, and this is the first Ogdoad." The mythological unfolding of this structure and the soteriology that is its aim are long and complex. In this context, the important point to note is the priority given to Silence and the Ineffable over the Logos or word.

In a provocative epilogue to his account of *The Gnostic Religion*, "Gnosticism, Existentialism, and Nihilism," Hans Jonas draws a fascinating connection between Gnostic theology and metaphysics and the twentieth-century existentialism. He traces the spiritual crisis from which existentialism comes back to the apprehension of silence, which began in the seventeenth century. "Among the features determining this situation is one which Pascal was the first to face in its frightening implications and to expound with the full force of his eloquence: man's loneliness in the physical universe of modern cosmology. 'Cast into the infinite immensity of spaces of which I am ignorant, and which know me not, I am frightened.' 'Which know me not': more than the overawing infinity of cosmic spaces and times, more than

the quantitative disproportion, the insignificance of man as a magnitude in this vastness, it is the 'silence,' that is, the indifference of this universe to human aspirations—the not-knowing of things human on the part of that within which all things human have preposterously to be enacted—which constitutes the utter loneliness of man in the sum of things." Irenaeus, "Against Heresies," in *Early Christian Fathers*, trans. Cyril Richardson (Philadelphia: Westminster Press, 1953), 1:363; Hans Jonas, *The Gnostic Religion: The Message of the Alien God and the Beginnings of Christianity* (Boston: Beacon Press, 1963), 322.

2 St. John of the Cross, *Dark Night of the Soul*, trans. E. Allison Peers (New York: Doubleday 1990), 106.

3 I will consider Kierkegaard's strategy of indirect communication in chapter 7.

4 Søren Kierkegaard, *Repetition: An Essay in Experimental Psychology*, trans. Walter Lowrie (New York: Harper and Row, 1941), 125–26.

5 Jack Miles, *God: A Biography* (New York: Knopf, 1995), 317.

6 Miles, *God*, 318, 314.

7 Søren Kierkegaard, *Fear and Trembling*, trans. Howard and Edna Hong (Princeton, NJ: Princeton University Press, 1983), 10.

8 Søren Kierkegaard, *Fear and Trembling*, trans. Walter Lowrie (Princeton, NJ: Princeton University Press, 1970), 91.

9 In his exploration of different forms of doubt, Kierkegaard was wrestling with how much to tell Regina about the reason he broke their engagement.

10 Kierkegaard, *Fear and Trembling*, Hong translation, 109.

11 Kierkegaard, *Fear and Trembling*, Lowrie translation, 91.

12 Kierkegaard, *Fear and Trembling*, Hong translation, 113.

13 Kierkegaard, *Fear and Trembling*, Hong translation, 114, 118.

14 Søren Kierkegaard, *Either-Or*, trans. Howard and Edna Hong (Princeton, NJ: Princeton University Press, 1987), 1:222.

15 James E. B. Breslin, *Mark Rothko: A Biography* (Chicago: University of Chicago Press, 1993), 465.

16 Thomas Hess, who was the first to stress the importance of the Kabbalah for Newman, goes too far when he argues that the two pyramids "meet at the point of maximum contraction and push in toward it with all their energy. That is, between the pyramid and the obelisk is Newman's reenactment of the drama of Tsimtsum, the instant of creation." Hess, in my judgment, misses the point of Newman's sculpture. The absence of the tips of the pyramids removes rather than reenacts the point of contact between the infinite and the finite. Hess, *Barnett Newman*, 121.

17 Hess, *Barnett Newman*, 121–23.

18 Barnett Newman, "Statement," in *Barnett Newman: The Stations of the Cross lema sabachthani* (New York: Guggenheim Museum, 1966).

19 Newman, *Interviews*, 189.

20 Newman, *Interviews*, 190, 187–88.

21 Lawrence Alloway, "The Stations of the Cross and the Subjects of the Artist," in *Selected Writings and Interviews*, by Barnett Newman, ed. John O'Neill (Berkeley: University of California Press, 1992), 190, 187–88.

22 I will consider Kelly's chapel in chapter 9.

23 Temkin, *Barnett Newman*, 229.

24 Breslin, *Mark Rothko*, 535. I have drawn on Breslin's fine work for the details of Rothko's suicide.

25 Quoted in Breslin, *Rothko*, 529.

26 Quoted in Breslin, *Rothko*, 539, 543.

27 John Logan, *Red* (London: Oberon Books, 2012), 21, 9, 3.

28 Quoted in Anna Chave, *Mark Rothko: Subjects in Abstraction* (New Haven, CT: Yale University Press, 1989), 80.

29 Quoted in Robert Rosenblum, *Modern Painting and the Northern Romantic Tradition: Friedrich to Rothko* (New York: Harper and Row, 1975), 215.

30 Sheldon Nodelman, *The Rothko Chapel Paintings: Origins, Structure, Meaning* (Austin: University of Texas Press, 1997), 302. Nodelman's study is the best work on Rothko's Houston chapel.

31 Breslin, *Rothko*, 480.

32 Quoted in Nodelman, *Rothko Chapel Paintings*, 301.

33 Breslin, *Rothko*, 482.

34 Nodelman, *Rothko Chapel Paintings*, 336.

35 Søren Kierkegaard, *Philosophical Fragments*, trans. David Swenson (Princeton, NJ: Princeton University Press, 1971), 55.

36 Quoted in Nodelman, *Rothko Chapel Paintings*, 306.

37 Quoted in Rosenblum, *Modern Painting*, 213.

38 "*Winter Light* (1963): Quotes," IMDb, accessed May 27, 2019, https://www.imdb.com/title/tt0057358/quotes.

39 Nodelman, *Rothko Chapel Paintings*, 304.

40 Ingmar Bergman, "The Seventh Seal," in *Four Screenplays* (New York: Garland, 1985), 138.

41 Bergman, "Seventh Seal," 149, 150, 175.

42 Bergman, "Seventh Seal," 197, 199, 200.

CHAPTER SEVEN

1 Quoted in Robert Ayers, "A Hole Beyond Measure," *ARTNEWS*, May 25, 2017, http://www.artnews.com/2017/05/25/a-hole-beyond-measure-anish-kapoor-on-his-watery-new-descension-and-the-intersection-of-meaning-and-not-meaning/.

2 Ayers, "Hole Beyond Measure."

3 Edgar Alan Poe, "Silence," in *Poe: Poetry and Tales* (New York: Library of America, 1984), 77.

4 Edgar Alan Poe, "Silence—A Fable," in *Poetry and Tales*. All quotations are from pp. 221–24.

5 Edgar Alan Poe, "MS. Found in a Bottle," in *Poetry and Tales*. All quotations are from pp. 189–99.

6 Kant, *Critique of Judgment*, 107.

7 Kant, *Critique of Judgment*, 92. Emphasis added.

8 Martin Heidegger, *Kant and the Problem of Metaphysics*, trans. Richard Taft (Bloomington: Indiana University Press, 1997), 112.

9 Immanuel Kant, *Critique of Pure Reason*, trans. Norman Kemp Smith (New York: St. Martin's, 1965), 183.

10 Ameena Meer, interview with Anish Kapoor, *BOMB*, January 1, 1990, https://bombmagazine.org/articles/anish-kapoor/.

11 Quoted in Germano Celant, *Anish Kapoor* (Milan: Edizioni Charta, 1996), xxiv.

12 Celant, *Anish Kapoor*, xix.

13 Quoted in Celant, *Anish Kapoor*, xx.

14 Celant, *Anish Kapoor*, xx.

15 Celant, *Anish Kapoor*, xxi–xxii.

16 Celant, *Anish Kapoor*, xiv.

17 Meer, interview with Anish Kapoor.

18 Quoted in Celant, *Anish Kapoor*, xxix.

19 "Vantablack," Surrey NanoSystems, accessed May 27, 2019, https://www
 .surreynanosystems.com/vantablack.
20 Sarah Cascone, "Anish Kapoor Adds New 'Super Black' to His Palette," *Artnet
 News*, September 23, 2014, https://news.artnet.com/art-world/anish-kapoor-adds
 -new-super-black-to-his-palette-111382.
21 Quoted in Celant, *Anish Kapoor*, xxx.
22 I will return to the issue of the maternal and feminine in Kapoor's work below.
23 Quoted in Celant, *Anish Kapoor*, xxx.
24 Celant, *Anish Kapoor*, xxviii–xxix.
25 Celant, *Anish Kapoor*, xxxi.
26 Celant, *Anish Kapoor*, xxxi.
27 Yves Klein anticipated Kapoor's licensing of Vantablack when he was issued a
 patent for the pigment he created.
28 Celant, *Anish Kapoor*, xxxiv. I have drawn the details about these works from
 Celant's study.
29 Sarah Cascone, "A Man Fell into Anish Kapoor's Installation of a Bottomless Pit at
 a Portugal Museum," *Artnet News*, August 20, 2018.
30 Meer, interview with Anish Kapoor, n.p.
31 Meer, interview with Anish Kapoor, n.p.
32 Celant, *Anish Kapoor*, xxxiv.
33 Jean Baudrillard, *The Ecstasy of Communication*, trans. Bernard and Caroline Schutze
 (New York: Semiotext[e], 1988), 21–22.
34 Kierkegaard, *Either-Or*, 1:3.
35 Kierkegaard, *Fear and Trembling*, Lowrie translation. 91.
36 Kierkegaard, *Fear and Trembling*, Hong translation, 83. Derrida discusses the secret
 at length in *The Gift of Death*, trans. David Wills (Chicago: University of Chicago
 Press, 1995).
37 Kierkegaard, *Fear and Trembling*, Hong translation, 38–39, 8.
38 Søren Kierkegaard, *The Concept of Anxiety*, trans. Reidar Thomte (Princeton, NJ:
 Princeton University Press, 1989), 123, 124.
39 Jacques Derrida, "*Fors*: The Anglish Words of Nicholas Abraham and Maria
 Torok," trans. Barbara Johnson, foreword to *The Wolf Man's Magic Word*, by Nicho-
 las Abraham and Maria Torok, trans. Nicholas Rand (Minneapolis: University of
 Minnesota Press, 1986), xiv.
40 Derrida, "*Fors*," xxxv. Translation modified.
41 Derrida, "*Fors*," xvii.
42 Quoted in Daniel Albright, *Representation and the Imagination: Beckett, Kafka,
 Nabokov, and Schoenberg* (Chicago: University of Chicago Press, 1981), 60.
43 Ihab Hassan, *The Literature of Silence: Henry Miller and Samuel Beckett* (New York:
 Knopf, 1967), chap. 5.
44 Elisabeth and James Knowlson, eds., *Beckett Remembering, Remembering Beckett:
 A Centenary Celebration* (London: Bloomsbury, 2006), http://www.ricorso.net/rx
 /az-data/authors/b/Beckett_S/xtras/xtra6.htm.
45 Samuel Beckett, *The Unnamable* (New York: Grove Press, 1958), 3. Throughout this
 section, references to this work are given in the text.
46 Edmund Husserl, *Ideas I*, trans. W. R. Boyce Gibson (London: George Allen and
 Unwin, 1931), 233.
47 *American Heritage Dictionary*.

1 Quoted in Albright, *Representation and the Imagination*, 40.

2 Albright, *Representation and the Imagination*, 45, 43.

3 Mats Persson, "To Be in the Silence: Morton Feldman and Painting," Chris Villars homepage, accessed September 10, 2018, http://www.cnvill.net/mfperssn.htm.

4 Morton Feldman, *Give My Regards to Eighth Street* (Cambridge, MA: Exact Change, 2000), 80–81.

5 "NEITHER, a libretto by Samuel Beckett for the Morton Feldman [hip-h]opera," http://bmichael.me/post/168372060/neither-a-libretto-by-samuel-beckett-for-the. Accessed September 10, 2018.

6 James Knowlson, *Damned to Fame: The Life of Samuel Beckett* (New York: Simon and Schuster, 1996), 556–57.

7 Persson, "To Be in Silence."

8 As we have seen, there is a countertendency in Heidegger's philosophy that under-cuts Hegelianism and anticipates Derrida's deconstructive practice. I will consider this in more detail in the last section of this chapter.

9 *American Heritage Dictionary*.

10 See also *The Ear of the Other: Otobiography, Transference, Translation*, ed. Christie McDonald (Lincoln: University of Nebraska Press, 1988).

11 Jacques Derrida, "Tympan," in *Margins of Philosophy*, x. Hereafter references to this book are given in the body of the text.

12 Edmund Jabès, *The Book of Margins*, trans. Rosmarie Waldrop (Chicago: University of Chicago Press, 1993), 65.

13 Maurice Merleau-Ponty, *The Prose of the World*, trans. John O'Neill (Evanston, IL: Northwestern University Press, 1973), 88–89.

14 Robert Venturi et al., *Learning from Las Vegas: The Forgotten Symbolism of Architec-tural Form* (Cambridge, MA: MIT Press, 1988), 61, 68.

15 Jean Baudrillard, *Simulations*, trans. Paul Foss, Paul Patton, and Philip Reitchman (New York: Semiotext[e], 1983), 2.

16 See Mark C. Taylor, "Rend(er)ing," in *Double Negative: Sculpture in the Land*, by Michael Heizer (New York: Rizzoli, 1991).

17 Andy Warhol, *The Philosophy of Andy Warhol* (New York: Harcourt and Brace, 1975), 92.

18 Michael Heizer, *Sculpture in Reverse*, ed. Julia Brown (Los Angeles: Museum of Contemporary Art, 1984), 11.

19 Heizer, *Sculpture in Reverse*, 11.

20 Heizer, *Sculpture in Reverse*, 16, 13.

21 Quoted in Celant, *Michael Heizer* (Milan: Fondazione Prada, 1997), 34.

22 Celant, *Michael Heizer*, xv.

23 Quoted in Celant, *Michael Heizer*, 162.

24 Quoted in Heizer, *Sculpture in Reverse*, 39.

25 Heizer, *Sculpture in Reverse*, 31.

26 Heizer, *Sculpture in Reverse*, 15–16.

27 Heizer, *Sculpture in Reverse*, 15.

28 Heizer, *Sculpture in Reverse*, 33.

29 Martin Heidegger, *Mindfulness*, trans. Arvis Emad and Thomas Kalary (New York: Bloomsbury, 2016), 77.

30 Heidegger, "The Thing," in *Poetry, Language, Thought*, 167, 169.

31 Heidegger, "The Thing," 208.

32 Jacques Derrida, "Khora," in *On the Name*, trans. David Wood, John Leavery, and Ian McLeod (Stanford, CA: Stanford University Press, 1995), 93.

33 Derrida, "Khora," 92–93.

34 Jacques Derrida, "How to Avoid Speaking: Denials," in *On Languages of the Unsayable: The Play of Negativity in Literature and Theory*, ed. Sanford Burdick and Wolfgang Iser (New York: Columbia University Press, 1989), 37.

35 Meister Eckhart, *The Essential Sermons, Commentaries, Treatises and Defense*, trans. Edmund Colledge and Bernard McGinn (New York: Paulist Press, 1981), 180–81.

36 Leonard Cohen, "Anthem," *You Want It Darker*, Columbia, SONY Music, 2016.

CHAPTER TEN

1 Jean Baudrillard, *America*, trans. Chris Turner (New York: Verso, 1988), 68–69.

2 It is noteworthy, of course, that all of these artists are men. While this was not unusual in the art world at that time, it seems that the affinity for the West was particularly strong among male artists.

3 I will return to Austin in the next chapter.

4 See, for example, Richard Parker, "The Rio Grande is Dying: Does Anyone Care?" *New York Times*, September 8, 2018.

5 Kathleen Shafer, *Marfa: The Transformation of a West Texas Town* (Austin: University of Austin Press, 2017), 66–67. I have drawn on Shafer's fine book for details about the town and surroundings of Marfa.

6 Quoted in Shafer, *Marfa*, 124.

7 *Donald Judd Writings* (New York: Judd Foundation, 2016), 849.

8 Judd, *Writings*, 425, 426, 428.

9 Quoted in Barbara Haskell, *Donald Judd* (New York: Norton, 1988), 46.

10 Shafer, *Marfa*, 92.

11 Judd, *Writings*, 115.

12 Judd, *Writings*, 136, 447.

13 Judd, *Writings*, 142–43, 833.

14 Judd, *Writings*, 836, 833.

15 Shafer, *Marfa*, 101–3.

16 Wittgenstein, *Tractatus Logico-Philosophicus*, 108.

17 Judd, *Writings*, 298.

18 Stevens, *Collected Poems*, 76.

19 "Parergon" in painting means "something subordinate or accessory to the main subject"; an "ornamental accessory or addition"; "a supplemental work." The word derives from the Latin *parergen*, which means an extra ornament in art. *Oxford English Dictionary*.

20 Jacques Derrida, *The Truth in Painting*, trans. Geoff Bennington and Ian McLeod (Chicago: University of Chicago Press, 1987), 63, 9.

21 Quoted in Michael Govan and Anna Bernardini, *Robert Irwin and James Turrell: Villa Panza* (New York: Del Monico Books, 2013), 68.

22 Quoted in Lawrence Weschler, *Seeing is Forgetting the Name of the Thing One Sees: A Life of Contemporary Artist Robert Irwin* (Berkeley: University of California Press, 1982), 6.

23 Robert Irwin, *Being and Circumstance? Notes Toward a Conditional Art* (San Francisco: Lapis Press, 1985), 14.

24 Quoted in Weschler, *Seeing*, 6.

25 Weschler, *Seeing*, 44.

26 Weschler, *Seeing*, 127, 61.

27 Govan and Bernardini, *Villa Panza*, 97.

28 Weschler, *Seeing*, 92.

29 Irwin, *Being and Circumstance*, 27.

30 Katie Mendelson, "Robert Irwin's Gardens at Dia: Beacon," *Garden Design*, accessed May 27, 2019, https://www.gardendesign.com/new-york/dia-beacon.html.

31 Weschler, *Seeing*, 178.

32 Weschler, *Seeing*, 160.

33 Ally Betker, "Robert Irwin's Grand Stand in Marfa," *W Magazine*, July 21, 2016, https://www.wmagazine.com/story/robert-irwin-project-marfa-chinati -foundation.

34 Irwin, *Being and Circumstance*, 29.

35 Jabès, *El, or The Last Book*, 4.

36 Quoted in Lawrence Weschler, "Playing It as It Lays & Keeping It in Play: A Visit with Robert Irwin," in *Robert Irwin*, ed. Russell Ferguson (New York: Rizzoli, 1993), 178.

37 Herman Melville, *Moby Dick or, The Whale* (Berkeley: University of California Press, 1979), 197–98.

38 Nietzsche, *Gay Science*, 181.

39 Quoted in Michael Agresta, "Miracle in the Desert," *Texas Monthly*, July 2016.

CHAPTER ELEVEN

1 Robert Irwin, "The Hidden Structure of Art," in *Robert Irwin* (New York: Rizzoli, 1993), 36.

2 Friedrich Nietzsche, "Dionysus-Dithyrambs," Nietzsche Channel, accessed May 27, 2019, http://www.thenietzschechannel.com/works-pub/dd/dd.htm.

3 Friedrich Nietzsche, *Thus Spoke Zarathustra: A Book for All and a Book for None*, trans. Adrian Del Caro (New York: Cambridge University Press, 2006), 6.

4 St. John of the Cross, *Dark Night of the Soul*, 181.

5 For a brilliant reassessment of the importance of beauty, see Richard O. Prum, *The Evolution of Beauty: How Darwin's Forgotten Theory of Mate Choice Shapes the Animal World and Us* (New York: Doubleday, 2017).

6 John Calvin, *Institutes of the Christian Religion*, trans. Ford L. Battles (Philadelphia: Westminster Press, 1960), 52. Calvin's emphasis on the aesthetic dimension of creation is notably different from Luther's doctrine of the Two Kingdoms in which faith is inward and the outer world is corrupt and must be regulated by divine laws enforced through human actions.

7 Jonathan Edwards, *A Treatise Concerning Religious Affections* (New Haven, CT: Yale University Press, 1959), 95.

8 Calvin, *Institutes*, 101.

9 Remember, for example, Alexander Pope's observation, "All looks yellow to the jaundiced eye."

10 See, for example, Melissa Gregg and Gregory Seigworth, *The Affect Reader* (Durham, NC: Duke University Press, 2010); Anjan Chatterjee, *The Aesthetic Brain: How We Evolved to Desire Beauty and Enjoy Art* (New York: Oxford University Press, 2014).

11 Antonio Damasio, *The Feeling of What Happens: Body and Emotion in the Making of Consciousness* (New York: Harcourt Brace, 1999), 172, 126.

12 Edwards, *Religious Affections*, 253–54.

13 Edwards, *Religious Affections*, 95.

14 Edwards, *Religious Affections*, 95, 366.

15 William James, *The Varieties of Religious Experience* (New York: Megalondon, 2008), 67.

16 James, *Varieties*, 109, 125.

17 James, *Varieties*, 11.

18 James, *Varieties*, 147, 43.

19 See *Being and Time*, pt. 1, chap. 1. As we have seen above, Heidegger concentrates his analysis of *Stimmung* on moods like anxiety, fear, and boredom. Preoccupied with being-toward-death, he overlooks the importance of joy.

20 Richard R. Niebuhr, *Experiential Religion* (New York: Harper and Row, 1977), 78, 45.

21 Søren Kierkegaard, *The Journals of Søren Kierkegaard*, ed. Alexander Dru (New York: Oxford University Press, 1988), 990.

22 Niebuhr, *Experiential Religion*, 96, 98–99.

23 Kierkegaard, *Journals*, 59.

24 Nietzsche, *Zarathustra*, 264.

25 Quoted in David Scott Kastan's valuable and informative book, *On Color* (New Haven, CT: Yale University Press, 2018), 112.

26 Melville, *Moby Dick*, 198.

27 Michael Taussig, *What Color is the Sacred?* (Chicago: University of Chicago Press, 2009), 31.

28 Georges Bataille, *Theory of Religion*, trans. Robert Hurley (New York: Zone Books, 1989), 36, 57.

29 Taussig, *What Color is the Sacred?*, 18.

30 Barthes, *Camera Lucida*, 81.

31 Hegel, *Phenomenology of Spirit*, 7.

32 Taussig, *What Color is the Sacred?*, 17, 19.

33 See Jack Shear, *Spencertown: Recent Paintings by Ellsworth Kelly* (New York: Anthony d'Offay, 1994).

34 Carter E. Foster, *Ellsworth Kelly: Plant Lithographs* (Stockbridge, MA: Berkshire Botanical Garden, 2018). This book features excellent reproductions of Kelly's plant drawings.

35 Holland Cotter, "A Giant of the New Surveys His Rich Past," *New York Times*, October 13, 1996.

36 E. C. Goossen, *Ellsworth Kelly* (New York: Museum of Modern Art, 1973), 11–12.

37 Mark Rosenthal, "Experiencing Presence," in *Ellsworth Kelly: A Retrospective*, ed. Diane Waldman (New York: Guggenheim Museum, 1996), 62.

38 For a full description of this process, see John Coplans, *Ellsworth Kelly* (New York: Harry Abrams, n.d.), 42–43.

39 Barbara Rose, "Ellsworth Kelly: The Focused Vision," in *Ellsworth Kelly: Paintings and Sculptures, 1963–1979* (Amsterdam: Stedelijk Museum, 1979), 5 (exhibition catalog).

40 Coplans, *Ellsworth Kelly*, 56.

41 Tricia Paik, *Ellsworth Kelly* (New York: Phaidon, 2015), 115.

42 Diane Waldman, *Ellsworth Kelly: A Retrospective* (New York: Guggenheim Museum, 1997), 28.

43 Goossen, *Ellsworth Kelly*, 79.

44 Coplans, *Ellsworth Kelly*, 52.

45 David Hickey, "Ellsworth Kelly's Oratorical Silence," in *Ellsworth Kelly: New Paintings* (New York: Matthew Marks Gallery, 1998), 6–7.

46 There is an excellent documentary film on Matisse's complex relation with Bourgeois: *A Model for Matisse: The Story of the Vence Chapel*, directed by Barbara F. Freed (2003; New York: First-Run Features, 2006), DVD.

47 Quoted in Marie-Thérèse Pulvènis de Sèligny, *Matisse: The Chapel in Vence* (London: Royal Academy Publications, 2013), 20, 23.

48 Pulvènis de Sèligny, *Chapel in Vence*, 31, 46.

49 Kierkegaard, *Fear and Trembling*, Hong translation, 40–41.

50 Quoted in Pulvènis de Sèligny, *Chapel in Vence*, 118.

51 The English translation renders Nietzsche's title *The Gay Science*. This is not incorrect—*frölich* can be translated gay, cheerful, merry, or joyous, joyful. *Die Frölichkeit* can be translated gaiety, gladness, or joyfulness. Given the analysis of joy I develop above, I find the translation of *frölich* as joyful preferable.

52 Nietzsche, *Gay Science*, 139, 322.

53 Rosalind Krauss, "Grids," in *The Originality of the Avant-Garde and Other Modernist Myths* (Cambridge, MA: MIT Press, 1986), 18.

54 Friedrich Nietzsche, *The Birth of Tragedy*, trans. Francis Golffing (New York: Doubleday, 1956), 43, 9.

55 Nietzsche, *Birth of Tragedy*, 33–34, 67, 35, 102–3, 145.

CHAPTER THIRTEEN

1 Robert Pogue Harrison, *Forests: The Shadow of Civilization* (Chicago: University of Chicago Press, 1992), 7.

2 William Bryant Logan, *Dirt: The Ecstatic Skin of Earth* (New York: Norton, 1995), 19.

3 Roland Barthes, *The Empire of Signs*, trans. Richard Howard (New York: Hill and Wang, 1982), 4.

4 François Berthier, *Reading Zen in the Rocks: The Japanese Dry Landscape Garden*, trans. Graham Parkes (Chicago: University of Chicago Press, 2000), vii, 3.

5 Quoted in Graham Parkes, "The Role of Rock in the Japanese Dry Landscape Garden," in *Reading Zen in the Rocks*, 92.

6 Berthier, *Reading Zen in the Rocks*, 20.

7 Berthier, *Reading Zen in the Rocks*, 12, 31, 37.

8 Berthier, *Reading Zen in the Rocks*, 37–38.

9 Michael Como, personal communication.

10 David Slawson, *Secret Teachings in the Art of Japanese Gardens: Design Principles, Aesthetic Values* (New York: Kodansha International, 1987), 96–97.

11 Quoted in Parkes, "Role of Rock," 111.

12 Slawson, *Secret Teachings*, 117.

13 Berthier, *Reading Zen in the Rocks*, 42, 13.

14 Barthes, *Empire of Signs*, 74.

15 Quoted in Parkes, "Role of Rock," 85.

16 "The Heart Sutra," accessed May 27, 2019, http://path.homestead.com/heartsutra .html.

17 Nishida Kitarō, *Last Writings: Nothingness and the Religious Worldview*, trans. Jan Van Bragt (Honolulu: University of Hawaii Press, 1987), 16.

18 Nishida, *Last Writings*, 82.

19 Keiji Nishitani, *Religion and Nothingness* (Berkeley: University of California Press, 1982), 107, 102.

20 Berthier, *Reading Zen in the Rocks*, 76–77.

21 Stephen Whittington, "Digging in John Cage's Garden: Cage and Ryōanji," Academia.edu, accessed October 3, 2018, https://www.academia.edu/7319210 /Whittington_Digging_In_John_Cages_Garden.

22 Whittington, "Digging."

23 Cage, *Silence*, 109–10.

24 Shizuteru Ueda, "Silence and Words in Zen Buddhism," *Diogenes*, no. 170 (Summer 1995).

25 *Grave Matters* (London: Reaktion Books, 2002); *Mystic Bones* (Chicago: University of Chicago Press, 2007); *Recovering Place: Reflections on Stone Hill* (New York:

Columbia University Press, 2014). For the art exhibitions, see https://massmoca
.org/event/grave-matters/ and https://www.clarkart.edu/Mini-Sites/Sensing-Place
/Exhibition. I will return to my work on Stone Hill in the next section.

26 Tom Heneghan, "Architecture and Ethics," Tadao Ando, *The Colors of Light*, ed.
Richard Pare (London: Pare Press, 1996), 12–13.

27 Tadao Ando, "Thinking in Ma," in *Tadao Ando* (Madrid: Croquis, 2000), 9.

28 *Tadao Ando in Conversation with Students*, ed. Matthew Hunter (Princeton, NJ:
Princeton Architectural Press, 2012), 23–24.

29 Georges Bataille, Lascaux, or The Birth of Art, 11.

30 Tadao Ando, "The Chichu Art Museum," in *Chichu Art Museum: Tadao Ando Builds
for Claude Monet, Walter De Maria, and James Turrell*, by Yuji Akimoto et al. (Berlin:
Hatje Cantz, 2005), 88.

31 Quoted in Philip Jodidio, *Tadao Ando at Naoshima: Art, Architecture, Nature* (New
York: Rizzoli, 2006), 28.

32 William J. R. Curtis, "A Conversation with Tadao Ando," in *Tadao Ando*, 13.

33 Quoted in Jodidio, *Tadao Ando at Naoshima*, 38.

34 Tadao Ando, "Spatial Composition and Nature," in *Tando Ando*, 11.

35 Ando, quoted in Barbara Nyawara, "Church of the Light by Tadao Ando,"
Archute, accessed May 27, 2019, https://www.archute.com/2015/11/05/church-of
-the-light/.

36 Though the color of Kelly's paintings and chapel appears to be at odds with the
restraint of Ando's architecture, the two had a congenial relationship. Early in
his career, Ando used images of Kelly's paintings in a model he created and sent
his design to Kelly. Kelly was impressed enough to suggest to Pritzker that Ando
would be the best architect to design the building for the foundation's art museum
in St. Louis.

37 Quoted in Heneghan, "Architecture and Ethics," 13.

38 Kenneth Frampton, "Ando at the Millennium," in *Light and Water* (New York:
Montacell, 2003), 6.

39 Heneghan, "Architecture and Ethics," 16.

40 Quoted in Frampton, "Ando at the Millennium," 6.

41 Ando, "Chichu Art Museum," 88.

42 "A Conversation between James Turrell and Tadao Ando in *Minamidera*," in Jodi-
dio, *Tadao Ando at Naoshima*, 24.

43 Quoted in Jodidio, *Tadao Ando at Naoshima*, 33.

44 Quoted in Sebastian Guinnis, "James Turrell," in *Chichu Art Museum*, 128.

45 Michael Como, personal communication.

46 Quoted in Jodidio, *Tadao Ando at Naoshima*, 13.

47 Jun'ichiro Tanizaki, *In Praise of Shadows*, trans. Thomas J. Harper (Stony Creek,
CT: Leete's Island Books, 1977), 20.

48 Werner Blaser, *Tadao Ando: Architecture of Silence* (Boston: Birkhauser, 2001), 15.

49 Jacques Derrida, "Letter to a Japanese Friend," July 10, 1983, https://grattoncourses
.files.wordpress.com/2012/11/letter_to_a_japanese.pdf.

50 Heidegger presents his discussion as an imaginary dialogue between a Japanese per-
son and an "Inquirer." Their exchange begins with the Japanese interlocutor recall-
ing that Count Shuzo Kuki had studied with the Inquirer, who responds that he
remembers Kuki well and even has a photograph of his grave located in the gardens
of the Kyoto temple. The Japanese reminds the Inquirer that Kuki devoted all his
reflection to "what the Japanese call *Iki*."

Reinhard May points out that according to Tezuka Tomio, who translated Hei-
degger's essay into Japanese, Heidegger did not actually discuss aesthetics with
Kuki. Furthermore, Tomio raises questions about Heidegger's understanding of
some of the central Japanese words and ideas considered in the dialogue. Tezuka

Tomio, "An Hour with Heidegger," in *Heidegger's Hidden Sources: East Asian Influences on His Work*, by Reinhard May, trans. Graham Parkes (New York: Routledge, 1996), 60–64. Parkes's essay, "Rising Sun over Black Forest: Heidegger's Japanese Connection," further illuminates the "Conversation." For a discussion of the term *iki*, see also Graham Parkes, "Japanese Aesthetics," *Stanford Encyclopedia of Philosophy*, December 12, 2005, https://plato.stanford.edu/entries/japanese-aesthetics/.

51 Heidegger, *On the Way to Language*, 45; 142. Translation modified.

52 Annie Dillard, *Teaching a Stone to Talk* (New York: Harper and Row, 1982), 131.

53 Serres, *Five Senses*, 195–96.

54 Dillard, *Teaching a Stone*, 125.

55 Heidegger, *Being and Time*, 208.

56 Reiner Schurmann, *Wandering Joy: Meister Eckhart's Mystical Philosophy* (Great Barrington, MA: Lindisfarne Books, 2001), 196.

57 Martin Heidegger, *Country Path Conversations*, trans. Bret Davis (Bloomington: Indiana University Press, 2010), 75.

58 Serres, *Five Senses*, 325.

59 Mark C. Taylor and Jose Marquez, *Motel Réal: Las Vegas Nevada* (Williamstown, MA: Williams College Museum of Art, 1997).

60 Susan Allport, "New England Stone Walls," in *Stone Walls: Personal Boundaries* (New York: Mariana Cook, 2011), 147–48. This book contains a collection of Mariana Cook's beautiful photographs of stone walls on the island of Martha's Vineyard.

61 Derrida's discussion of the hymen is relevant in this context. See *Dissemination*, trans. Barbara Johnson (Chicago: University of Chicago Press, 1981).

62 Dan Snow, *In the Company of Stone: The Art of the Stone Wall* (New York: Artisan, 2001), vii, 8.

63 Snow, *Company of Stone*, 95, 67, 17.

64 Snow, *Company of Stone*, 80.

65 Snow, *Company of Stone*, 6. Andy Goldsworthy is another artist who has built impressive stone walls. His walls, however, are neither as subtle nor as carefully calibrated to fit with the landscape as Snow's walls. Many of them look like they could have been placed anywhere. See Andy Goldsworthy, *Wall at Storm King* (New York: Abrams, 2000); and *Stone* (New York: Abrams, 1994).

66 *Stone Rising: The Work of Dan Snow*, directed by Camilla Rockwell (Burlington, VT: Fuzzy Slippers Productions, 2005), DVD.

67 Ashfield Stone homepage, accessed May 27, 2019, http://www.ashfieldstone.com.

68 Friedrich Nietzsche, *Thus Spoke Zarathustra: A Book for Everyone and Nobody*, trans. Graham Parkes (New York: Oxford University Press, 2009), 283.

INDEX

References to figures or tables are denoted by an "f" or "t" in italics following the page number.

Hegel, Georg Wilhelm Friedrich (*cont.*)
Spirit of, 56, 69–70, 98, 222, 264; *Science of Logic* of, 56–57

Heidegger, Martin, 11–15, 21, 41–43, 56, 69, 83–89, 160, 171, 186, 188, 219, 262–63, 290n8; *Being and Time* of, 43, 196, 262; "Dialogue on Language between a Japanese and an Inquirer" of, 258, 295n50; *Kant and the Problem of Metaphysics* of, 13, 145; "Language" of, 83–84; *On the Way to Language* of, 84 *f*, 258; "The Origin of the Work of Art" of, 61–62; "The Question Concerning Technology" of, 21; "The Thing" of, 186–87

Heizer, Michael, 142, 174–86, 195, 198, 204–5; "Between" of, 26; *Displaced/ Replaced Mass* of, 180–81, 187; *Displacement Paintings* series of, 179–80; *Double Negative* of, 174, 176, 179, 182–86, 189, 192, 264; *45°90°180°* of, 51, 192; *Levitated Mass* of, 181–82; *Negative Painting* of, 180; "Reverse" Las Vegas of, 179 *f*

Heneghan, Tom, 248, 251–52

Hess, Thomas, 71, 77, 82–83, 125, 283n31, 287n16

Hickey, David: "Ellsworth Kelly's Oratorical Silence" of, 226–27

Hilderbrand, Reed, 256

Hinduism, 48, 146; cosmology of, 148. *See also* religion

history: end of, 70, 98; of philosophy, 112; of theology, 112

Hitler, Adolf, 34, 39

Hokusai, Katsushika, 103

Hopkins, Gerard Manley, 19, 106; "The Habit of Perfection" of, 19

Hopps, Walter, 204

horizon: approaching, 201–8; circular, 50; derivation of, 208; and landscape, 54, 197; of life, 66; of sense, 187; and silence, 21; unsayable, 80

Houston, 192, 221

Hsieh, Tehching: *One Year Performance 1978–1979* of, 25–26

Hume, David, 56, 96, 196

Husserl, Edmund, 160–61

Huxley, Aldous, 29; *The Perennial Philosophy* of, 29–30

Ibiza, 202–4

idealism: absolute, 56; philosophical, 95–97; Platonic, 75; subjective, 56

images: culture of, 35; negation of, 15; and sounds, 36; Word and, 14. *See also* media

imagination, 1, 74, 86; and art, 217; and creativity, 154; transcendental power of, 145

India, 147–48

Ings, Simon: *A Natural History of Seeing: The Art and Science of Vision* of, 59–60

Irenaeus, 286n1

Irwin, Robert, 47, 192, 201–13, 242, 251; *Disc Paintings* of, 204; *Dot Paintings* of, 204; "Toward" of, 26

Isozaki, Arata, 239

Izenor, Stephen, 175; *Learning from Las Vegas* of, 175–76

Izutsu, Toshihiko, 258

Jabès, Edmond, 1, 16, 58, 78, 209; *The Book of Margins* of, 172; *The Book of Questions* of, 16–17; *El, or The Last Book* of, 209–10

James, William, 59; *The Principles of Psychology* of, 59; *The Varieties of Religious Experience* of, 218–20

Japan, 240, 247, 258

Job, 119–20. *See also* Bible

Johns, Jasper, 24

Johnson, Mark, 60

Johnson, Philip, 25, 124, 129, 247

Jonas, Hans, 286n1

Jones, Jennie C., 25

Joyce, James: *Finnegan's Wake* of, 159

Judaism: Bible of, 120–21; traces of, 146; tradition of, 126. *See also* Kabbalah; religion

Judd, Donald, 109, 192, 195–201, 205; *15 Untitled Works in Concrete* of, 200, 207; *100 Untitled Works in Mill Aluminum* of, 199; "Some Aspects of Color in General and Red and Black in Particular" of, 198; "Specific Objects" of, 197; "Toward" of, 26

Jung, Carl, 147, 154

Kabbalah, 16, 287n16; mythology of the, 80; theology of the, 79–80. *See also* Judaism; theology

Kafka, Franz, 26

Kamps, Toby, 23, 25

Kandinsky, Wassily, 98–101; *Der Blaue Reiter* of, 99; *Concerning the Spiritual in Art* of, 99; *Point and Line to Plane* of, 78

Kant, Immanuel, 13–14, 15, 56, 59, 76, 86–87, 95–97, 122, 144–45, 156, 206; *Critique of Judgment* of, 74–75, 95–96; *Critique of Pure Reason* of, 96, 196

Kapoor, Anish, 52, 141–55, 157; *Adam* of, 151; *Angel* of, 152; *Anthropomorphic Ritual* of, 146; *At the Edge of the World* of, 154;

Schurmann, Reiner: *Wandering Joy: Meister Eckhart's Medieval Philosophy* of, 262
secrets, 155–63
seeing: and color, 67; of the invisible, 66; origin of, 47; rapture of, 224; of silence, 10, 24, 66, 77, 258, 260–72. *See also* hearing; light; perception; silence
Serra, Richard, 55; *Torqued Ellipses* of, 206
Serres, Michel, 29, 43; *The Five Senses: A Philosophy of Mingled Bodies* of, 260–61, 263
Shafer, Kathleen, 199
silence: of Abraham, 121, 123; absolute, 59; of abyssal vortices, 141–42; artful, 20–26; autumnal, 27–28; aversion to, 27–33; broken, 69, 187; color of, 1, 28, 100, 103–10; creation and, 66; and creativity, 18; demonic, 157; dimensions of, 19–20, 25; ecstasy and, 192; eternal, 214, 233, 270; experience of, 46, 76; fear of, 76; of God, 121, 125, 134–39, 156–57; hearing of, 1–2, 10, 22–24, 28, 176; hollowing out of, 25; impossibility of, 2, 16, 22; inauthentic, 40–41; of the infinite, 101; invisibility of, 24; language and, 1, 14, 18, 21, 29, 78, 83–88, 158; in the light, 49; marketing of, 38–39; moments of, 258; overwhelming, 184; pocket of, 129–34; polyphony of, 25; presenting, 69–77; reflecting on, 265; reliving the past in, 5; of the seasons, 27; and secrecy, 156; seeing of, 10, 24, 66, 77, 258, 260–72; sensitivity to, 202; and silences, 17–20, 246; social strategies of, 77; sounds and, 18, 23–24, 43–44, 69, 113, 139, 244–45; and stillness, 1–2, 17; taxonomy of, 32; terminal, 231–33; tolling, 83–91; total abstraction as a kind of, 100; two types of, 18; understanding of, 171; voluntary, 19; Word and, 1–13, 66, 69, 78, 80, 83, 116, 118, 123. *See also* desert; hearing; seeing; void
Slawson, David, 241
Smith, Roberta, 26
Smith, Tony, 72, 82
Snow, Dan, 265–67, 296n65; *In the Company of Stone: The Art of the Stone Wall* of, 265–67; *Listening to Stone* of, 265
Sontag, Susan, 16, 18–19, 43, 110; "The Aesthetics of Silence" of, 18–19
Soseki, Musō: *Dream Dialogues* of, 240
sounds: accidental, 24; of everyday life, 31; hypersonic, 37; of Muzak, 36; and silence, 18, 23–24, 43–44, 69, 113, 139,

244–45; taxonomy of, 32*t*; technological uses of, 36. *See also* music; noise
Soviet Revolution, 98
space: and color, 198; creation of, 251; emptiness of, 184; matrix of, 249; and place, 247; private, 29; public, 29; sacred, 61, 242; as spacing, 199; spiritual, 228; three-dimensional, 226; time and, 60, 200; vastness in the small, 242. *See also* time
Spinoza, Baruch, 71
Squier, George Owen, 36
Steiner, Rudolph, 98
Stella, Frank, 25, 198
Sterzing, Andreas: *silence = death* of, 25
Stevens, Wallace, 61; "Anecdote of a Jar" of, 200; "The Snow Man" of, 91
Stone, Alan, 127
structuralism, 232
sublime: absolute feeling of the, 76; alchemical process of the, 99; dynamic, 75; formlessness of the, 77; mathematical, 75; negative pleasure as the, 88, 115; notion of the, 154; in the pedestrian, 231. *See also* aesthetics
suffering, 219–20, 231
Sufism: conversion to, 196; mysticism of, 80. *See also* religion
suicide, 127–29
surrealism, 107, 222–23
Suso, Henry, 105
Suzuki, D. T., 105
Sylvester, David, 107

Tachibana no Toshitsuna: *Sakuteiki* of, 241–42
Tanizaki, Jun'ichiro: *In Praise of Shadows* of, 257
Tauler, Johannes, 105
Taussig, Michael, 222–23
technology, 35–36, 43; mass communications, 39; recording, 155; surveillance, 155
television, 35–36. *See also* media
theology: apophatic, 109, 113, 188; Christian, 286n51; foundational principles of, 77; kataphatic, 113, 188; modern, 96; negative, 64, 79, 91, 104, 109–15, 131, 144, 161, 188, 286n53; Western, 86. *See also* God; religion
Thoreau, Henry David, 28, 168
Tiger's Eye, 75
time: instant of, 12; and memory, 3; passing of, 253; private, 29; public, 29; sensation of, 73; and space, 60, 200. *See also* space